John Twachtman (1853–1902)
A "Painter's Painter"

May 4–June 24, 2006

All works can be viewed at the gallery and online at www.spanierman.com

For further information contact Christine Berry (christineberry@spanierman.com)

A fully illustrated catalogue by Lisa N. Peters, Ph.D., accompanies the exhibition.

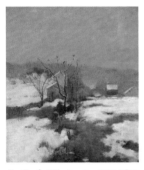

An Early Winter, ca. 1883 (Cat. 14)
Oil on canvas, 17 × 14 inches
Collection Villa America

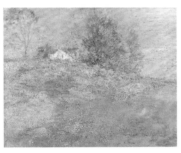

Artist's Home in Autumn, Greenwich, Connecticut, ca. 1895 (Cat. 38)
Oil on canvas, 25¼ × 30¼ inches
Signed lower right: *J. H. Twachtman*
Price on request

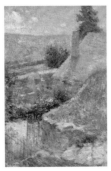

Artist's Home Seen from the Back,
ca. 1893–95 (Cat. 37)
Oil on panel, 24 × 15 inches
Signed lower left: *J. H. Twachtman*
Private Collection

Artist's House, Greenwich, Connecticut, ca. 1893 (Cat. 72)
Pen and ink on paper, 3 × 8½ inches
Signed lower left: *J. H. Twachtman—*
$8,500

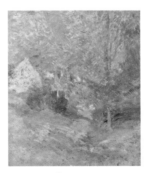

Autumn Afternoon, ca. 1894–95 (Cat. 36)
Oil on canvas, 20 × 16 inches
Signed lower left: *J. H. Twachtman*
Private Collection

Autumn Mists, ca. 1890s (Cat. 44)
Oil on canvas, 25 × 30 inches
Signed lower left: *J. H. Twachtman*
Price on request

Balcony in Winter, ca. 1901–2 (Cat. 68)
Oil on canvas, 30 × 30 inches
Stamped lower left: *Twachtman Sale*
Private Collection

Barn in Winter, Greenwich, Connecticut, early 1890s (Cat. 40)
Oil on canvas, 18 × 26 inches
Signed lower left: *J. H. Twachtman*
Price on request

Boat at Bulkhead, ca. 1878 (Cat. 71)
Pencil on paper, 11¼ × 15¼ inches
Signed lower right: *J. H. T.*
$18,500

D1422521

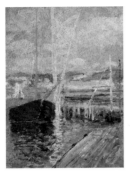

Boat Landing, ca. 1902 (Cat. 69)
Oil on panel, 13½ × 9½ inches
Stamped lower left: *Twachtman Sale*
Private Collection

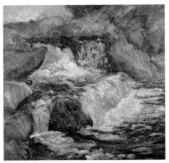

The Cascade, late 1890s (Cat. 57)
Oil on canvas, 30 × 30 inches
Signed lower left: *J. H. Twachtman*
The Cummer Museum of Art,
Jacksonville, Florida

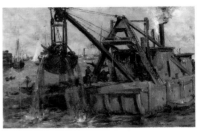

Dredging the Harbor, ca. 1879 (Cat. 7)
Oil on canvas, 12 × 18 inches
Signed lower right: *J. H. Twachtman*
Private Collection

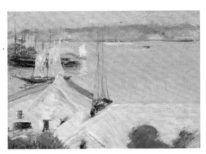

Boats at Anchor, ca. 1900 (Cat. 61)
Oil on panel, 7½ × 9⅝ inches
Signed lower left: *J. H. Twachtman*—
$135,000

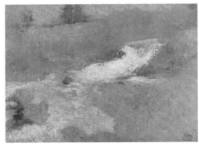

The Cascade in Spring, ca. 1890s (Cat. 55)
Oil on canvas, 22 × 30¼ inches
Stamped lower right: *Twachtman Sale*
Price on request

*Edge of the Emerald Pool,
Yellowstone*, ca. 1895 (Cat. 53)
Oil on canvas, 25 × 30 inches
Signed lower right: *J. H. Twachtman*
Price on request

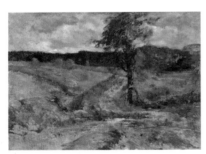

Branchville, ca. 1888–89 (Cat. 26)
Oil on canvas, 60 × 80 inches
Price on request

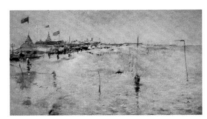

Coney Island: From Brighton Pier,
ca. 1879–80 (Cat. 8)
Oil on canvas, 14 × 24 inches
Signed lower left: *J. H. Twachtman*
Private Collection

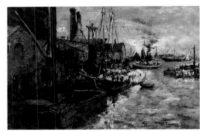

End of the Pier, New York Harbor, 1879 (Cat. 6)
Oil on canvas, 12⅛ × 18 inches
Signed, dated, and inscribed lower
right: *J. H. Twachtman N. Y. 79*
Signed lower left: *J. H. T.*
Ackerman Family Collection

Brook among the Trees,
ca. 1888–91 (Cat. 29)
Pastel on paperboard
10⅛ × 8⅜ inches
Private Collection

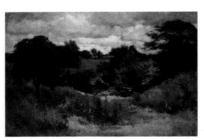

Dark Trees, Cincinnati, 1882 (Cat. 12)
Oil on canvas, 32 × 48 inches
Signed and dated lower left:
J. H. Twachtman 1882
Collection of Mr. and Mrs.
Stephen G. Vollmer

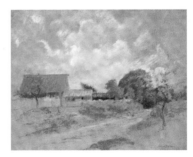

Farm Scene, ca. 1888–91 (Cat. 24)
Pastel on academy board, 17 × 21 inches
Signed lower right: *J. H. Twachtman*—
Private Collection

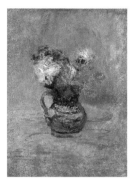

Flower Still Life, ca. 1890s (Cat. 39)
Oil on canvas, 20½ × 14½ inches
$225,000

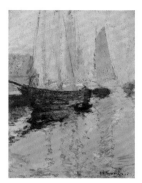

Gloucester Boats, ca. 1901–2 (Cat. 70)
Oil on panel, 12⅞ × 9¼ inches
Signed lower right: *J. H. Twachtman—*
$215,000

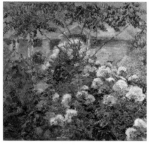

J. Alden Twachtman and John Henry
Twachtman, *Greenwich Garden,*
late 1890s (Cat. 34)
Oil on canvas, 30 × 30 inches
Signed lower left: *J. Alden Twachtman*
Price on request

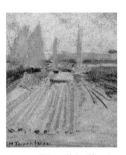

Fog and Small Sailboats, ca. 1900 (Cat. 64)
Oil on panel, 6⅜ × 5⅛ inches
Signed lower left: *J. H. Twachtman*
Private Collection

Gloucester Harbor, ca. 1900 (Cat. 60)
Oil on panel, 13¼ × 22¼ inches
Signed lower right: *J. H. Twachtman—*
Price on request

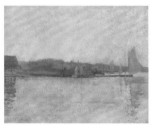

Harbor Scene, Newport, ca. 1889
Oil on board, 15⅝ × 18⅜ inches
Signed lower left: *J. H. Twachtman*
$175,000

Fountain, World's Fair, ca. 1894 (Cat. 43)
Oil on panel, 7 × 10½ inches
Inscribed on verso: *Sketch by
John H. Twachtman [1893] Chicago,
Martha S. Twachtman, 1918*
The Orr Collection

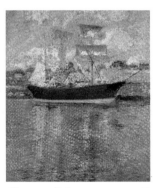

Gloucester Schooner, ca. 1900 (Cat. 59)
Oil on canvas, 30 × 25 inches
Private Collection

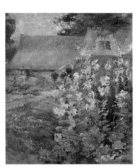

Hollyhocks, ca. 1892 (Cat. 33)
Oil on canvas, 29 × 24 inches
Signed lower right: *J. H. Twachtman*
Private Collection

French River Scene, ca. 1884 (Cat. 19)
Watercolor and gouache on paper laid
down on board, 6¾ × 11⅞ inches
Signed lower left: *J. H. Twachtman*
$90,000

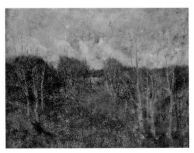

Gray Day, 1882 (Cat. 13)
Oil on canvas, 22¼ × 28 inches
Signed and dated lower right:
J. H. Twachtman—1882—
$250,000

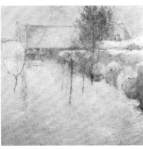

House in Snow, early 1890s (Cat. 35)
Oil on canvas, 30 × 30 inches
Private Collection

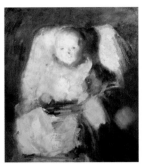

*Infant Portrait of Godfrey
Twachtman*, ca. 1897
Oil on canvas, 30 × 25 inches
$85,000

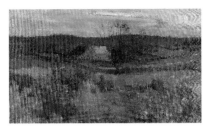

Middlebrook Farm, ca. 1888 (Cat. 23)
Oil on canvas, 18⅛ × 29⅛ inches
Signed lower left: *J. H. Twachtman*
Private Collection

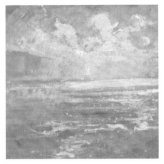

Niagara Gorge, ca. 1894 (Cat. 49)
Oil on canvas, 30 × 30 inches
Private Collection

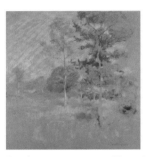

Landscape, ca. 1888–91 (Cat. 27)
Pastel on paper, 13¾ × 13 inches
Signed lower right: *J. H. Twachtman—*
$125,000

Morning Glory Pool, Yellowstone,
ca. 1895 (Cat. 54)
Oil on canvas, 29¾ × 24½ inches
Signed lower left: *J. H. Twachtman—*
Private Collection

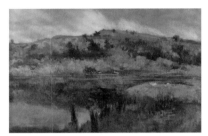

Paradise Rocks, Newport, ca. 1889 (Cat. 31)
Oil on canvas, 31½ × 47 inches
Signed lower right: *J. H. Twachtman*
Price on request

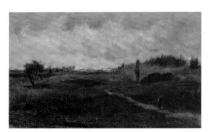

Landscape, Tuscany, ca. 1880 (Cat. 9)
Oil on canvas, 16⅝ × 25¾ inches
Signed lower left: *J. H. T.*
$140,000

Near Paris, ca. 1885 (Cat. 15)
Pastel on paper, 7½ × 10¾ inches
$60,000

*Path in the Hills, Branchville,
Connecticut*, ca. 1888–91 (Cat. 25)
Pastel on paper, 10 × 12 inches
Signed lower left: *J. H. Twachtman—*
$120,000

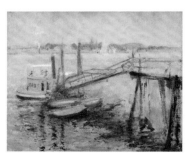

Little Giant, ca. 1900–1902 (Cat. 62)
Oil on canvas, 20 × 24 inches
Price on request

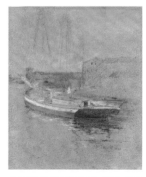

Newport Harbor, ca. 1889 (Cat. 32)
Pastel on pumice paper, 12¼ × 9¾ inches
Signed lower right: *J. H. Twachtman*
$120,000

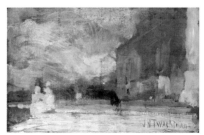

The Quai, Venice, ca. 1885 (Cat. 20)
Oil on panel, 4⅝ × 7⅛ inches
Signed lower right: *J. H. Twachtman*
$45,000

Road over the Hill, ca. 1890s (Cat. 42)
Oil on panel, 19 × 20 inches
Stamped lower left: *Twachtman Sale*
Private Collection

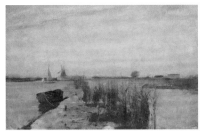

Scene along a Dutch River, ca. 1885 (Cat. 17)
Oil on canvas, 9¾ × 14⅛ inches
Private Collection

Tulip Tree, ca. 1889–91 (Cat. 28)
Oil on canvas, 43¼ × 30¼ inches
Price on request

Road Scene, ca. 1890s (Cat. 73)
Pastel and charcoal on paper
7 × 10¼ inches
$35,000

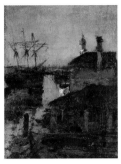

Ship and Dock, Venice,
ca. 1878 (Cat. 3)
Oil on canvas, 14¾ × 10⅝ inches
$70,000

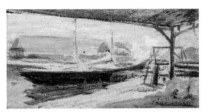

Under the Wharves, ca. 1900 (Cat. 63)
Oil on panel, 5⅛ × 9¼ inches
Signed lower right: *Twachtman*
Collection of Mr. and Mrs.
Stephen M. Sessler

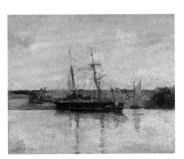

Sailing Boats, Dieppe Harbor,
ca. 1883–85 (Cat. 16)
Oil on panel, 13½ × 15½ inches
Signed lower left: *J. H. Twachtmann*
Signed lower right: *J. H. Twachtman*
Collection Villa America

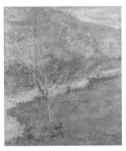

Spring, ca. 1890s (Cat. 46)
Oil on canvas, 30⅛ × 25⅛ inches
Signed lower right: *J. H. Twachtman—*
Private Collection

Upland Pastures, ca. 1890s (Cat. 45)
Oil on canvas, 25 × 30 inches
Stamped lower left: *Twachtman Sale*
Price on request

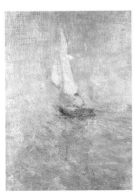

Sailing in the Mist, ca. 1895 (Cat. 47)
Oil on canvas, 30 × 21 inches
Private Collection

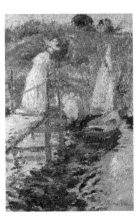

Summer Afternoon, ca. 1900 (Cat. 48)
Oil on canvas, 26 × 16 inches
Signed lower right: *J. H. Twachtman*
Private Collection

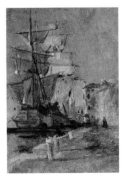

Venetian Sailing Vessel, 1878 (Cat. 4)
Oil on canvas, 15¼ × 10½ inches
Signed, dated, and inscribed lower
right: *Venice / J. H. Twachtman 78*
Private Collection

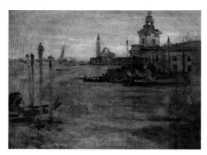

Venice, ca. 1878 (Cat. 2)
Oil on canvas, 16 × 20 inches
Signed lower right: *J. H. Twachtman*
The Orr Collection

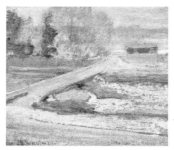

View from the Holley House,
ca. 1901 (Cat. 67)
Oil on panel, 8¼ × 9½ inches
Signed lower left: *J. H. Twachtman*
Inscribed lower right: *To Mrs. E. L. Holley*
Private Collection

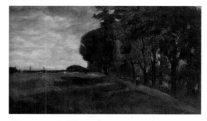

View near Polling, ca. 1876–77 (Cat. 1)
Oil on canvas, 32¼ × 54 inches
Signed lower right: *J. H. Twachtman*
$175,000

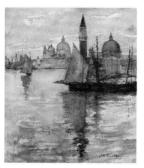

Venice, 1881 (Cat. 11)
Watercolor on paper, 13⅛ × 11 inches
Signed and dated lower right:
J. H. Twachtman/1881
Private Collection

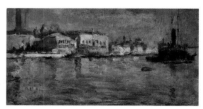

View of Venice, 1878 (Cat. 5)
Oil on canvas, 7¼ × 13¼ inches
Signed, dated, and inscribed lower
left: *J. H. Twachtman / Venice 78*
Private Collection

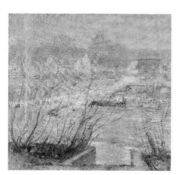

*View from the Holley House, Cos Cob,
Connecticut*, ca. 1901 (Cat. 65)
Oil on canvas, 30 × 30 inches
Signed lower left: *J. H. Twachtman*
Private Collection

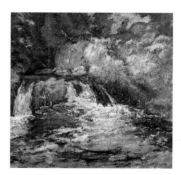

Waterfall, ca. 1898 (Cat. 56)
Oil on canvas, 30 × 30 inches
Signed lower right: *J. H. Twachtman—*
Private Collection

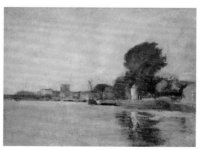

View along a River, ca. 1883–85 (Cat. 18)
Oil on canvas, 12 × 16 inches
$200,000

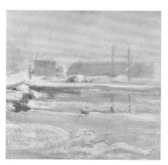

View from the Holley House, Winter,
ca. 1901 (Cat. 66)
Oil on canvas, 25⅛ × 25⅛ inches
The Hevrdejs Collection

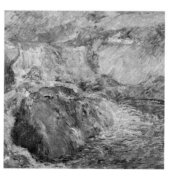

Waterfall, ca. late 1890s
Oil on canvas, 30 × 30 inches
$350,000

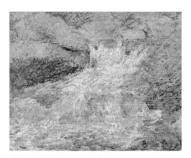

Waterfall, Greenwich, late 1890s (Cat. 58)
Oil on canvas, 25 × 30 inches
$225,000

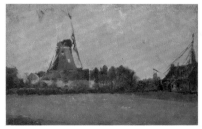

Windmill in the Dutch Countryside,
ca. 1881 (Cat. 10)
Oil on canvas, 10¾ × 15¾ inches
$100,000

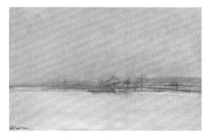

Winter Landscape with Barn,
ca. 1885 (Cat. 21)
Oil on canvas, 12¼ × 18 inches
Signed lower left: *J. H. Twachtman*
Private Collection

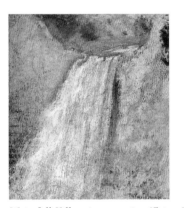

Waterfall, Yellowstone, ca. 1895 (Cat. 52)
Oil on canvas, 30¼ × 25 inches
Signed lower right: *J. H. Twachtman*—
Price on request

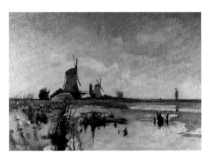

Windmills, ca. 1885 (Cat. 22)
Oil on canvas, 38 × 51½ inches
Signed lower left: *J. H. Twachtman*
Collection of Mr. and Mrs.
Stephen G. Vollmer

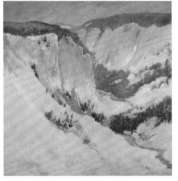

Yellowstone Park, ca. 1895 (Cat. 50)
Oil on canvas, 30 × 28½ inches
Signed lower right: *J. H. Twachtman*—
Private Collection

Wildflowers, ca. 1888–91 (Cat. 30)
Pastel on paper, 17½ × 13 inches
Signed lower right: *J. H. T.*
Private Collection

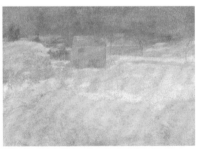

Winter Landscape, early 1890s (Cat. 41)
Oil on canvas, 22⅛ × 30 inches
Signed lower left: *J. H. Twachtman*
Private Collection

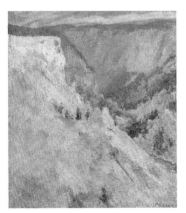

Yellowstone Park, ca. 1895 (Cat. 51)
Oil on canvas, 30 × 25 inches
Signed lower right: *J. H. Twachtman*—
Price on request

Etchings

Abandoned Mill, ca. 1888 (Cat. 75)
Etching on heavy cream wove paper
State II, Fifth Avenue Galleries,
large-paper edition, printed ca. 1889
Etching: 5 × 3½ inches
Sheet: 11⅞ × 8¾ inches
Signed in plate lower left: *J. H. T.*
Baskett, no. 20
$2,800

Branchville Fields, ca. 1888 (Cat. 76)
Etching on heavy cream wove paper
Printed by Caroline Weir Ely between
1919 and 1942 in an edition of 25
Etching: 6⅝ × 10 inches
Sheet: 10 × 11¼ inches
Signed and inscribed in pencil by Mrs.
G. Page Ely (née Caroline Weir) in plate
lower right: *J. H. Twachtman / C. W. E. imp.*
Inscribed in margin lower left: *This plate
found among those of J. Alden Weir / and
was first printed under his name — in Dec.
1942 / plate and several prints given to
Alden Twachtman / Not in Z / Sketch Fields*
Not in Baskett
$4,000

Bridgeport, ca. 1888–89 (Cat. 77)
Etching on heavy cream wove paper
State II, Fifth Avenue Galleries,
large-paper edition, printed ca. 1889
Etching: 3⅞ × 6 inches
Sheet: 8¾ × 11⅞ inches
Signed in plate lower left: *J. H. T.*
Baskett, no. 24
$7,000

Dock at Newport, ca. 1889 (Cat. 78)
Sepia etching on thin cream wove paper
Unique artist's proof, printed ca. 1889–93
Etching: 5 × 7 inches
Sheet: 7⅞ × 9½ inches
Signed in plate lower right: *J.* [in reverse]
H. T. and below *J. H. T.* [in reverse]
Inscribed on label: *Artist's Proof*
$8,500

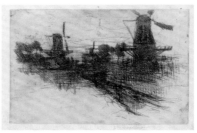

Evening, ca. 1881 (Cat. 74)
Etching on thin translucent paper
Lifetime impression, printed ca. 1881
Etching: 4¹³⁄₁₆ × 7⁷⁄₁₀ inches
Sheet: 7¾ × 9¾ inches
Signed lower right in margin:
J. H. Twachtman
Baskett, no. 11
$12,000

*Not illustrated in catalogue

Spanierman Gallery, LLC

www.spanierman.com

45 East 58th Street New York, NY 10022-1617 Tel (212) 832-0208 Fax (212) 832-8114
Monday through Saturday, 9:30 to 5:30

UP4001

John Twachtman

(1853–1902)

A "Painter's Painter"

LISA N. PETERS

with contributions by

JOHN NELSON and SIMON PARKES

May 4 – June 24, 2006

Spanierman Gallery, LLC

www.spanierman.com

45 East 58th Street New York, NY 10022 Tel (212) 832-0208 Fax (212) 832-8114

christineberry@spanierman.com Monday through Saturday, 9:30 to 5:30

10003243

Cover: *Autumn Mists* (detail of Cat. 44)

Published in the United States of America in 2006 by
Spanierman Gallery, LLC, 45 East 58th Street, New York, NY 10022.

Copyright © 2006 Spanierman Gallery, LLC.

All rights reserved. No part of this publication may
be reproduced, stored in a retrieval system, or transmitted
in any form or by any means, electronic, mechanical,
photocopying, recording, or otherwise, without prior
permission of the publishers.

Library of Congress Control Number: 2006902168

ISBN 0-945936-77-X

Design: Marcus Ratliff
Composition: Amy Pyle
Photography: Roz Akin
Color imaging: Center Page Inc.
Lithography: Meridian Printing

Contents

Foreword

THE FOLLOWING is from my introduction to the catalogue for the 1987 exhibition *Twachtman in Gloucester: His Last Years, 1900–1902*, held in our old gallery at 50 East Seventy-eighth Street: "I have felt a great affinity for the art of John Henry Twachtman since my first look at his work about forty [now almost sixty] years ago. Perhaps it was the gentle seductiveness of his vision or the way in which he seemed to probe the mysteries of distance. Twachtman's paintings don't come to me, but rather I go to them. They are paintings that make me work. At first I didn't suspect this danger. His landscapes appeared so low-keyed, wistful, and calm. But once I was drawn in, I discovered a world of poetic and haunting beauty.

Over the years I have had some adventures with Twachtman's art. In the early 1960s I bought a painting entitled *The Cascade* at a small auction on University Place in downtown New York City. The painting had yellowed under its oxidized varnish and had faded under the accumulation of over fifty years of grime, soot, and dust. I was nevertheless excited by this coup and I phoned Ray Horowitz, at that time the only collector I knew who was keenly interested in Twachtman. He rushed over, and I proceeded to clean a small "window" through the dirt and varnish. Ray was astonished, as he had never before seen a painting being cleaned. Confronted by this sudden promise of great beauty, he purchased the work. Due to the generosity of Ray and his wife, Margaret [both of whom have now sadly passed away], *The Cascade* is now in the collection of the Newark Museum of Art. It was an important gift that delighted Bill Gerdts, then curator of paintings at the museum.

In 1968 Ira Spanierman Gallery held an important Twachtman exhibition. We placed *Arques-la-Bataille* (Fig. 51), the great masterpiece of Twachtman's French period, on the east wall of the gallery. Although the show was not widely reviewed, word of its beauty, and particularly of the beauty of *Arques-la-Bataille*, spread quickly.

Artists came in a constant stream to admire this wonderful painting. John Howat, the newly appointed curator of American art at the Metropolitan Museum of Art in New York, had the insight to purchase the painting for the museum. During the show *Arques-la-Bataille* could have been sold ten times over, but happily it was soon hung just across the road at our grand old Met."

I have always felt that the art of Twachtman was not fully understood by the general public. One almost needs a "code" to break into the meaning of his works. To read them properly, it is necessary to possess a perspicacious "eye" and an understanding of nature's deeper levels of meaning. His works will then reveal themselves to you, layer by layer, each layer adding yet another puzzle buried within it and yet to be revealed.

Once I heard a renowned architect say to his client that "space is a very mysterious thing." Certainly Twachtman must have perceived this as well, for he employed his poetic artistry to reveal the silent mysteries of space.

Our current exhibition, with its accompanying catalogue, reveals that Twachtman's work grows more interesting and compelling over time. Indeed, his peers were aware of the fact that esteem and admiration for his art would only increase as the years went by.

An accumulation of knowledge has been gathered over the years on Twachtman. The curator of this show and the author of this catalogue, Dr. Lisa N. Peters, did a remarkable job of research and scholarship. She drew from her previous work on Twachtman, gathered in her capacity as my coauthor of the Twachtman Catalogue Raisonné (still in progress), from her 1995 dissertation on the artist, and from *John Henry Twachtman: An American Impressionist*, the catalogue she wrote to accompany the exhibition that was organized by the High Museum of Art in Atlanta, Georgia, in 1999 (and traveled to the Pennsylvania Academy of the Fine Arts, Philadelphia, and the Cincinnati Art Museum). Here Dr. Peters has presented a great amount of new material, revealing many discoveries on individual works and fresh perspectives on the artist in relation to his time. Christine A. Berry did a wonderful job of organizing the exhibition and played an important role in its many facets, as did our entire staff, all of whom made enormous contributions to this exhibition and catalogue.

Ira Spanierman

Acknowledgments

THIS CATALOGUE and its accompanying exhibition have been a truly collaborative effort, and I am grateful to the many people who played roles in its various aspects. My first thanks go to the lenders, whose generosity and enthusiastic support made this exhibition possible. Many of the works they made available have never or rarely been exhibited, affording opportunities to study aspects of Twachtman's art that had been little known. I also wish to express appreciation to the staffs of the many museums and institutions and the individuals who provided illustrative material for this publication.

I am extremely lucky that John Nelson and Simon Parkes were involved in this project; both contributed essays to this catalogue. In his essay, Nelson conveys his personal and deeply knowledgeable perceptions of Twachtman's former house and property in Greenwich, Connecticut, where Nelson has lived for thirty-five years. Nelson also provided invaluable information on the sites in Twachtman's Greenwich works, as well as shared experience from his long years as a sailor, by analyzing the nautical forms in many paintings. Through decades of restoring Twachtman's works, Parkes has become attuned to Twachtman's processes and intentions, and his essay conveys the understanding and admiration that he has gained of Twachtman's art through his experience as a conservator and painter.

For their long-term commitment to Twachtman scholarship, I am indebted to Richard J. Boyle and William H. Gerdts who, along with Ira Spanierman and myself, have been part of the Twachtman Catalogue Raisonné committee for many years, devoting their time and energy to studying the paintings, pastels, watercolors, and drawings that have been brought in for review. Through his publications, teaching, and lecturing, Gerdts has established the standards to which American art scholarship has aspired in the last few decades, and my gratitude extends to both his work and his role as a mentor to me, beginning with my earliest days in graduate school. I would also like to express a special thanks to Gerdts for allowing me to use his extensive American art library, which has been crucial to the research for this catalogue.

Of the individuals who have gone out of their way to provide assistance and expertise, I would like to single out several for special mention. Karen Frederick, curator at the Historical Society of the Town of Greenwich, worked diligently on sorting out the details of Twachtman's time in Cos Cob, Connecticut, and made photographic material available from the society that is being reproduced here for the first time. Frederick, along with Debra L. Mecky, executive director at the society, have worked extensively with us in arranging for part of this show to travel to Cos Cob in the summer and fall of 2006. This will provide an opportunity for Twachtman's art to be seen in the place that he loved and where he created many of his works, the Holley House, which is the home of the historical society today. Mary Baskett, the author of the definitive catalogue raisonné of Twachtman's prints, published in 1999, was an essential consultant on the etchings in this show, diligently helping us to differentiate Twachtman's different editions and impressions. As in the case of past catalogues, Fronia W. Simpson was a superb copy editor, and Amy Pyle and Marcus Ratliff produced a beautifully designed publication. Appreciation is due to Candace Hyatt for her thorough job of indexing this catalogue. To Joshua and Zachary Wakefield, I owe great thanks for their patience and interest in this project, which included a trip to Twachtman's home in Greenwich. I am, as always, beholden to Jerome Wakefield for his incredible perspicacity.

Many other people have provided critical assistance, including Tony Alvarez, Alvarez Restoration; Paul R. Baker, professor emeritus, history department, New York University; Stephanie Buck, Library and Archives, Cape Ann Historical Association, Gloucester, Massachusetts; Mary Caldera, Manuscripts and Archives, Yale University Library, New Haven, Connecticut; Mona L. Chapin, Mary R. Schiff Library and Archives, Cincinnati Art Museum; Marilyn Gould and Scotty Taylor, Wilton Historical Society, Connecticut; Scott Hisey, Cincinnati Art Museum; Mike Klahr, Boone County Cooperative Extension Service, Burlington, Kentucky; Susan G. Larkin; Meredith Long, Meredith Long and Company, Houston, Texas; Liz Makrauer, Save Venice, Inc., New York; Roy Pedersen; Bennard Perlman; Andrew Porteus, Reference, Niagara Falls Public Library, Ontario; Remak Ramsay; Jane Richards; David Stradling, department of history, University of Cincinnati; Dolores Tirri and Maria Abonnel, Weir Farm Trust, Wilton, Connecticut; Jeanette Toohey, Cummer Art Museum, Jacksonville,

Florida; William Vareika, William Vareika Fine Arts, Newport, Rhode Island; Carl White, Greenwich Public Library, Connecticut; and James L. Yarnall, Salve Regina University, Newport, Rhode Island.

All members of Spanierman Gallery have played essential roles in the exhibition and catalogue. I would like to mention a few especially. Christine Berry, who organized the exhibition, has been a full collaborator in the best sense, consulting and supervising with enthusiasm on all elements of this project. Kristen Wenger has been indispensable in her involvement with every detail of this catalogue, fastidiously pursuing many complex research questions, taking part in the editorial process, and overseeing illustrative materials. For the perfectionism and attentiveness of her work as a photographer and for her involvement with the reproductions in this catalogue, I am indebted to Roz Akin. Bill Fiddler excelled as registrar, and Katrina Thompson has been an extremely conscientious archivist. Carol Lowrey was a valuable consultant. Other members of the staff to whom I owe gratitude are Lisa Cipriano, Michael Colon, Nino Deleon, Alyssa Fridgen, Luis Garay, Gina Greer, Michael Horvath, David Major, Jennifer Martinez, Jennifer McMenemy, Jack Ming, Barbara Minor, Susan Nelly, Mary Clare Reis, Judy Salerno, Angelica Sanchez, Ralph Sessions, Elizabeth Sise, Gavin Spanierman, Jodi Spector, Kenneth Stevens, and Joe Zhou.

Above all I would like to thank Ira Spanierman for the opportunity over all these years to devote time to Twachtman's work, for his steadfast commitment to art historical scholarship, and for his sustained deep and perceptive understanding of Twachtman's art.

Lisa N. Peters

Introduction

IT HAS BEEN almost twenty years since a project to create a catalogue raisonné of John Twachtman's work was begun at Spanierman Gallery, under the authorship of Ira Spanierman and Lisa N. Peters. The amount of information and archival material that has been gathered for this future publication over this time through the efforts of many people—too many to name here—is enormous, encompassing detailed documentation of the artist's oeuvre, life, exhibitions, and references. In addition, great numbers of works have been brought before the Twachtman Catalogue Raisonné Committee, consisting of its authors as well as the noted scholars who have done in-depth research on Twachtman—Richard J. Boyle, William H. Gerdts, and John Douglass Hale (until his death in 1992)—enabling a thorough study and understanding of Twachtman's techniques and art to emerge as well as providing a venue in which many previously unknown works have come to light. During this period, insight into Twachtman has, of course, also come from the tremendous flowering of scholarship on American art of the late nineteenth century, produced by museums, academic institutions, and individuals. Seemingly on a daily basis, new information on artists, movements, groups, colonies, and associations comes to light.

This exhibition and catalogue, including almost eighty works from all phases of Twachtman's career, have benefited from the great wealth of scholarship in the last decades on the artist and the period. Curated by Lisa N. Peters, this show includes both well-known works and many that have never or rarely been on view. It builds on the monographic approach that Peters took in the catalogue for the 1999–2000 exhibition *John Twachtman: American Impressionist*, organized by the High Museum of Art in Atlanta, Georgia, using previously established information on Twachtman as a way of moving forward to consider new perspectives. The show and catalogue have also been organized in collaboration with the Twachtman Catalogue Raisonné, providing full documentation on all the works in the show.

The title of this show, *John Twachtman (1853–1902): A "Painter's Painter,"* reflects the fact that Twachtman was admired more by his fellow

artists than by art collectors of his time. The underlying aim of the exhibition is to explore why this was the case and to consider Twachtman's role in the context of his era.

The catalogue consists of five essays. The first, by John Nelson, provides a personal perspective on Twachtman's house and property in Greenwich, Connecticut, where Nelson has lived for thirty-five years. Nelson writes of the way that the house and its grounds are imbued with a spirit that Twachtman felt and captured, and expresses how both the land and Twachtman's art provide a refuge against the depredations that have occurred over the last century due to both development and changes in the land. The second essay is an appreciation by Simon Parkes, who looks at Twachtman's art from the perspective of a conservator. A great admirer of the artist, Parkes has derived a deep understanding of Twachtman's work from decades of restoring his paintings.

Three essays by Peters follow. In the first, she reveals that Twachtman acquired the label of a "painter's painter" during his lifetime and considers how he was perceived during his era, both within the context of the art world and among his peers. In her second essay, Peters addresses the topic of Realism as manifested in the works of Twachtman and other American artists of the 1870s and early 1880s who were associated with the Munich School. The essay elucidates the ways that critical attitudes toward Realism changed in this country, from a time in which the painting of modern life was encouraged to one in which artists were urged to paint more poetic types of subjects, when nationalist aspirations were on the rise. In her third essay, Peters examines the critical commentaries on Twachtman's works from the mid-1880s through the period just following his death in 1902. She explores how these writings reflected changing views in America on the nature of Impressionism and how this style, imported from France, was perceived in relation to a mode that became identified as American Tonalism in the mid-1890s. The essay brings out the way that each of these aesthetics had its own promoters, whose advocacy often had more to do with their own agendas than with deep stylistic differences between the two modes.

Peters's entries provide thorough documentation of each of the works in the exhibition and analyze their significance within Twachtman's oeuvre. Although building on the resources of the Twachtman catalogue raisonné, the entries reveal the many discoveries that have been made in the process of organizing this exhibition.

A central figure in the American art scene of his time, Twachtman, as suggested by this show's title, was probably the artist of his era who was most admired by his peers. Incapable of following trends or painting to please contemporary art buyers, he never created derivative or simply pretty images. His art, which sometimes can be difficult to understand at first glance, stands above that of many of his contemporaries for its modernity, sensuousness, and originality, qualities that still grip artists today and draw the attention of those who take the time to enter their quietly absorbing realms.

Christine A. Berry

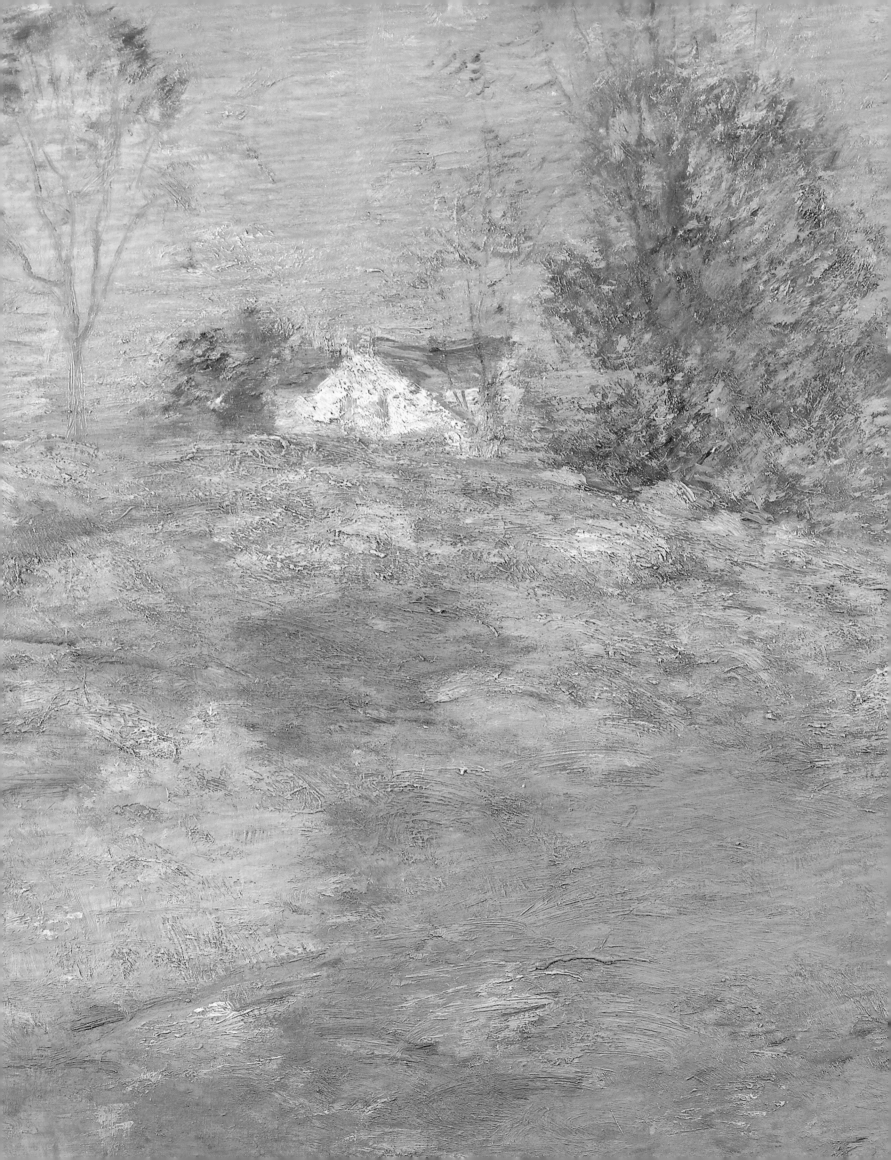

From a Personal Perspective

JOHN NELSON

I feel more and more contented with the isolation of country life. To be isolated is a
fine thing and we are all then nearer to nature. I can see how necessary it is to live
always in the country—at all seasons of the year.

—Twachtman to Weir, Greenwich, December 16, 1891, Weir Family Papers

FOR THE past thirty-five years I have lived in the house occupied and painted extensively by John Henry Twachtman from approximately 1889 through 1900. I am not a scholar, an art expert, or a historian, nor am I an artist. I am just a person who has always loved this house (it was love at first sight) and was given the privilege of buying it thirty-five years ago from its previous owners, Jim and Jane Henson of Muppet fame. It was not until after I moved in that I discovered the work of Twachtman featuring the house and its environs (Fig. 1).

Although the house itself is largely the way Twachtman left it over one hundred years ago, its surroundings bear testimony of the ravages of the twentieth and twenty-first centuries—almost more ravages in the first five years of the twenty-first than in all of the twentieth. What were once a dirt road, open fields, and pastures with an idyllic stream and beautiful farmhouse is now a major road lined with new mansions, high stone walls, security gates, and klieg lights. Add to this the toll mother nature has taken. The deer have eaten all the gardens, the trees have replaced open fields, where there was

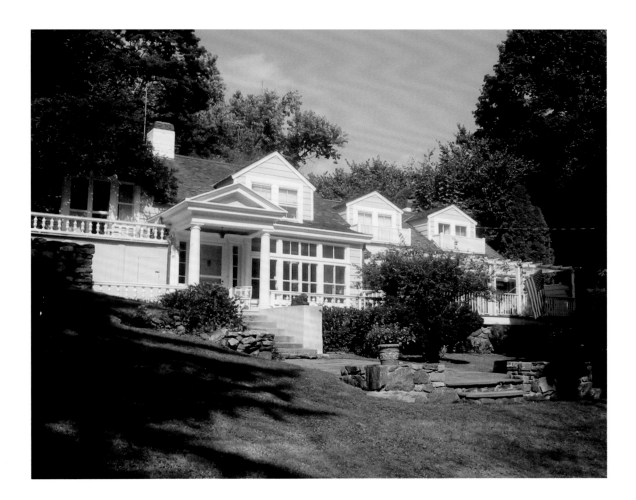

Fig. 1
Photograph, south/
front facade of
Twachtman's house
on Round Hill Road,
Greenwich, 2004.

Opposite:
*Artist's Home in Autumn,
Greenwich, Connecticut*
(detail of Cat. 38).

Fig. 2
From letter, Twachtman, "Willowbrook," to Weir, ca. fall 1889, Archives, Weir Farm National Historic Site, Wilton, Connecticut, WEFA 350.

Fig. 3
Photograph, north/back facade of Twachtman's house, Greenwich, Connecticut, ca. 1902, from Goodwin, "An Artist's Unspoiled Country Home," 1905, p. 627.

Fig. 4
Photograph, looking toward the root cellar on the north/back side of Twachtman's house, Greenwich, Connecticut, 2004.

once sunlight there is now shadow, and, owing to climate changes, much of the vegetation of Twachtman's time is not doing so well.

There are two aspects of living in Twachtman's house that make these depredations more bearable. One, of course, is the house itself; the other is Twachtman's art.

The House

Twachtman had probably heard his close friend J. Alden Weir state that "you must make a subject a part of yourself before you can properly express it to others,"* just as Weir knew the farm in Branchville that he painted extensively and at

which Twachtman was a frequent visitor. Having never been in the same place for very long since his childhood in Over the Rhine, the German section of Cincinnati, it is likely that Twachtman set out to find a place where he could be close to nature, raise a family, and make a home. Someone he met suggested he go to Greenwich to be near New York (where he had been offered a job at the Art Students League) and find land there. Greenwich had its wealthy residents even then, referred to by Twachtman as the "Queen Anne People." But subsequent events and commentary suggest that he wanted something more unspoiled and rural, something off the beaten track, surrounded by open fields, perhaps even with

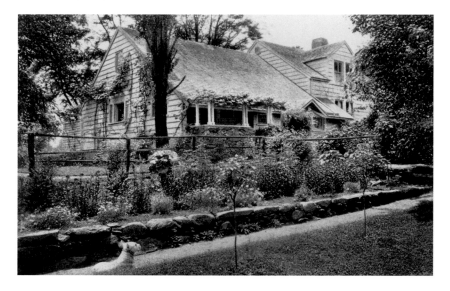

a stream running through it. So, one fine day when he was looking for property, he went hiking up Horseneck Brook with his son. When he came to that portion of the creek where it narrows into the cut between the rocks near the house, he knew he had found what he wanted and set about immediately to purchase the house and surrounding acreage (a few acres at first, then more, until he ended up with seventeen acres) from its owner. There is a painting at the Butler Museum of American Art in Youngstown, Ohio, known simply as *Landscape*, which could be a rendering of just what Twachtman saw from down in the valley that day—a few trees, mostly open fields, a cut where Horseneck Brook goes through a low hill, and with just the suggestion of a house along the ridge corresponding to where the house stands today. (The same view today would have about seven houses in it and would be mostly woodlot and no open fields.)

It was the land with its surrounding fields and sense of removal from the bustle of the rest of the world, more than the house itself, that first attracted Twachtman. The house he bought was an added-onto structure that was somewhat lacking in aesthetic qualities. In fact, for a while he planned to build a larger house, which he would call Willowbrook (Fig. 2) on top of the hill (Willowbrook being a reference to the willows that he planted along the brook, as seen, for example, in *Spring* [Cat. 46], *Misty May Morn* [Fig. 60], and *The White Bridge* [Fig. 78]).

After spending more time with his new house and land, he realized (unlike the developers of the twentieth and twenty-first centuries) that the beauty of the contours of the land that he loved so much would be destroyed by such a structure and instead decided on what in today's parlance would be called the "extreme makeover." He probably saw that the way the house was situated was good but that the house itself needed to be brought into closer harmony with the hill it was perpendicular to but not part of. He altered the north facade's vertical five-bay front by replacing the house's high roof edge with symbiotic low eaves to better subordinate it to the hill and the adjacent root cellar (also built into the hill) (Figs. 3–4).

When I was shown a copy of a painting he did of the north facade before his makeover (Fig. 5) (everyone loves before-and-after pictures, and the casual nature of this painting leads me to believe that that is what he had in mind), I did not even recognize this as the house I was living in. But then I saw a photograph taken by Theodore Robinson (Fig. 6), which clearly shows where the old roofline

(dark shingles) has been moved way down (lighter-colored shingles) to where it is now. Then I could relate this to the old center stairway that is still here but walled over and could see how dramatic his gesture was. You can see the same shingle-color line in *From the Upper Terrace* (ca. 1890s; private collection) if you look carefully. An even more graphic illustration of his alteration is in the vertical seam lines still visible on the east wall of the house. They show an original width of the house as 19 feet 3 inches to which Twachtman added 6 feet 3 inches to the south (not counting the arbor) and 9 feet 3 inches to the north. The gutter edge of the north facade roof was about 15 feet, which Twachtman boldly dropped to 7½ feet.

Fig. 5
Twachtman,
Twachtman's House,
ca. 1889–90,
oil on canvas, 15½ × 18½ inches, Thomas Colville Fine Art, LLC, New Haven, Connecticut.

Fig. 6
Photograph, Theodore Robinson, Twachtman's house in the snow, early 1890s, Archives, Spanierman Gallery, LLC, New York.

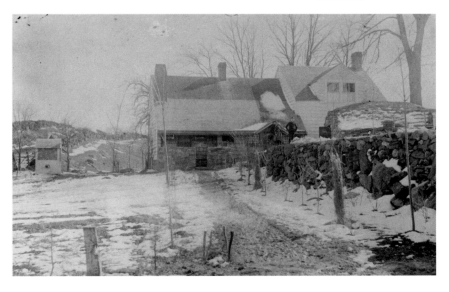

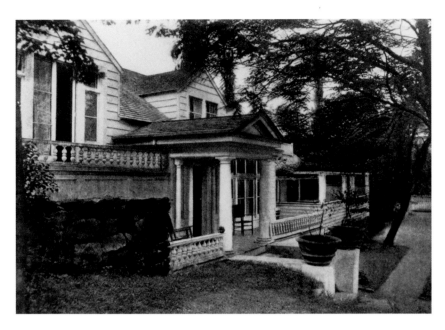

Fig. 7
Photograph, south/front
of Twachtman's house
featuring the portico,
Greenwich, Connecticut,
ca. 1902, from Goodwin,
"An Artist's Unspoiled
Country Home," 1905,
p. 626.

duck in order to go out the back door Twachtman wants me to genuflect to nature and the lines it has required (and I am glad to do so). Even when he added the portico and remodeled the south facade in about 1894 or 1895, the classic feeling of the portico is balanced by the fact that it is way below the main roofline and doesn't try to raise itself to grand proportions. The steps of the portico pull it down into the descending line of the hill, and the horizontal lines of the balustrades and window clerestories subordinate it to the horizontal contours of the house and the land (Figs. 7–8).

The low Twachtman eaves reach down to the earth and literally root the house in the soil (and are responsible for a lot of bumped heads on the way out the back door).

But bumped heads bring up something fundamental about this house and Twachtman's approach, and that is humility. The house is subservient to its surroundings, and that subservience is reflected in its lines and its position on the property. I sometimes think that by making me

This feeling of harmony with one's surroundings and the sense of security derived from being built into a hill all contribute to an almost spiritual calm when you are in the house. When I read of Twachtman's artist friends spending great evenings just discussing things by the fire in the winter or on the porch, watching the fireflies in the summer (still a magnificent show today—especially when the neighborhood's various tree lights, security lights, and floodlights are off), I can easily see how this spirit was felt by them, just as it has been by my family and our friends.

Beyond the immediate structure itself, he extended the house's lines into the landscape with walls, terraces, balustrades, arbors, and gardens that also serve to marry it to the hill and enhance the contours of the hill. A by-product

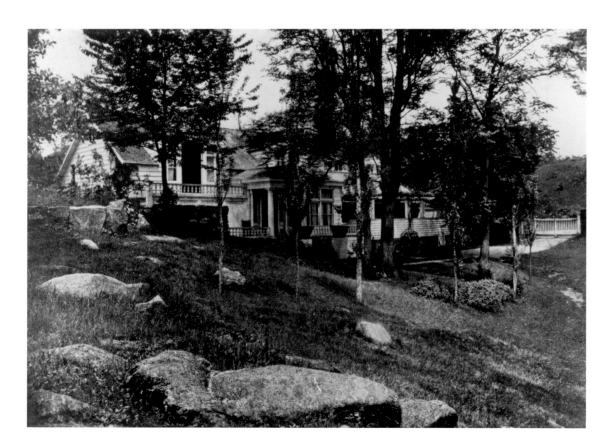

Fig. 8
Photograph, the
south/front of
Twachtman's house,
Greenwich, Connecticut,
ca. 1902, from Goodwin,
"An Artist's Unspoiled
Country Home," 1905,
p. 626.

of this is that there are lots of little terraces and porches to sit on depending on the weather and season; you literally are part of the house whether you are inside it or out. He also used plantings, vines, bushes, and trees to soften the corners and lines into more natural events. His friend Robinson wrote in his diary on May 16, 1894 (a diary that is preserved at the Frick Art Reference Library, in New York), that "Twachtman, as usual [was] making a trellis or porch for vines."

Another result of all these little landscaping nooks and separate one-off spaces is that you never see the whole property at once; it's all divided up (but in a very natural way) into different self-contained but interrelated spaces. Often after walking friends or guests around outside I ask how much land they think they've just seen. They usually reply with a number that is two to five times as large as the small piece that we have left. A testimony to good landscaping, reverence for what's here and, of course, an artistic sense.

But back to the house itself and a word about the outstanding south facade with its portico "attributed to" (never any language stronger than that) Stanford White, its romantic bedroom balcony dubbed by Childe Hassam "the Juliet balcony" (on the west wing that Hassam helped lay the foundations for), and its beautiful linear style. This facade is truly a masterpiece of balancing lines and concepts, as I have discovered every time I consider changing anything. (Mitzi Gaynor used to sing as part of her vaudeville routine, "every little movement has a meaning all its own.") When I first moved here and thought of replacing the intricacies of the living room's front windows with their matching clerestory (see Fig. 1) with one big bay window to optimize the view, I realized that the clerestory is balanced by the opposite balustrade and had to stay the way it was. Similarly, all the vertical lines of the porch under the grape arbor are reflections of the spacing and vertical lines of the portico and balustrades.

Another interesting aspect of the south facade is that a huge amount of its surface is windows. One friend mused that there was so much glass that it reminded her of one of those glass-walled ant farms we had as kids—"Look, now they're going from the living room to the bedroom." I was more comfortable when an architect friend pointed out that it is an early example of passive solar design. Its many windows let in copious and warming sun in the winter but are shaded by vines in the summer. These vines, probably personally selected and trained by Twachtman, flourish in the summer when shield from the heat

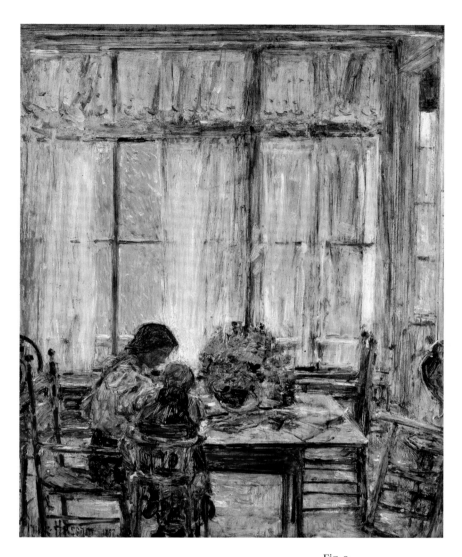

Fig. 9
Childe Hassam,
The Children, 1897,
oil on mahogany panel,
18½ × 14¼ inches,
Cincinnati Art
Museum, Bequest of
Ruth Harrison.

is needed and go away in the winter when the sun's rays are needed. These same windows also provide truly spectacular tableaux from inside looking out onto beautiful woodland and plantings (looking at magnolias and dogwoods through wisteria is truly a treat).

And speaking of living room windows. The living room has two quite large windows facing north. Artists, I understand, like the north light for painting in order to achieve truer colors. Pictures of the living room from the early 1900s and Hassam's 1897 painting *The Children* (Fig. 9) of two children working at a table in front of the south windows suggest that Twachtman's choice of living room furniture was functional. I have always wondered if he perhaps did his painting outdoors, then brought it into the living room by those big north windows to finish it off. They give a view of trees, plants, earth, and sky similar to those found all over the property.

From Twachtman's originality and marrying of the house to its surroundings I, and anyone else

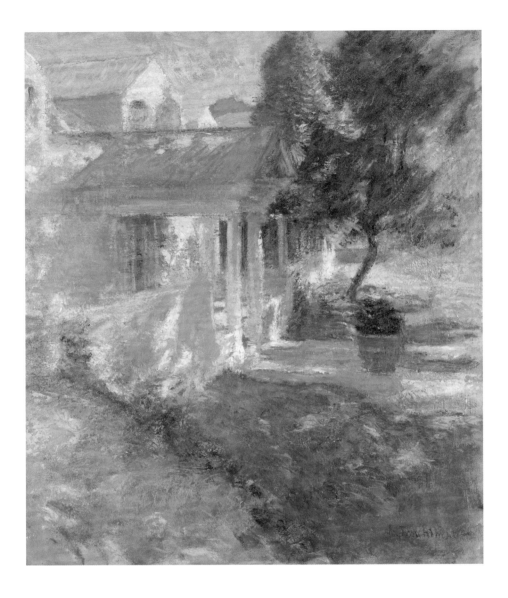

Fig. 10
Twachtman, *My House*,
ca. 1895–1900, oil on
canvas, 30⅛ × 25 inches,
Yale University Art
Gallery, New Haven,
Connecticut, Gift of
the artist.

coming to the house, can still feel the sense of harmony and integration with nature, which he intended. Intended may be a strong word if, as I suspect, he just moved spontaneously with ideas as they struck him, and that there may not have been so much a master plan as there was a serendipitous Gothic-ness about how the house grew to being the way it is now. This impulsiveness would fit with the story (told by his student Carolyn Mase) of him ordering breakfast when he was at the Holley House in Cos Cob, but by the time it was brought to the table he had bolted outside and started painting—struck by something he saw just then and forgetting all about his breakfast.

One final word on the Gothic-ness point. This house has grown like Topsy, and one analytical tool when looking at a catalogue of Twachtman paintings and photographs of the house is to look for things like the number and location of dormers or chimneys in each and use that as a way to date where in the period of his stay here that each

picture fits in. Compare, for instance, the house that was portrayed in *Summer* (ca. late 1890s, Phillips Collection, Washington, D.C.) with the one in *From the Upper Terrace* (mid-1890s, private collection).

The Art

Moving then to his art. How do paintings that were created one hundred years ago help me put up with all the new building, thwarting walls, lights, and traffic? The easy answer is that they are beautiful reminders of the house and the land that were and are in and of themselves beautiful.

But the deeper answer is that because Twachtman was so good at painting the essence of things, he teaches anyone who looks at enough of his work to see in these surroundings the essence of what makes them beautiful. Part of this may come from Weir's directive that the artist should know to the core whatever it is he paints. When

you see enough of Twachtman's paintings you come to appreciate not just the tree or the house, but the essence of the tree or the essence of the house; the way the light plays on them, the tonalities and subtleties they have, their shadows, and textures, which he rendered so well.

Many artists (and others) have said that there is something unique about the sky and air of southern France. I can agree with them and love that area and the paintings of it. But just as southern France's uniqueness can be agreed on, it should be remembered that New England has its own skies, qualities of light, and atmospheric tonalities. One of the ways that Twachtman incorporates this into his work is painting the same thing in different seasons, different lights, and different conditions.

The fact that the trees that are here now aren't the very trees he painted makes no difference because he was painting the essence of trees, not a particular tree—their angles, the way they bend, the way they trap the light. I am living in the same seasons, the same lights, the same skies, snows, and mists. Because of the insight he had and conveyed so well, I can experience those same evanescent qualities in a way I did not before.

One of my favorite paintings is called simply *My House* (Fig. 10). It shows the portico on the south facade at about 8:30 on a late spring morning. No, the date and time are not stamped or written on the picture; they don't have to be. Once you've seen that light and that brilliantly clear sky you don't forget it. It comes after what we call around here a "clearing northerly" a weather pattern often with thunderstorms, which in the summer clears out the muggy or rainy weather and replaces it with clear, dry, cool air and a refreshing breeze. As you look at *My House*, memories of mornings like that are awakened and enhanced, the brilliance of his sky, the cool clarity of the shadows, the refreshing quality of cool, dry air, and the intensity of sunlight it produces. This painting not only captures the essence of the front of the house, the portico, the balustrades (with so much sunlight reflected off them that you practically have to shield your eyes), and the arbor, but, more importantly, re-creates in the viewer the feelings and senses of a fresh and cool country morning.

This to me is Impressionism at its best— using a particular subject to re-create a sensuous experience—an impression.

He does the same thing with snow, mist, clouds. When you look at *The Last Touch of Sun* (Manoogian Collection) you can actually feel the piercing cold of a blustery winter day. In other scenes, he captures the opalescence of sunlight on snow. His ability to portray his own perceptions of these phenomena is so well done that the viewer soon develops his or her own mechanism of perception, and subsequent experiences with sunlight, snow, mist, or clouds then take on a more meaningful and artistic dimension.

A painter who missed painting the essence of things might be interesting if what you wanted was a factual recounting of exactly how things looked back then or a historical record and something to satisfy the curiosity. But because Twachtman painted the soul of his subjects you can still, one hundred years later, experience his subjects the way he did.

So here I am surrounded by the things Twachtman painted, in the atmosphere he painted them in and painted into them. I find myself perceiving as he perceived (I wish I could paint!), enjoying the essence of what is around me and, back to the original question . . . ignoring the advent of new houses or traffic, but seeing instead the workings of nature on a beautiful landscape with a beautiful farmhouse in it.

*Quoted by Joseph McSpadden, *Famous Painters of America* (New York: Dodd, Mead & Co., 1917), pp. 388–89.

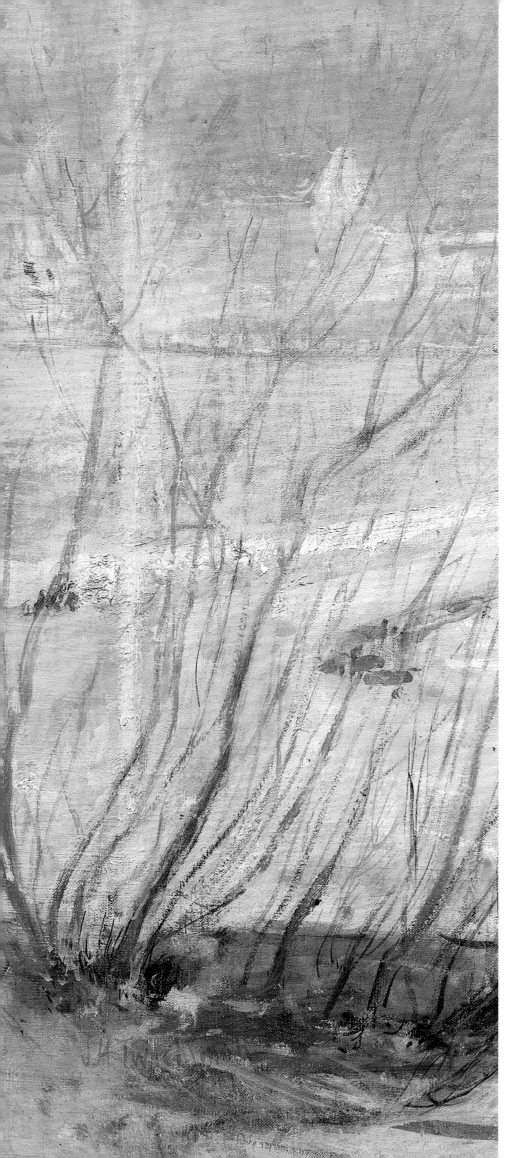

A Conservator's Appreciation

SIMON PARKES

PERHAPS we admire John Twachtman for his place as the most original of American Impressionists, for his consistency, and his dedication to his own vision. Regardless, he did not rest on his laurels (maybe he thought he didn't have any), and we are all the better for it.

He grew up as an artist with great opportunities, wonderful friends and influences, and the drive to achieve. Learning from and with Frank Duveneck in Munich, visiting Venice with Duveneck and William Merritt Chase, studying in Paris at the Académie Julian, and deriving influence from James McNeill Whistler certainly helped. Whistler changed the concept of composition through his use of long uprights and sharply angled corners, harsh perspectives and silhouettes, and profiles, which only suggest, leaving much to the imagination. When Twachtman developed his own style, he left a great deal of his early guidance behind, while continuing to draw from what he learned in Europe.

I am never so aware of pentimenti as I am when looking at Twachtman's early work. Many artists change their mind or paint over works of lesser importance, but Twachtman used this underpainting to his advantage, leaving evidence of the shapes and colors he was painting over. This process could easily be construed as opportunistic in a lesser artist, but in Twachtman's case, the organic nature of his work is never in doubt, and he did not make errors of taste or execution. Together with odd and sometimes unrelated underpainting, he often scraped passages he felt were too strong and finessed pictures in unique and personal ways.

From a restorer's standpoint, it is clear that Twachtman was well schooled in the professional techniques of his time. He obviously knew how to prime a canvas, mix his paints, and follow rules of draftsmanship and perspective, but his departure from the norm can be seen in his seemingly unusual angles and almost awkward juxtapositions of shape and color. He took chances that other American artists did not have the courage to take and would not have been successful in taking. By using a limited palette and a sometimes unre-

solved technique, he favored original composi- tions that resulted in abbreviated spaces, a shrink- ing down of the line of vision, and off-center focal points. He then wrestled with these results, adding or subduing forms to create balances that were subtle, dynamic, or asymmetrical.

He also used highly untraditional techniques. He painted over pictures and often intentionally roughed up his gesso before painting to give his pictures some life and spontaneity, even before a stroke of color was placed. He harshly scraped surfaces to suppress the impact of certain areas (Cat. 1), and he signed and deemed complete paintings that do not seem resolved in the con- ventional sense (Cat. 31). He was fearless when it came to using thin, descriptive lines that were then integrated into his designs. In his scenes of water and boats, he used a distinctive light touch, creating meandering, aqueous effects. Other American Impressionists often used strong, obvi- ous brushstrokes to paint water, but Twachtman employed different brushes and techniques to connect the physical movement of the brush more closely to his subjects. This is the nature of Twachtman's art and no one else's.

In his early work he constantly incorporated blacks and silhouettes, using them to center his pictures (Cat. 3). In Venice, of all places, he painted black, contemporary, everyday, unromantic vessels in the Grand Canal (Cat. 5). Was he trying to play off the beauty of the Doge's Palace and the Piazza San Marco against the crude forms of an indelicate steamboat? Probably not. Rarely, if ever, does one see a well-lit gondola carrying a romantic couple and parasol.

Looking through his oeuvre, we are constantly confronted with familiar themes of boats in harbors, flower gardens, views in the snow, reflec- tions in water, but his eye and treatment of these everyday subjects were fresh and revolutionary. Twachtman put a lot of energy into painting the same subjects repetitively. He frequently seems to have had an idea that was unresolved, that he wanted to work with further.

Twachtman did not force his pictures or play to the crowd. He occasionally layered his surfaces heavily and sometimes used the thinnest, lightest touch to describe a mast or rigging. Many of Paul Cézanne's paintings are similarly overworked in certain areas, while the actual descriptive technique is almost nonexistent in others.

I cannot think of another artist besides Twachtman who would paint a scene and put a leafless bush or shrub in the way, so you have to look at and through this obstruction to what

is there for you to see (Cat. 65). His angles and unapologetic diagonals are so severe that they would be hard to control in lesser hands, but he was consistently able to corral these hard shapes to create poetry (Cat. 62).

Questions often emerge in discussing conserva- tion strategies for Twachtman's works. Is a painting scraped, or has it been overcleaned? What was the artist trying to tell us in a particular work? I wish he were here to explain. Of course I would love to watch John Singer Sargent paint—who wouldn't? But to see Twachtman work at his canvases even before starting to paint and scrape his surfaces as part of his technique, to be there as he chose what to paint and why, and to be in his mind when he said "Finished," and signed a painting other artists would only just have started (or not even chosen as a subject at all) would be a treat!

Twachtman's trip to Yellowstone in the fall of 1895 produced some of the most startling concep- tual treatments of a subject painted in America in the nineteenth century (Cats. 53–54). With com- plete disregard for traditional guidelines of composition, he created works that bring the viewer face to face with great natural wonders and ask us to journey with him farther into their voids. His desire to express his feelings for these subjects, whittling down his compositions to the pools themselves and their amazing blues, is intensely modern and ambitious. Looking at these pictures is to understand a journey that only Twachtman could make.

As a restorer and painter, I am excited every time a painting by Twachtman comes to my studio. It presents a chance to learn, to think in an area in which so much is taken for granted, and to marvel at the skill and freedom that pro- duced these subtle, sometimes diminutive, but always beautiful pictures. Twachtman died very young. Would he have settled into a comfortable, boring late period like so many before or since? I doubt it. He was always curious and searching, always breaking new ground.

Opposite:
View from the Holley House, Cos Cob, Connecticut (detail of Cat. 65).

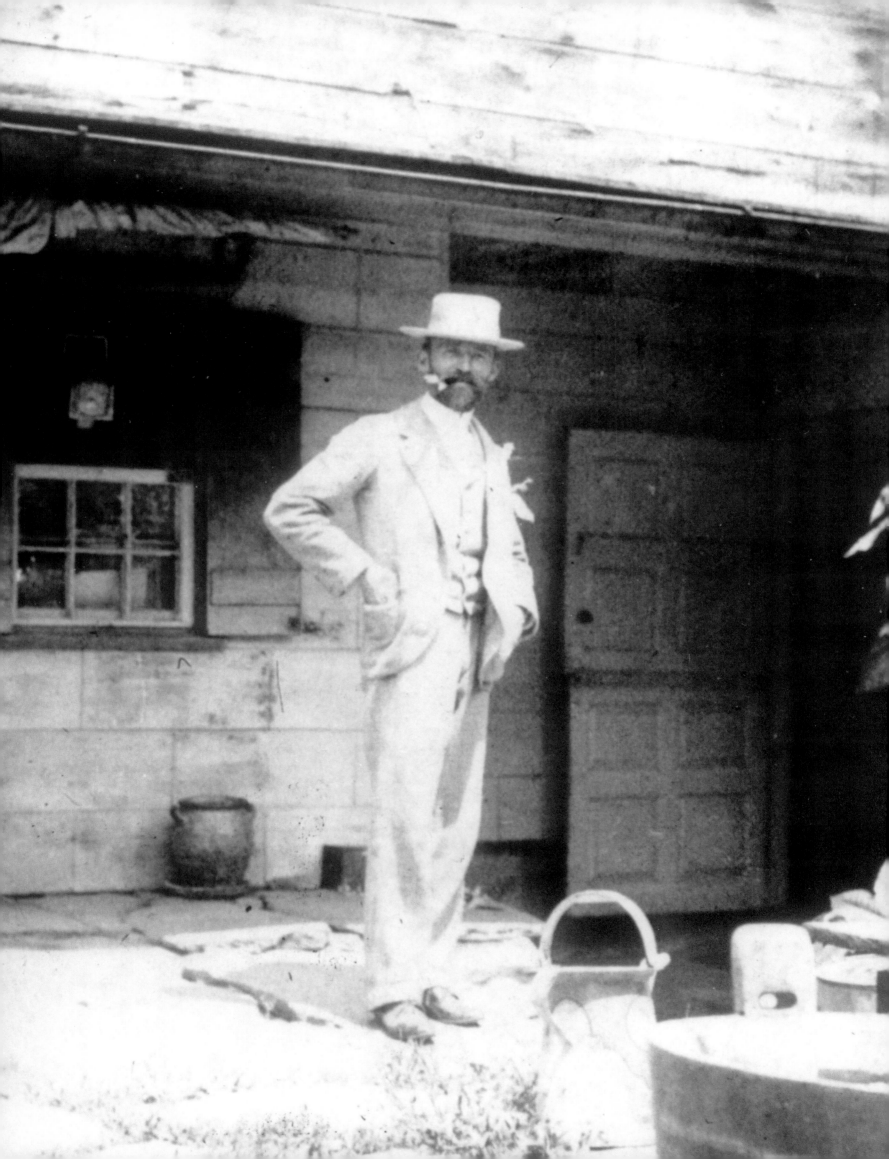

A "Painter's Painter" in an Age of Artistic Self-Awareness

Lisa N. Peters

In *Inventing the Modern Artist: Art and Culture in Gilded Age America* (1996), Sarah Burns identifies the social conventions to which American artists adhered at the end of the nineteenth century.[1] Among the subjects Burns addresses is the new professionalism they adopted as a way of establishing credibility in an increasingly commercialized and competitive society. Abandoning the appearance of eccentricity and the Romantic aura of the impoverished bohemian that had been associated with the artist earlier in the century, they took their cues from the world of business, dressing conservatively, establishing connections through networking, using strategic methods to market their works, and sometimes developing sophisticated public personas—often expressed through their art—that further enhanced their stature.

John Twachtman outwardly fit the profile described by Burns of the successful modern American artist of his time. Whereas in 1887, he is shown in a recently discovered photograph in a quaint beret with a tassel and loose painter's clothing (Fig. 11), in the next decade, as photographs portraying him alone or with his peers at club gatherings reveal, he had chosen to don the professional look that denoted prominence (Figs. 12–13). He is seen dressed in black three-piece business suits with starched, high, white piqué collars or all-white suits, at times matched by white hats (Figs. 14–15). His pointed, trimmed beard and groomed, medium-length mustache, akin to those of so many other artists of his time, further demonstrate his compliance with the fashions of the vanguard artist. At home in Greenwich, Connecticut, or while teaching in nearby Cos Cob, he dressed more casually, in open jackets and knickers or loose white sweaters (Figs. 16–18).

Twachtman also established the right sorts of social and professional associations for a successful artist of his time. From the beginning of his career, he had been at the center of the most progressive art alliances of his day, joining the Society of American Artists and the Tile Club in the 1870s.

In the 1890s he belonged to the Salmagundi and Players clubs, and in 1897 he helped instigate and became part of the most sophisticated artists' group of the era, the Ten American Painters. He took great pleasure in the opportunities for fraternal bonding and networking that these groups afforded, as is suggested in several photographs of him with similarly attired fellow artists attending formal dinners at the Players Club (Fig. 13).

That he was fully involved in the exclusive male-artist society of his era is demonstrated by his participation in the famous "Pie Girl" dinner, held on May 20, 1895 at the studio of the photographer James Lawrence Breese. While Breese made photographic place cards for the event, Twachtman is known to have created an etching that was used as a seal or device for the menu. The attendance list for the dinner reads like a roster of the notable figures in the New York art world, including the architects Stanford White, Charles McKim, and William Rutherford Mead (see Cat. 9), the sculptor Augustus Saint Gaudens, and the painters Willard Metcalf, Robert Reid, Edward Simmons, and Twachtman's closest companion J. Alden Weir. The scientist Nikola Tesla was also among the guests. At the dinner, which was organized as a combined birthday present and tenth wedding anniversary honoring John Elliot Cowdin (1858–1941), who was part of a firm that produced silk ribbon for the women's wear field, the highlight was when a sixteen-year-old girl with a stuffed blackbird perched on her head emerged from a pie along with a "bevy of canaries." The event was viewed as scandalous by the New York press, and its depravity was condemned.[2]

Twachtman also demonstrated his desire for recognition by avidly sending his works to exhibitions from the 1870s onward and by participating in important annuals and expositions, including the World's Columbian, held in Chicago in 1893 and the Pan-American, held in Buffalo in 1901. Like several of his esteemed contemporaries, he taught at the Art Students League, the leading American art school of his day (Fig. 19).[3]

Fig. 14
Photograph, John Twachtman, ca. 1890s, Weir Farm National Historic Trust, Wilton, Connecticut.

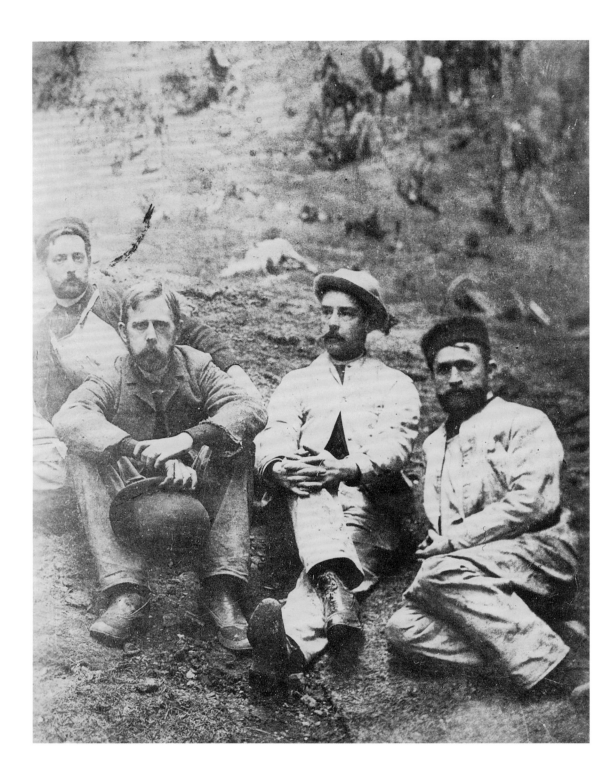

Fig. 11
Photograph, Chicago,
Gettysburg Cyclorama
participants, 1887.
From left to right:
Oliver Dennett Grover,
Jack Anderson,
Albert Reinhart, and
Twachtman, 1887,
courtesy Roy Pedersen.

Yet Twachtman lacked the managerial skills and the ability to promote his art that were mastered by many artists of a similar standing. He struggled with the administrative tasks of sending his works to exhibitions; even titling them was onerous for him.[4] He was bereft of the strategic skills many of his contemporaries honed to package their work. His friend Childe Hassam, for example, was described by the painter Jerome Myers as an artist "in full possession of his power of production . . . with a keen knowledge of distribution, the tactical ability to place his work."[5] By contrast, Twachtman was so clueless as to how to bring his work to the attention of buyers that his friends at times intervened to save him from utter failure at doing so. In his autobiography, *From Seven to Seventy*, Edward Simmons wrote of "walking wearily up and down Fifth Avenue all of one afternoon with Twachtman, each of us with one of his unframed landscapes under his

arm, visiting dealer after dealer in a vain effort to sell one of them for twenty-five dollars in order that he might obtain enough money to remain a member of The Players."[6] To shield Twachtman from the disappointment of being unable to sell a single work from a show of his art, Weir himself anonymously purchased one of his paintings, allowing Twachtman to celebrate having attracted a buyer, unaware that his only sale had been a surreptitious act of caring on the part of his closest friend.[7]

If Twachtman's dress was consonant with that of his peers, he did not present the smooth, refined, and confident facade achieved by many of them. For example, Burns noted that William Merritt Chase—a friend of Twachtman's since their student days in the late 1870s— constructed for himself "an image of competence, discipline, social skill, organization, and managerial acumen."[8] Weir, was repeatedly observed to exude a combination of affability and gentlemanly dignity. Twachtman's temperament seems to have been more erratic and inconsistent, so that his public image never became firmly established.

The reports of those who knew him vary greatly, as can be seen in the letters received and interviews conducted about 1955 by John Douglass Hale, when he was researching his 1957 dissertation on Twachtman.[9] On joining Twachtman's class in preparatory antique drawing at the league, Allen Tucker's first impression was of "a gentleman and an artist." Tucker recalled: "It was when I showed him my drawing of a block hand that I first saw that straight, thin, nervous, shy figure, the fair bearded face, and the seeing blue eyes."[10] Another student, Violet Oakley, observed that his eyes were often "half hidden under a sort of tangle of fair hair," which gave him a faunlike look also mentioned by Simmons.[11] Oakley remembered Twachtman's character as combining gentleness and strength.[12] He "carried with him a certain atmosphere of Romanticism," wrote Robert J. Wickenden, a fellow student in Paris in the 1880s.[13] The painter William Langson Lathrop, who roomed with Twachtman in the late 1880s, described him as "a most inspiring companion" who was "utterly unconscious of most anything but his work."[14]

Yet to his students Twachtman often seems to have appeared either downcast or irritable. One called him a "nervous man...not very happy,"[15] while another described him as mercurial: "one day a thing appealed to him, the next...it bored him. One day his talk was spiritual—you looked

for the halo. The next...you laughed at yourself for the feeling."[16] Twachtman also could be suddenly cantankerous with his students, criticizing them harshly. One of his league pupils called his appearance "ferocious,"[17] while another described him as "unapproachable."[18]

Fig. 12
Photograph, John Twachtman, ca. 1890s, Peter A. Juley & Son Collection, Smithsonian American Art Museum, Washington, D.C.

Fig. 13
Photograph, The Players Club, ca. 1890s. From left to right: J. Alden Weir, Twachtman, Harry Hall. Weir Farm National Historic Trust, Wilton, Connecticut.

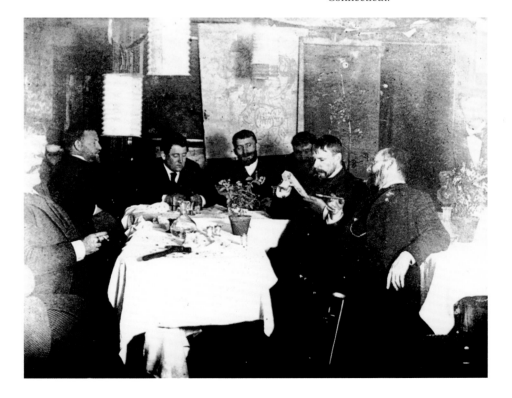

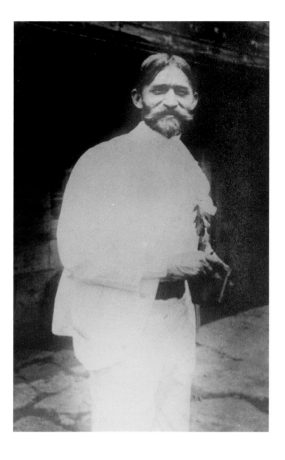

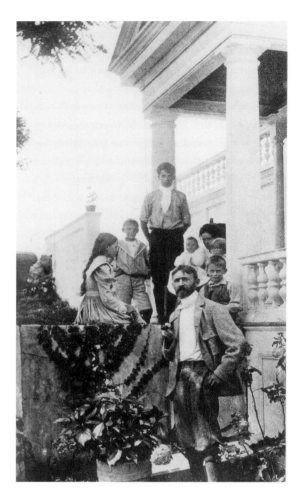

Fig. 15
Photograph, Twachtman at the Holley House, ca. 1900, Historical Society of the Town of Greenwich, Cos Cob, Connecticut.

Fig. 16
Photograph, Gertrude Käsebier, Twachtman and family at the front of the Greenwich house, ca. 1900. From *Craftsman* 14 (June 1908), p. 344.

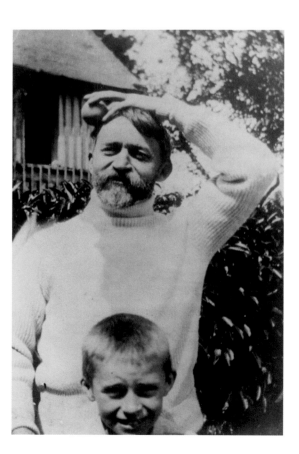

Fig. 17
Photograph, Twachtman with students at Palmer and Duff Shipyard, Cos Cob, Connecticut, ca. 1890s. From left to right: Elmer MacRae, unidentified, Twachtman. Historical Society of the Town of Greenwich, Cos Cob, Connecticut.

Fig. 18
Photograph, Twachtman with son, Quentin, ca. 1898, private collection.

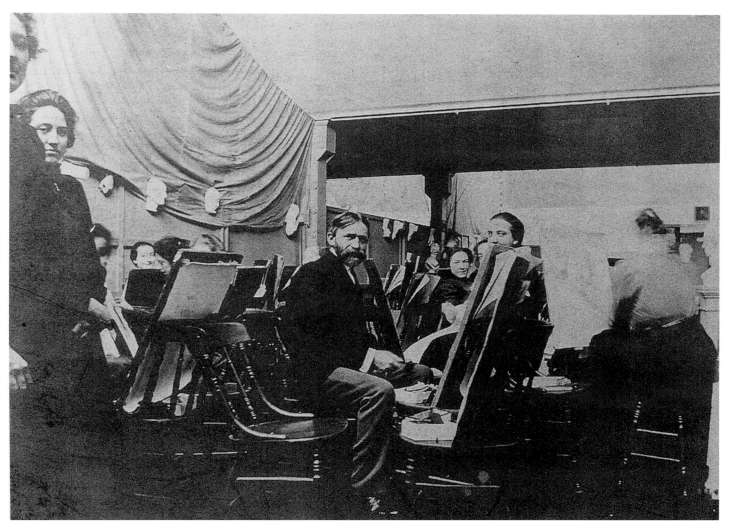

Fig. 19
Photograph,
Twachtman at the
Art Students League,
ca. 1890s, Milch Gallery
Papers, Archives of
American Art, Smith-
sonian Institution,
Washington, D.C.

Among friends, Twachtman was far more at ease, often becoming convivial and loquacious and even exhibiting leadership qualities. Carolyn Mase, who studied with him and published an article on him in 1921, wrote that his discussions in Cos Cob, where he was usually surrounded by supportive companions and adoring students, would always "drift to art, for he was bubbling over with it, and he dominated the conversation, as great men do."[19] Robert Reid, who visited with him regularly at his home in Greenwich, felt that "enthusiasm seems to have been the keynote of his character."[20] However, Twachtman did not sharpen his conversational skills to achieve the finesse and exhibit the showmanship exemplified by James McNeill Whistler, as his pleasure in companionship was genuine rather than self-aggrandizing. Although he could be mocking—Lincoln Steffens recollected his wry wit at dinners at the Holley House in Cos Cob[21]—he appears to have been mostly playful rather than derisive.

Eliot Clark remarked in a 1955 interview with Hale that while Twachtman sometimes appeared apt at "aphorism and repartee," he often was "more personal than brilliant."[22]

With Weir and Robinson, his closest companions, Twachtman let down his guard fully and was a loyal, committed, and caring friend. He openly expressed his affection for Weir in letters to him, and he often welcomed Robinson within the familial fold of his Greenwich home.[23] Twachtman also seems to have been a devoted husband and father. Although his wife Martha appears to have been very independent, often departing for visits with family and friends in her native Cincinnati and giving Twachtman the freedom to spend time with and travel with his artist friends on several occasions, the couple is thought to have shared many interests and been happy in their marriage.[24] Martha no doubt regretted having given up the career as an artist that she began during the 1870s after devoting herself to childrearing, but such

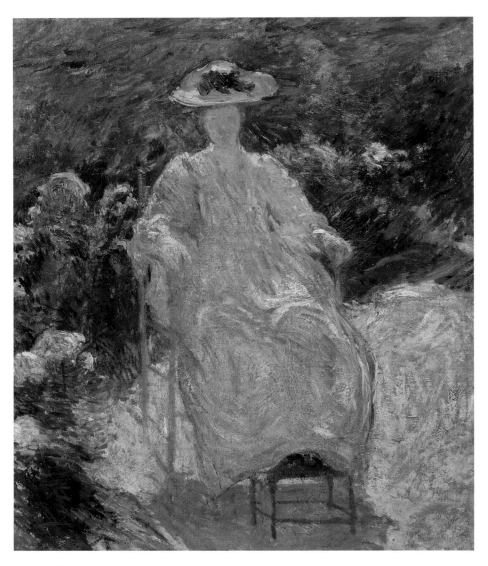

Fig. 20
Twachtman, *In the Sunlight*, ca. 1893, oil on canvas, 30 × 25 inches, private collection.

details of the property and, less directly, simply through their presence. These include his views of his children in sailboats on Horseneck Brook (see Cat. 46), a scene of his wife and children on their back porch, a vine trellis reaching halo-like above them and the garden's flowers encircling them, both perhaps placing an aura of sanctity on domestic life (Fig. 61), and a painting in which he generalized Martha's form and that of the garden surrounding her, in which he expressed a sense of pure pleasure in the ease and refreshing qualities of life in Greenwich (Fig. 20). In a rare interior, Twachtman depicted Martha holding a swathed baby up to a mirror so that it could see its reflection (Fig. 21). While Martha gazes with steady affection at her child, the child studies the reflected image with quiet interest. Including the hint of a pastel on the wall at the right in the work, Twachtman recorded this gentle, personal moment in his own life, while capturing an experience that can be universally appreciated. In paintings of his Greenwich home and its surroundings, Twachtman often used formal means to express the satisfaction and security that he experienced in a place with which he was intimately familiar and where he felt he belonged, while at times he conveyed his delight and surprise in finding new features in a place he knew well, such as the way he accentuated the appearance of a tree with new spring foliage juxtaposed with a countryside covered in snow (Cat. 35).

That Twachtman often created works with highly personal content perhaps contributed to the degree to which his images were not as readily understandable to the public as that of many of his peers, who could more easily separate their emotions from their art. In addition, the way in which he was driven by inner necessity to express his own deeply felt responses to his life and subjects explains why he could not shape his work to fit trends and fashions in the art world.

Twachtman was similarly unable to construct a persona for himself that would have helped to give him a definable identity within the public arena. This was an approach used successfully by many of his peers. Among them was Thomas Dewing, whose friendship with Twachtman began in the 1880s. Dewing created spare, quiet depictions of ethereal women in subtly toned "decorations" that encouraged the notion that he was a refined ascetic who lived like "a monk in a cell," regardless of the truth of this claim.[25] Hassam expressed his patriotic sentiments and cheerful optimism through his vivid, sparkling images of rural countrysides and gracious city squares.

a pattern was unfortunately quite typical for women artists of her time, and it is likely that she simply accepted the path that her life had taken. That Martha was dedicated to her children is reflected in her decision to take them with her to Paris, probably early in 1901, when her eldest son Alden began a course of study at the École des Beaux Arts. She left her husband behind to fulfill his teaching responsibilities, and she and the children were still abroad in August of 1902 when Twachtman died on the eighth of the month (only his daughter Marjorie, who had sailed from Europe to join him at Gloucester, Massachusetts, was with him at the time).

Twachtman expressed his love for his wife and children in the images he created of them in Greenwich, in which he conveyed their pleasure in the countryside that they had helped shaped over the course of several years—probably both literally helping him in his constant attention to

Weir was often commended for conveying the gentleness of his personality in his art. "The atoms of the organization of his thought are peculiarly harmonious," wrote Guy Pène du Bois, referring to Weir's sensibility in general.[26]

Neither buoyantly uplifting nor elegantly austere and refined, the appeal of most of Twachtman's works was less easily grasped by general audiences and art buyers of his day than those of his colleagues of equal standing. The typical reaction of outsiders to his art is suggested in Frederic Newlin Price's tale of a time when Weir tried to help Twachtman sell his paintings to a "Fifth Avenue dealer." Price wrote that on seeing what Weir had brought to him, the dealer "held his hands aloft and exclaimed, 'Why doesn't he paint beautiful fields with flowers in the foreground and a brook rushing over pebbles? Why does he paint such dismal swamps?'"[27]

At the same time, Twachtman did not perceive that the rejection of his art offered him an opportunity. This was aptly noted by Forbes Watson, an outspoken ally of progressive art during the 1920s, who contrasted Twachtman with Whistler, writing that Twachtman "did not set up any antagonism to the popular verdict. There was never in his work the slightest trace of bumptiousness or defiance, and he was incapable of using unpopularity for advertising purposes as Whistler did. He simply painted."[28] John Cournos, the Imagist novelist, perceived Twachtman's lack of insight as to how his art came across as a positive trait. Writing in the *Forum* in 1914, he posited that Twachtman's strength as an artist had been his "self-abnegation," which was reflected in a technique that made itself "imperceptible," losing "itself in the soul of things."[29] A similar praise for Twachtman's unself-conscious nature won him the admiration of many early-twentieth-century American modernists, including Marsden Hartley, Arthur Dove, Milton Avery, and Arshile Gorky. Hartley wrote that Twachtman's "own personal lyricism surmounted his interest in outer interpretations of light and movement," so that he "leaves you with his own notion of a private and distinguished appreciation of nature."[30]

Burns suggests that many artists of Twachtman's era strove to counterbalance an appearance of complicity with the commercial arena, in which works of art became commodities, by acting out a "compelling individualism against 'corporate' art culture," and those who were successful were those "who engineered the greatest detachment from and indifference to the world of sales and

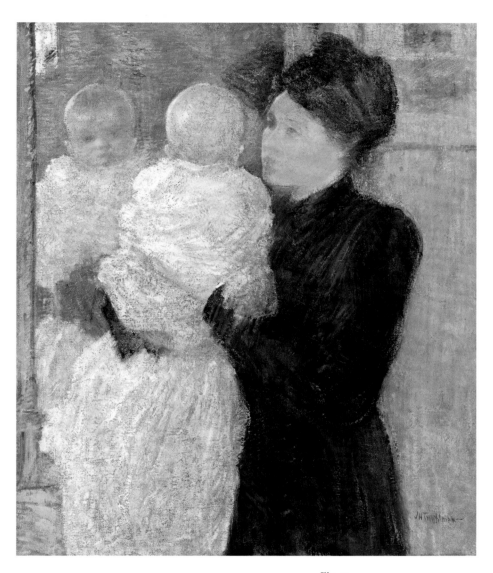

Fig. 21
Twachtman, *Mother and Child*, ca. 1893, oil on canvas, 30⅛ × 25⅛ inches, Jacob Stern Collection, on loan to the Fine Arts Museums of San Francisco, Jacob Stern Family Loan Collection.

the rituals of seduction."[31] More naïve and less calculating than many of the other artists with whom he associated, Twachtman, in his highly personal way of painting, epitomized this individualism and indifference to fashionable trends in the art world, but he did not manufacture nonchalance. At the same time, the benefits of such distancing did not accrue to him, as they did to others.

To his student and biographer Eliot Clark, it seemed that Twachtman had held himself above manipulative tactics due to his uncompromising nature. Clark, explained: never "an opportunist or faddist," Twachtman had an "absolute and unimpeachable integrity for which he sacrificed popularity and reward."[32] Yet Twachtman's "sacrifice" does not seem to have been intentional, because he could not understand why his work was poorly received. Mase described his bafflement over the public's disinterest in paintings that

he himself "knew were destined for everlasting fame,"[33] and Weir wrote of Twachtman's "demoralization with the lack of appreciation of his art."[34] Twachtman seems to have felt that his art should have been valued on its own terms without needing him to hype it to dealers and collectors. While, as Hassam noted, Twachtman was conscious of the "constant war mediocrity wages against the unusual and superior things,"[35] he does appear to have become embittered by the indifference of the public to his work. As Hale explained it:

> We must return...to the conclusion that the "outwardly gruff, hedonistic, skeptical and insensitive" Twachtman was a protective personality which he had developed to guard the inner "impressionable...delicate and loving" one, and to help a sensitive man cover his disappointment at the increasing difficulty that he had in finding buyers for his paintings. For Twachtman...sold more paintings during his early years, before the full maturing of his style. Later, when he felt that he was doing his best work, he found less appreciation and understanding, a difficult thing to take gracefully.[36]

In his discussions with Twachtman's acquaintances and students, Hale often encountered reports that Twachtman was a drinker, but never appeared drunk.[37] In the footnote in his dissertation that constitutes his only proof of these stories, Hale extrapolates that such drinking might have contributed to Twachtman's early death, although Hale had not been able to learn the cause of Twachtman's death, which is now known to have been a brain aneurysm, occurring after a few days in which he was ill. Kathleen Pyne went further in 1989, suggesting that Twachtman's disappointment in his life was manifested in "his tendency to drink heavily."[38] Although the impulse to fit Twachtman into the romanticized stereotype of the neglected artist forced by misery into drinking and dying an early death is a culturally conditioned one, it is not clear how much he drank, how his drinking affected his moods or his art, whether alcohol contributed to his death to a greater degree than genetic factors did, or whether the ill effects of heavy drinking combined with his general inattention to his health or with the cigars and pipes that he regularly smoked. One might, nonetheless, extrapolate that the heartbreak of losing his young daughter Elsie at age nine to scarlet fever, the strain of leaving the home in Greenwich that he loved in about 1900, the separation from his family in the last year of his life, and the sense of discouragement he felt in the poor reception to his art among collectors might have broken his spirit and contributed to an extreme decline in his health from which he could not recover.

"His Time Will Come"

The response of the art students of Twachtman's time to his work stands in direct contrast to the disinterest of art buyers. From the beginning of his career onward, fellow artists repeatedly made a point of proclaiming their esteem for Twachtman, extolling the individualism of his art and his integrity. As early as 1879, *Culture and Progress* reported in a review of the second exhibition of the Society of American Artists that Twachtman's fellow artists gave his "Venetian marines...the highest compliment" by buying them "for their own studies."[39] During the years that followed, critics often remarked on the high regard with which Twachtman and his art were held by his other artists. "What his fellows thought of Twachtman," stated the *New York World* in 1882, "is proved by the fact that his snow scene won more votes from the Committee on Admissions [consisting of the artists evaluating selections to the annual exhibition of the Society of American Artists] than did any other candidate whatsoever."[40] In January 1886, when a solo show of Twachtman's art was held in Boston, the noted Boston portraitist Frederick Vinton (who had known Twachtman in Munich in the mid-1870s) remarked that Twachtman's following even consisted of Boston artists: "I know that Mr. Twachtman has found friends and admirers here before, and I am sure he will add to their number if the amateurs of artistic painting will look in at his collection now at Chase's, 7 Hamilton place."[41]

In 1894 a jury of painters and sculptors (Frank Benson, George H. Bogert, Alexander Stirling Calder, Joseph DeCamp, Charles Melville Dewey, Charles Grafly, Thomas Hovenden, William Sergeant Kendall, Carl Newman, William Trost Richards, Theodore Robinson, Robert Vonnoh, Weir, and Twachtman himself) voted to bestow the Temple Gold Medal—an award given to the best painting in the annual exhibition of the Pennsylvania Academy of the Fine Arts—to an Impressionist landscape by Twachtman entitled *Autumn* (possibly Fig. 59). This selection aroused strong opposition in Philadelphia. In fact, the objections to it were so vehement that the *New York Times* devoted an article to describing them, noting the "regret" at the choice, voiced by the

Philadelphia Sunday Times, and reprinting the comments of the *Philadelphia Inquirer*, which stated that honoring such a "small impressionist picture—a misty agglomeration of blues and reds—a thing of shreds and patches" was wrong, as it revealed that approval had been given to "the false idol of Impressionism," whereas there were "a dozen pictures in the exhibition of very high merit, to any one of which the Temple Medal might appropriately have been given," which would have "encouraged a more legitimate sort of art."[42]

By the late 1890s the discrepancy between the view of artists and that of the public toward Twachtman's work had begun to be recognized. In a review in 1898 of the first exhibition of the Ten American Painters, a writer for the *Critic* remarked that Twachtman was the only artist in the group "of whom it can be said that his work is not appreciated as it should be," and concluded: "His time will come."[43] Another reviewer of the same show observed that in Twachtman's paintings, such as *Pool in the Woods* (identity unknown), "it is the common penalty of originality that it is not understood until late, while the mediocre artist who paints in a manner which some better man has made popular is sure of immediate recognition and reward."[44] By 1901 Twachtman had been given the epithet "painter's painter," a label that would be associated with him for decades to come. In that year, when his art was shown as far from his milieu within the New York art world as Columbus, Ohio, the *Columbus Journal* reported:

> Mr. Twachtman is known as a painter's painter. He is honored by all honest artists because he is always true to his talent and never descends to painting commonplace things or turning out "pot boilers." He never works unless he feels what he paints. He studied under many masters of many schools and has associated with great painters, but there is no suggestion of these men in his work.[45]

Other critics used this label in the years that followed his sudden and untimely death in 1902. As the *New York Times* noted in an article discussing Twachtman's memorial exhibition of 1903: "The fact is that John H. Twachtman was more a painter's painter than a painter for the public."[46] Two years later, a critic reviewing an exhibition of his art at M. Knoedler and Company in New York made a similar remark in a comparison of Twachtman to the also recently deceased French Naturalist painter Jean-Charles Cazin: "Cazin appeals to a wider circle and has almost

always a suggestion that he thought of his spectators, while Twachtman seems to have oftener painted for himself without a thought of the public. He was and is a painter's painter who retired within himself."[47]

The art students of Twachtman's time made a public declaration of their reverence for him at the memorial sale of art from his estate, held in 1903. So many attended this event that "would-be buyers were crowded out," and the applause and "exclamations of surprise" by those in "artistic habits" when "a picture brought a good price" reflected "[the students'] regard for art and Twachtman."[48] More than just applauding though, the artists themselves were among the buyers, including William Louis Carrigan, George Munn (see Cat. 45), George Pratt, Robert Reid, Edward Rorke (see Cat. 52), Allen Tucker, and Weir (see Cats. 6, 63).

In a collaborative memorial article of 1903 five of Twachtman's friends explained the discrepancy between the view of artists and buyers by pointing out that his work had simply been too modern for its era. Simmons wrote: "The canvases which Twachtman has left us, like all work of signally original merit, may prove for a time too fine a food for the general public."[49] Dewing stated: "He is too modern, probably, to be fully recognized or appreciated at present; but his place will be recognized in the future, and he will one day be a 'classic,' to use the literary term; for the public catches but slowly the professional opinion, though in the end the professional opinion becomes the public opinion."[50] Weir similarly predicted, "Rare as were the qualities which Twachtman possessed, it is hard to think that they [will] remain veiled from the public."[51] Hassam wrote of the unfairness befalling an American artist "who was an able painter and a joyous, energetic individuality, who worked for the love of it and worked well . . . has not yet been adequately appreciated."[52]

An artist who both belonged to his age and stood apart from it, Twachtman created works that reflected the stylistic trends of his era, while using them in his own way. He understood that how we see a subject and the associations we bring to it shape our perception of it, and he used color, form and texture in his art to explore this process. The only direct account of his viewpoint is the advice to his students in Cos Cob, Connecticut, in 1899, that was quoted in the *Art Interchange*. The author of the article reported that Twachtman advised his pupils: "If you are working from the figure, do not do the conventional sort of thing that we find in a sketch-class

model, but rather the unconscious attitude. . . . Do we like people who pose? No. A figure that is obviously arranged affects one in the same way. . . . Do not do the girl with a book unless you can make us see something new.[53] He recommended giving the effect of a flat country by placing "the horizon line below the middle of the canvas," trying "a gray subject on a yellow canvas" to achieve a feeling of warmth, and choosing a particular tone of green, not by matching it to the grass but by considering "it in relation to the sky and other parts."[54] Twachtman's understanding of such perceptual issues is even more apparent in his work.

A study of Twachtman's art in relation to the contemporary reviews it received reveals that despite his independence, he was an artist of his own time whose work dovetailed with issues within his American milieu. Yet he never conceded to fashion, continuing to render images until the end of his life that received great accolades, while also they were at times described as unusual, obscure, and puzzling. Because of the uniqueness of Twachtman's art, critics often took the time to analyze his work in great depth, frequently discussing its traits and true nature at length; a consideration of their writings provides not only a perspective on Twachtman but also a sense of how the stylistic modes he explored were envisioned and re-envisioned over time in his American context. The two essays that follow thereby suggest the ways in which Twachtman—and, by extension, many of his contemporaries as well—was inspired both by the European modes to which they were exposed and by how these modes were understood and viewed in their own country.

Today, Twachtman is still seen as a painter's painter, and his works continue to have the power to draw us into them, so that in observing them, we not only see his sites as he did, but enter into them in a way that we feel we are taking part in them ourselves.

NOTES

Full citations for abbreviated references may be found in Selected Exhibitions, pp. 245–46 and Selected References, pp. 247–48.

1. Sarah Burns, *Inventing the Modern Artist: Art and Culture in Gilded Age America* (New Haven, Conn.: Yale University Press, 1996).

2. On the "Pie Girl" dinner, see Paul R. Baker, *Stanny: The Gilded Life of Stanford White* (New York: Free Press, 1989), pp. 250–51.

3. Among those whose years of teaching at the Art Students League coincided with Twachtman's were J. Carroll Beckwith, Robert Blum, William Merritt Chase, Kenyon Cox, Joseph DeCamp, Frederick Dielman, Benjamin Fitz, Willard Metcalf, H. Siddons Mowbray, Douglas Volk, J. Alden Weir, and many others.

4. In 1897, in answer to a request for the title of one of his works from Harrison Morris, director of the Pennsylvania Academy of the Fine Arts, Twachtman complained: "I do not know title of [the] picture and you will have to fill out that part. . . . a hell of a lot of bother painters have. They not only have to paint the pictures but do a lot besides." Twachtman to Harrison Morris, Pennsylvania Academy of the Fine Arts, Philadelphia, December 2, 1897, Archives, Pennsylvania Academy of the Fine Arts.

5. Jerome Myers, *Artist in Manhattan* (New York: American Artists' Group, 1940), p. 101, quoted in H. Barbara Weinberg et al., *Childe Hassam: American Impressionist* (New York: Metropolitan Museum of Art, in association with Yale University Press, 2004), p. 16.

6. Edward Simmons, *From Seven to Seventy: Memories of a Painter and a Yankee* (New York and London: Harper & Bros., 1922), p. 324.

7. Reported in Charles Van Cise Wheeler, *Sketches* (Washington, D.C.: Privately printed, 1927), p. 113.

8. Burns, *Inventing the Modern Artist*, 1996, p. 23.

9. Hale, *Life and Creative Development*, 1957, vol. 1, pp. 102–59.

10. Tucker, *John H. Twachtman*, 1931, p. 7.

11. Oakley to John Douglass Hale, Philadelphia, August 17, 1955, quoted in Hale, *Life and Creative Development*, 1957, vol. 1, p. 102. Simmons, *From Seven to Seventy*, 1922, p. 325.

12. Oakley to Hale, August 17, 1955, quoted in Hale, *Life and Creative Development*, 1957, vol. 1, p. 102.

13. Wickenden, *Art and Etchings of John Henry Twachtman*, 1921, p. 9.

14. "The Week in Art Circles," *Cincinnati Enquirer*, July 11, 1915.

15. Charles Hopkinson, Manchester, Massachusetts, to John Douglass Hale, August 19, 1955, quoted in Hale, *Life and Creative Development*, 1957, vol. 1, p. 127.

16. Mase, "John H. Twachtman," 1921, p. lxxii.

17. Hopkinson to Hale, quoted in Hale, *Life and Creative Development*, 1957, vol. 1, p. 106.

18. Richard F. Maynard, Old Greenwich, Conn., to John Douglass Hale, , December 11, 1955, quoted in Hale, *Life and Creative Development*, 1957, vol. 1, p. 116.

19. Mase, "John H. Twachtman," 1921, p. lxxii.

20. Robert Reid, in Dewing et al, "John Twachtman: An Estimation," 1903, p. 558.

21. Steffens, who developed a close rapport with Twachtman, wrote in his *Autobiography* of the artist's central role in evening gatherings at the Holley House in Steffens, *The Autobiography of Lincoln Steffens* (New York: Harcourt, Brace & World, 1931), p. 437: "There was a long veranda where the breezes blew down from the river, up from the Sound, and cooled the debaters and settled the dinner debates that Twachtman started. We dined all together at one long table in a fine, dark, beflowered dining-room. The game was always the same. Twachtman would whisper to me as he passed on to his place, 'I'll say there can be no art except under a monarchy.' Waiting for a lull in the conversation, he would declare aloud his assertion, which was my cue to declare the opposite.... Others would break in on his side or mine, and marking our followers, he and I led the debate, heating it up, arousing anger—any passion, till, having everybody pledged and bitter on a side, we would gradually change around till he was arguing for the republic, I for the monarchy. Our goal was to carry, each of us, all our party around the circle without losing a partisan."

22. Eliot Clark, interview with John Douglass Hale, 1955, in Hale, *Life and Creative Development*, 1957, vol. 1, p. 119.

23. Twachtman's letters to Weir belong to Weir Family Papers, MSS 41, Harold B. Lee Library, Archives and Manuscripts, Brigham Young University, Provo, Utah. Transcripts of them may be found in Peters, *John Twachtman and the American Scene*, 1995, vol. 1, pp. 536–48. Robinson often mentions time spent with Twachtman and his family in his diaries, Frick Art Reference Library, New York.

24. On the relationship between Twachtman and Martha, see Hale, *Life and Creative Development*, 1957, vol. 1, p. 127. Hale quotes from Alden Twachtman, the artist's eldest son, and Constant Holley MacRae, the daughter of Josephine and Edward Holley, attesting to the happy marriage of John and Martha Twachtman and their mutual interests.

25. Burns observed the discrepancy between the public image of Dewing and his lifestyle. Burns, *Inventing the Modern Artist*, 1996, pp. 73–74.

26. Guy Pène du Bois, "The Idyllic Optimism of J. Alden Weir," *Arts and Decoration* 2 (December 1911), p. 50.

27. F. Newlin Price, "Weir—The Great Observer," *International Studio* 75 (April 1922), p. 130.

28. Watson, "John H. Twachtman, 1920, p. 422.

29. Cournos, "John H. Twachtman," 1914, p. 248.

30. Marsden Hartley, *Adventures in the Arts* (New York: Boni and Liveright, 1921), p. 77.

31. Burns, *Inventing the Modern Artist*, 1996, p. 67.

32. Clark, "Art of John Twachtman," 1921, p. lxxx.

33. Mase, "John H. Twachtman," 1921, p. lxxv.

34. J. Alden Weir to C. E. S. Wood, September 18, 1902, roll 125, frame 91, Weir Papers, Archives of American Art.

35. Childe Hassam, in Dewing et al, "John Twachtman: An Estimation," 1903, p. 557.

36. Hale, *Life and Creative Development*, 1957, vol. 1, p. 137. Quoted remarks are from Hale's interview of 1955 with Eliot Clark.

37. Ibid., pp. 99ff.

38. Kathleen Pyne, "John Twachtman and the Therapeutic Landscape," in Chotner, Peters, and Pyne, *John Twachtman: Connecticut Landscapes*, 1989, p. 65.

39. "The Society of American Artists," *Culture and Progress* 18 (June 1879), p. 312.

40. "The Society of American Artists," *New York World*, May 1, 1882, p. 2. Mariana Van Rensselaer similarly reported: "[Twachtman's] brother artists proved their estimate of [*Winter*'s] claims by giving it more votes [for acceptance to the show] than fell to the lot of any other picture offered." M. G. Van Rensselaer, "The Society of American Artists—New York—I," *American Architect and Building News* 2 (May 13, 1882), p. 219.

41. Frederick P. Vinton, "Mr. Twachtman's Paintings," *Boston Daily Evening Transcript*, January 25, 1886, p. 6.

42. "New Pictures at the Academy," *Philadelphia Inquirer*, December 16, 1894, p. 5.

43. "The Fine Arts: A New Group of American Artists," *Critic* n.s., 29 (1898).

44. "Ten American Painters," *Art Amateur* 38 (May 1898), p. 134.

45. "Twachtman's Painting—To Be Exhibited at Mr. Fauley's Studio Next Week," *Columbus (Ohio) Journal*, January 27, 1901.

46. "Twachtman's Paintings: Memorial Exhibition and Sale of Works by John H. Twachtman," *New York Times*, March 22, 1903, p. 9.

47. "Twachtman's Painted Poems: Comparisons with French and Japanese Impressionists," *New York Times*, January 10, 1905, p. 6.

48. "Twachtman Picture Sale," *New York Times*, March 25, 1903, p. 5, and "Twachtman Pictures, $16,610," *New York Sun*, March 25, 1903, p. 5.

49. See T[homas] Dewing, in Dewing et al, "John Twachtman: An Estimation," 1903, pp. 554–62; Simmons, pp. 560–61.

50. T[homas] Dewing, in Dewing et al, "John Twachtman: An Estimation," p. 554.

51. J. Alden Weir, in Dewing et al, "John Twachtman: An Estimation," p. 562.

52. Childe Hassam, in Dewing et al, "John Twachtman: An Estimation," p. 557.

53. Quoted in "An Art School at Cos Cob" 1899, p. 56.

54. Ibid., pp. 56–57.

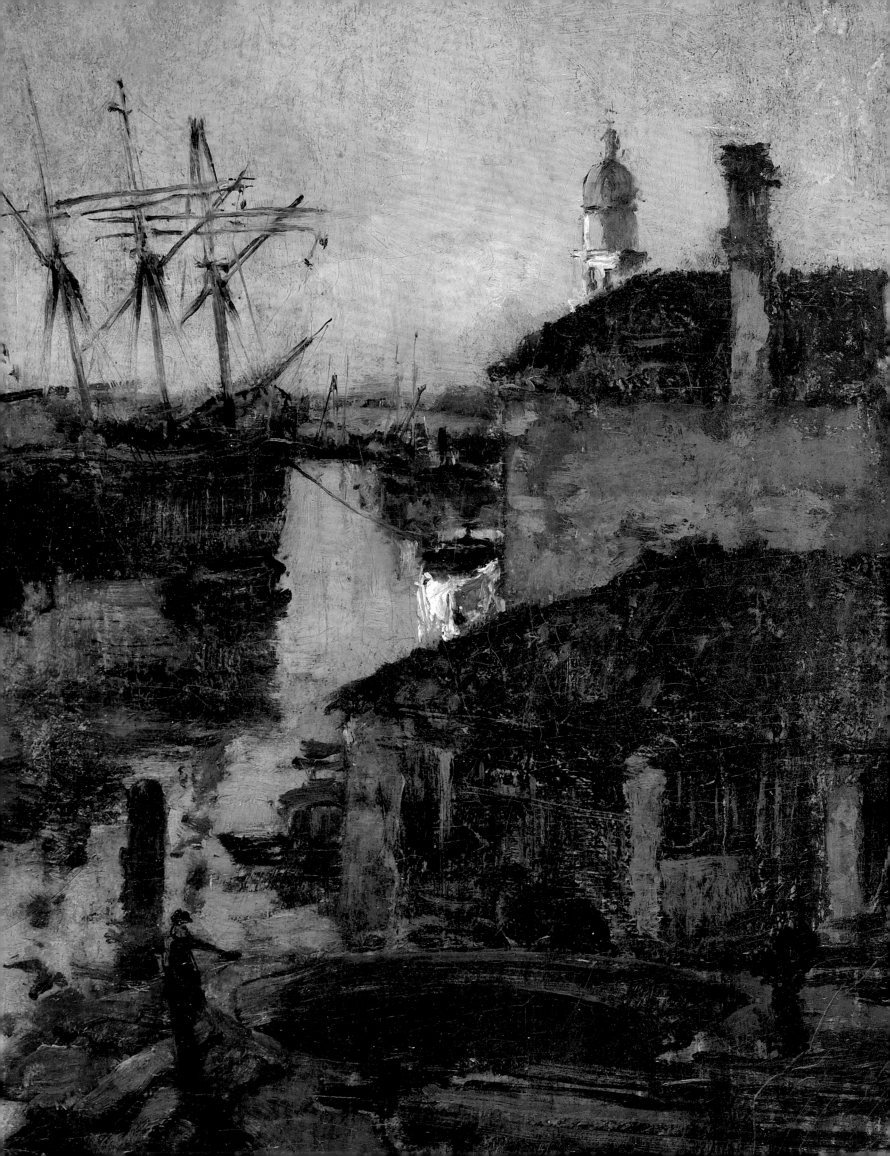

Twachtman's Realist Art and the Aesthetic Liberation of Modern Life, 1878–83

LISA N. PETERS

THE 1870s were a period of transition in American art, when the style of the Hudson River School had become anachronistic in the years following the Civil War, and a new generation of artists began to explore a variety of approaches to which they were exposed while studying and traveling in Europe. During the decade a group of American artists who trained in Munich, Germany, adopted a bold form of Realism that entailed the painting of everyday life in a direct, spontaneous manner. When exhibited in New York at the end of the decade, their works drew a significant amount of attention from the critics who, in the course of their reviews, debated the role of Realism as represented by the Munich School.

The issues that were at the heart of these discussions are illuminated by a consideration of the work that Twachtman, a leading member of the Munich School, created and of the criticism it received. A focus on Twachtman's art of the late 1870s and early 1880s and its critical context demonstrates the different ways that Realism was perceived in America and how views of it changed over time, as its benefits and drawbacks were weighed.

Whereas at first, the critics, in general, responded favorably to Realist views that revealed the truths of modern life, gradually they shifted their perspective to one in which they suggested that Realism was instead useful mainly as a tool whereby artists could develop individualistic styles and depart from worn-out conventions. Denigrating works that were of what they perceived to be unattractive or "sooty" types of motifs, they recommended that American artists turn to the portrayal of more poetic sorts of subjects, in the view that such works would be of greater universal and lasting value than those portraying modern life's less stable, more transitory forms. Although Twachtman was by nature a Realist, and followed a natural progression as his career developed, this trajectory is reflected in his work and in the reviews it received.

Drawn to Modern Life

Born in Cincinnati, Ohio, in 1853, Twachtman grew up in the city's famed German neighborhood of Over the Rhine, where his parents (both immigrants from Hanover, Germany) had settled in the 1840s.[1] Choosing art as a career over his father's trade of carpentry and other business opportunities available in the bustling industrial city of his youth, Twachtman enrolled in 1868, when he was fifteen, at the Ohio Mechanics' Institute. He transferred in 1871 to the McMicken School of Design, where he remained a student for five years. In 1873 he painted a landscape (Fig. 22) that he exhibited that year with the title of *Tuckerman's Ravine* at the Cincinnati Industrial Exposition. As has recently been determined, he copied his design for this work in almost all respects from a wood engraving of a painting by the English-born artist Harry Fenn that appeared with the title "Tuckerman's Ravine, from Hermit's Lake" (Fig. 23) in the popular volume *Picturesque America: or, The Land We Live In* (1872), edited by the poet William Cullen Bryant.[2] Portraying this detail-filled panoramic scene of a mountainous landscape in which a vivid sunset is reflected in the surface of a still lake, Twachtman demonstrated his adherence to the idiom of the Hudson River School, with which Fenn had also earlier been associated. In this respect, Twachtman followed the typical preferences of Cincinnati patrons, who, beginning at mid-century, had gathered large holdings of romanticized, meticulously rendered landscapes by both native artists and the painters of the German Düsseldorf School.[3]

Yet, at about the same time that he painted *Tuckerman's Ravine*, Twachtman had begun to focus on modern life in Cincinnati. In *The Loyal Hotel* (ca. 1871–72; private collection) he featured a boardinghouse and saloon that was under the proprietorship of his uncle and namesake in 1871 and 1872, which city directories reveal was located at the corner of Smith and Second Streets. Close to the public landing on the Ohio River, this site

Opposite:
Ship and Dock, Venice
(detail of Cat. 3)

31

Fig. 22
Twachtman,
Tuckerman's Ravine,
1873, oil on canvas,
15⅛ × 18 inches,
private collection.

Fig. 23
Harry Fenn,
"Tuckerman's Ravine,
from Hermit Lake,"
wood engraving from
William Cullen Bryant,
ed., *Picturesque America:
Or, The Land We Live In*
(New York: A. Appleton
and Company, 1872),
vol. 1, p. 160.

Fig. 24
Twachtman, *Miami Canal, Cincinnati*, ca. 1874, oil on canvas, 13½ × 23⅝ inches, The Philbrook Museum of Art, Tulsa, Oklahoma, Gift of Mrs. Helen C. Markley.

was in a marginal, lower-class part of Cincinnati in the 1870s, and the establishment's clientele probably consisted mostly of the working poor living in the neighborhood.[4] In Twachtman's painting, the small figure of a man and a white horse in front of the corner entryway to the building accentuate the height of the three structures rising several stories above them. The buildings in turn are bracketed by the chimney of a factory at the left, its black smoke rising into the sky, and at the right, a bell tower, possibly used by a factory to call workers to their jobs. Although Twachtman may have chosen this subject because he had access to it, his depiction of it also suggests that he was interested in showing the actualities of life in Cincinnati, rather than creating a glossy, picturesque view of the city—often referred to in glowing terms as the "Queen" or the "Athens" of the West in writings of the era. He made no attempt to idealize his subject, and while he showed the small boardinghouse seeming to offer some refuge from its bleak environment, even this corner building does not appear to exude much of a sense of welcome.

Twachtman also focused on the impact of industry on Cincinnati in a painting that he probably rendered about 1874 (Fig. 24).[5] His subject is a view looking in a northwest direction from Over the Rhine toward the Miami Canal (completed in 1832), which was created with the intention of providing a passage from the Ohio River to the Erie Canal.[6] As a photograph from the era reveals (Fig. 25), Twachtman recorded his site accurately, including buildings along its north and west sides that housed tanneries and breweries.[7] Here he

again chose to represent a place in which nature has been replaced by commercial interests: the shore of the manmade waterway is rutted from wheel tracks; barrels from breweries have been thrown haphazardly beneath a street lamp; and smokestacks rise against hills that themselves seem denuded, as if in preparation for their development as well. By the mid-1870s, the Miami Canal had already passed its heyday, as steam engines had replaced barges as the modes of choice for transporting goods across the country, and Twachtman's image evokes the drab, inhospitable feeling of a place passed over. Our eye is drawn across the water to the dark shadows of buildings that accentuate the stillness of the water, while the only barge in view is beached. Again he did not sentimentalize this scene, simply portraying what he saw.

Fig. 25
Photograph, the Miami and Erie Canal, Over the Rhine, Cincinnati, ca. 1870s, Cincinnati Historical Society.

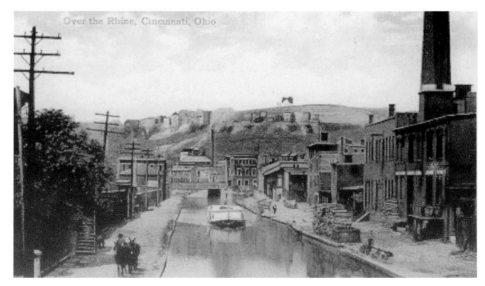

A Favorable Climate for Realism

Twachtman found encouragement for his natural Realist sensibilities when he joined a free evening class taught at the Mechanics' Institute in 1874 by Frank Duveneck, who also hailed from the local German community. Five years older than Twachtman, Duveneck had recently completed four years of study in Munich, where he had been the center of a lively community of artists committed to a radical approach following that of the German painter Wilhelm Leibl, who himself was a disciple of the French Realist Gustave Courbet (Leibl had met Courbet in Munich in the fall of 1869 and visited Paris on Courbet's invitation shortly thereafter).[8] Introducing Leibl's methods to his young Cincinnati students, Duveneck encouraged them to derive their subjects from their observations of everyday life rather than from the antique casts that were used as models in art schools at the time. He showed them how to work in both charcoal and oil in an alla prima manner, rendering their images with the rapid freedom of quick sketches, rather than according to the labored rules of academic draftsmanship. That his students followed his example became evident when works they displayed at an exhibition at the Mechanics' Institute in March 1875 were described as "crayons" and oils that featured "street characters—some of them picked up at station-houses" that were "painted from life and life-size for the most part."[9] "With these faces on the walls," the *Cincinnati Enquirer* reported, "the hall was powerfully suggestive of the interior of an infirmary or municipal lodging-house."[10]

In Cincinnati paintings that had brought Duveneck fame in Munich were received without enthusiasm and were even subject to mockery.[11] This was not surprising in a city that Twachtman

would later declare "an old foggied place," where only the "art of the old Dusseldorf school...comes in for its full share of honor."[12] Duveneck, who had retreated to Cincinnati under duress to replenish the financial resources he had depleted in Munich, sought to return as soon as possible to the German city. The opportunity to do so occurred when an exhibition of his art, held in Boston in June 1875, brought him both acclaim from the critics (including high praise from the future literary luminary Henry James) and profit, as many of his paintings sold.[13] Now able to return to Munich, Duveneck invited his promising young student, Twachtman, to accompany him, and the two artists set sail in August 1875 for Germany.

Since early in the century, Paris had been the preeminent art center in the Western world, but in the years surrounding the Franco-Prussian War of 1870–71, the tensions that rocked the French capital prompted foreign artists to seek other venues in which to pursue their studies. Munich, a city beautified by the campaigns of several Bavarian rulers and having gained a reputation for a strong, revitalized art school—the Munich Royal Academy—rose to prominence in the early 1870s as a robust and attractive option.[14] Duveneck, who had first gone there in the fall of 1869 on the recommendation of his teachers in the workshop in Covington, Kentucky, where he had been learning to paint church altarpieces, arrived just before the art scene in Munich came to life, and he had witnessed the rise of the city as a hotbed of the radical mode of Realist painting promulgated by Leibl, who had himself just returned from Paris in early 1870, where he had been embraced by Courbet's circle, including Édouard Manet and Henri Fantin-Latour. Painting frank views of humble subjects, Leibl was in full accord with the view of Courbet and such advocates of Realism as the critic Jules-Antoine Castagnary, who believed that artists had a moral obligation to paint subjects drawn from their own era as only they could understand their own time and provide a true record of it for posterity.[15]

However, by the time Twachtman reached Munich with Duveneck in 1875, Leibl had left the city to paint in more isolated surroundings in the country and had turned from a radical painterly style involving gestural, sweeping brushwork to a crisp, linear approach in the tradition of Hans Holbein and Albrecht Dürer. Nonetheless, the influence of Leibl's earlier art prevailed among the community of young artists in Munich, which had continued to grow even as Paris recovered its stability. Among the large contingent of Munich's

Fig. 26
J. Frank Currier, *Moors at Dachau*, ca. 1875, oil on canvas, 51 × 81 inches, private collection.

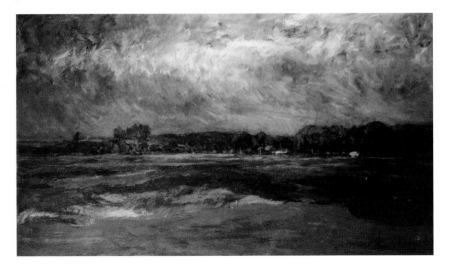

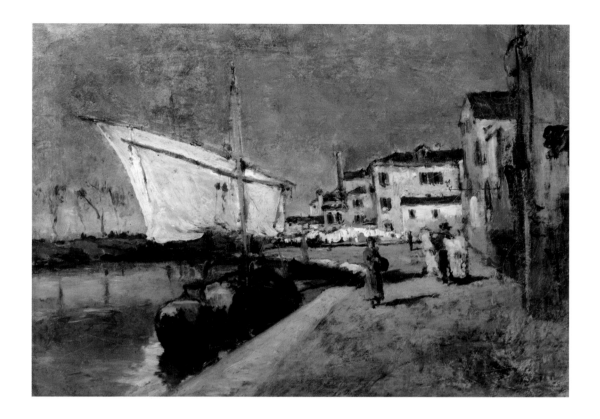

Fig. 27
Twachtman, *Venice,
Campo Santa Marta*,
ca. 1878, oil on canvas,
17 × 23 inches,
private collection.

art students were many Americans, who provided a comfortable social milieu for Twachtman. He readily took part in the lively gatherings that took place at the American Artists' Club of Munich, established in 1875.[16] He also visited the Bavarian town of Polling, a popular place for American artists to paint and fraternize in a peaceful, countryside setting.[17] There Twachtman may have crossed paths with and followed the example of the American artist J. Frank Currier.[18] Born in Boston, Currier had first studied in Antwerp. Arriving in Munich in 1870, he spent two years at the Royal Academy before leaving it to become a full devotee of Leibl's Realist approach. Among the Americans in Munich, and possibly among all of the artists who followed Leibl, Currier seems to have taken his method to its most extreme degree. Applying thick glutinous paints with muscular force onto large-scale canvases, he built up dense lathery surfaces that he swirled up with sticks, often creating images in which the pigment itself seemed more critical to a work than its subject (Fig. 26). Twachtman's exposure to Currier and his art is suggested in *View near Polling* (Cat. 1), a large-scale outdoor sketch, painted in a forceful direct manner.

Like other American art students in Munich, Twachtman enrolled at the Royal Academy,[19] but as is suggested in his Polling image, his approach was informed by the style to which he had been introduced in Cincinnati by Duveneck, who continued to instruct him privately in Munich. However, Twachtman did not follow his mentor's predilection of the time for portraiture. Applying Leibl's approach to landscape painting instead, Twachtman recorded his observations of his immediate surroundings in a direct way. His technique was also rooted in the methods initiated by Leibl and disseminated by Duveneck. Painting without interruption, he wielded his brush in a dynamic, freely expressive fashion, seeking to imbue his images with the spontaneity of vision itself. Forgoing the finishing process, he further sought to preserve the freshness with which he observed his sites in his completed works. Yet he also adhered to the dark chiaroscuro popularized by Leibl, which reflected an admiration for the rich, tenebrous art of Dutch and Spanish old masters, such as Rembrandt van Rijn, Diego Velázquez, and Frans Hals.

Despite the mooring of his art in the dark tones of old master paintings, Twachtman began to formulate his own approach in the scenes of Venice he created during a sojourn of 1877–78, when he was accompanied by Duveneck and William Merritt Chase (whose student years in Munich lasted from 1871 through the summer of 1878, overlapping Twachtman's) (Cats. 2–5, Figs. 27–30). The artists resided at the Pensione Bucintoro, located in the Castello district on the Riva San Biagio.[20]

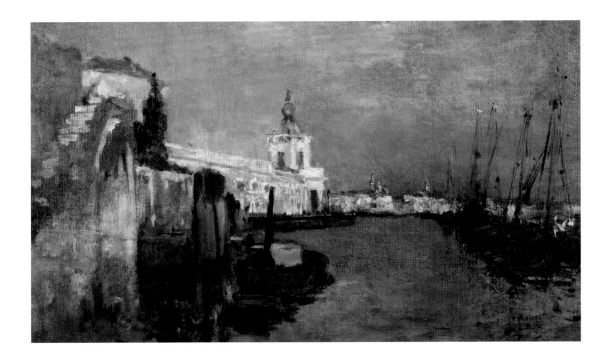

Fig. 28
Twachtman, *Venice*,
ca. 1878, oil on canvas,
10 × 16 inches,
private collection.

From there, Twachtman mostly walked west, painting in and near the Piazza San Marco, which offered views of the Dogana (the Venetian custom-house) and beyond it to Palladio's San Giorgio Maggiore on the Isola di San Giorgio. He also traversed the Fondamenta della Zattere, the wide walkway at the southwestern end of Venice, going as far as the Campo Santa Marta, a working-class neighborhood at the western end of the city, where he rendered a square that James McNeill Whistler would portray in 1880 (Fig. 27).[21]

While many of his paintings portray well-known Venetian locales, often he chose unusual vantage points and painted even the most renowned architectural structures simply as formal elements within his scenes, giving them no greater importance than weathered pilings, debris-filled boatyards, industrial warehouses, and crumbling stone walls (Cats. 2–5). He challenged himself to produce unique compositions from a site by depicting it from different angles. Although he portrayed the Dogana from the vantage point favored by many artists, looking southeast from near the Accademia, with San Giorgio visible in the distance (Cat. 2), the building is cropped and sidelined, so that the open space of the waterway is of greater significance in the arrangement than the celebrated buildings. In another work, he depicted the Dogana from an unusual vantage point at its southern side, looking northwest from which the Doge's Palace and a glimpse of the campanile of St. Mark's in the distance are in view, while the boatyard at the right plays a central role in the design (Fig. 28). He featured the gondola-making workshops in the San Trovaso district, in which he juxtaposed the working life of the city, as represented by the rough boat-building sheds, with a reminder of its glamour, in the presence of the glistening white campanile of a church rising overhead (Fig. 29). Unlike other artists, who preferred to see only Venice's gondolas, Twachtman did not edit out the steamships ever-present then on the Guidecca and in St. Mark's Basin (see Cat. 5). More than a year before Whistler arrived in the city for his first only visit, Twachtman explored the "Venice in Venice" that Whistler would claim "that "others seem never to have perceived."[22]

Fig. 29
Twachtman,
San Trovaso, Venice,
ca. 1878, oil on panel,
7½ × 10½ inches,
private collection.

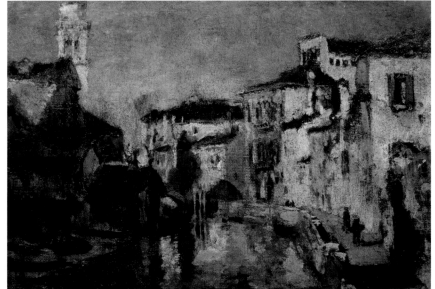

Realism Must be Real

In the spring of 1878 Twachtman sent three of his Venetian scenes to the first exhibition of the Society of American Artists in New York, which had been formed a year earlier by a group of mainly foreign-trained painters as a reaction against the increasingly restrictive and conservative policies of the National Academy of Design. He again showed three images of Venice in the second show of the society, held the following spring. At these exhibitions, the works of the American artists associated with the Munich School had a significant presence, and they were given widespread coverage by the press—most of it negative. Of all the Munich artists represented at the society, Currier received the greatest amount of condemnation.

American critics were most offended by Currier's portraits rendered with syrupy, swirled-up paint. He was attacked for taking the Munich manner too far. Critics described his images as "slapdash" works that suggested "mania" and even "ill-health."[23] They denounced him for creating images that were "affected" and "sensationalistic," insinuating that he had merely appropriated the Munich approach to show off the virtuosity of his brush-handling skills, rather than using his brush with any particular purpose. As one critic observed, he had confused "shouting for oratory; loud beating of drums and blaring of trumpets for music; affectation for original genius." This commentator went on to label Currier a "mountebank," associating him with a quack doctor who proffered false panaceas.[24] As these statements suggest, the critics were especially troubled that Currier, although using an approach associated with Realism, created images that, in their viscous surfaces, seemed to stray from the truth. Such works irked the critics because they seemed self-aggrandizing rather than heartfelt.

For many American critics, the Munich School, as represented by the art of Currier and other native artists, belied its own aim of capturing the world as seen anew, because they had all simply imitated the manner of Leibl rather than using his approach to achieve its objectives. Commentators suggested that American artists had adopted the Munich manner merely to attain the cache of modernity but had achieved only the veneer of modernity because the sameness of their art undermined their intention. A writer for the *Nation* encapsulated this point of view in a description of works by Munich School artists on view at the first exhibition of the society in 1878,

stating: "These Bavarian canvases are so even in merit, so self-possessed and successful in an inferior aim, that they are to be dreaded among our young painters. The pupils who have gone to Munich paint alike, and the one as well as the other; there seems to be a recipe for arranging a tableau of emotion, a tableau of genre, a tableau of still life; nobody ever fails, and no success worth attaining is ever achieved."[25] It was not Realism to which American critics objected, but an abuse of the style associated with it.

Perhaps the most frequent complaint about Munich School art was that it was too dark. This aspect was seen to demonstrate that works lacked the "truth" they purported to reveal, and they were all too much the same in this regard. The critic Samuel Benjamin identified this phenomenon, sarcastically remarking in 1880:

> Is it necessary to affect the low tone so common with some of the artists of the Munich school in order to interpret the truths of nature? We think this tone is the result of an excessive admiration of the rich dark paintings of the Renaissance. But it should be remembered that, owing to age, these pictures are much darker now than when they were first painted. By parity of reasoning, one is almost afraid to think how excessively black and meaningless some of the paintings of to-day will look two centuries hence.[26]

In this context, Twachtman was recognized as exemplifying the Munich School idiom, and his Venetian scenes received some of the same criticisms as did Currier's and those of other Munich artists, especially for their dark tonal values. However, many reviewers of the society's shows saw Twachtman as an artist who had escaped the pitfalls into which his compatriots had fallen. Through his use of Munich methods to achieve the freshness and candor that the style was supposed to achieve, they felt he had expressed the true nature of his subjects. They saw Twachtman as fulfilling what Realism promised: a representation of subjects as they were perceived rather than shown with only the stylistic overlay of Realism. To American critics, a Realist "style" should be synonymous with Realist objectives.

One writer saw a landscape by Twachtman as "simply an affectation" in the mode of, but "less pronounced" than, "Mr. Currier's experiments," but then pointed out that Twachtman had demonstrated a greater correctness "in local tone than was usual with painters of Venetian subjects."[27] Writing for the *New York Times*, a reviewer of the

Fig. 30
Twachtman, *House on a Canal, Venice*, 1877, oil on panel, 17 × 12 inches, location unknown.

society's 1878 show went further, noting that Twachtman had held "to his Munich teachings," but, unlike other Munich painters, he had kept his contrasts "in view," resulting in "a very powerful style of picture, which looks well at a great distance." He manages "to inspire the belief that there is thought and life behind his mall-stick."[28] The critic for the *Aldine* was more favorably inclined toward the Munich School art on view at the society in 1879 than were his peers, weighing in with the comment: "Pictures which may be regarded as purely impressions, making no pretension to anything more, were numerous, and in some cases very good." Singling Twachtman out for such work, he or she remarked: "Perhaps the best of these, because answering the above requirements, and so painted that a real picture could be seen when examined from the proper focal distance, was a 'Venetian Sketch,' by

J. W. [*sic*] Twachtmann [*sic*]. In this we had a row of houses on the shore, a line of ships drawn up in the water, good atmospheric effects and brilliant colors."[29]

A critic for the *New-York Tribune* focused on a work that Twachtman exhibited at the society in 1878 that is surely his painting known today as *House on a Canal, Venice* (Fig. 30), describing it as showing "a corner of the wall that shuts on the canal, with its red water pots, its straggling trellis, its shelves for flowers stuck up any where and every where." The writer observed that the painting demonstrated "a tidy untidiness and a confusion without disorder, a picturesqueness that comes naturally from the situation of the dwelling and the easy-going way of life of the inhabitants." In this critic's view, Twachtman had captured the "real" Venice, rather than that of "Turner's fairy visions," by showing "a spot the like of which may be seen every hour in Venice." While to this writer, Twachtman's works were "unequal in interest," they nonetheless "all showed a certain verity extremely valuable after the stage-play of the general run of artists who take Venice in hand."[30]

The critics appreciated how Twachtman's innovative methods had enhanced the feeling of reality in his works. Susan Carter described Twachtman's images of Venice on view at the society in 1879 as demonstrating "very vigorous effects rapidly laid in" and noted: "the satisfactory points of all sketches—and we think they had more merit than any others in the collection— were the agreeable massing of light and shadow, the positive and knowing way in which bits of light and dark were made to tell against each other, and an agreeable effect of daylight in all."[31] The reviewer for the *Aldine*, quoted above, explained that it was possible for an "impressionist" (a term applied often to artists of the Munich School in the 1870s) "to execute an artistic and pleasing picture, warm in color, possessing elements of beauty, and well composed."[32]

New York Harbor: The New American Landscape

Twachtman returned to the United States on learning of his father's death in the spring of 1878. In a painting that he inscribed "J. H. Twachtman Cin. 78," he perhaps expressed his sadness at his loss (Fig. 31). Within a work rendered in sepia and gray-brown tones, a lone bent figure, seen from the back, treads away from us along a damp, muddy road stretching into the distance; while the clouds are heavy and full, the dark landforms

Fig. 31
Twachtman, *Road Scene,
Cincinnati*, 1878, oil on
canvas, 13½ × 23⅞
inches, private collection.

at the horizon played up against the glimmering light of the sun's afterglow. Read as an image of the artist's sorrow—shown as much through the image as the way it is painted—*Road Scene, Cincinnati* may be related to Twachtman's moving *Sailing in the Mist* images of ca. 1895 (Cat. 47 and Fig. 77), portraying a figure sailing a small boat into a misty unknown, in which he conveyed his grief at the death of his nine-year-old daughter Elsie from scarlet fever.[33]

In the fall of 1879, Twachtman settled in New York. There he took an apartment in the University Building on Washington Square and joined the Tile Club, which had been founded in 1877 by a group of American artists and a few writers who sought to provide a venue for participation in the decorative art movement that had begun earlier in Europe. While the purpose of their meetings was to paint ceramic tiles, they also debated issues of modern art and aesthetics. Among the Tilers were the artists J. Alden Weir, Chase, Edwin Austin Abbey, Robert Swain Gifford, Winslow Homer, Arthur Quartley, F. Hopkinson Smith, and Augustus Saint-Gaudens; the Japanese artist and importer Heromichi Shugio; the art critics William MacKay Laffan and Earl Shinn (who used the pseudonym Edward Strahan); and the architect Stanford White.

In New York Twachtman focused on painting the harbors on the Hudson River near Tenth Street. He may have chosen this area because it provided a subject matter similar to that of Venice, but he may have been drawn to it for other reasons as well. At the time, the harbors of New York were notorious for their rough, dingy, and unsightly qualities; they were described in publications of the day as "wretched, half-decayed and dirty,"[34] and their wharves created a "tattered dirty fringe to the city."[35] Yet with their blend of old fishing vessels, tugboats, and steamships, which clogged the waterways and fashioned a lively vision along crowded, makeshift docks, they epitomized the vivacious new spirit of the burgeoning metropolis and represented its changing character. Twachtman may have felt compelled by this subject matter, as its lack of a pictorial tradition in America facilitated a direct way of seeing and painting. He also perhaps found a parallel between the city and his own exuberance at the time, as he delighted in life in New York.

In a number of instances, Twachtman seems to have purposefully chosen motifs that typified the novel character of the waterfront as well as of New York (Cats. 6–7, Figs. 33, 36). At a time when a increasingly commercialized society spawned competition, even the oyster sellers on the city's waterfront were seeking new ways of increasing efficiency while enticing their clientele; they did so intriguingly through the construction of oyster-sloop boathouses. These were shacks built on boats that sold fish from colorfully painted storefront facades that were delivered directly from the

Fig. 32
"Boat Stores," illustration from James D. McCabe Jr., *Lights and Shadows of New York Life; Or, the Sights and Sensations of the Great City* (1872; facsimile, New York, 1970), p. 835.

water to their unadorned back sides (Fig. 32).[36] Twachtman portrayed the rougher seaward side of this subject in a work entitled *Oyster Boats, North River* (Fig. 33). In another painting, he depicted a large dredge lifting its scow arm from which mud drops heavily into the water (Cat. 7). He also focused on modern life in a number of views of Jersey City, one of the New York City's

fastest-growing suburbs during the second half of the nineteenth century. In these images he depicted the sprawling apartment buildings that crowded around the Green Street Boat Basin (Fig. 34) and the low sand hills along the shore where the countryside was partially developed. This subject is shown in *Harbor View* (Fig. 35), in which Twachtman contrasted a steam tug on the water with a primitive shanty settlement on the shore.

Although Twachtman's choice of subject matter that did not come burdened with an iconographic tradition afforded him a vehicle for his continued exploration of Realism, it also provided a stimulus for him to further develop an individualistic style. Following his practices in Venice, he stood close to his motifs and painted in a rapid, vigorous fashion, omitting as much of the surrounding context as possible. This process enabled him to bring out relationships of shapes and lines that caught his eye without falling into conventional strategies of pictorial organization. Using a lighter, more calligraphic brushwork than in his Venetian scenes, he emphasized the rhythmic patterns created by the crossing of masts and their jostled reflections in the water and counterbalanced the broad masses of boat hulls and warehouses with the staccato verticals of tugboat smokestacks.

Twachtman's approach in his New York scenes was described by William MacKay Laffan, a friend from the Tile Club, who published an article in the *American Art Review* of 1880 describing an anony-

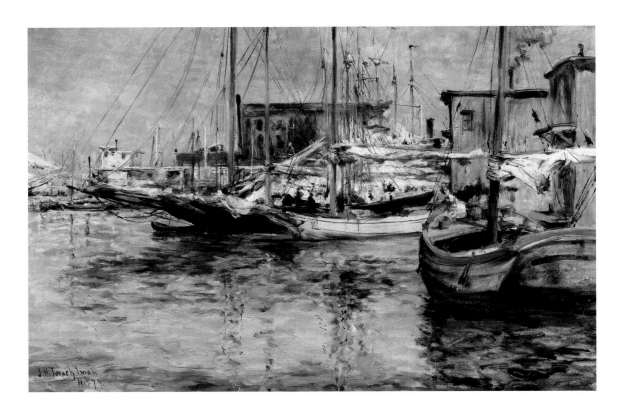

Fig. 33
Twachtman, *Oyster Boats, North River*, 1879, oil on canvas, 16 × 24 inches, Princeton University Art Museum, New Jersey, Bequest of Gilbert S. McClintock, Class of 1908.

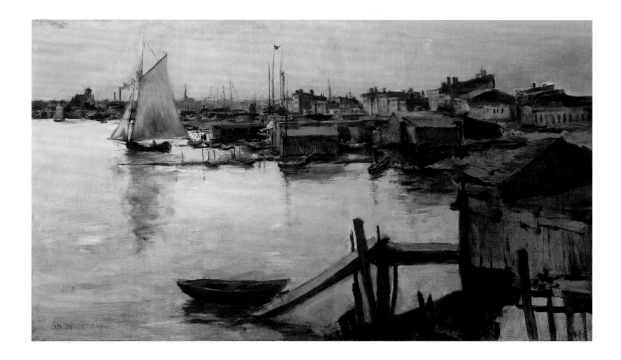

Fig. 34
Twachtman, *The Shore*,
ca. 1879, oil on canvas,
14 3/16 × 24⅛ inches,
San Diego Museum of
Art, California, Gift of
Mrs. Henry A. Everett.

mous artist painting scenes of New York harbor, an artist who was undoubtedly Twachtman. "On his canvas," Laffan wrote, "was a transition of cool gray emphasized and held by a patch of white borrowed from the sail in the distance." With such an approach, Laffan reported, the artist had secured the "equipoise" in "black and white" of a locale in which "a long row of pilings…projected far beyond the wharves and bulkheads" that extended into a river, where a "dozen stout timbers bound together with iron bands" were "worn away and jagged and battered by the impact of swinging steamers." To the left of the artist, Laffan wrote, "there rose up a mass of great beams and stout weather-boarding, surmounted by a tall crane, that swung and creaked with its tackle," while "over all was grime and blackness of the coal, a thing defining and forbidding, and spreading its greasy dust upon the water." Laffan advocated that American artists follow in the mode of

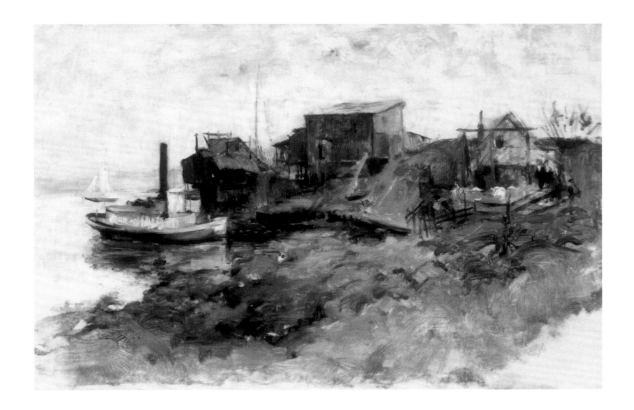

Fig. 35
Twachtman, *Harbor
View*, ca. 1879, oil on
canvas, 14¼ × 22 inches,
Jack S. Blanton Museum
of Art, The University
of Texas at Austin,
Michener Acquisitions
Fund, 1969.

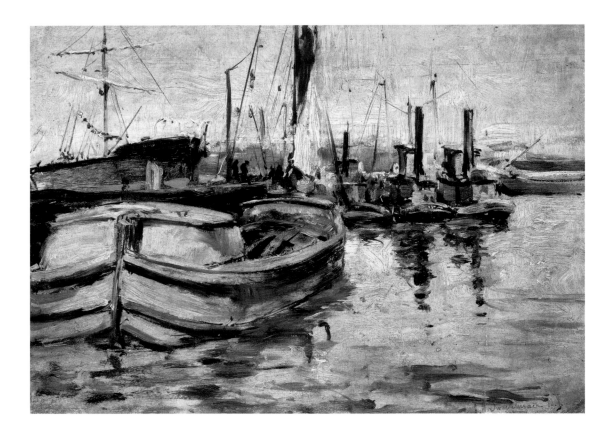

Fig. 36
Twachtman, *New York Harbor*, ca. 1879,
oil on pressed board,
8¹⁵⁄₁₆ × 12¹⁄₁₆ inches,
Cincinnati Art Museum,
Bequest of Mr. and
Mrs. Walter J. Wichgar.

Fig. 37
Louis Comfort Tiffany,
Duane Street, New York,
ca. 1877, oil on canvas,
26¾ × 30¹⁄₁₆ inches,
Brooklyn Museum of
Art, New York, Dick S.
Ramsay Fund.

his model artist, drawing from "the material of the American landscape" for their art, a subject that too many avoided in the painting of "bric-a-brac landscapes in their studios," often because of their feelings that a harbor was "valueless without a Venetian sail or a gondola, and humanity superfluous unless clad in fez or turban."[37]

A similar viewpoint had been expressed by a writer for the *New York Sun* in a discussion of the work of Louis Comfort Tiffany on view at the first exhibition of the Society of American Artists. Although the *Sun* critic was impressed with Tiffany's view of a market day in Brittany and a street in Roccabruna, Italy, the focus of the article was a scene of Duane Street in New York City (Fig. 37) that Tiffany had shown at the National Academy of Design earlier in the year. The critic described *Duane Street, New York* as a view of "an ordinary down-town corner, a bit of an old street not ordinarily suggestive of picturesque qualities" with which Tiffany had not taken "any particular liberties," treating it "on its merits and with, if anything, a little too much literalness." Noting that the painting had been a "success," the critic advised other artists to follow Tiffany's lead, as "there should be more joy over one decent study of a dirty New York tenement house with its familiar accessories, than over ninety and in regulation proprieties from Normandy and Bagdad [*sic*]." The critic remarked: "there are brick walls about New York as good as any in Brittany, and they have just as valuable discolorations and their details of decay are just as interesting. And yet nothing will do that has not the European glamour upon it!" Like Laffan, the *Sun* writer saw artistic value in the commonplace aspects of New York life, suggesting that finding inspiration in such locales would result in works that were more worthy than the "empty things

Fig. 38
Twachtman, *Bridge across the Ohio River at Cincinnati* (recto of two-sided drawing), ca. 1880–83, pencil on paper, 8½ × 11⅛ inches, private collection.

that Mr. F[rederick] A. Bridgeman [*sic*] is striving after."[38] However, it would not be until after the turn of the century in the art of the Ashcan School that American artists would follow this critic's advice and focus their attentions on the gritty, dynamic qualities of the different polarities of New York City life.

Suburbanization Conquers the Hills

Returning to Cincinnati in the fall of 1879, Twachtman moved back to his family's home on Race Street and began teaching drawing and oil painting at the three-year-old Women's Art Museum Association.[39] He traveled twice to Europe in the years ahead, but his base remained Cincinnati until the fall of 1883, when he left for an extended sojourn in Paris.

Although Twachtman perceived Cincinnati as an unsympathetic environment in which to work, offering "no good art influence,"[40] he again found inspiration in modern life. He had painted scenes of the waterfront in Venice and New York, but this subject was not his focus in Cincinnati, and his only known image of it is a pencil drawing in which he featured the suspension bridge designed by John Roebling that crossed the river between Cincinnati and Covington, Kentucky (Fig. 38). He also did not return to portraying the Miami Canal. Instead, he now mostly painted the hills of the city, which were just then undergoing a dramatic transformation.

Rising steeply upward from the river basin, itself set on a plateau approximately 430 feet above sea level, these undulating hills range from 400 to about 800 feet above the city. Although modest by comparison with the heights of truly mountainous regions, these land rises had not been easily surmountable in the nineteenth century and were viewed through the 1860s as "valueless on account of their inaccessibility."[41] The strange situation of hills that could be negotiated but not easily settled had been recognized decades earlier by the Englishwoman and theatrical promoter Frances Trollope (and mother of the novelist Anthony Trollope), who visited the city in 1827–29 and wrote in her 1832 *Domestic Manners of the Americans*: "To the north Cincinnati is bounded by a range of forest-covered hills, sufficiently steep and rugged to prevent their being built upon, or easily cultivated, but not sufficiently high to command from their summits a view of any considerable extent."[42] By the end of the 1860s, the need for the settling of the hills suddenly became urgent, as the city's dramatically increasing population was outgrowing the river basin, and the dank, smoky air, caused both by the heating of homes with bituminous coal and the intensification of industrial expansion along the banks of the Ohio River, was trapped there by the hills, making Cincinnati probably the most polluted city in America at the time. In his article on Cincinnati in the *Atlantic Monthly* in 1867,

Fig. 39
Photograph, Mt. Auburn
Incline (Main Street),
ca. 1877–78, from
Richard M. Wagner and
Roy J. Wright, *Cincinnati
Streetcars, No. 2*
(Cincinnati, Ohio:
Wagner Car Company,
1968), p. 29.

Fig. 40
Twachtman, pencil
drawing from Cincinnati
sketchbook, ca. 1880,
private collection.

Fig. 41
Twachtman, pencil
drawing from Cincinnati
sketchbook, ca. 1880,
private collection.

James Parton described the "yellow river of the Ohio" and the ever-present smoke in the city, which "begrimes the carpets, blackens the curtains, soils the paint, and worries the ladies." He observed how smoke in the city deposited such "a fine soot" that the "stranger … keeps up a continual washing of his hands, but soon sees the folly of it, and abandons them to their fate." Parton decried the "Stygian pall [which] lies low upon the town."[43] Of the view from one of the city's hills, he remarked: "Around the base of this unsightly mountain are slaughter-houses and breweries, incensing it with black smoke, and extensive pens filled with the living material of barreled pork."[44] Twachtman had suggested this vision of Cincinnati in his Miami Canal view of ca. 1874 (Fig. 24).

Pressed to remedy what were viewed as increasingly dire conditions, a group of Cincinnati businessmen formed the Cincinnati Inclined Plane Railway Company in 1871,[45] and by the following year, the first of the city's inclines was built, running from the head of Main Street to the top of Mt. Auburn (Fig. 39), where a number of wealthy families had already established homes on the highest summits.[46] While Twachtman was abroad, three more inclines began to operate.[47] Elevator-like contraptions raised by pulleys, the inclines had fascinated Twachtman even when he was in Munich. He had written to his niece in 1876 mentioning that when he came home from Germany he would "ride in the inclined plane cars that go on the hill."[48]

When he returned to Cincinnati in 1879, Twachtman would have witnessed the sudden expansion of the city into its hills after the completion of the inclines, and he found his subject matter in this locale, where middle-class communities were rapidly surfacing in places that had previously been overgrown wilderness or had only the markings of rudimentary settlement in the form of an occasional farm or mill. His interest in the changes taking place in Cincinnati are evident in his only existing sketchbook, inscribed with a date of August 25, 1880, which he used to record views of the city itself—portraying buildings and crowds—and of its hills, where the development taking place is reflected in his depictions of houses, figures, and paths (Figs. 40–41). In his earliest paintings of the Cincinnati hills—many of which are inscribed "Cin. O. 1880"—he used his canvases in the same way, to record what he observed from the vantage point of the hills themselves. His direct involvement in these landscapes is suggested by his choice of intimate viewpoints from the slope of the hills themselves, from which he often directs our gaze upward to suggest the route by which he would proceed. He brought out the seemingly discordant qualities in these transitional places, showing the high vertical buildings

characteristic of Cincinnati homes of the era, included fences that seem to veer off at angles inconsistent with the lay of the land, and portrayed lone figures who are neither farm folk nor affluent landowners, who stand, seemingly without purpose, on the slanting gradients of the untilled land (Fig. 42). In a few paintings, dashes of white glimpsed through the trees suggest the presence of houses that have been settled almost surreptitiously into the forested landscape (Fig. 43).

It was probably one of his images of a green Cincinnati hillside that Twachtman sent to the Society of American Artists exhibition held in March 1880 with the title *April Clouds*. This painting, described in reviews as "a quiet picturesque landscape"[49] and "an afternoon effect"[50] portraying "wet, drifting clouds above a green undulating [landscape],"[51] was possibly similar to his *Cincinnati Landscape* (Fig. 42). In discussing this painting, the critics expressed their appreciation for Twachtman's ability to find aesthetic value in such a seemingly inauspicious scene. A writer for *New York Herald* commented that, "though peculiar in treatment," the painting is "pleasing and unconventional in composition."[52] A reviewer for the *Art Journal* reported that the work has the capacity to "carry the thought back most forcibly to similar conditions in Nature,"[53] while the noted critic Samuel Benjamin deemed it one of the best landscapes in the exhibition, because "in general artistic sentiment, this simple landscape by Mr. Twachtman is rich alike in promise and in achievement."[54]

At the same time, some commentators faulted Twachtman for a palette that was still too dark and observed that such a tendency undermined the truthfulness of his work. The reviewer for the *Art Interchange* saw the painting as "too sombre, the uncertain glory of the April day has here been transformed into November."[55] Despite his admiration for Twachtman's art in general, Benjamin stated that the "defect" of *April Clouds*, "which is apparent in all the works of this artist, is that it is pitched in too low a key to be wholly agreeable. Although, judging from the shadows, the scene must be supposed to be illuminated by the broad light of mid-day, the effect is as if the sun were partially eclipsed."[56]

In October 1880 Twachtman left Cincinnati behind for Italy, where he taught at a school that Duveneck had begun in Florence. The paintings Twachtman created there are similar to those that he had recently made in Cincinnati, although his images of the green hills of Tuscany, including houses that appear harmoniously situated on

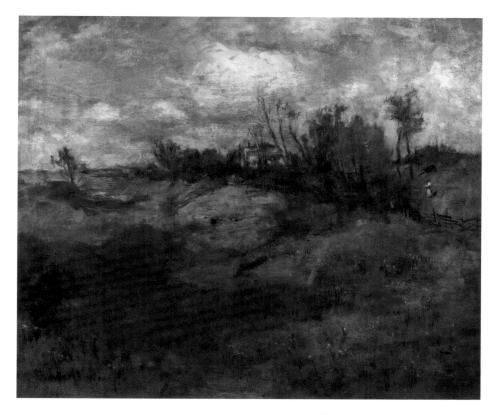

hilltop terraces, have a more refined look and are painted with a lighter touch than his scenes of Cincinnati (Cat. 9). This contrast naturally reflected the difference between a landscape in which middle-class homes were pitched awkwardly for the convenience of commuters and a countryside of gracious villas, aligned aesthetically in accord with the flow of the land.

Fig. 42
Twachtman, *Cincinnati Landscape*, 1880, oil on canvas, 20½ × 24 inches, private collection.

Fig. 43
Twachtman, *Avondale, Ohio*, ca. 1882, oil on canvas, 11 × 16 inches, private collection.

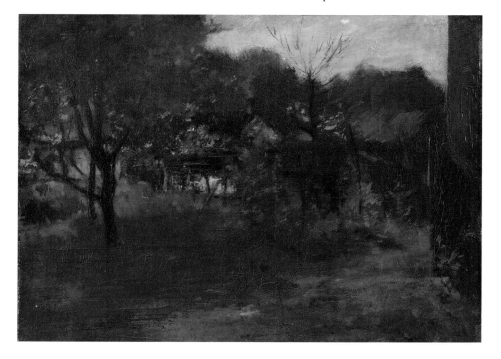

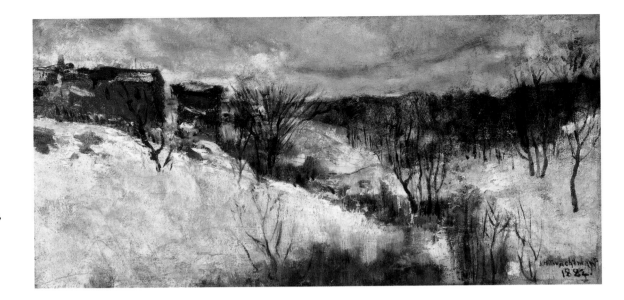

Fig. 44
Twachtman, *Bloody Run*, 1882, oil on canvas, 12 × 24 inches, Cincinnati Art Museum, Gift of the Proctor & Gamble Company.

Fig. 45
Twachtman, *Twachtman's Home, Avondale, Ohio*, ca. 1882, oil on canvas, 18¾ × 27 inches, location unknown.

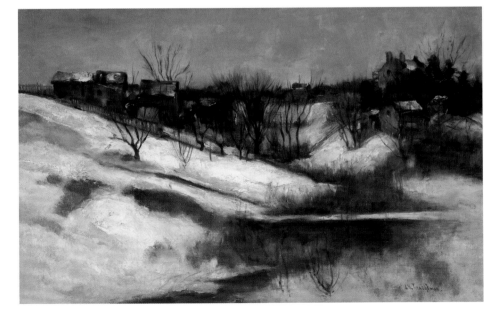

Twachtman returned to his hometown sometime before April 21, 1881, when he married the Cincinnati artist and etcher Martha Scudder (1861–1934), who had studied at the Women's Art Museum Association and possibly also in Munich.[57] The newlyweds honeymooned in Europe during the summer and fall after their wedding, spending most of their time in Dordrecht and its surroundings in southern Holland. There they were joined by J. Alden Weir and his half brother John Ferguson Weir (1841–1926). The artists stayed in the nearby town of Papendrecht, took an excursion to neighboring Alblassadam, and visited "picture galleries" in Amsterdam, The Hague, Rotterdam, and Haarlem, including the Frans Hals Museum.[58] Their association with the artists of the Hague

School is suggested in a comment in a letter that J. Alden Weir sent to his mother in which he mentioned the presence of Twachtman and his wife and noted: "We have been made members of the club here and last night we had a charming out of door concert."[59] John Weir wrote home of his enthusiasm for the warm light and quiet beauty of the Dutch countryside, and observed that while the sky in Italy or America might "be thin and sparking or transparent," in Holland it "has a breadth and solidity wholly their own— I don't know otherwise to describe it than palpable."[60] The works Twachtman created on the sojourn, such as *Windmill in the Dutch Countryside* (Cat. 10), suggest his concurrence with John Weir's descriptions. At some point during the sojourn, Twachtman sought out the noted Hague School painter Anton Mauve, who critiqued his work.[61] It seems likely that the example of Mauve's art demonstrated to Twachtman ways that he could lessen the dark pitch of his palette and use tonal gradations to capture more discreet nuances of light and atmosphere.

The impact of Twachtman's sojourn in Holland also emerged in works he created in Cincinnati after his honeymoon. Instead of returning to Over the Rhine, the artist and his wife (now pregnant with their first child) moved into her father's home in the Cincinnati suburb of Avondale.[62] Next to the suburb of Clifton—reached by the Bellevue Incline after it began operation in 1876—Avondale grew significantly after the inclines were built. Now the subject matter that Twachtman had begun to paint in 1880 was suddenly even more accessible. An area of about eight hundred acres, Avondale had become renowned in the late 1860s

as a green enclave where one could find "the quiet and simple pleasures of rural life, remote from any thing to suggest the crowded, noisy, dusty city."[63] By 1879 Avondale had turned into a commuter community, the home "largely of the families of business men who are actively employed in Cincinnati; there are relatively few of any other class,"[64] as D. J. Kenny reported in his 1879 *Pictorial Guide to Cincinnati and the Suburbs of Cincinnati.* Kenny noted that the houses of Avondale were "singularly attractive in their appearance, but without ostentation, and intended more for comfort than show," with many "occupying the crests of the waves of land that sweep away in beauty as far as the eye can distinguish."[65]

By contrast with Kenny's effort to promote the beauty of Cincinnati's suburbs through flattering descriptions, Twachtman's images of Avondale demonstrate that he continued to paint what he observed, creating works in which he expressed the character of Cincinnati's hills. This may be seen especially in *Bloody Run* (Fig. 44), dated 1882, and *Twachtman's Home, Avondale, Ohio* (Fig. 45). These works, portraying an area within Avondale that was nicknamed for either an old massacre of Native Americans or for the runoff from slaughterhouses,[66] are probably among Twachtman's first snow scenes, and they reveal that he had already developed the approach he would use for snow for the rest of his career. He depicted the old, encrusted surface of the ground cover with thick, scumbled white impasto, while rendering the broad areas where the snow had thawed, leaving muddy earth exposed, with a blend of browns, rusts, and grays. Here he suggested a parallel between a landscape in the throes of change, as the snow melted, and a place in transition, where new homes were being erected quickly, their tentativeness demonstrated in the way that they seem awkwardly positioned against the steep slopes of the land.

In another painting of this time, Twachtman again depicted industrial Cincinnati (Fig. 46), as he had in his earlier scene of the Miami Canal. His view in this painting is across Mill Creek Valley, where a road stretches toward the smoke-filled hills of the city. The hills form a continuous ridge in the background; the Gothic spire of Oakwood, the Clifton mansion of the businessman and art collector Henry Probasco (still standing today), is visible in the middle distance. A tall rust-red building situated in the middle distance is featured prominently in the work and viewed from the back, its position set before the hills as if to suggest its potential to halt the forward movement of the

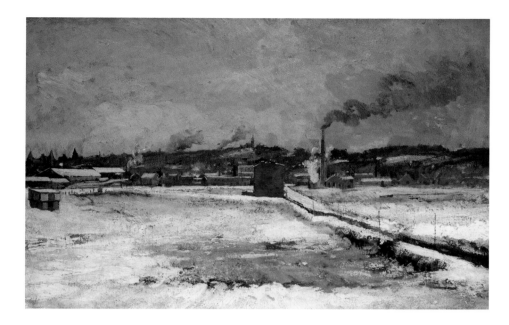

Fig. 46
Twachtman, *Winter, Mill Creek Valley, Cincinnati,* ca. 1882, oil on cradled panel, 15¾ × 24 inches, private collection.

city, yet its presence also keeps our attention focused on the empty space of the wet and melting snow in the foreground. In observing the work, we have the sense of an area rife for development, as the forward movement of industry through the valley seems inevitable, while the factories at the left and right—probably largely consisting mostly of slaughter houses— seem stacked as if they are preparing to march forward across the as yet undeveloped land.

Twachtman sent a few of his Cincinnati images to exhibitions of the society, displaying a painting entitled *Suburbs of Cincinnati* in the annual of 1881 and a work entitled *Winter,* which was probably similar to *Bloody Run,* in the annual of 1882. Twachtman's forthright approach to his subjects struck the right note for many critics. A writer for the *Atlantic Monthly* associated Twachtman's contribution to the 1881 show with Thomas Eakins's *Singing a Pathetic Song* (Fig. 47), observing that where Eakins had avoided rendering "Italian peasants and colonial damsels and pretty models" in his "strong and real" image, Twachtman had approached "our outdoor scenes in a similar spirit, dealing with the most prosaic and local of themes." The writer went on to note that with *Suburbs of Cincinnati,* Twachtman had proven "that even such homely material may be wrought into satisfactory and, of course, quite original sorts of art."[67] In the *New York World,* a critic similarly wrote of Twachtman's *Winter*: "some deny that there is beauty in such work . . . but beauty is of a thousand kinds and we have to thank Mr. Twachtman for thus developing it, as he surely does, from unpromising materials which no one

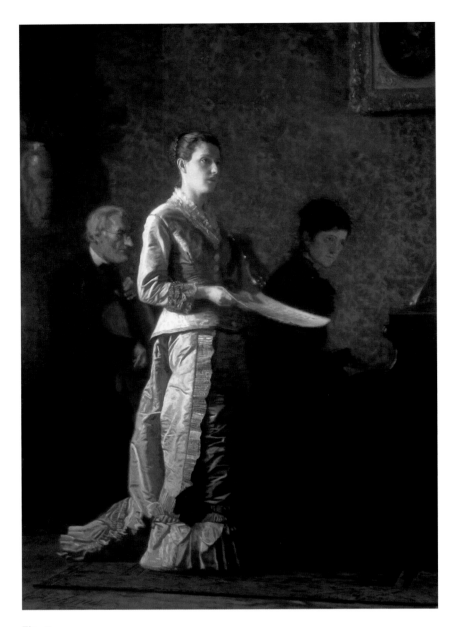

Fig. 47
Thomas Eakins,
Singing a Pathetic Song,
1881, oil on canvas,
45 × 32³⁄₁₆ inches,
Corcoran Gallery of Art,
Washington, D.C.,
Museum Purchase,
Gallery Fund.

of an American town," and she felt the painting exemplified the fact that American art "must seek its materials from immediate surroundings if it is to be truly vital and characteristic."[70]

However, at the same time, Van Rensselaer suggested that what Twachtman painted was less important than the fact that he had chosen a subject from which he could derive direct inspiration, enabling him to "clothe" his images with "artistic charm and poetry drawn from his own nature and his originality of brush." To Van Rensselaer, American art would be stronger and "doubly valuable" if artists were not dependent on their motifs for their inspiration, drawing material from them that also spurred their own individualistic creative results.[71] In 1881 Archibald Gordon had made a similar point, remarking that in the works Twachtman was displaying in the society's show, including both *Suburbs of Cincinnati* and *Tenth Street Dock*, he had "not merely yielded to the inspiration of the genius loci," instead "transcribing what he saw with capital boldness and precision." Gordon went on to comment: "in fact, [Twachtman's] technique is as much to be commended as his choice of a subject and the fidelity to nature with which he has healed it."[72] The same critic who reviewed the society's 1881 show for the *New York Tribune* made the related point that Twachtman had *not* given "the portraiture of the places he paints," but had "proved his power to see vividly and clearly, and to record with force the aspect of things," so that his images "could as easily have been rendered in Venice as in New York." According to this critic, although Twachtman "in the popular reckoning belongs to the so called 'impressionist' school," it was clear that he was "of the same dough that good painters are made in all ages and in every country." The critic explained: "If we could well get out of our heads the notion that there is one way of painting, and only one, we should be in a better mood to recognize the essential oneness which this superficial vanity presents our seeing."[73]

These commentators seem to be suggesting that if our artists painted familiar subjects honestly, this very frankness would help them develop individualistic styles. Rather than calling for a new national "style," the critics promoted individualism as the quality that would assure the greatness of American art in the future.

There was, nonetheless, one writer who suggested that Twachtman would not hurt the quality of his work if he were to soften the harshness of images such as *Winter*, shown in 1882. Comparing this painting with a winter scene by Bruce Crane,

had cared to touch before."[68] A writer for the *Art Journal* enthused about the same work: "The 'Winter' of J. H. Twachtman, two hillside slopes with sparse wood, and snow-covered, has all the bleakness of desolation which is to be found in such localities. It is given unrelentingly real and shows surprising power."[69]

For the perceptive critic Mariana Van Rensselaer, Twachtman's *Winter* had provided an example of how, by finding material for their art in typical American scenes—even if it seemingly bleak or dreary—native artists could create a new national form of landscape painting, reviving the dormant American landscape tradition. She recognized Twachtman's continued preference for "the most unhackneyed and prosaic and locally characteristic of themes" in his view "showing the outskirts

an artist strongly influenced by the art of the French Barbizon painters, the reviewer for the *Art Journal* commented that Crane's work had "mitigating qualities, which were not to be found in the severe rigors which Mr. Twachtman so pitilessly presented." The writer noted that Crane's images were "no less truthful, but more pleasing" than Twachtman's.[74]

That other painters of the time were also being urged to turn to quieter rather than more jarring sorts of imagery was reflected in the comment of a critic reviewing the society's 1881 exhibition for the *New York Evening Post*, who was probably referring to the art of the Munich School in enthusiastically pronouncing that "the era of slapdash has slipped away." This critic went on to observe that, happily, "the general aspect of the pictures is not sooty at all. Sweetness and light have taken the place of soot." In this type of work, the critic saw the emergence of "a strong poetic impulse, struggling to express by color and line some great truths of the imagination."[75] The same preference was echoed a few years later. Reviewing a show of works by Twachtman held at Chase's Gallery in Boston in 1885, a critic for the *Boston Evening Transcript* remarked that although Twachtman's technique in its "bluntness" in representing shades of red and its inattention to method made it frequently "slovenly in the extreme," the "supreme beauty of the idea" saved his pictures from condemnation. The critic commented: "Happily . . . there is little of this brutality in the most recent work, and one is led to hope it is definitely abandoned in favor of sensitiveness to poetic impression and a feeling for the most subtle and varying color."[76]

Toward "Sweetness and Light"

At some point during 1882 Twachtman's approach began to change, as he developed his art in the direction advocated by the critics. As if heeding Van Rensselaer's suggestion that artists did not need to depend on their subjects for inspiration, he began to focus on more generic sorts of rural scenes rather than places obviously impacted by progress. In many works, he cropped his views to give more emphasis than in the past to pure relationships of forms, as is demonstrated in *Snow Scene* of 1882 (Fig. 48), in which his interest was in an arrangement of the rhythmic, calligraphic dark lines of forms against the white ground. Twachtman also at times created more formally conceived compositions such as *Dark Trees, Cincinnati* (Cat. 12), dated 1882, in which he created

a view balanced between a direct observation of a landscape and a more carefully structured arrangement. The result is an iconic image, seemingly created as if to lock in the natural beauty of the scene before it was changed forever by industrial or suburban development.

The most dramatic change in Twachtman's approach may be seen in a comparison of his winter scenes of 1882, such as *Bloody Run* (Fig. 44), with snow scenes he created a year later (Cat. 14 and Fig. 49). In his later images, he still painted fluidly, but used a gentler, more controlled touch, thinning his pigments to create subtle tonal effects, emphasizing the echoing rhythms of roads, fences, and brooks, and blurring the contours of background shapes so that they blend into the atmosphere. He used thin strokes to delineate the delicate lines of tree branches set off against forms that become progressively less defined as we move toward the background. He focused on fine distinctions in texture, such as between the powdery surface of the snow-covered ground and the glistening qualities of reflected light in streams of liquefied snow. These qualities, in works such as *Winter in Cincinnati* (Fig. 49), seem included as aids to reflection and intended to instill a feeling of repose in the viewer. *Winter in Cincinnati* was perhaps similar to a work that Twachtman exhibited with the title of *Frosty Morning* in an exhibition at Closson's Gallery in Cincinnati in 1883, of which a critic remarked that the atmosphere was "apparently full of the 'white frost' which has fallen."[77]

Fig. 48
Twachtman, *Snow Scene*, 1882, oil on canvas, 12 1/16 × 16 1/16 inches, Cincinnati Art Museum, Bequest of Louise Drude.

Fig. 49
Twachtman, *Winter in Cincinnati*, ca. 1883, oil on canvas, 13¼ × 15¾ inches, private collection.

A work entitled *Silver Poplars* that Twachtman exhibited at the society in 1883 was similarly viewed as reflecting the artist's sensitivity to poetic nuances in nature. A writer for the *New York Sun* described it as depicting "a green field at the back of an ordinary farm house in early spring [with] a row of leafless poplars to the left and another to the right [and a] sky … filled with a mist of fine drifting snow."[78] From this description it seems likely that the work on view was the painting now known as *Gray Day* (Cat. 13). A writer for the *New York Sun* called *Silver Poplars* "more interesting than any other landscape in the room because it fixes for some years at least on the canvas a very transient and very beautiful natural effect which has not, to our knowledge been previously been attempted."[79] However, a few other reviewers felt that Twachtman's unusual treatment in *Silver Poplars* had made the work depart too far from the truth of its subject. The critic for the *Nation* described the painting as consisting "mostly of a flat space of dull green paint, with some dirty gray rarified brush lines drawn through it and a space of ungraduated leaden gray above for a sky." This writer hoped that "our artists will soon cease to throw away their time and materials on such vagueries."[80] For the *New York Daily Tribune* reviewer, Twachtman's painting, along with works by several other artists, showed that "the devotion to tone and color …

is growing to be a besetting sin." Singling out Twachtman's *Silver Poplars*, this writer stated that it was not enough for artists merely to "juggle with colors, matching and contrasting them like so many worsteds," and went on to explain that "art is but superficial which utterly neglects the thought and aims at only a tickling fancy by the form."[81] As usual, more insightful than her fellow critics, Van Rensselaer was able to take a broader perspective. Recognizing the divergent opinions that were expressed, she wrote, "some observers … cannot understand what there is in [Twachtman's *Silver Poplars*] to make it seem to others one of the very best things of the year." Explaining what Twachtman was trying to do, she praised the work's "individuality, its poetry of sentiment, its harmony of color and tone, and the way in which, unlike such work as Mr. [Ruger] Donoho's, it suggests far more than it describes."[82]

As the comments on *Silver Poplars* suggest, in the early 1880s, American critics were urging artists to paint simplified, quiet landscapes conducive to thought and reflection, but they advised against their reducing works so far that they seemed merely to be formal exercises. At the same time, demonstrating their receptivity to the Realism exemplified by the Munich School, they encouraged artists to underscore their art with a truth that reflected sincerity and freshness, but they advocated against too much of a dose of truth, as revealed, for example, in the disclosing of the realities of modern life. Such ideas lay at the basis for the emergence of the Tonalist movement, which became a recognized force in the American art scene in the mid-1890s.

The changing attitudes of American critics in the late 1870s and early 1880s provide insight into a time when the direction of American art was in flux and when there was a greater receptivity to Realist avenues than there would be later in the century. However, as the discussions in the press indicate, ideas as to how Realism was to be manifested evolved so that its association with modern life was gradually severed, probably due to the linkage of American art with nationalist aspirations, a connection that would continue to play out as native artists explored stylistic modes associated with Impressionism and Tonalism beginning in the late 1880s.

Full citations for abbreviated references may be found in Selected Exhibitions, pp. 245–46 and Selected References, pp. 247–48.

1. Twachtman's parents, Frederick Christian Twachtman (1815–1878) and Sophia Droege (1823–1895), probably came to Cincinnati in the early or mid-1840s in one of the large waves of Germans escaping Prussian oppression in the years before the German Revolution of 1848. They married in the mid-1840s, welcoming their first child, Amilia, in 1846. A descendant of property owners who had achieved some stature in German society, Frederick Twachtman is listed in Cincinnati city directories before the Civil War as a carpenter and cabinetmaker in 1853, 1860, 1861, and a candy maker in 1857. He was listed as a policeman in 1862 and 1863, suggesting that he may have been drawn by the demand for law enforcement that arose in the city during the war. In 1867, 1869, and 1870 he was listed as a dry-goods salesman. On the background of Twachtman's father's family, see Hale, *Life and Creative Development*, 1957, vol., 1, p. 8; Clark, *John Twachtman*, 1924, pp. 15–17 nn.

2. William Cullen Bryant, ed., *Picturesque America: Or, The Land We Live In* (New York: A. Appleton and Company, 1872), vol. 1, p. 160.

3. For information on the Cincinnati patrons of the Düsseldorf School, see Peters, *John Twachtman and the American Scene*, 1995, vol. 1, pp. 18–19 nn.

4. For information on this location, I would like to thank David Stradling, associate professor, Department of History, University of Cincinnati, email correspondence of January 18, 2006.

5. This painting has an indistinct date that ends in a 4, but appears to be 1894. A date of 1874 seems far more probable given the view of the subject, which would have been far more extensively overbuilt in the 1890s, as suggested by David Stradling, email correspondence, January 18, 2006.

6. Created as a means of contributing to Cincinnati's role as a dominant center for the transport of commerce across the country, the canal was constructed during a time of "canal mania" in America, when canals were seen as the most modern and reliable means of transporting goods over long distances, and the Miami & Erie, which eventually extended from the Ohio River to Lake Erie—the terminus for the Erie Canal as well—provided a link for Ohioans with the prosperous markets on the East Coast. The canal nostalgically evoked the Rhine River for its predominantly German immigrant population and gave the neighborhood its name. See Kevin Grace and Tom White, *Images of America: Cincinnati's Over-the-Rhine* (Charleston, S.C.: Arcadia Publishing, 2003).

7. For help in identifying this site, I would like to thank David Stradling, email correspondence of January 18, 2006.

8. After meeting with Courbet during the French painter's visit to Munich in early November 1869, Leibl traveled at the end of the year on Courbet's invitation to Paris. He was probably exposed to such works as Manet's *Portrait of Émile Zola* (1868) and *The Balcony* (1869) and Fantin-Latour's *An Atelier in the Batignolles* (1870), all in the Musée d'Orsay, Paris.

9. "Ohio Mechanics' Institute: Exhibition of the School of Design," *Cincinnati Commercial*, March 10, 1875, p. 3.

10. "Nineteenth Exhibition of the School of Design," *Cincinnati Enquirer*, March 10, 1875, p. 8.

11. When Duveneck's *Caucasian Soldier* (1870; Museum of Fine Arts, Boston)—which had won him a prize in his Munich class—was put on view in the window of a local auction house, it was considered "a matter of jest to the connoisseur and received no attention from buyers," as the *Cincinnati Times* reported in 1876. "Duveneck's Soldier," *Cincinnati Times*, March 18, 1876. On Duveneck's reception in Cincinnati, see Michael Quick, *An American Painter Abroad: Frank Duveneck's European Years*, exh. cat. (Cincinnati: Cincinnati Art Museum, 1987), pp. 33–34.

12. Twachtman, Avondale, Ohio, to Weir, March 5, 1882, Weir Family Papers, MSS 41, Harold B. Lee Library, Archives and Manuscripts, Brigham Young University, Provo, Utah.

13. On Duveneck's reception in Boston, see Quick, *An American Painter Abroad*, 1987, pp. 34–35ff.

14. On the academy, see Michael Quick and Eberhard Ruhmer, *Munich and American Realism in the 19th Century*, exh. cat. (Sacramento, Calif.: E. B. Crocker Art Gallery, 1978).

15. Linda Nochlin's *Realism* (Harmondsworth, Middlesex, Eng.: Penguin Books, 1971) is the seminal study of this subject. Separating Realism as a historical movement in art and literature from the usage of the word *realism* as it surfaces in philosophical discourses, Nochlin established a foundation for understanding the Realist movement that originated in France in the mid-1850s. As Nochlin observes, the movement established a new view of history that was grounded in the belief that the only valid expression of a historical era that could last was one in which artists and writers drew from their own immediate experience of life around them. Courbet's remark, "I hold the artists of one century basically incapable of reproducing the aspect of a past or future century," along with his famous battle cry, "Il faut être de son temps" (One must be of one's own time), encapsulated the Realist attitude. This viewpoint resulted in frank views of middle- and lower-class subjects; such images offended and shocked an art world accustomed to classicized portrayals of posed models and carefully composed images portraying subjects drawn from antiquity, mythology, and literature. Associating ideas in Realism with the scientific inquiries of the time, such as Courbet's belief that by representing real and existing things, artists would be showing truth, Nochlin presented Realism less as a particular style than as an attitude, manifested by artists through their choices of subjects and their commitment to creating unidealized images that revealed their immediate, time-bound perceptions with as little editing and modification of their visual impressions as possible.

16. Modeling its programs on German artist-associations of the era, the American Artists' Club of Munich organized a variety of events, such as performances of *tableaux vivants* after paintings by Dutch and Flemish masters. The club also mounted exhibitions and held festivities on particular occasions, including an extravaganza in a Munich hotel that celebrated the American Centennial in July 1876. See G. Henry Horstman, *Consular Reminiscences* (Philadelphia: J. B. Lippincott Co., 1886), pp. 178–79.

17. On Polling, see Lisa N. Peters, "'Youthful Enthusiasm under a Hospitable Sky': American Artists in Polling, Germany, 1870s–1880s," *American Art Journal* 31 (2000), pp. 56–91. Twachtman signed the guestbook maintained in Polling at some point between April 1 and May 7, 1876, but he could also have visited the town on other occasions.

18. Currier's visit in Polling lasted two years, from approximately the summer of 1877 through the summer of 1879. On Currier, I am grateful to Professor William H. Gerdts for providing me with the English translation of his essay on the artist, published in German: "Der vergessene Künstler: J. Frank Currier," in Katharina Bott and Gerhard Bott, *ViceVersa: Deutsche Maler in Amerika—Amerikanische Maler in Deutschland, 1813–1913* (Munich: Hirmer Verlag, in association with Deutsches Historisches Museum, 1996), pp. 114–26.

19. Twachtman registered for "ein Naturklasse," on October 15, 1875. See Matriculant's Book, Academy of Fine Arts, Munich.

20. On the back of a Venice scene (private collection), that Twachtman dated 1878, is an inscription written by his son, Alden, noting that the site in the work is the "Pensione Bucchintoro [sic], on the Fondamenta della Zattere, where Twachtman stayed with Duveneck in Venice." The Pensione Bucintoro still stands in Venice at 2135 Riva San Biagio.

21. James McNeill Whistler, *Campo S. Marta: Winter Evening* (1880, pastel on paper, Freer Gallery of Art, Smithsonian Institution, Washington, D.C.).

22. James McNeill Whistler, January 1880, to Marcus Huish, Fine Art Society, London, Glasgow University Library; quoted in Katharine A. Lochnan, *The Etchings of James McNeill Whistler* (New Haven, Conn.: Yale University Press, 1984), p. 184.

23. For example, see "Landscape Paintings Considered," *Daily Graphic: New York*, March 8, 1878, p. 54; "Fine Arts: The Lessons of a Late Exhibition," *Nation* 26 (April 11, 1878), p. 251; and "Fine Arts: The Society of American Artists," *New York Evening Mail*, March 5, 1878, p. 4.

24. "Society of American Artists. II," *New York Mail*, March 8, 1878, p. 4.

25. "Fine Arts: The Lessons of a Late Exhibition," 1878, p. 251.

26. S. G. W. Benjamin, "The Exhibitions: IV. Society of American Artists, Third Exhibition," *American Art Review* 1 (1880), p. 259.

27. "Fine Arts: Exhibition of the Society of American Artists—Supplementary Notice," *New York Herald*, March 28, 1878, p. 6.

28. "The American Artists," *New York Times*, March 28, 1878, p. 4.

29. J. B. F. W., "Society of American Artists," *Aldine* 9 (1879), p. 275.

30. "American Art: Society of American Artists," *New-York Tribune*, March 30, 1878, p. 6.

31. S[usan] N. Carter, "Exhibition of the Society of American Artists," *Art Journal* 5 (March 1879), p. 157.

32. J. B. F. W., "Society of American Artists," 1879, p. 275.

33. For Twachtman's images of the *Sailing in the Mist* theme, see Cat. 47.

34. James D. McCabe, *Lights and Shadows of New York Life; Or the Sights and Sensations of the Great City* (1872; facsimile, New York: Farrar, Straus and Giroux, 1970), p. 835.

35. Charles H. Farnham, "A Day on the Docks," *Scribner's Magazine* 18 (May 1879), p. 38.

36. A description of the dockside experience of the oyster market appears in ibid., p. 36.

37. Ibid.

38. "The Society of American Artists," *New York Sun*, March 23, 1879, p. 2.

39. In 1879, 1880, and 1881 Twachtman is listed in Cincinnati directories at 520 Race Street. On the Women's Art Museum Association, see Lea J. Brinker, "Women's Role in the Development of Art as an Institution in Nineteenth Century Cincinnati," Master's thesis, University of Cincinnati, 1970, and *A Sketch of the Women's Art Museum Association of Cincinnati, 1877–1886* (Cincinnati: Robert Clark & Co., 1886), p. 88.

40. Twachtman, Avondale, Ohio, to Weir, March 5, 1882, Weir Family Papers.

41. James Parton, "Cincinnati," *Atlantic Monthly* 20 (August 1867), p. 233. See also Olive Logan, "Cincinnati," *Harper's New Monthly Magazine* 67 (July 1883), pp. 265–66.

42. Frances Trollope, *Domestic Manners of the Americans* (London: George Routledge and Sons, 1832), p. 34.

43. Parton, "Cincinnati," 1867, p. 234.

44. Ibid., p. 236.

45. On Cincinnati's inclines, see Richard M. Wagner and Roy J. Wright, *Cincinnati Streetcars: No. 2, The Inclines* (Cincinnati: Wagner Car Company, 1968). See also Richard Rhoda, "Urban Transport and the Expansion of Cincinnati, 1858–1920," *Cincinnati Historical Society Bulletin* 35 (Summer 1977), pp. 130–45 and Daniel Hurley, *Cincinnati: The Queen City* (Cincinnati Historical Society, 1982).

46. Charles Dickens found the "suburb" of Mt. Auburn "charming" on his 1842 visit to Cincinnati. Dickens, *American Notes for General Circulation* (1842; London: Chapman and Hall, 1874), chap. 9, "Cincinnati," p. 90; Parton, "Cincinnati," 1867, p. 236, had described the area in 1867: "Mount to the cupola of the Mount Auburn Young Ladies' School, which stands near the highest point, and look out over a sea of beautifully formed, umbrageous hills, steep enough to be picturesque, but not too steep to be convenient, and observe that upon each summit, as far as the eye can reach, is an elegant cottage or mansion, or cluster of tasteful villas, surrounded by groves, gardens, and lawns. This is Cincinnati's Fifth Avenue. Here reside the families enriched by the industry of the low, smoky town." But even Parton could see that the wealthy would not remain the only inhabitants of Mt. Auburn. He predicted (p. 236): "Here, upon these enchanting hills, and in these inviting valleys, will finally gather the greater part of the population, leaving the city to its smoke and heat when the labors of the day are done."

47. The Price Hill Incline opened for passengers in 1875 and for freight in 1877; the Mt. Adams Incline opened in 1876 (also known as the Eden Park and the Highland Incline); and the Bellevue Incline also opened in 1876 (also known as the Clifton and the Elm Street Incline. The fifth and last was the Fairview Incline, which opened in 1894.

48. Twachtman, Munich, to Miss Alice Minning, Cincinnati, November 16, 1876, private collection, Cincinnati.

49. "The Society of American Artists," *World: New York*, March 28, 1880, p. 4.

50. "Fine Arts: Third Annual Exhibition of the Society of American Artists—Second Article," *New York Herald*, March 22, 1880, p. 8.

51. S[usan] N. Carter, "The Society of American Artists," *Art Journal* (New York) 42 (1880), pp. 155–56.

52. "Fine Arts: Third Annual Exhibition of the Society of American Artists—Second Article," *New York Herald*, March 22, 1880, p. 8.

53. Carter, "Society of American Artists," 1880, p. 155.

54. Benjamin, "The Exhibitions: IV. Society of American Artists," 1880, p. 259.

55. "Society of American Artists' Exhibition," *Art Interchange* 4 (March 31, 1880), p. 55.

56. Benjamin, "The Exhibitions: IV. Society of American Artists," 1880, p. 259.

57. Hale reported that Twachtman and Scudder met in the Munich studio of the American painter Toby Rosenthal (1848–1917). See Hale, *Life and Creative Development*, 1957, vol. 1, pp. 22–23. In the winter of 1879 both Twachtman and Scudder became members of the Etching Club of Cincinnati, and were creating etchings together in the following year. On Scudder, see Peters, *John Twachtman (1853–1902) and the American Scene*, 1995, vol. 1, pp. 124–28.

58. The museum's register indicates that the Twachtmans visited on August 1; the Weir brothers visited the museum at some point before August 9. On the artists' visits to the Frans Hals Museum, see Annette Stott, *Holland Mania: The Unknown Dutch Period in American Art and Culture* (Woodstock, N.Y.: Overlook Press, 1998), pp. 276–77. The visits of J. Alden and John Weir to museum are also noted in Petra Ten-Doesschate Chu, "Nineteenth-Century Visitors to the Frans Hals Museum," in *The Documented Image: Visions in Art History*, ed. Gabriel P. Weisberg and Laurinda S. Dixon (Syracuse, N.Y.: Syracuse University Press, 1987), p. 137.

59. J. Alden Weir, Dordrecht, to his mother and father, July 15, 1881, J. Alden Weir Papers, Archives of American Art, Smithsonian Institution, roll 70, frame 10.

60. John Ferguson Weir, "Typescript from John F. Weir's Memories," undated, J. Alden Weir Papers, roll 71, frame 1090.

61. Clark, *John Twachtman*, 1924, p. 23, and Hale, *Life and Creative Development*, 1957, vol. 1, p. 45n.

62. Urged by her father, John Milton Scudder (1829–1894), a noted Cincinnati doctor who had seen several of his first wife's babies die during their delivery (as well as his first wife's own death probably from giving birth to Martha), John and Martha Twachtman moved into his house in the quickly growing suburb of Avondale, where he lived with his second wife and their then teenage sons.

Dr. John Milton Scudder was a prominent figure in the Cincinnati medical world. The son of a cabinetmaker who died when he was eight or nine years old, John Scudder began to work in his youth at a button factory in Reading, Ohio. At age twelve, he had saved enough money to enter Miami University in Oxford, Ohio. Fulfilling his own belief in a strong work ethic, after leaving college he made a living from cabinetmaking in the winter and painting in the summer before opening a general store in Reading. He married Jane Hannah in 1849. The couple had five children, only two of whom survived infancy, among them, their daughter Martha, born in 1861.

Deeply affected by the deaths of his three young children during the mid-1850s, John Scudder changed his professional trajectory to a career in medicine. He studied at the Eclectic Medical Institute in Cincinnati, graduating in 1856. Soon thereafter, he joined the faculty of the institute, while maintaining a busy medical practice. He gave up his practice to devote his time to the institute at a point when it was on the brink of closure. He was the chair of Obstetrics and Diseases of Women and Children from 1858 to 1860 and then became chair of Pathology and Principles and Practice of Medicine. When his wife Jane died in 1861, Scudder married her sister in the same year, with whom he had five sons, three of whom also graduated from the Eclectic Medical Institute. In 1887 Scudder retired, moving to Daytona, Florida. See Harvey Wickes Felter, *John Milton Scudder, M.D.* (Cincinnati: The Lloyd Library, 1894).

63. George E. Stevens, *The City of Cincinnati: A Summary of Its Attractions, Advantages* (Cincinnati: George S. Blanchard & Co., 1869), p. 67.

64. D. J. Kenny, *Cincinnati: Illustrated; A Pictorial Guide to Cincinnati and the Suburbs of Cincinnati* (Cincinnati: Robert Clarke & Co., 1879), p. 13.

65. Ibid., pp. 12–13.

66. Today, this route is the Victory Parkway.

67. "The New York Art Season," *Atlantic Monthly* 48 (August 1881), pp. 194.

68. "The Society of American Artists," *New York World*, May 1, 1882, p. 2.

69. "Society of American Artists," *Art Journal* (May 1882), p. 159.

70. M. G. Van Rensselaer, "The Society of American Artists—New York—I," *American Architect and Building News* 2 (May 13, 1882), p. 219.

71. Ibid.

72. Archibald Gordon, "The Impressionists," *Studio and Musical Review* 1 (July 16, 1881), p. 79.

73. "Society of American Artists: Fourth Annual Exhibit, *New York Tribune*, April 3, 1881, p. 7.

74. "The Society of American Artists," *Art Journal* (June 1882), p. 191.

75. "The Society Exhibition," *New York Evening Post*, March 28, 1881, p. 4.

76. "Art Notes: Mr. Twachtman's Landscapes," *Boston Evening Transcript*, February 17, 1885, p. 2.

77. "Exhibition of Paintings at Closson's—'Whar's Dat Squirrel Gone?'" *Cincinnati Enquirer*, February 6, 1883, p. 8.

78. "Art Exhibitions: The Society of American Artists," *New York Sun*, March 25, 1883, p. 5.

79. Ibid.

80. "The Sixth Annual Exhibition of the Society of American Artists," *Nation* 30 (April 12, 1883), p. 327.

81. "The Society of American Artists: Sixth Annual Exhibition," *New York Daily Tribune*, March 25, 1883, p. 5.

82. Mariana G. Van Rensselaer, "Spring Exhibitions in New York—II," *American Architect and Building News* 3 (May 12, 1883), p. 221.

Twachtman and the American Equipoise of Impressionism and Tonalism

LISA N. PETERS

A New "Truth of Impression"

Motivated by a belief that his drawing skills had been neglected in Munich,[1] in the fall of 1883 Twachtman left Cincinnati for Paris, drawn by the lure of the French capital that was attracting countless numbers of art students from America and other nations. Munich by this time had declined as an art center, and a course of study in Paris was considered almost obligatory for American artists to advance in their careers. For the two and a half years that followed, Twachtman studied at the Académie Julian, working under Gustave Boulanger and Jules-Joseph Lefebvre, both well known for their classicized genre scenes that were prominent annual features at the Paris Salon. With a diligence that the architect Stanford White described as "slavery—I should think to [Twachtman]—but a slavery he will never regret,"[2] Twachtman labored to improve his draftsmanship skills by drawing from the figure. Escaping Paris during the summers, he painted in the country-sides of Normandy and Holland (see Cats. 15–22).

While abroad, many new sources influenced Twachtman. The art of the French painter of peasants set in naturalistically rendered landscapes, Jules Bastien-Lepage, whom Weir had earlier sought out and befriended, may have encouraged the American to observe subtleties of outdoor light more closely than in the past, even though Twachtman found Bastien's work too materialistic, as he seldom went "beyond the modern realism which ... consists too much in the representation of things."[3]

Twachtman may have been inspired by the Japanese prints that were sold by Parisian street vendors of the day, as is suggested in his preference for off-center compositional designs and his ten-dency to organize his arrangements around a few discrete shapes. His reliance on a tonal palette of primarily soft grays and greens and his refined and simplified schemes attest his debt to the art of James McNeill Whistler. Although Twachtman pro-bably never met Whistler, he would have known of him through his many friends who became close to the noted American expatriate in London and

Venice. Twachtman also would have had opportu-nities to see Whistler's work in New York and Paris.[4]

The influence of the French Barbizon and Hague Schools strengthened in Twachtman's work during the period, as is demonstrated in his portrayal of quiet, cultivated countrysides in which he observed subtle relationships of form and tone. In this respect, the works that Twachtman made in Europe proceeded from the art he had been creating in Cincinnati in 1883.

Among his best-known paintings of the period, *Springtime* (Fig. 50) depicts the Bethune River in the Normandy town of Arques-la-Bataille, where he resided in the summer of 1884. Deriving his inspiration from the tranquility, restfulness, and delicacy of the landscape before him, Twachtman used a limited palette of blues and greens modi-fied by pale and silvery grays, generalized his forms by blurring their edges, and layered his paint so thinly that it bled into the canvas. Within the over-all arrangement of soft, subdued tones, the curve of the river becomes the focus of our gaze, its graceful line emphasized by the lithe poplar trees in the middle ground, their reflections in the river's surface adding to the work's quiet symmetry.

In his *Arques-la-Bataille* (Fig. 51), painted in his Paris studio in the winter of 1885 from plein-air sketches he created the previous summer, Twachtman worked on a larger scale than in the past, creating an iconic work that went even further in the direction of simplification. Here he portrayed a view in which a river and the hills behind it are flattened to bands of gradually modulated grayish greens. A feeling of tranquility is created by the planar treatment of forms and the balance of horizontals with the thin, calligraphic verticals of reeds, which end just to the right of the canvas's center. Although we seem to be look-ing down, the landscape before us appears to rise upward, paralleling the picture plane so that we have the feeling of being suspended, floating above and within the scene. Placing darker tones of earth and watery reflections in the center of the work, between the lighter-keyed blue-grays of the near water and sky, creates a harmonious,

Opposite:
Winter Landscape
(detail of Cat. 41).

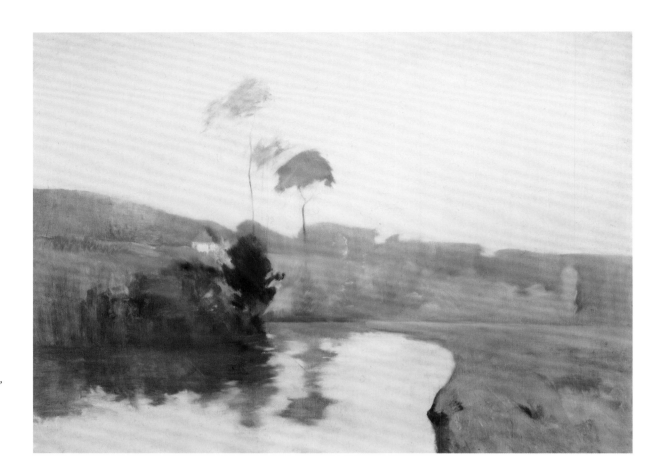

Fig. 50
Twachtman,
Springtime, ca. 1884,
oil on canvas,
36⅞ × 50 inches,
Cincinnati Art
Museum, Gift of
Frank Duveneck.

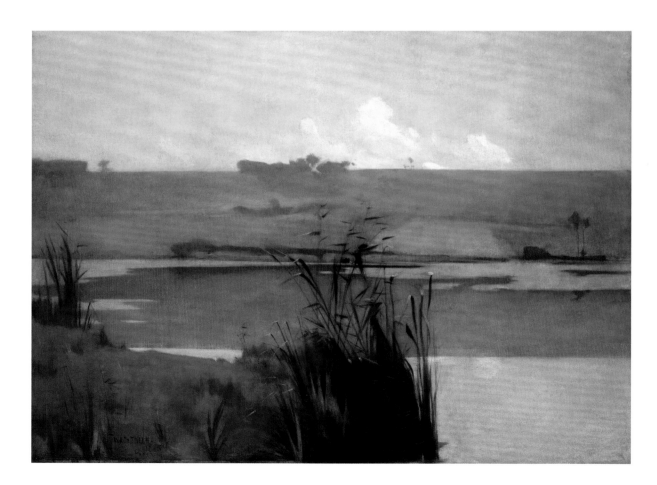

Fig. 51
Twachtman,
Arques-la-Bataille,
1885, oil on canvas,
60 × 78⅞ inches,
The Metropolitan
Museum of Art,
New York, Morris K.
Jessup Fund, 1968.

near-abstract tonal arrangement, suggestive of a musical composition. A synthetic image, in which Twachtman distilled and poeticized his subject to capture its essence rather than its precise topography, this painting accords with the idea that would propel many artists who would later be termed Tonalists, namely, that "poetry is not an element of nature, but a quality of the painter's mind," as Charles Caffin would later remark of Dwight Tryon's paintings.[5]

When a group of Twachtman's paintings was shown at J. Eastman Chase's Gallery in Boston in February 1885, critics recognized this reductive quality in his works. A *New York Times* writer, who traveled to Boston to see the show, commended the art on view for the "tenderness and delicacy" of the artist's handling, "his feeling for modulations of color...his power of rendering atmosphere distances, [and] his sensitiveness to the poetic impression."[6] A local Boston critic observed that in looking at Twachtman's "exquisite pictures," one would think, "'What a pleasant place! I would have enjoyed being there, and what pleasure the painter took in it, since he has given us not only the look of the place (at the fresh morning hour, when everything in France is softened by a faint film of gray), but also a frank record of his own agreeable emotions in the presence of the scene.'" He concluded that Boston had not had for years seen "lovelier pictures than these—works so permeated with true artistic feeling, so poetical, so spontaneous, and so joyous."[7] He stated that it was "easy to sum up Mr. Twachtman's qualities as displayed in these pictures, first of all being true and sensitive poetive power, then a quick grasp of entire effects, consciousness of actual relations, and a delicate feeling for subtle shades of color."[8]

When Twachtman exhibited his work at Chase's gallery the following January, a critic for the *Boston Evening Transcript* credited him with having slowly lost "the taint of Munich, with its blackness," and he attributed the "immense gain" in Twachtman's art to the "new school of French landscape painting," which had shown "that *Nature out of doors* is the true guiding influence for a landscape painter, not arbitrary rules as to what Nature should be, read by the artificial light of a studio." This critic went on to discuss Twachtman's *Hollandsch Diep*, most likely the painting known as *Windmills* (Cat. 22). In observing the work, the critic noted that at first the painting's handling seemed "curiously vague and coarse" and the "quality of form is entirely absent." But, looking at it some more, the critic reported, "of a sudden critical capacity fails and the conscious-

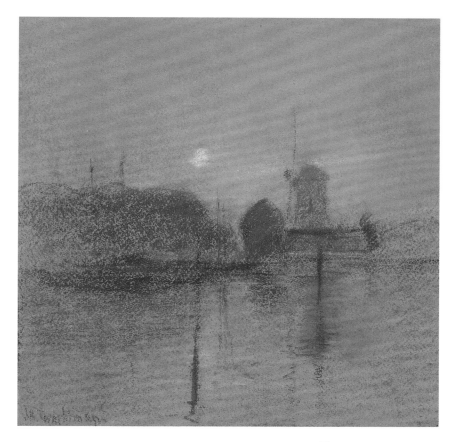

Fig. 52
Twachtman, *Dutch Landscape*, ca. 1885, pastel on paper, 12½ × 12½ inches, private collection.

ness comes that a great mistake has been made, and that Mr. Twachtman cared nothing for these things. For very subtly the picture itself begins to exert its influence....Mr. Twachtman has discriminated delicately, and has produced a picture that, while lacking the truth of form of Nature, yet has that which is always sacrificed—truth of impression."[9] This critic suggested that Twachtman had given precedence to capturing the impact the scene made on his mind over the recording of its actual features.

In the pastels that Twachtman began to create during his French period, he moved even more in the direction of a Whistlerian aesthetic. Portraying minimalist images of moonlit seas, in which he covered the surface of his paper with thin layers of chalk in a severely limited palette of pale grayish blues (Fig. 52), and showing works at Chase's in 1886 with such titles as *Late Twilight*, *Sunset*, and *Moonlight*, these images presage the type of motifs that would become standard in the repertoire of artists who became known as Tonalists in the following decade. It was exactly Twachtman's ability to be independent from conventions that appealed to critics of the time. The *Boston Evening Transcript* writer pronounced Twachtman "manifestly a painter, with a painter's eye and a painter's soul; he is not a manufactured man."[10]

The Rise of Impressionism: "Science" Infused with the "Breath of Poetry"

Soon pastel became a medium that helped Twachtman move his art in the direction of Impressionism. In 1888 he finally left his native Cincinnati behind permanently, and that summer he stayed in the southwestern Connecticut town of Branchville, near the home of Weir.[11] The two artists spent their days using pastel in the outdoors, and such a plein-air approach encouraged them to adopt brighter colors and a more spontaneous execution (see Cats. 24–25, 27; Fig. 71). Yet Twachtman continued to emphasize quiet, gentle tonal harmonies in his pastels, even while his handling became more direct and expressive. Using toned papers with pumice and oatmeal finishes, to which the slightest amount of pastel would adhere, he explored the nuances he could create by varying densities of chalk and by the interaction of pastel colors with his papers, which served more of an atmospheric than a background function.

Twachtman's new approach also derived from his purposeful decision to ally himself with Impressionism, which had only recently begun to be accepted in America. Even though the coterie of radical French artists—who showed together for the first time in 1874 under the name the Société anonyme des artistes, peintres, sculpteurs, graveurs—had scandalized the Paris art world in the 1870s, American audiences were not aware of their art then or in the decade that followed, and those Americans who did come into contact with this new art were mostly appalled by it. Weir's often-cited report of his visit to the Impressionist exhibition held in 1877 reflected the general outlook of his compatriots. He wrote to his parents, "I never in my life saw more horrible things.... They do not observe drawing or form, but give you an impression of what they call nature. It was worse than the Chamber of Horrors."[12]

Nonetheless, in America, a few works by avant-garde French artists had begun to be seen in the early 1880s, especially those of Édouard Manet, and a few collectors had acquired examples of the new art, among them Erwin Davis, who was helped by Weir in the purchase of two works by Manet (apparently Weir's antipathy to progressive French painting had softened by the early 1880s— at least with respect to the art of Manet).[13] Yet these developments had little impact on art in the United States, even as Impressionism began to find acceptance in France.

However, in 1886, Americans suddenly could no longer ignore the French movement, as Impressionism made a dramatic entrance on the New York art stage. In the spring of that year, the Paris dealer Paul Durand-Ruel brought an exhibition to New York of nearly three hundred works, mostly by French Impressionist artists. The show opened at the American Art Association on April 10, but it proved so popular that it was extended and moved to the National Academy of Design, where it reopened on May 25. The city's reviewers likened the showcasing of the new French art to "an invasion"[14] in which "virtually an entire school of art...has been transported bodily from one country to another."[15] The New York displays had detractors, but of the Impressionists Edgar Degas and Claude Monet seem to have been the most consistently singled out for praise. For example, a writer for the *Studio* exclaimed: "And Claude Monet! What observation, what variety of execution, surprising us at every turn, what independence of all methods prescribed, and his own, when he pleases!...If Mr. Durand-Ruel had done nothing more than to bring us the pictures of this artist, he would have rendered us a great service. For ourselves, we thank him heartily for the gift."[16] This equating of Monet and Impressionism with "independence" occurred repeatedly in reviews of the 1886 exhibition.

While some American critics simply dismissed the new art, a point made in many articles, both critical and accepting, was that American artists needed to see French Impressionist art, for it would provide them with an infusion of energy and innovation that would in turn rejuvenate American art and liberate American artists, now armed with new ideas as to how to be independent. A writer for *Art Age* commented that with the arrival of the exhibition, "the tiresome old roof of our New York art exhibitions has been broken up very efficiently by the sudden appearance of this ultra-modern group of French painters in our midst."[17] A writer for the *New York Daily Tribune* argued that the Impressionists' "exposition of [new] theories is needed as a safeguard against stagnation and conventionalism." Noting that "when we have artists who are developed on all sides we shall have a greater art than there is at present," the *Tribune* writer proposed that American artists could learn from the Impressionists without jettisoning academic foundations. In this critic's view, the French painters also "would be the better for a course under [Gustave] Boulanger or [Jean-Léon] Gérôme, if they could keep their individuality."[18]

Referring to Durand-Ruel, a critic for the *New York Sun* expressed the view that "the public owes a considerable debt" to the organizer of the show, "for it is a most instructive and interesting exhibition, not only to the public at large, but for every art student in the United States. There is perhaps more to be learned from it from the point of view of practical instruction than from any exhibition … that has yet been held in this country or made in any way accessible to the great body of art students, now numbering some thousands in this city alone, for whom art is a permanent vocation."[19] Apt as usual, Mariana Van Rensselaer echoed this attitude, stating: "Whatever the public may think about the exhibition, I am sure that every artist will have found in it many things which have not only delighted his eye but given him fresh and valuable hints, and sensibly widened his ideas of his pictorial performance."[20] A similar point was made by a writer for the *Mail and Express*, even though he was far less enthusiastic about the art on view. He filled his commentary with sarcastic comments, such as, "one can scarcely resist the doubt that there is malice prepense [premeditated] in much of this audacity," but he ended what was essentially a diatribe by noting: "As a last word, I may say, that it can only do our young artists good to study these pictures. If they can only free their minds of all prejudice. The example of independence is of itself worthy of imitation."[21]

As such remarks suggest, American critics and, by extension, American artists wrestled with French Impressionism from the time that it burst onto the New York art scene, and they began to consider how this style should be viewed and made use of within an American context. By suggesting that French Impressionism was a vehicle of emancipation rather than a style that demanded full loyalty, critics seem to have expressed the idea that Impressionism could be acceptably absorbed by American artists, without their having to forego the hard-won accomplishments of their earlier training and experience.

Twachtman was exposed to Impressionism after his move east in 1888 at New York exhibitions and through friends such as Theodore Robinson (who was close to Monet during stays in the Anglo-American artists' colony of Giverny, France, from 1887 until his permanent return to America in 1892). He created works in the early 1890s that were at the center of this simmering debate about the place of Impressionism in American art. In particular, commentaries on Twachtman's work of this time try to balance Impressionism against the idea that had coalesced earlier—as reflected in the reviews of Twachtman's French-period works—that art should go beyond a transcriptive approach to touch the soul and strike an emotive chord in a viewer. The reviews of Twachtman's first solo exhibition in New York, held at the Wunderlich Gallery in 1891, reveal the nature of these discussions: could there be a midpoint between the new Impressionist mode and the older, poetic one?

Although Twachtman was regularly referred to as an Impressionist by 1891, his Wunderlich show included softly toned images in a vein that would soon be joined by works by others that were described as "Tonalist."[22] The presentation included thirty pastels and twelve oil paintings; the pastels were mostly images of Branchville, and the oils were primarily views of Twachtman's home and property in Greenwich, Connecticut, where he had settled in 1889. The predominance of pale-toned pastels in the show may have given Wunderlich's owners the impetus for the design of the installation. Just two years earlier, Wunderlich had held a show of Whistler's art in which he transformed the gallery, tinting its walls to accord with the light and subtle tones of the "Notes," "Harmonies," and "Nocturnes" that were on display.[23] Wunderlich chose the same approach for Twachtman's exhibition, no doubt because his similarly tonal art would also be enhanced by such a presentation. As the *Studio* reported: "All the surroundings are in harmony with the delicate tints of the paintings; even the chairs are painted some light color, and grayish hangings on the walls serve as an excellent background to the white and daintily framed pictures."[24] The *New York Evening Post* stated: "It is only by looking intently at the walls for a moment that one perceives that there is no dust, but that the impressing of its existence is given by the peculiar effect of white cheesecloth stretched on the walls, the pale ashiness of tone of most of the pictures and the white frames in which they are bordered."[25]

The show gave the New York art press the opportunity to weigh the relative merits and qualities of Impressionism. For the most part, the critics praised Twachtman's images for exemplifying the right kind of Impressionist approach. The critic for the *New York Mail and Express* used his review of the exhibition as a way to remark that all forms of Impressionism should not be condemned and that there were many degrees of the aesthetic: "The word 'impressionist' has an ill meaning to some persons. But there are impressionists and impressionists. Some assault your vision with splashes of crude and harsh color and

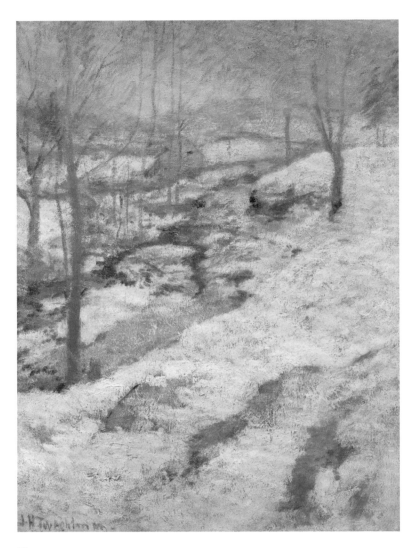

Fig. 53
Twachtman, *Frozen Brook*, ca. 1893, oil on canvas, 30 × 22 inches, private collection.

was a medium by which artists could rid themselves of "mannerisms" and find an inspiration that "lay between themselves and nature."[28]

Several other critics proposed that Twachtman's Impressionist approach had actually enhanced his ability to convey a poetic response to nature. One wrote that Impressionism had helped Twachtman confirm the "tender vaporousness"[29] that had already been part of his art, while another commented that Twachtman had produced works in which there was "science enough for the scientific," and yet had imbued "through the whole structure the breath of poetry," so that "what in other hands would be mere landscape-painting becomes in his, visible song."[30] A writer for the *Studio* stated that the works at Wunderlich's were "entirely of the impressionistic order, the pastels especially, and many find fault with them on the ground that they are too hazy and indistinct; I overheard one person pronounce them ghosts." For this critic, Twachtman's "Impressionist" art could actually provide the sort of poetic result that would be the aim of Tonalist painting, noting that the works were grounded in reality and yet, through the way they engaged the viewer, had the ability to guide us from the physical to a purely mental realm:

> Here the painter leads you to some quiet spot—you see the damp melting snow,—the bare wet trees, and the swiftly flowing brook, you feel that the air is laden with moisture—it is one of those gray, damp days. You are not restricted to the narrow limits of the canvas, you feel as though you could follow the brook's course farther down, and see way into the distance. This is the charm about these pictures—they are not placed before you as facts; they are awakeners of certain trains of thought; you feel even more than you see.[31]

Such an experience is still apparent in works such as *Frozen Brook* (Fig. 53), where we are drawn away from the physicality of the snow-covered ground that sweeps up directly from the picture plane. Through the sinuous lines of the thawing brook and the back-and-forth motion of the trees, we are lulled into a feeling of quietude and a realm of thought.

Indeed, the reviews of Twachtman's Wunderlich exhibition suggest that in 1891 Impressionist inspiration was viewed as readily mergable with the poetic approach to nature. That this was seen as an American take on Impressionism was suggested by a critic for the *Art Amateur*, who wrote that Twachtman's "sincere" and "refined" images had "caught

with vague suggestions of little interest, and some woo you with delicate hints of beauty of form and exquisite revelations of color." But he went on to point out that it would be best for viewers not simply to see the exhibition as an example of "audacious impressionism," but rather to perceive it as "the sincere and earnest effort of a painter with a thoroughly artistic temperament to give expression to what he sees in nature." This critic's idea was that the time had passed when American audiences should expect art to "follow certain conventional rules," and that "a peep through Mr. Twachtman's glasses will certainly be suggestive in so far as it broadens our sympathies."[26] A reviewer for the *New York Times* similarly remarked that certain "old objections" were sure to be made, that the work on display was "impressionist, mere notes," and commented that this was a "superficial view of people who refuse or have not time to grant these delicious creating and considerations... their due."[27] These comments accorded with the perspective of Van Rensselaer, that Impressionism

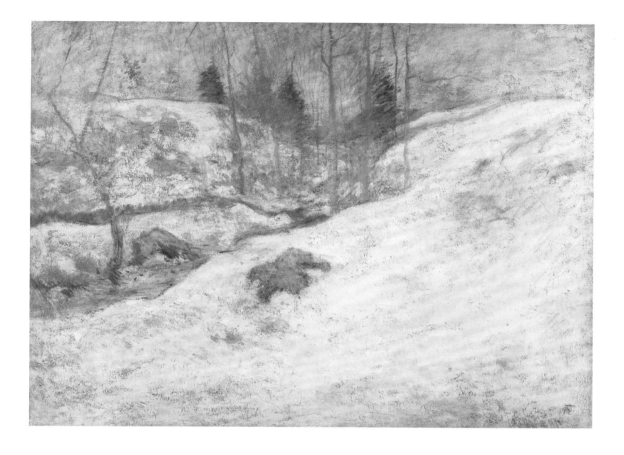

Fig. 54
Twachtman, *Brook in Winter*, ca. 1892, oil on canvas, 36⅛ × 48⅛ inches, Museum of Fine Arts, Boston, The Hayden Collection—Charles Henry Hayden Fund.

the spirit of American landscape" more successfully than works by any other artists of his time.[32]

In the year following the show, Twachtman sent his *Brook in Winter* (Fig. 54) to the annual spring exhibition of the National Academy of Design. In a review of the show, a writer for the *New-York Tribune* stated that Twachtman's work could be perceived as standing between that of Weir and the Boston painter Edmund Tarbell, stating, "Like the former, he has the intuitive gift and gets at the heart of the subject and like the latter he has an active sense of form." This critic grouped Twachtman's two winter scenes on view with winter images by "Parish" (Stephen Parrish [1846–1938]) and Dwight Tryon, and suggested a connection between the expression of a spiritual component in nature and Impressionism's encouraging of free exploration, writing, "The spirit underlying their uncommon truth and beauty is the spirit of freedom and personal investigation." The *Tribune* writer observed that this approach worked with "greater subtlety in the art of Tryon than in that of Twachtman," but commented that the art of all three presented

> a strong contrast to the kind of snow study that was popular not so very long ago and that still lingers here and there, the study that would perhaps better not be called a study, for it is

based on the blind acceptance of Nature in her winter garb as offering a model in monochrome. The observant man knows better, is familiar with the grays, blues and purples that lurk in shadowed places, with the pinks and yellows that spring from under brilliant sunlight, and the observant artist transfers these fugitive hues to his canvas. Moreover, in order to increase the interest of his picture he is not afraid to give it texture by skillful brushing.[33]

Snow scenes seem to have been amenable subjects for American artists to bring together Impressionist approaches with the modes that in the mid-1890s would be seen as Tonalist. This was no doubt because they offered opportunities to study reflections of light and effects of atmosphere, combined with their capacity to suggest quiet moods and transform a landscape into a dreamlike and magical realm.

Twachtman, in fact, alluded in an 1891 letter to Weir to the ability of a snow-covered landscape to perform the metamorphosing role of "hushing nature to silence." He stated: "We must have snow and lots of it. Never is nature more lovely than when it is snowing. Everything is so quiet and the whole earth seems wrapped in a mantle. That feeling of quiet and all nature is hushed to silence."[34] From this it is but a short step to the

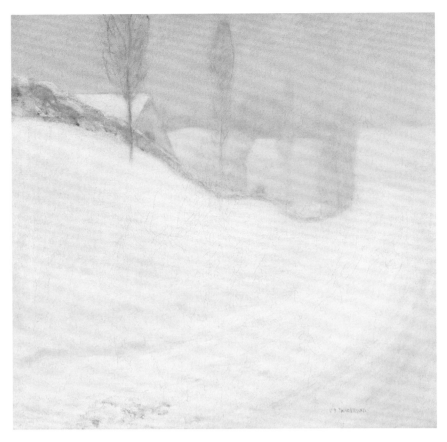

Above: Fig. 55 Twachtman, *Round Hill Road*, ca. 1890–1900, oil on canvas, 30¼ × 30 inches, Smithsonian American Art Museum, Washington, D.C., Gift of William T. Evans.

Below: Fig. 56 Willard Metcalf, *The White Veil*, 1909, oil on canvas, 36 × 36 inches, Detroit Institute of Art, Gift of Charles Willis Ward.

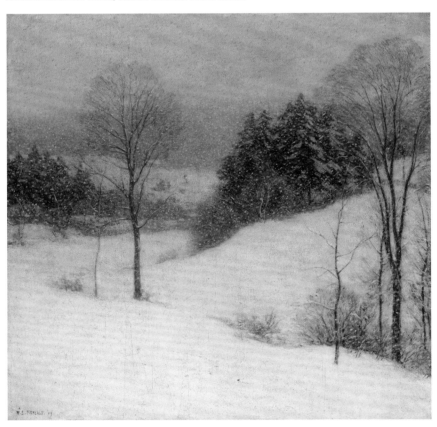

contemporaneous American belief that winter quieted the human spirit and provided refuge from anxiety, restiveness, and agitation. Writing in the *Forum* in 1914, John Cournos implied that such an idea motivated Twachtman, stating: "He always painted winter with great tenderness. He did not attempt to paint it as a harsh and wrathful visitant, but as a tranquil guest, who, as manifestation of the world's visible beauty, lent serenity to the soul."[35] A similar attitude was ascribed to Willard Metcalf by Leila Mechlin, who would be a Tonalist enthusiast in the early twentieth century.[36] She stated that Metcalf's winter scenes exemplified the longing of his time "for tranquility and peace, a yearning for quietness among those who are compelled to live in the midst of turmoil, scurrying along with bated breath, with no time for anything."[37]

It is not clear that artists such as Twachtman or Metcalf were committed to the idea, as proposed recently by Sarah Burns, that winter imagery could serve "as a rest cure for the eyes—a vacation from the labors that forced them to exceed their capacities."[38] However, snow scenes such as Twachtman's *Round Hill Road* (Fig. 55) and his views of his barn (Cats. 40–41) or Metcalf's *The White Veil* (Fig. 56) effectuate a calming process in the viewer even today, suggesting a certain intentionality on the part of the artists. In these works (although more so in Twachtman's), snow creates a veil-like surface shroud through which our eyes naturally seek the obscured linear forms that both structure to the landscape, in the process organizing the blurriness of our first impression into a calm clarity that is reassuring and steadying.

Impressionist Artistry

In 1893 Twachtman was again allied by a critic with Tryon and several other artists who would later be considered Tonalists. In a review discussing the American landscapes on view at the World's Columbian Exposition held in Chicago that year, a writer for the *Inland Architect and New Record* stated:

It is in a certain quality of undefinition that the very charm and essence of [works such as Tryon's *Rising Moon*, No. 9, and Whistler's *Nocturne: Valparaiso*, No. 787] lie, as also of such themes as Mr. [J. Francis] Murphy in "November Grays," No. 57, Mr. Twachtman, in "Autumn Shadows," no. 1180, Mr. Tryon in "Starlight," No. 737, and Mr. Inness, in "September Afternoon," No. 977. This repose of evening,

this reminiscent sadness of late autumn, this vagueness of this calm of night, are not substantial, defined things, to be realized by exact and imitative touch. They are spirits of the air and laugh to scorn the uncomprehending mortal who thinks thus to chain them....It is because Mr. Inness, and Mr. Tryon, and Mr. Twachtman, and Mr. Murphy have been soul to soul with nature that the very spirit comes so home to us when we look at their pictures. We feel before them that in very truth, she is ours; her sunlight for gladness, her cool shadows for rest; her calm stars for consolation.[39]

However, in the same year, Twachtman was also acclaimed as a leading American exponent of Impressionism. The forum in which this view emerged was the American Art Galleries in New York, where a four-person show in May juxtaposed the works of Twachtman and Weir with art by the French painters Monet and Paul-Albert Besnard, a portraitist who employed a painterly style similar to that of his friend John Singer Sargent. The four artists were represented by different media and varying numbers of works: Monet and Besnard were represented only by paintings, fifteen by the former and thirteen by the latter; Weir's display included twenty-one paintings and sixty-eight etchings, and Twachtman's had twenty-eight paintings and sixteen pastels. For critics, the exhibition provided an opportunity to compare the Impressionism of the Americans, as exemplified by Twachtman and Weir, with that of Monet. The *New York Times* described the show as "a large collection of paintings and pastels by four artists...who are devotees of the latest effort to give the impression either of sunlight in the open, or of the brightest diffused light when the sun is obscured."[40]

In a consideration of the works by Twachtman included in the show that can be identified, it is clear that he had begun to utilize more of the strategies associated with French Impressionism than earlier.[41] Most of the images he exhibited were scenes of his Greenwich home and property, and while a few works were snow scenes, several were depictions of sunlit days. In keeping with this presentation, many critics pointed out how Twachtman affiliated "very naturally with Monet" in his pursuit of "light, color, and air."[42] At the same time, almost all of the reviews emphasized that there was a more "poetic" and "artistic" quality to Twachtman's art (as well as to Weir's) than to Monet's. This element was not seen as detrimental but merely viewed as a way that the Americans

diverged from their French counterpart. The *New York Sun* critic commented that "while, like Monet, they [Twachtman and Weir] have striven toward the expression of impressions of landscape and figure, they have looked with soberer eyes. There is none of the splendid, barbaric color that distinguishes the works of the Frenchman. They tend to silvery grays modified by greens and blues quite as silvery." The critic called the two snow scenes by Twachtman on view "both delightful works and full of the sentiment that a poet-painter may hope to express."[43]

An article that appeared in the *New York Evening Post* further clarified the difference between the American and French artists: while "Weir and Twachtman, in their general point of view, affiliate very naturally with Monet...the distinction between them, if we can make it apparent, is that Monet pursues the representation largely for truth's sake, while Weir and Twachtman use the representation for art's sake." The critic went on to comment that the American art had a decorative quality, but qualified this statement, remarking, "by 'decorative' we do not mean the common reproach of something arbitrary or not serious. We mean in saying a picture is decorative to pay it the very highest compliment in our power. It is the decorative sense that produces art in contradistinction to the realistic sense which produces merely the representation." Using Twachtman's paintings of floral landscapes, in which the viewer is thrust into the midst of blossoming wildflowers (Fig. 57) and his *Snowy Day* (location unknown) as examples, the critic explained:

The landscape is true to nature, but nature is brought together in a pleasing, artistic way. The round sweep of the distant hill, the lines of the middle distance, the little tree at the right, all combine for rhythmical composition; the light, the air, the snow all combine to make charming color. It is this that we call the decorative quality, and it is this that we often miss in Monet, and almost always find in Twachtman and Weir. Both of these Americans are artists to their fingertips, both of them transpose and recombine in an artistic way.[44]

Another critic saw the distinction between Twachtman and Monet as exemplified in a comparison of a painting by Monet of his Vétheuil home set in a garden of sunflowers (Fig. 58) and some of Twachtman's images of his Greenwich home "in summer and winter," which the critic described as showing the artist's "more picturesquely situated"[45] dwelling. Perhaps the flowers

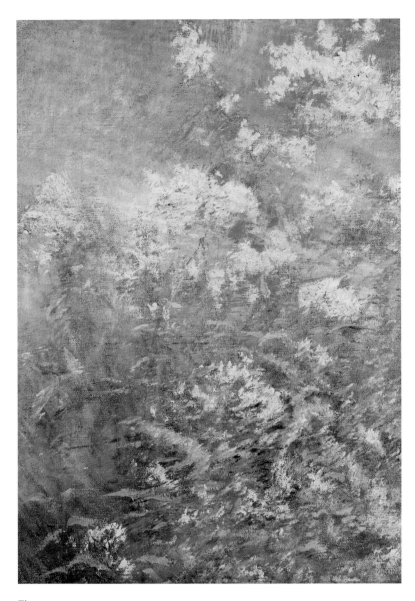

Fig. 57
Twachtman, *Meadow Flowers* (*Golden Rod and Wild Asters*), ca. 1890s, oil on canvas, 33⁵⁄₁₆ × 22³⁄₁₆ inches, Brooklyn Museum of Art, New York, Caroline H. Polhemus Fund.

other artists to derive their own individualistic inspiration from the path he had laid.

The reviewers of the 1893 show suggested that a particularly American version of Impressionism involved a tendency to transpose nature into a form that captured its beauty, rather than a form that emphasized its "truth." Such a viewpoint was taken further by a writer for the *Art Interchange* in 1895, who advocated that underpinning an Impressionist approach with emotive feeling would Americanize the style: "If artists could paint without being burdened by rules and conventionalities: this would enable artists to put forth all the fire of enthusiasm, and work as their impulses lead; if they could put down their impressionism, either of color or sentiment, as they feel them, regardless of public criticism or censure, and if more thought could be given to the spiritual than to the mechanical, we would have a more truly-called Impressionistic school."[47]

In Twachtman's case the 1893 show was a turning point. Even while the critics dubbed him a leading American exponent of Impressionism, a few reviewers criticized him for creating work that was just not robust enough. One writer noted that in some of his canvases, there "is a delicacy that fades into vagueness, and in others a carelessness that is irritating."[48] Van Rensselaer deemed Twachtman's pastels, hung in one of the small rooms, to be the "poorest" of his works: "They are faint, vague, pretty harmonies of color, but they actually represent nothing and they even suggest half remembered dreams rather than actualities."[49]

These comments perhaps reflect a sea change in the New York art world, as the notion began to sink in that American artists could not have their cake and eat it too: they could not be both Impressionists and poetic dreamers, both painters of truth and distillers of nature recalled through reflection. It was for this reason that Impressionist supporters such as Van Rensselaer disapproved of Twachtman's light-toned pastels and oils; they were not Impressionist enough and were overpowered by his other works that exhibited more identifiable Impressionist qualities.

Articles of the time urged Americans to use Impressionism to Impressionist ends, not to create vague, undefined, and brooding images of the sort that would soon be associated with Tonalism. This attitude was suggested in a review of the 1894 annual exhibition of the Society of American Artists that appeared in the *New-York Tribune*. The author of this article referred to the many American artists whom he or she viewed as "imitators" of Monet but then pointed out that

in Monet's painting, which seem to reside both back in space and on the picture plane, were disconcerting to the critic, by contrast with the way Twachtman's images draw us more gradually toward his house, its shape often harmoniously echoing that of the canvas format (Cats. 35, 37).

Van Rensselaer used her review of the show to reinforce her position as to the freeing nature of Impressionism, commenting of the Americans: "To say that they have been influenced by Monet is not to their discredit. They have not tried to imitate him. They have merely been inspired by his results, as true artists always may be inspired by results which seem to them very admirable and novel enough to promise that a fresh path in art is opening out, offering fresh triumphs to any earnest student who will try, standing on his feet to explore it."[46] Van Rensselaer suggested that it was the very greatness of Monet that allowed

some American artists, including Twachtman, Childe Hassam, and Robinson, had been able to create Impressionist landscapes that revealed "a flavor of irresistible truth." According to this writer, in these works "there is no subjective feeling apprehended ... and the grasp of natural facts ... is not imaginative." Noting that the artists produced their works "from without" rather than according to "natural impulses held in check by technical faculties highly cultivated," the writer suggested that Impressionist art by nature must be produced by a process of a direct recording of perceptual experience rather than by artistic shaping. Nonetheless, the writer had mixed feelings about the validity of Impressionist art defined in this way, as is suggested in [his or her] half-hearted lament, "This absence of any strong sympathy in the impressionistic landscapes contrasts curiously with the beauty of the pictures painted in the older manner."[50]

Indeed, it is no coincidence that in 1894 the Lotos Club in New York began a series of exhibitions of works by a "certain group of American painters more closely identified with a muted palette rather than with the bright colors and broken brushwork of Impressionism,"[51] as Jack Becker noted in his dissertation of 2002, *Studies in American Tonalism*. Becker, building on the earlier scholarship of William H. Gerdts, has substantiated that it was, in fact, the acceptance of Impressionism in America that galvanized those who opposed the style into a strong, unified, and organized force of patrons, critics, and artists, for whom New York's Lotos Club was a nucleus and stronghold of activity. Although many American artists had been using tonal palettes and abstracting forms to vague essences for some time—many following the lead of George Inness—it was only after 1894 (perhaps not coincidentally, the year of Inness's death) that the club's art committee began explicitly promoting works that were termed "Tonal" or "Tonalist."[52] With collectors forming the committee that organized exhibitions at the club—most notably William T. Evans, who was the committee's chairman from 1896 to 1912—and Henry Ward Ranger as secretary of the club, it promoted most of the artists who are now considered to be fall under Tonalist aegis.[53]

In shows at the club, works by American "Tonalist" artists were juxtaposed with those by Barbizon and Hague School artists as well as with those by old masters, particularly Dutch painters of the seventeenth century, as a way of suggesting that the Tonalists were "heirs to a European tradition" and to prove that "American-

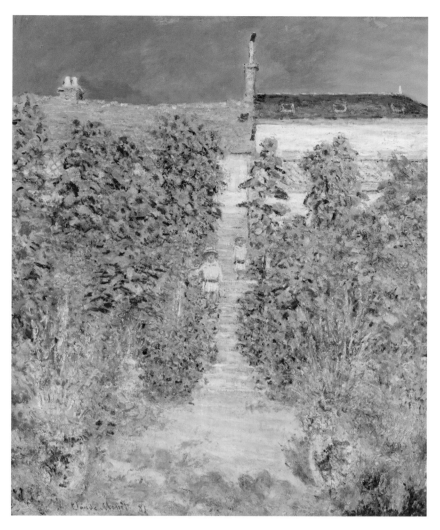

Fig. 58
Claude Monet, *Le jardin de l'artiste à Vétheuil*, 1881, oil on canvas, 29½ × 32 inches, private collection.

born artists were the equals of European counterparts."[54] What rankled the Lotos Club's leading members was that Impressionism might overtake the "muted color harmonies of tonal painting." Becker demonstrates that Evans and others believed tonal painting capable of having "a positive effect on the viewer" through creating a "rich and restful" feeling.[55] To Tonalist advocates, such a feeling would ultimately be more sustaining than a more descriptive kind of art because it could "create a mood and spark the imagination."[56] Perceiving Impressionism to be a "fad," a "cult," or "burlesque," they thought the French style was bound to be a short-lived phenomenon, one that had temporarily conned Americans to believe that just following its method would assure fame.[57] In their view, Impressionism was detached from historical precedents, whereas, Tonalist painting, with its roots in the art of the past, was destined to be the wave of the future.[58] This idea was based on the premise that "tone" in art was equated with the "poetic feeling" that was the quintessential ingredient of all great art.[59] By contrast, Impression-

Fig. 59
Twachtman, *Hemlock Pool (Autumn)*, ca. 1894, oil on canvas, 15½ × 19½ inches, private collection.

ism was seen as materialistic and overly "scientific" in its approach to nature.

In the mid-1890s Twachtman was at a juncture, and he could have turned his art toward either the Impressionist or the Tonalist pole; he chose Impressionism. Clearly he had established many friendships and associations over the course of his career with artists who followed the Tonalist route, and he retained close relations with a good number of them throughout his life. The Players Club, to which Twachtman belonged from 1889 until his death in 1902, was a venue in which many friendships between Impressionists and Tonalists were cemented. In his diaries, Robinson frequently mentioned times when he had dined with Twachtman at the Players, along with William Langson Lathrop (who roomed with Twachtman in New York in the late 1880s), Leonard Ochtman, and other artists identified as Tonalists who were members of the club.[60] Ochtman, who moved to Greenwich in 1891, was visited there by Robinson during his stays in Cos Cob, and undoubtedly Twachtman dropped in to see him as well.[61]

However, Twachtman held back from the principal Tonalist stronghold: he was never a member of the Lotos Club and, except for one painting of a waterfall, included in the exhibition at the club of

the collection of George Hearn in 1901,[62] he never sent his works to shows at the Lotos Club, nor was he identified as a Tonalist in articles about the club or about Tonalism. After the mid-1890s critics ceased to mention his name in association with Tryon, J. Francis Murphy, or Inness. He was instead almost always referred to as an Impressionist, as a follower of Monet, or as a painter of "vibratory effects."[63]

Twachtman also demonstrated his decision to follow an Impressionist path in his art. In December 1894 he exhibited a painting entitled *Autumn*—possibly the painting known today as *Hemlock Pool (Autumn)* (Fig. 59)—at the Pennsylvania Academy of the Fine Arts, where it was recognized as an extreme example of the French style. Despite this view of the painting, it won the academy's Temple Gold Medal, an annual award given to the best painting in the show.[64] Yet, this acclaim may have had to do with those who judged it. Indeed, Twachtman himself was on the jury that selected his work, and other members of the jury were Impressionist-inspired friends, including Frank Benson, Joseph DeCamp, Robinson, and Weir.[65] That Impressionism was still controversial was reflected in the comments about the painting that appeared in Philadelphia papers. One called it

"a misty agglomeration of blues and reds—a thing of shreds and patches,"[66] while another termed it "experimental" and "hardly a picture."[67] The Philadelphia reviews resonate with the attitude of Tonalist proponents of the day—Impressionism had "only the subterfuge of an affected technique to recommend it"[68]—and images such as Twachtman's demonstrated the "vagary of art preferred above that painstaking serious effort of years, which is grounded upon the first principles of art."[69]

Impressionist Impressionism

While Tonalism was being promoted by the Lotos Club, Impressionism was also being promoted by Paul Durand-Ruel and other parties with a vested interest in its acceptance. This was pointed out as early as 1891 by a writer in the *Magazine of Art* in a review of a solo exhibition of Weir's art being held at the Blakeslee Gallery in New York. The critic complained that Weir had gone "over, bag and baggage to the disciples of Manet and Monet," and while the new style suited some of his "late afternoon effects" and "landscapes in early spring," it failed him when he tried "to render crisp American autumn" or when he painted "a lady's portrait in streaks of pale candy [in which] he thwarts his own power." The critic stated:

This case shows how far the later Impressionist propaganda has gone in America. In Boston, in Philadelphia, and in New York young artists crop up with what appears a passing fashion in France.... The Impressionist Exhibition at the American Art Association's galleries some years ago was unsuccessful as regards the public and not even a *succès d'estime* among the critics. Nevertheless, the taste spreads. John Sargent leans toward it in his outdoor pictures. Theodore Robinson, [Theodore] Wendel, [Charles] Dana, Robert Reid and others give more or less open adhesion, and now Mr. Weir falls into line, though he has not been to Paris for many a year. Impressionist pictures are being pushed for their French makers by M. Durand-Ruel, who has galleries for the sale of paintings in Paris and New York and has lately established a French paper to circulate in America as well as Paris. Nay, the Union League of New York is about to exhibit, in the little theater of the club, a chosen set of paintings by Monet, the great apostle of neo-Impressionists.[70]

By the mid-1890s, in keeping with Durand-Ruel's hopes, Impressionism in the scintillating French manner had clearly taken hold, but many

American artists were seen to adopt the style in ways that were too derivative. The annuals of the Society of American Artists filled up with what some critics and artists felt were sloppily dashed off works that were lacking in quality and that simply imitated, but did not come close to equaling, the example of Monet. It was in this context that the Ten American Painters came into being.[71] Opposed to the large shows of mixed quality that had been mounted by the society in previous years, the Ten dedicated themselves to holding small exhibitions of consistently well-crafted works by only their own members. A leading force in the founding of the group, Twachtman was joined in it by many of his closest friends: Weir, Hassam, Thomas Dewing, Metcalf, Benson, Tarbell, Joseph DeCamp, Robert Reid, and Edward Simmons.[72]

While artists committed to Impressionism—at least for most of their production—dominated the Ten, the group also included Dewing, who painted images in a Tonalist vein of misty landscapes and ethereal figures lost in reverie. Others used Impressionistic methods in their art to varying degrees, such as Benson and Tarbell, who, in the winter, painted dimly lit interiors that owed much to the influence of Jan Vermeer and, in the summer, created vibrant, Impressionist views of figures wearing white in sunlit landscapes. Nonetheless, the Ten promoted itself as allied with Impressionism. Weir alluded to this connection in his remarks to a reporter in 1898, in which he stated, "one object of [my] friends and [myself], following the Japanese view, is to get rid of the barbaric idea of large exhibitions of paintings. And so [we] propose to give each year a small exhibition limited to the best three or four paintings of the men interested in the new movement."[73]

While the "new movement" undoubtedly referred to Impressionism, it may be that the artists in the Ten, especially those who focused on landscape, sought by stressing their own individuality to distance themselves from the schism within the New York art world, in which Impressionism and Tonalism were at odds. Discussing the Ten's first exhibition in 1898, a writer for the *New York Times* articulated this objective precisely: "It will not surprise the art-loving reader to learn that the atmosphere of the display in general is that of French impressionism. They have been diligent students, these younger and older men, of Manet and Monet, of Degas, Lenoir [*sic*; Renoir], Pissarro, and Sisely, but they have enough of originality and individuality to make their pictures as a rule something more than mere reflections of these

leaders and masters of the French plein airists."[74] By emphasizing their uniqueness, each member of the Ten could freely show works in an array of styles without having to be labeled as belonging to one camp in the art world or another.

In Twachtman's case, this strategy worked, as critics once again evaluated his art on its own terms, rather than according to how it fulfilled the requirements of Impressionism. One wrote that his *Early Spring* (probably Cat. 46), included in the first show of the Ten in 1898, demonstrated a "charm of light, form, and color; ... without distorting or giving a false impression of nature," proving that "truth and the decorative may go hand in hand." Of *Baby's Reflection* (now known as *Mother and Child*) (Fig. 21), an unusual figurative work by Twachtman, this same critic commented that the work revealed "the broad truth of form ... with ... the added charm of light and color." "Why not?" the critic asked, and answered: "A picture that fails to please the eye will have hard work reaching the mind or the emotions."[75] The success of the Ten in emphasizing originality over stylistic affiliation was suggested in 1898 by a writer for the *Art Amateur*, who stated: "Most people, in fact, see nothing in which they have no practical interest until some one points it out to them and provides them with some reason for looking at it. That is what an original painter does; and the visitor to the exhibition of the Ten should have his eyes opened to some things worth seeing."[76]

Fig. 60
Twachtman, *Misty May Morn*, ca. 1899, oil on canvas, 25⅛ × 30 inches, Smithsonian American Art Museum, Washington, D.C., Gift of John Gellatly.

Impressionism Allied with American Strength

In the years that followed, Twachtman contributed to exhibitions of the Ten both works that were clearly in an Impressionist mode as well as some that crossed the line into Tonalist territory, despite his lack of affiliation with the Tonalists or the Lotos Club. In the latter category, one of his paintings entitled *Morning*, which may be the work known today as *Misty May Morn* (Fig. 60), received considerable praise when it was shown at the exhibition of the Ten in 1899. A critic for the *New-York Tribune* called it "a sympathetic and almost a masterly interpretation of an enchanting scene, studied in an enchanting hour. The tender, palpitating light; the fragile, elusive tree forms; the rare sentiment of the theme, the inarticulate poetry of it, are all brought together in a pictorial whole that is conceived with originality and handled with sure understanding."[77]

At the same time, some of Twachtman's hazier, quieter works began to be faulted by critics who began to voice a preference for a strong, overtly positive form of Impressionism. This attitude reflected the view that Impressionism was the ideal style to represent the growing strength of America during a time when an American Empire seemed assured as the country became one of the world's wealthiest—even superseding France, which had led the world in wealth in the 1860s— and as it acquired new territories: Hawaii was annexed in 1898; the Philippines were ceded to the United States in 1899 as a result of the Spanish-American War; Guam and Puerto Rico were wrested from Spain in 1899; and American Samoa was granted to the United States in a treaty with Germany and Great Britain in 1900. Twachtman was certainly not the only artist to be a target of such criticism. For example, a critic for the *Boston Evening Transcript* reviewing the Ten's 1898 show in Boston commented that the "vagueness of form" from which Twachtman's *On the Terrace* (Fig. 61) "suffers" was "a besetting sin of many painters of this school."[78] However, Twachtman's gentle, discrete arrangements made his art highly susceptible to this kind of commentary.

The same critic from the *Transcript* called Twachtman's works "vague impressionist things," which had "considerable delicacy, but not much strength."[79] A similar viewpoint was expressed by the *New York Mail and Express* reviewer of the Ten's show of the next year, 1899, who stated, "Mr. Twachtman works in low, subdued tones, achieving his results, when he does achieve them, by methods so delicate as often to become

effeminate, and sometimes dropping into such morbid expressions as 'The Brook' or 'Morning.'"[80] Weir's low-toned works often were subject to the same sort of rebukes. A writer for the *Artist* commented that his contributions to the show of the Ten in 1900 were "almost sad in their subdued mood."[81]

Other critics began to describe light-toned and evanescent examples of Impressionism with feminine descriptive words that gave them a negative cast. A writer for the *Art Interchange* noted in 1899: "The slumberous tone of the clouds and woods and even the oxen and men in Weir's painting were poetic, and still more dreamy was the violet haziness through which Twachtman's brook brawls. There was almost too sweet a beauty about these idealizations, a daintiness that is almost cloying."[82] A writer for the *Critic* similarly noted in the same year: "Mr. Twachtman still paints dreams rather than landscapes, and in his favorite snow scene—a view of his house and garden, the dream is lapsing into nothingness. If we had not seen the view before, painted with some degree of definition and relief, we should hardly know what to make of it."[83]

Comments of this sort continued to be made just after the turn of the century. Of Twachtman's solo exhibition in New York in 1901, a writer for the *New York Mail and Express* stated that the artist, "in casting out the unnecessary, has gone too far. He has over-refined his product, if it be permissible to refer to his work in this fashion; he has distilled it, and passed it through so many processes as to rob it of its vital principle." The writer further noted that Twachtman could "enhance his work if he were not so anxious to keep it colorless, bloodless, lifeless."[84] In a review of the Ten's show of 1900, a critic commented that although Twachtman's *Brook in Winter* (probably Fig. 54) was "not without a touch of loveliness," his art, in general, "has not much weight," revealing "a technical habit that is … tentative." Calling Twachtman's outlook on nature "narrow," the critic felt that the painter had "a blurred vision of [nature's] beauties," and concluded: "Mr. Twachtman lends vitality to his work by virtue of a somewhat individualized manner, but there is no power in his brush."[85]

The gender-loaded language that appeared in some of the criticisms of Twachtman's work in the years surrounding the turn of the twentieth century can perhaps be associated with the shift that occurred as Impressionism became increasingly linked with male virility as opposed to the delicacy of Tonalism, which was often described as weak in terms that at times had feminine associations. A lack of strength and a certain "fogginess" and "vagueness" were at times elements decried in Tonalist art after the turn of the century, even as the movement's promoters saw the style as providing an example whereby American art could emerge from and supersede that of Europe.

Perhaps a sensitivity to the attitudes of his time contributed to the new stylistic direction that occurred in Twachtman's art at about the turn of the century, as is reflected in some of the paintings he created in Greenwich as well as those he rendered during summers that he spent in Gloucester, Massachusetts, from 1900 through 1902. In Greenwich, he painted the same motifs on his property that had held his attention before, but now rendered them with a new vitality and potency, as is evident in many of his waterfalls (Cat. 56–58), in which he abbreviated the forms of cascades and showed them flush with the picture plane so that they have a dynamic, abstract quality.

His new style became most apparent, however, in his Gloucester scenes. There, painting the harbors, shores, and fishing boats of this quintessential New England fishing village, he used a vivid Impressionist palette combined with a direct alla prima approach, similar to that of his student years in Munich, but demonstrating a new confidence and certainty. Painting with calligraphic panache, he applied each stroke with succinct force, making "every brushmark tell."[86]

Fig. 61
Twachtman, *On the Terrace*, ca. 1897, oil on canvas, 25¼ × 30⅛ inches, Smithsonian American Art Museum, Washington, D.C., Gift of John Gellatly.

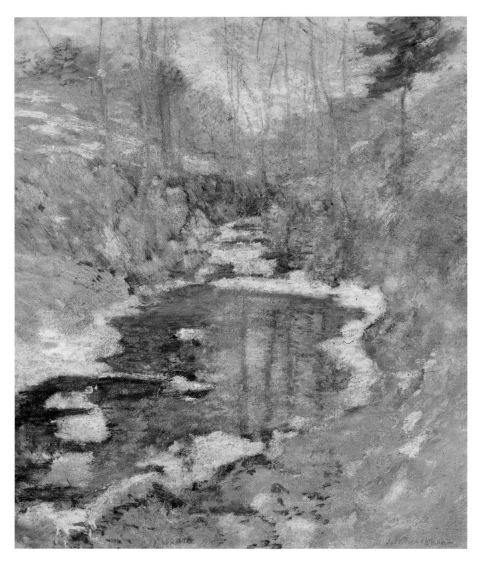

Fig. 62
Twachtman, *Hemlock
Pool*, ca. 1900, oil on
canvas, 29⅞ × 24⅞
inches, Addison Gallery
of American Art, Phillips
Academy, Andover,
Massachusetts, Gift of
anonymous donor.

The critics noted these works of Twachtman's
new style, although often the softer, more delicate
scenes he exhibited received more attention.
As early as April 1900, Charles Caffin noticed
Twachtman's "new robust method of brushwork,
revealing a thickness of pigment and an incisive
stroke" in his *Hemlock Pool* (Fig. 62).[87] When
Twachtman exhibited a Gloucester painting along
with two new waterfalls at the Ten's show of 1901,
the *New York Mail and Express* reported: "Among
the powerful voices of the surrounding pictures in
this exhibition, some of the work recently shown
by this artist in these galleries would have been
completely silenced. These three landscapes,
however, hold their own, for they are colorful and
vibratory beyond his usual methods."[88]

When a solo show of Twachtman's art, including
mostly Gloucester images, was held in Chicago
in 1901, the *Chicago Post* recognized the boldness
and strength of the paintings on view, noting:
"Even the boats in the harbor retain the fresh-

colored paint on their hulls in a way that would
seem little short of miraculous to a Chicago River
pilot."[89] The *Chicago Chronicle* similarly stated,
"he takes homely river scenes, coal barges, and
the like and puts brilliant dresses on them in a
manner really astonishing. The water he delights
to paint is a novel mixture of bright yellows,
blues and greens and what not, seemingly put
on helter-skelter."[90] Of the Gloucester works
Twachtman included in his 1901 show at New
York's Durand-Ruel Gallery, a critic for the *New
York Commercial Advertiser* observed: "A 'Ferry
Landing,' presumably of Gloucester, Mass. is
thoroughly entertaining in arrangement and
execution, and there are innumerable sketches of
sea, river, wharves, shipping and landscapes that
excite enthusiastic admiration at the skill, crafts-
manship and good color taste" (Cats. 59–64).[91]

The change in Twachtman's style was best
characterized in the obituary probably written
by Royal Cortissoz for the *New-York Tribune*, that
stated: "[O]f late years, [Twachtman's] ideas
underwent a clarifying process; his hand became
firmer as his vision became more acute, and in
the paintings of this period, he showed that he
had traveled far from the uncertainties of his
earlier experiments."[92]

Twachtman's turn to a more forceful style can
be related to the gestalt in which a rugged, vibrant,
masculine form of Impressionism became equated
with nationalism. For example, as early as 1899,
Robert Reid, one of the Ten American Painters,
was praised for works of "boldness and vigor" that
revealed a "splendid masculinity."[93] In 1921 Anna
Seaton Schmidt associated Benson with the new
American spirit, extolling him for creating paint-
ings that were "typically American" for exuding a
"spirit of optimism, of daring, a surety, of happi-
ness."[94] Cortissoz was one of the most enthusiastic
promoters of the new, emboldened, Americanized
Impressionism. He wrote often of the American
qualities in Metcalf's art and called Hassam "the
robust champion of American art."[95] Similarly,
Ernest Lawson, a student of Twachtman's in the
1890s and later a member of the New York Realists
known as the Eight, was praised in 1907 for can-
vases that were "tonic," in which "cold breezes
sweep across them; the snow is prismatic; tree
trunks gleam in the setting sunshine," revealing a
"direct, virile vision."[96]

The Impressionist artist most consistently
associated with American manliness and potency
was the Pennsylvania landscape painter Edward
Redfield, known for powerful, rough brushwork
and strong coloristic elements in his images of

the countryside near his home in Center Bridge in Buck's County, Pennsylvania. In 1909 John D. Trask stated:

> Among the men whose work may be considered typical of our time no one is more characteristically American than Mr. Redfield. His great successes have been made through the presentation of the aspects of the landscape under climatic and atmospheric conditions peculiarly our own. The national characteristics, vitality and decision, are his in the practice of his art, and in his tireless effort to acquire able craftsmanship he has in his painting developed great frankness and honesty.[97]

A year later, J. Nilsen Laurvik wrote similarly that Redfield had "done the most to infuse an authentic nationalism into contemporary American art," becoming "the standard bearer of that progressive group of painters who are glorifying American landscape painting with a veracity and force that is astonishing the eyes of the Old World, long accustomed to a servile aping of their standards." For Laurvik, Redfield was both a "rejuvenating force in our art" and an artist "in whom is epitomized the emancipating struggle of the younger men."[98]

Walter Schofield, a friend of Redfield's and another Pennsylvania Impressionist, came up with a reason that painting in the outdoors in the Impressionist manner led to a vitality that studio-produced works lacked. He pronounced: "The landscape painter is of necessity, an outdoors man.... For vitality and convincing quality only come to the man who serves, not in the studio, but out in the open where even the things he fights against strengthen him."[99] His own work was seen in these terms as well, and the critic C. Lewis Hind went so far as to use Twachtman to describe its antithesis. Hind stated that Schofield's art was "virile...crisp and candid." Hind observed that "among his compatriots Schofield is as near to the vigorous banner of Winslow Homer as he is far from the tenderly tinctured oriflamme of Twachtman."[100]

Yet it was the quiet, subtle qualities of Twachtman's art, its ability to probe beneath superficial surfaces to express the essence of his subject matter that were its strength, and it was these elements that drew the admiration of American modernists of the early twentieth century. That Twachtman had avoided the patriotic bluster, the bravado, and the cheerful boosterism of much American Impressionist art made his

work transcend the trends and the fluctuating tastes of his time. It was precisely Twachtman's capturing of the discrete and unobvious qualities in his sites that gave his art a depth that was lacked by many of the works so touted by turn-of-the-century critics.

Those critics who were more discerning never lost their appreciation of Twachtman's originality, and in even in his most delicate of images, they found an understanding that went beyond the transcriptive or pretty art of his time. They valued the way that he drew inspiration from within himself, painting according to how he visually and emotionally experienced his sites, organizing his compositions to bring out the salient qualities in a scene that had drawn his attention. They admired his refusal to portray a subject because it was easy or to work according to popular stylistic modes. Indeed, some of the aspects of Twachtman's art that reviewers of at the end of the nineteenth century felt to be undefined or tenuous reflected the fact that he was painting according to certain abstract principles that were ahead of his time. For example, he understood how the placement and structure of motifs within a picture affected how it was seen, and this intuitive understanding of form is reflected both in his scenes of days enveloped in mist and in his sunlit views of harbors in Gloucester. As Sheldon Cheney explained in 1958:

> In the nineties a painter named John Henry Twachtman taught the impressionist technique to many American art students, and he was then classified as an impressionist by critics and historians. "A mere impressionist" was the way the full-blooded realists of 1908–1910 phrased it, as did some of the moderns after them. But Twachtman put into his art a quality that makes it imperative to place him as the second American master of modernism, close to Ryder. In his day formal, structural values were not easily recognized or considered significant, and he was put down as a school man, particularly admired for the luminosity of his colour and the misty delicacy of his nature effects, but considered to have risen not at all above the routine production of the American followers of Monet and Pissarro. Time, however, has worked in Twachtman's favour, and many museums are discovering that in his canvases they have examples of post-impressionist form manipulation, and examples that are deeply moving even while fragile and lovely on the sensuous side.[101]

Twachtman: A Posthumous Tonalist

In the years following his death, Twachtman's art finally began to attract the interest of the collectors who had ignored it earlier, including many of the leading patrons of Tonalist art. Indeed, among the organizers of his estate sale were Evans, Charles Lang Freer, and John Gellatly—the preeminent supporters of Tonalist art. Gellatly, whose collection included European, Asian, and American art—including many works by Dewing, Abbott Thayer, and Albert Pinkham Ryder—was one of the only collectors actually to purchase works directly from Twachtman.[102] By 1899 he owned Twachtman's *On the Terrace* (Fig. 61); in 1902 he acquired *Hemlock Pool* (Fig. 62), presumably from the artist. Gellatly, who became wealthy when he married the daughter of a locomotive builder, bought three works from Twachtman's estate sale, and from 1910 to 1920 he purchased other works, including three paintings and four pastels that he bequeathed to the Smithsonian Institution in 1929 (now in the collection of the Smithsonian American Art Museum, Washington, D.C.).[103]

Fig. 63
Twachtman, *Niagara in Winter*, ca. 1893, oil on canvas, 30⅛ × 25⅛ inches, New Britain Museum of American Art, Connecticut, Harriet Russell Stanley Fund.

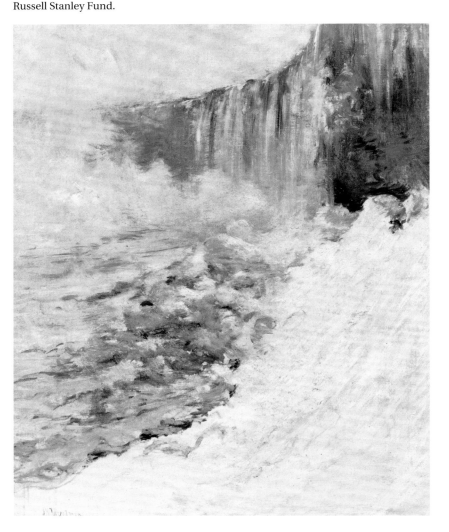

The Tonalist patron Evans, the president of a dry-goods firm, was the other major buyer of Twachtman's work in the early twentieth century; he had added American Impressionist works to his collection during his later years of acquiring art, while he was continuing to promote Tonalism. Often he chose Impressionist paintings of a tonal type.[104] This is mostly true of the works by Twachtman that he acquired. He purchased only one painting from Twachtman's 1903 estate sale, *Niagara in Winter* (Fig. 63), but between 1904 and 1909 he acquired nineteen more works. In 1909 Evans gave a large selection of art from his collection to the Smithsonian, including *End of Winter* (Fig. 64), *The Torrent* (Smithsonian American Art Museum, Washington, D.C.), *Round Hill Road* (Fig. 55), *Meadow Flowers* (Fig. 57), and *Fishing Boats at Gloucester* (Smithsonian American Art Museum, Washington, D.C.). Four years later, under financial duress, Evans was forced to sell the rest of his collection in its entirety, and the works by Twachtman that had remained in his possession were dispersed at that time.

Among the other collectors who organized Twachtman's estate sale, only a few expanded their collections of paintings by Twachtman in the years following the sale. Freer's *Drying Sails* became part of the Freer Gallery of Art's collection, and in 1913 Freer purchased *The Hidden Pool* (Fig. 65) from the Evans sale, adding it to the Freer Gallery collection. Other early buyers of Twachtman's works include the prominent collectors of Tonalist art Frederic Bonner, Louis Ettinger, George Hearn, Dr. Alexander Humphreys, Burton Mansfield (see Cat. 44), and John Harsen Rhoades.[105] This attention to Twachtman's art on the part of Tonalist devotees suggests that, although he was generally perceived as an Impressionist in his lifetime, posthumously he was drawn into the Tonalist fold.

Indeed, Twachtman was given the true test of Tonalist approval when a show of twenty-one of his works was held at the Lotos Club in 1907.[106] Many of the paintings were from Twachtman's estate, but some were lent by collectors including Evans and Hearn, suggesting that his art was being brought into the campaign to legitimize the poetic Tonalist style as the true American landscape mode, even as its art was increasingly seen as "monotonous," "affected," and "unimportant."[107]

However, that Impressionism had finally superseded Tonalism by 1910 was reflected in a show held in December of that year at the Lotos Club entitled *Exhibition of Paintings by French and American Luminists*. This show, organized

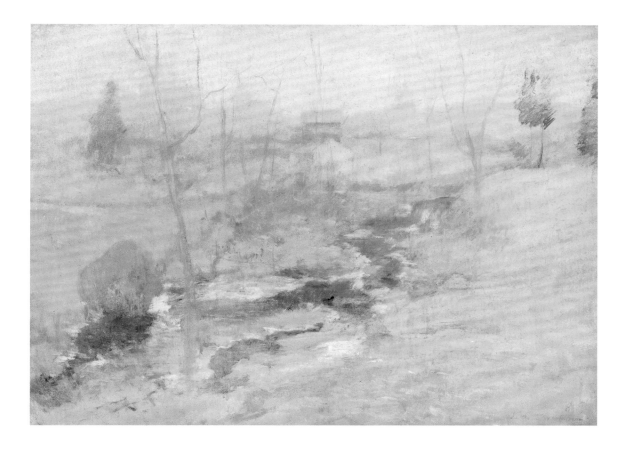

Fig. 64
Twachtman, *End of Winter*, ca. 1890–95, oil on canvas, 22 × 30⅛ inches, Smithsonian American Art Museum, Washington, D.C., Gift of William T. Evans.

by the art committee (still chaired by Evans), juxtaposed works by leading French and American Impressionists. The artists featured were Eugène Boudin, Mary Cassatt, Degas, Hassam, Metcalf, Monet, [Camille] Pissarro, Reid, Renoir, Robinson, Sisley, Twachtman, and Weir. "As nearly as possible," a critic for the *New York Herald* reported, "the committee has divided the paintings equally between the French and the native painters." To heighten the contrast between the two groups, the works were "separated by only a few inches of intervening space." The critic observed: "Doubtless the art committee of the Lotos Club never arranged a show in which it has manifested in a greater degree its sincere appreciation of the works of those men who have striven so well with the subtleties of light and air."[108]

Twachtman and "Tonal-Impressionism"

Statements about Twachtman's art from the late 1880s through the early years of the twentieth century reveal an essential problem with art "isms."[109] Where the critics perceived that Twachtman veered more toward Impressionism or more toward Tonalism is difficult to determine by simply looking at his work, and such a distinction is relatively insignificant without considering how these "isms" were defined during his era. In addition, Tonalism and Impressionism in this country were at least as much particular aesthetic modes as they were constructed idioms, to which advocates of each camp attributed certain ideas and qualities. Thus, Twachtman's "Impressionism" came out of the context of his time in America as much or more than it came out of the French style in which its aesthetic originated. In addition, while "Tonalist" elements can be seen in Twachtman's art of early 1880s, he only "became" a Tonalist after his death.

Despite some basic differences that can be pointed out between Impressionism and Tonalism (such as the former's preference for outdoor painting by contrast with the latter's emphasis on working from memory in the studio; the former's palette of bright colors by contrast with the muted tones of the latter; the former's direct and vigorous brushwork by contrast with the latter's tendency to build up layers with glazes), the two movements were less antithetical to each other than is sometimes posited. Both had a common foundation, an awareness that the connection between observation and reality did not exist. Exponents from both groups shared an understanding that artists could capture only the shifting nature of "appearances." This view

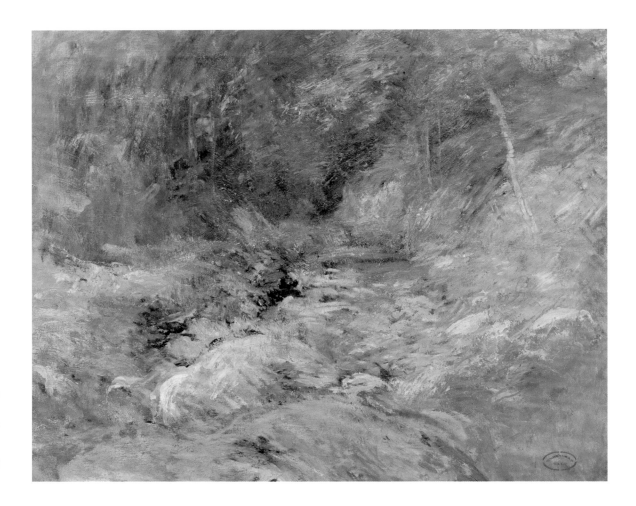

Fig. 65
Twachtman, *The Hidden Pool*, ca. 1900, oil on canvas, 22 × 27⅛ inches, Freer Gallery of Art, Smithsonian Institution, Washington, D.C., Gift of Charles Lang Freer.

was cogently summed up by the artist Birge Harrison, considered a Tonalist, in an article of 1909 in *Scribner's Magazine* entitled "The True Impressionism in Art." Harrison attributed the new awareness to the invention of photography. He stated that it was initially believed photography would be of "inestimable value" to artists; nonetheless, he noted, it was clear that "the human eye and the human brain behind it declined to accept as a symbol of motion anything which the eye had not been able to see for and by itself unaided." Because of this understanding, Harrison suggested that "art has nothing to do with things as they are, but only with things as they *appear* to be, with the visual not the actual, with the impressions not with realities."[110]

This is exactly the shift in understanding that the art historian–philosopher Jonathan Crary outlines in his books *Techniques of the Observer* (1990) and *Suspensions of Perception* (1999). Crary posits that the idea of perception, understood in the seventeenth and eighteenth century as stable, atemporal, and existing beyond the boundaries of the body, changed in the early nineteenth century as research revealed that the optic nerve had only

the function of recording visual stimuli and was thus fallible with respect to reality, making it the role of the mind to process raw sensations and transcend the distortions received by the eye.[111]

Given this global transformation, it is possible to see the mutual foundation on which the American Tonalist and Impressionist movements were based. While Tonalists emphasized the moods that nature's "appearances" presented and Impressionist-inspired Americans paid more attention to the visual "appearances" of their sites, it was also the case that Tonalists were often interested in capturing perceptual phenomena, while the Impressionists often sought to capture the feelings that their sites evoked. Therefore, frequently artists not only blended stylistic elements associated with the two styles, but they also often merged philosophical aspects of them as well.

As discussions of Twachtman's art reveal, the differences between the two aesthetics were often less significant than it might seem, despite the often clear differences in the stylistic modes used by artists associated with each camp. While there was no category during the era called Tonal-Impressionism, such a term would fit many works

by Twachtman as well as those by other American artists of the era who at times blended elements of the two styles and echoed the ideas of each. Nonetheless, as both aesthetics were repeatedly re-envisioned and adapted by their advocates and by the press and suited to their American context, such a category is less interesting as a stylistic approach than as a manifestation of a mind-set that reflected the rich tapestry of beliefs and understandings that sustained American landscape painting at the turn of the twentieth century.

NOTES

Full citations for abbreviated references may be found in Selected Exhibitions, pp. 245–46 and Selected References, pp. 247–48.

1. Twachtman wrote to Weir in December 1883: "I am studying from the figure, nude, this winter and you know how much I need drawing. I don't know a fellow who came from Munich that knows how to draw or ever learned anything in that place." Twachtman, Paris, to Weir, December 7, 1883, Weir Family Papers, MSS 41, Harold B. Lee Library, Archives and Manuscripts, Brigham Young University, Provo, Utah.

2. Stanford White, Paris, to Weir, May 3, 1884, Weir Family Papers.

3. Twachtman, Paris, to Weir, January 2, 1885, Weir Family Papers.

4. For exhibitions of Whistler's art in America, see Linda Merrill, ed., *After Whistler: The Artist and His Influence on American Painting*, exh. cat. (Atlanta, Ga.: High Museum of Art, 2003).

5. Charles Caffin, *American Masters of Painting* (London: Grant Richards, 1903), p. 162.

6. "Art Notes," *New York Times*, February 20, 1885, p. 6.

7. "The Fine Arts: Mr. Twachtman's Paintings," *Boston Daily Advertiser*, February 13, 1885, p. 4.

8. "Art Notes: Mr. Twachtman's Landscapes," *Boston Evening Transcript*, February 17, 1885, p. 2.

9. "Paintings and Pastels by J. H. Twachtman," *Boston Evening Transcript*, January 23, 1886, p. 6.

10. Ibid.

11. After receiving 155 acres of property in Branchville, Connecticut, in exchange for a painting, Weir established his summer quarters there. His home on Nod Hill Road, an old farmhouse built about 1790 and expanded in the Greek Revival style in 1825, is still standing today and is now part of a historic site, maintained by the National Park Service. The main monographic sources on Weir are Dorothy Weir Young, *The Life and Letters of J. Alden Weir* (New Haven, Conn.: Yale University Press, 1960); Doreen Bolger Burke, *J. Alden Weir: An American Impressionist* (Newark, Del.: University of Delaware Press, 1983); Hildegard Cummings, Helen K. Fusscass, and Susan G. Larkin, *J. Alden Weir: A Place of His Own* (Storrs, Conn.: William Benton Museum of Art, University of Connecticut; Greenwich, Conn.: Bruce Museum, 1991); and Nicolai Cikovsky Jr. et al.,

A Connecticut Place: Weir Farm—An American Painter's Rural Retreat (Wilton, Conn.: Weir Farm Trust in collaboration with the National Park Service, 2000)

12. J. Alden Weir to Mr. and Mrs. Robert W. Weir, April 15, 1877, quoted in Young, *The Life and Letters of J. Alden Weir*, 1960, p. 123.

13. On Weir's relationship with Erwin Davis, see Burke, *J. Alden Weir*, 1983, pp. 114–15.

14. "The Impressionists. II," *Mail and Express* (New York), April 17, 1886, p. 5. The sentence in which this word appears reads: "A part of Paris, of intellectual France, has been brought to our doors; Mahomet has come to the mountain; and we cannot but gladly and gratefully acknowledge the complement, as well as the unique character of the invasion, and feel the rites of hospitality would be violated if a courteous reception were not accorded the strangers."

15. "The Fine Arts: The French Impressionists," *Critic* 5 (April 17, 1886), p. 195.

16. "The Impressionist Pictures: The Art-Association Galleries," *Studio* 1 (April 17, 1886), p. 253.

17. "The Impressionists," *Art Age* 3 (July 1886), p. 165.

18. "Art News and Comments," *New York Daily Tribune*, April 12, 1886, p. 2.

19. "The Impressionists," *New York Sun*, April 11, 1886, p. 9.

20. "Fine Arts: The French Impressionists. II," *Independent* 38 (April 29, 1886), p. 524.

21. "The Impressionists. III," *Mail and Express* (New York), April 24, 1886, p. 5.

22. As suggested by Jack Becker, the first usage of the terms "Tonal painting" and "Tonalism" to refer to works now considered to exemplify American Tonalism occurred in the press materials of the Lotos Club about 1895. See Jack Becker, *Studies in American Tonalism*, Ph.D. diss., University of Delaware, 2002, chapter 1: "Championing Tonal Painting: The Lotos Club," pp. 21–37.

23. *"Notes"—"Harmonies"—"Nocturnes,"* exh. cat. (New York: Wunderlich Gallery, 1889). The show's installation was described in "Mr. Whistler's Pictures at the Wunderlich Gallery," *New York Sun*, March 10, 1889, p. 14.

24. "A Criticism," *Studio* 6 (April 25, 1891), p. 203.

25. "Art Notes: Pictures by J. H. Twachtman at Wunderlich," *New York Evening Post*, March 9, 1891, p. 7.

26. "The World of Art: An Impressionist's Work in Oil and Pastel—Mr. J. H. Twachtmann's [*sic*] Pictures," *New York Mail and Express*, March 26, 1891, p. 3.

27. "Art Notes," *New York Times*, April 12, 1891, p. 12.

28. "The World of Art: An Impressionist's Work in Oil and Pastel, 1891, p. 3.

29. "Art Notes," *New York Times*, March 9, 1891, p. 4.

30. "Paintings in Oil and Pastels by J. H. Twachtman," *Studio* 6 (March 28, 1891), p. 162.

31. "A Criticism," *Studio* 6 (April 25, 1891), p. 203.

32. "My Notebook," *Art Amateur* 24 (April 1891), p. 116.

33. [Royal Cortissoz], "The Spring Academy," *New-York Tribune*, April 19, 1892, p. 7.

34. Twachtman to Weir, Greenwich, December 16, 1891, Weir Family Papers.

35. John Cournos, "John H. Twachtman," 1914, p. 246.

36. See Leila Mechlin, "Contemporary American Landscape Painting," *International Studio* 39 (1902), pp. 3–14.

37. Leila Mechlin, "The North Window," *Washington Post*, January 8, 1925 (review of Metcalf retrospective at the Corcoran Gallery of Art, Washington, D.C.), quoted in Barbara J. MacAdam, *Winter's Promise: Willard Metcalf in Cornish, New Hampshire, 1909–1920*, exh. cat. (Hanover, N.H.: Hood Museum of Art, Dartmouth College, 1999), p. 32.

38. Sarah Burns, *Inventing the Modern Artist: Art and Culture in Gilded Age America* (New Haven, Conn.: Yale University Press, 1996), p. 141.

39. "Painting and Sculpture at the World's Fair," *Inland Architect and News Record* 22 (November 1893), p. 35. Tryon's *Rising Moon* was lent by Charles Lang Freer (now in the Freer Gallery of Art, Washington, D.C.); his *Starlight* was lent by Thomas B. Clarke; and Whistler's *Nocturne: Valparaiso* (now in the collection of the Freer Gallery of Art, Washington, D.C.) was lent by John Charles Day of London. Inness's *September Afternoon* is now in the collection of the Smithsonian American Art Museum, Washington, D.C.).

40. "Some Dazzling Pictures," *New York Times*, May 4, 1893, p. 6.

41. For a discussion of the works Twachtman showed in 1893, see Peters, *John Twachtman (1853–1902) and the American Scene*, 1995, vol. 1, pp. 352–60.

42. "Some French and American Pictures," *New York Evening Post*, May 8, 1893, p. 7.

43. "A Group of Impressionists," *New York Sun*, May 5, 1893, p. 6.

44. "Some French and American Pictures," 1893, p. 7.

45. "French and American Impressionists," *Art Amateur* 29 (June 1893), p. 4.

46. M[ariana] G. Van Rensselaer, "Questions of Art," *New York World*, June 25, 1893, p. 9.

47. M. E. R., "Impressionism," *Art Interchange* 35 (October 1895), p. 90.

48. "Some French and American Pictures," 1893, p. 7.

49. Van Rensselaer, "Questions of Art," 1893, p. 9.

50. "Landscapes and Portraits: Exhibition of the Society of American Artists, Second Notice," *New York Tribune*, March 26, 1894, p. 5.

51. Becker, *Studies in American Tonalism*, 2002, chapter 1: "Championing Tonal Painting: The Lotos Club," p. 15.

52. See Becker, "Studies in American Tonalism," 2002, chapter 1: "Championing Tonal Painting: The Lotos Club," pp. 21–37. The most thorough recent published source on Tonalism is Ralph Sessions et al., *The Poetic Vision: American Tonalism*, exh. cat. (New York: Spanierman Gallery, 2005).

53. On the artists who may be viewed as Tonalists, see Ralph Sessions et al., *The Poetic Vision* (New York: Spanierman Gallery, 2005).

54. Becker, "Studies in American Tonalism," 2002, chapter 1: "Championing Tonal Painting: The Lotos Club," p. 22.

55. Ibid., p. 34.

56. Ibid., p. 42.

57. See ibid., pp. 33–35.

58. See ibid., pp. 41–43.

59. Ibid., pp. 34–37.

60. On February 22, 1893, Robinson noted in his diary that he dined at the Players with Twachtman and there met the Tonalist advocate and Rutgers professor John C. Van Dyke, whom Robinson described as "a handsome man grey hair and black moustache." On December 14, 1893, Robinson wrote of dining at the Players with Twachtman and seeing Birge Harrison, Robert Reid, and "a lot of men." On March 24, 1894, Robinson wrote: "To the Players—rather amusing—dinner with Twachtman and . . . Lathrop—[Oliver] Herford, Dewing, [Stanford] White, and others." Robinson diaries, Frick Art Reference Library, New York.

61. On Ochtman in Greenwich, see Susan G. Larkin, *The Ochtmans of Cos Cob*, exh. cat. (Greenwich, Conn.: The Bruce Museum, 1989), pp. 18–24.

62. *Exhibition of American Paintings from the Collection of George Hearn*, Lotos Club, New York, March 1901.

63. For example, see "Art Notes," *New York Mail and Express*, March 19, 1901, p. 5.

64. See *Catalogue of the Sixty-fourth Annual Exhibition, Pennsylvania Academy of the Fine Arts* (Philadelphia: Pennsylvania Academy of the Fine Arts, 1894). The show was held from December 17, 1894, to February 23, 1895. Previous Temple Award winners included Sargent (1893), Whistler (1893), Thayer (1891), Charles Sprague Pearce (1885), and George Maynard (1884).

65. The other members of the jury were George H. Bogert, A. Stirling Calder, Charles Melville Dewey, Charles Grafly, Thomas Hovenden, William Sergeant Kendall, John Lambert Jr., Carl Newman, William Trost Richards, and Robert Vonnoh.

66. "New Pictures at the Academy," *Philadelphia Inquirer*, December 16, 1894, p. 5.

67. "The Academy Exhibition," *Philadelphia Times*, December 16, 1894.

68. Ibid.

69. "New Pictures at the Academy," 1894.

70. "Minor New York Exhibitions," *Magazine of Art* 14 (1890–91), p. xiv.

71. The most thorough account of the Ten is William H. Gerdts et al., *Ten American Painters* (New York: Spanierman Gallery, 1990). On Twachtman's participation in the Ten, see Lisa N. Peters, "John H. Twachtman," pp. 129–34 and "John H. Twachtman: *The Torrent*," pp. 166–69 in ibid. See also Ulrich W. Hiesinger, *Impressionism in America: The Ten American Painters* (Munich: Prestel-Verlag, 1991).

72. Frank Benson attributed the Ten's existence entirely to Twachtman, suggesting that Twachtman had provided the impetus for his resignation from the society and proposed the idea for the new organization. Frank W. Benson to Dorothy Weir Young, July 8, 1938, Weir Family Papers, quoted in Sheila Dugan, "Frank W. Benson," in Gerdts et al., *Ten American Painters*, 1991, p. 85. Twachtman's son, J. Alden, went even further, stating that his father had "taken on himself the organizing and running of the shows at the Durand-Ruel Galleries," quoted in Hale, *Life and Creative Development*, 1957, vol. 1, p. 96. Most accounts, however, attribute the idea for the Ten to Childe Hassam. But even Hassam seems to have perceived Twachtman as a guiding force in the organization, as Twachtman and Weir were the first artists to whom Hassam turned in seeking support for the new group. Childe Hassam, "Reminiscences of Weir,"

in Duncan Phillips et al., *Julian Alden Weir: An Appreciation of His Life and Works* (New York: Century Club, 1921), pp. 67–68. Hassam also later admitted that Weir and Twachtman contributed most to the artistic success of the Ten. See Gerdts, "Ten American Painters: A Critical Chronology," in Gerdts et al., *Ten American Painters*, 1991, p. 11.

73. "Eleven Painters Secede," *New York Times*, January 9, 1898, p. 12.

74. "American Painters' Display," *New York Times*, March 30, 1898, p. 6.

75. "Ten American Painters," *New York Evening Post*, April 1, 1898, p. 7.

76. "Ten-American Painters," *Art Amateur* 38 (May 1898), p. 134.

77. [Royal Cortissoz], "Art Exhibitions: The Ten American Painters," *New York Daily Tribune*, April 4, 1899, p. 6.

78. "The Fine Arts: Exhibition by Ten American Painters at the St. Botolph Club," *Boston Evening Transcript*, April 27, 1898, p. 16.

79. "The Fine Arts: Exhibition by Ten American Painters at the St. Botolph Club," 1898, p. 16.

80. "Art Notes," *New York Mail and Express*, April 4, 1899, p. 5.

81. "Third Annual Exhibition of the Ten American Painters," *Artist* 27 (May 1900), p. 27.

82. "Exhibitions," *Art Interchange* 43 (May 1899), p. 115.

83. "The Fine Arts," *Critic* 34 (1899), p. 461.

84. "Art Notes," 1901, p. 5.

85. "Art Exhibitions: The 'Ten American Painters,'" *New York Daily Tribune*, March 17, 1900, p. 8.

86. "Twachtman's Painting—To Be Exhibited at Mr. Fauley's Studio Next Week," *Columbus (Ohio) Journal*, January 27, 1901.

87. Charles Caffin, "Third Exhibition of the 'Ten American Painters,'" *Harper's Weekly* 44 (April 14, 1900), p. 338.

88. "Art Notes," *New York Mail and Express*, March 19, 1901, p. 5.

89. "Exhibitions Next Week," *Chicago Post*, January 5, 1901, unpaginated clipping, Scrapbook, Ryerson Library, Art Institute of Chicago.

90. *Chicago Chronicle*, January 14, 1901, untitled and unpaginated clipping, Scrapbook, Ryerson Library, Art Institute of Chicago.

91. "The Art-World: Mr. Twachtman at Durand-Ruel's," *New York Commercial Advertiser*, March 5, 1901, p. 4.

92. [Royal Cortissoz], "John H. Twachtman," *New-York Tribune*, August 9, 1902, p. 8.

93. Henri Pène du Bois, "Plays of Light Painted by Nine Men," *New York Journal and Advertiser*, April 4, 1899, p. 10.

94. Anna Seaton-Schmidt, "Frank W. Benson," *American Magazine of Art* 12 (November 1921), pp. 365–66.

95. See William H. Gerdts, *American Impressionism* (New York: Abbeville, 1984), p. 299.

96. "Monet, Lawson, Dougherty," *New York Sun*, February 7, 1907, p. 8.

97. [John] E. D. T[rask], introduction to *Exhibition of Paintings by Edward W. Redfield*, exh. cat. (Philadelphia: Pennsylvania Academy of the Fine Arts, 1909), n.p.

98. J. Nilsen Laurvik, "Edward W. Redfield—Landscape Painter," *International Studio* 41 (August 1910), p. xxix.

99. Quoted in Thomas Folk, *The Pennsylvania School of Landscape Painting: An Original American Impressionism* (Allentown, Pa: Allentown Art Museum, 1984), p. 52.

100. C. Lewis Hind, "An American Landscape Painter: W. Elmer Schofield," *International Studio* 48 (February 1913), p. 282.

101. Sheldon Cheney, *The Story of Modern Art* (New York: Viking Press, 1958), p. 423.

102. On Evans, see William H. Truettner, "William T. Evans, Collector of American Paintings," *American Art Journal* 3 (Fall 1971), pp. 50–79, and Becker, "Chapter Two: William T. Evans, Collector of American Art," in "Studies in American Tonalism," pp. 1–56. On Freer, see Thomas Lawton and Linda Merrill, *Freer: A Legacy of Art* (New York: Abrams, 1993); on Gellatly, see Thomas B. Brumbaugh, "The American 19th Century, Part 3: The Gellatly Legacy," *Art News* 67 (September 1968), pp. 48–51+.

103. Gellatly's gifts to the Smithsonian, all presently in the Smithsonian American Art Museum, were *On the Terrace* (Fig. 61); *Misty May Morn* (Fig. 60); *Figure in Sunlight (Artist's Wife)*; *Niagara Falls*; *Hemlock Pool, Autumn*; *The Brook, Greenwich, Connecticut*; *Haystacks at the Edge of the Woods*; *Flowers*; *Wild Flowers*; *Tiger Lilies*; and *Chestnuts*

104. See Truettner, "William T. Evans," 1971.

105. Many of these collectors were part of the Society of Art Collectors that helped organize the show *Comparative Exhibition of Native and Foreign Art*, held in New York in 1904. To the show, Evans lent *Hemlock Pool* (Fig. 62) while Gellatly lent *The Torrent* (Smithsonian American Art Museum, Washington, D.C.). See Becker, "Studies in American Tonalism," chap. 4, pp. 1–28. Hearn visited Twachtman in 1894. As Robinson wrote in his diary on August 26, 1894: "On the way home—walking, we met Mr. Hearn and daughter driving a swell turnout, going to Twachtmans."

106. *Exhibition of Paintings by the Late John H. Twachtman*, exh. cat. (New York: Lotos Club, 1907).

107. "Art," *(New York) Mail and Express*, April 17, 1903, p. 4, quoted in William H. Gerdts, "Society of American Landscape Painters," in Sessions et al., *The Poetic Vision*, pp. 39–50.

108. "Colorful Art Show at the Lotos Club," *New York Herald*, December 16, 1910, sec. 2, p. 11.

109. On Tonal-Impressionism in the art of Weir and Twachtman, see Peters, "'Spiritualized Naturalism,'" 2005, pp. 73–85.

110. Birge Harrison, "The True Impressionism in Art," *Scribner's Magazine* 6 (October 1909), p. 491.

111. Jonathan Crary, *Techniques of the Observer: On Vision and Modernity in the Nineteenth Century* (Cambridge, Mass.: MIT Press, 1990), and Crary, *Suspensions of Perception: Attention, Spectacle, and Modern Culture* (Cambridge, Mass.: MIT Press, 1999).

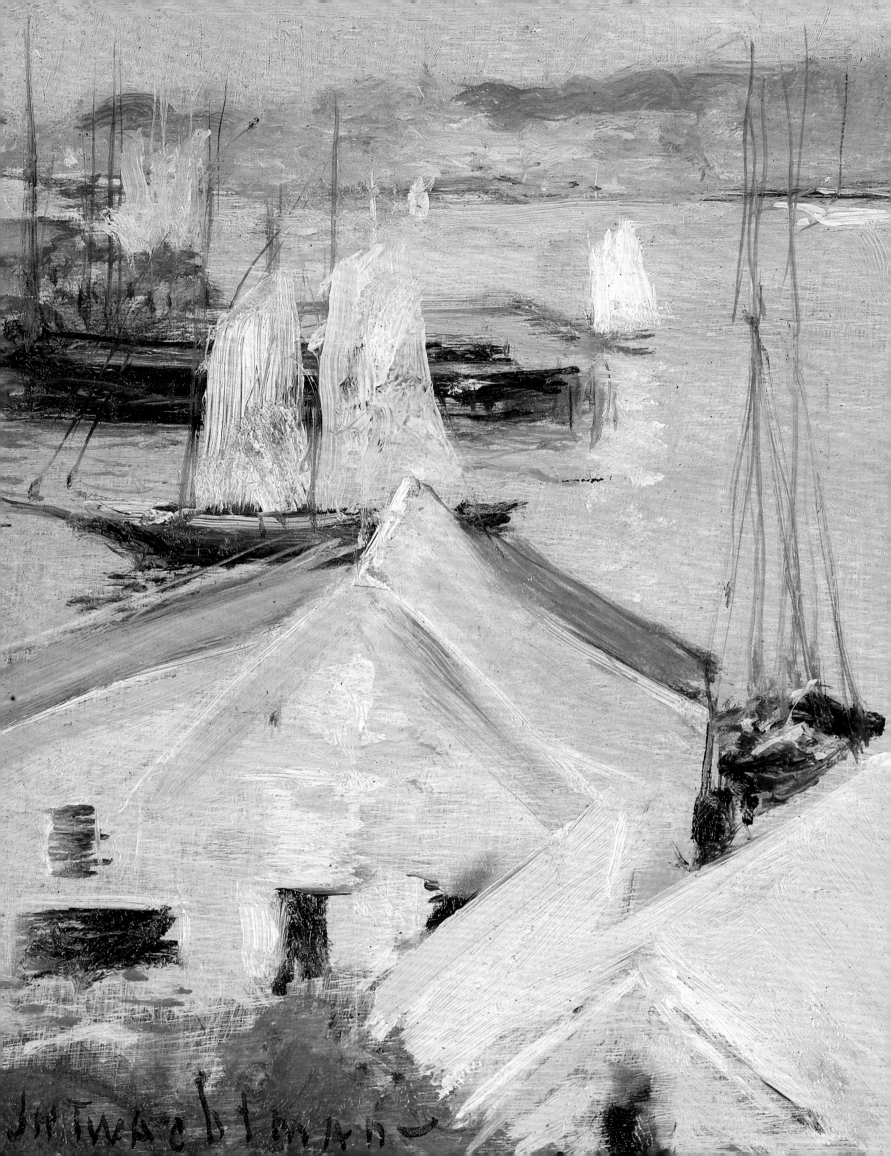

Notes to the Entries

LISA N. PETERS

Documenting Twachtman's art presents many challenges. The foremost is that as much as Twachtman had a passion for painting, he disliked the administrative side of his profession. He admitted that he found the naming of his works bothersome, which is borne out by the fact that during his lifetime the same painting was sometimes shown with different titles, and the same title was clearly used for several different works. When he did give titles to works when they were sent to exhibitions, he tended to use generic names, often having to do with the seasons or, generally, with a location. This practice makes it extremely difficult to determine which *Winter*, *Summer Afternoon*, *Venice*, or *Gray Day* (to use some of the titles of pictures in this exhibition) was on view in a particular show. It was probably because his art was suggestive rather than descriptive that Twachtman did not feel that giving a specific name to a subject was important. Perhaps he wanted his works to speak for themselves rather than to be burdened with overtly poetic or explicit titles.

Just as in titling his works, Twachtman appears to have been inattentive, and perhaps disinterested, in signing and dating them. Before 1883 he dated many paintings, but he discontinued this practice with only a few exceptions after this date. Although he may have signed works when he sent them to exhibitions, there is little explanation as to why he signed some and not others. As is suggested in an essay in this catalogue entitled "A 'Painter's Painter' in an Age of Artistic Self-Awareness," even though he desperately wanted his works to be appreciated by the art buyers of his day, he had no skill, or interest, in marketing them, and he did not maintain any records that would have helped in cataloguing them. In addition, because his sales were so rare, few histories of their early ownership can be traced to his lifetime.

A great amount of the artist's oeuvre remained in his hands at the time of his death in 1902. Many works left in his estate were probably untitled and given random names either by members of his family or by their new owners. Often owners and galleries changed the titles of Twachtman's works in the years following his death. As a result, some titles do not accord with their subjects, some were assigned arbitrarily, and others are purely descriptive. Thus, faulty scholarship has at times come from analyses based on the titles of Twachtman's works.

In this catalogue, despite all of these hindrances, the early histories of many of the works have been determined, in part thanks to the many reviews of Twachtman's works in the publications of his day, which often provided detailed descriptions. When it seems likely that a work was in a collection or exhibition, or was mentioned in a review, this information is provided with the necessary qualifications and explanations. In several cases, works in this show have been reunited with their original titles, providing information that has been lost for decades. In exhibition and literature listings, titles for works are only given when they differ from current titles.

Twachtman's solo exhibitions and important references are included in abbreviated form in the entries that follow, their full citations provided in Selected Exhibitions, pp. 245–46, and Selected References, pp. 247–48. Many of the works in this exhibition were included in John Douglass Hale's 1957 dissertation, *The Life and Creative Development of John H. Twachtman*, which also included a catalogue raisonné. Hale divided this catalogue raisonné section into two parts: Catalogue A, those works for which he had locations; and Catalogue G, those works that were unlocated or for which he only had a reference from an exhibition or publication. In a number of cases, several different catalogue numbers from Hale can be assigned to a single work. All of the works in this show will be included in the catalogue raisonné of Twachtman's art, written by Ira Spanierman and me, which is in progress. The numbering of works in this future publication has not yet been determined.

Several works in this show bear red stamps that read *Twachtman Sale*. These stamps were placed on unsigned works included in the artist's estate sale, held on March 24, 1903, at the American Art Galleries in New York. Works that were in the sale that were signed already did not receive such stamps.

Documentation on each work is included in the most complete form possible at this time. In a few cases, works had labels on their versos indicating their inclusion in particular exhibitions. This information has been provided even if we were unable to find full details of these shows.

Opposite:
Boats at Anchor
(detail of Cat. 61).

1.

View near Polling ca. 1876–77

Oil on canvas
32¼ × 54 inches
Signed lower right: *J. H. Twachtman*
Spanierman Gallery, LLC, New York

PROVENANCE

(Newhouse Galleries, New York); (Maxwell Gallery, San Francisco); to private collection, 1971; to present coll., 2006.

LITERATURE

Peters, *John Henry Twachtman: An American Impressionist*, 1999, pp. 25–26 color ill.

Fig. 66
William Merritt Chase, *View near Polling (Landscape with Sheep)*, ca. 1875–76, oil on canvas, 36¼ × 48 inches, private collection.

ALTHOUGH the origin of this painting's title is unknown, it bears all the earmarks of having been painted by Twachtman in 1876 or 1877 during a visit to the village of Polling, Germany, a popular retreat in the foothills of the Bavarian Alps for American artists who studied in Munich in the 1870s and early 1880s.[1] The only official record of Twachtman's stay in the town is his signature in the spring of 1876 in a guest book of a Polling inn that recorded visitors to the town,[2] but he may have traveled there on other occasions as well, painting alongside his old friend Frank Duveneck and perhaps working also with J. Frank Currier. Duveneck painted the beechwood groves and meadows just beyond Polling's old walls in the dark, robust style popular among Munich painters of the time, while Currier is known to have led groups of artists on sketching trips into the countryside.[3]

Currier's practice during the 1870s was to paint large canvases directly in the outdoors (see Fig. 26). Twachtman took this approach in *View near Polling*. Loading his brushes with thick, unctuous pigments in tones of pitch black and dark greens, he rendered the trees with forceful strokes, while spreading thinner layers of paint with a palette knife in the foreground to indicate the broad patterns of light and shadow across the open field. The brighter tones in the sky suggest that some color was added in this area of the work at a later point than the rest of the landscape.[4] The composition in this work is one that Twachtman would use repeatedly throughout his career, in which a diagonal path serves an organizing role within a composition, creating spatial recession while providing a means of bringing the viewer into a scene.

Twachtman's method in this painting is similar to that in a Polling view by William Merritt Chase from about the same time (Fig. 66), which Chase included in his solo show at the Boston Art Club in 1886. A reviewer of this show remarked that the artist's landscapes looked as if he had "seized upon his impression at its first inception, leaving out whatever would mar its artistic vividness."[5] Such a comment would similarly apply to Twachtman's Polling image. That Twachtman and Chase lived and painted together in Venice from the spring of 1877 through the spring of 1878 suggests that they were aware of their affinity for each other, from the beginning of their careers.

1. See Lisa N. Peters, "'An Atmosphere of Youthful Enthusiasm under a Hospitable Sky': The American Artists' Colony in Polling, Bavaria, 1872–1881," *American Art Journal* 31 (2000), pp. 56–91.

2. Twachtman signed the Polling guest book at some point between April 1 and May 7, 1876. Ibid., p. 91.

3. For Duveneck's recorded visits to Polling, see ibid., p. 89. Among his Polling works are *Beechwoods at Polling* (ca. 1876; Cincinnati Art Museum) and *Pool at Polling, Bavaria* (ca. 1880; Cincinnati Art Museum). Currier's stay in Polling is discussed in ibid., pp. 70, 73.

4. The added paint in the sky is indicated in a condition report conducted by Simon Parkes, conservator, January 2006.

5. "A Boston Estimate of a New York Painter," *Art Interchange* 17 (December 4, 1886), p. 179.

2.

Venice ca. 1878

Oil on canvas
16 × 20 inches
Signed lower right: *J. H. Twachtman*
The Orr Collection

PROVENANCE

(Macbeth Gallery, New York, by 1913–ca. 1920); Adolph Lewisohn, New York, by 1926; to (Parke-Bernet, New York, *Works of Art from the Collection of the Late Adolph Lewisohn*, May 16–17, 1939, lot 248); to T. Finger or T. Fiager; Lovenick; to (Babcock Galleries, New York, by 1942); to private collection, 1960; by descent in the family to the present.

EXHIBITED

Macbeth Gallery, New York, *Fourth Exhibition of Intimate Paintings*,
 November 30–December 31, 1920, no. 88.
1942 Babcock Galleries, no. 2.

REFERENCES

Clark, "Art of John Twachtman," 1921, p. lxxix ill.
Clark, *John Twachtman*, 1924, p. 32.
Forbes Watson, "American Collections: No. III—The Adolph Lewisohn Collection,"
 The Arts 10 (July 1926), p. 46 ill.
Hale, *Life and Creative Development*, 1957, vol. 1, pp. 181, 189; vol. 2, p. 502
 (catalogue G, no. 650).
Peters, *John Twachtman (1853–1902) and the American Scene*, 1995,
 vol. 1, pp. xiv, 53–54; vol. 2, p. 597 (Fig. 38).

Fig. 67
Joseph Mallord Turner,
*Venice: The Dogana and
San Giorgio Maggiore*,
1834, oil on canvas,
36 × 48 inches,
National Gallery of Art,
Washington, D.C.,
Widener Collection.

TWACHTMAN painted this readily recognizable Venetian view from near the front of the Accademia on the Riva degli Schiavoni looking southeast. Cropped at the right is the Dogana di Mare, the customhouse built in the seventeenth century—positioned at the tip of the city's Dorsoduro district at the point where St. Mark's Basin merges with the Grand Canal. Beyond the diagonal of the Dogana are the domes and campanile of San Giorgio Maggiore, across the Giudecca.

A similar viewpoint was used by Joseph Mallord Turner in *Venice: The Dogana and San Giorgio Maggiore* (Fig. 67), in which the angle of the Dogana, along with a flotilla of colorful sailing craft at the left, draw our attention to the varied reflective qualities of light within the scene. By contrast with Turner, Twachtman portrayed his scene in the manner of a quick sketch, not attempting to differentiate his motifs as much as to use them as forms within his overall design. By leaving the foreground unfilled, he creates the effect of drawing our attention to the periphery, where the pilings compete on an equal footing for our attention with the esteemed architectural landmarks of Venice. His rich dark grays and deep rusts, as well as his broad strokes of thick paint spanning the width of the canvas, are typical of his Munich approach, revealing his desire to capture a direct impression of his subject, undistracted by the need to create a convincing transcription.[1]

Venice belonged during the 1920s and 1930s to the noted philanthropist and art collector Adolph Lewisohn (1849–1938), who made his fortune in the mining and importing businesses and lent his support to the many universities that named buildings for him. Lewisohn also owned a Venetian watercolor by Twachtman (Cat. 11).

For another view by Twachtman featuring the Dogana from the opposite point of view, see (Fig. 28).

1. An inspection by conservator Simon Parkes reveals that Twachtman painted this work over an earlier image, from which pentimenti remains.

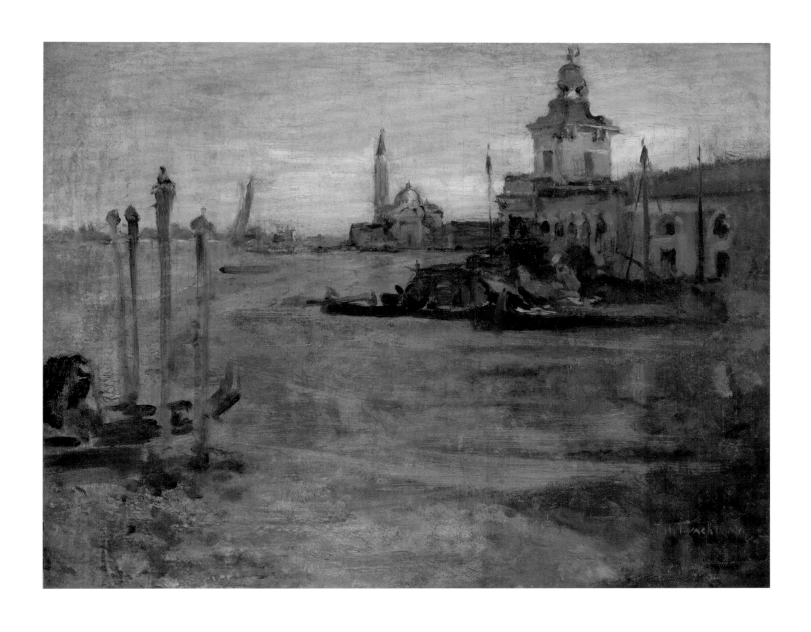

3.

Ship and Dock, Venice ca. 1878

Oil on canvas
14¾ × 10⅝ inches
Spanierman Gallery, LLC, New York

PROVENANCE

J. Alden Weir; to his daughter Mrs. G. Page Ely (née Caroline Weir), Old Lyme, Connecticut, by 1957; by descent through the family; to present coll., 2002.

EXHIBITED

Lyman Allyn Museum, New London, Connecticut, *The Art of J. Frank Currier and Painters of the Munich School*, February 9–March 9, 1958, no. 66 (as *Waterfront*, 15 × 10½ inches, lent by Mr. and Mrs. G. Page Ely, Old Lyme, Connecticut).

REFERENCES

Hale, *Life and Creative Development*, 1957, vol. 2., p. 569 (catalogue A, no. 541, as *Ship and Dock*).
Peters, "Twachtman: A 'Modern' in Venice," 1992, pp. 67–68 ill.
Peters, *John Twachtman (1853–1902) and the American Scene*, 1995, vol. 1, pp. xiv, 56; vol. 2, p. 601 ill. (Fig. 43).

LEAVING behind the picturesque sights that drew tourists to Venice, Twachtman painted this scene of warehouses and boat sheds in a direct alla prima manner. At the same time, he carefully structured the scene. Depicting it from a high vantage point, he radically foreshortened the buildings in the foreground, directing our attention to the focal point of the work, the bright red-white reflective form situated in its center, probably representing the drying sail of a boat (one of Twachtman's favorite motifs). With the anchored three-masted schooner closing in the arrangement at the left, our gaze is drawn into the distance across the silvery-gray surface of the water, which reflects the tone of the sky in the early evening. This work anticipates the views that James McNeill Whistler would create on his visit to Venice in 1879–80, in which he similarly found artistic value in the mundane aspects of the city, painting them at dusk, and arranging their forms with an eye to aesthetic harmony.

J. Alden Weir, the first owner of this painting, probably met Twachtman shortly after he had returned from Venice, and the two men had an instant affinity. Weir's daughter Dorothy recalled that from the beginning they "shared a dedication to art and an attitude toward their own painting sufficiently critical to keep them searching for new and more effective styles."[1] Weir's ownership of *Ship and Dock* suggests his appreciation of its balance of spontaneity and "architectonic balance"—a term used by Eliot Clark to describe Twachtman's Venetian art.[2] This painting one of eleven works in this show that belonged to Weir (see Cats. 6, 15, 26, 63, 64, 73, 74–78). It was inherited by Weir's eldest daughter Caroline (1884–1974) and remained in the Weir family until 2002.

1. Dorothy Weir Young, *The Life and Letters of J. Alden Weir* (New Haven, Conn.: Yale University Press, 1960), p. 149.
2. Clark, *John Twachtman*, 1924, p. 31.

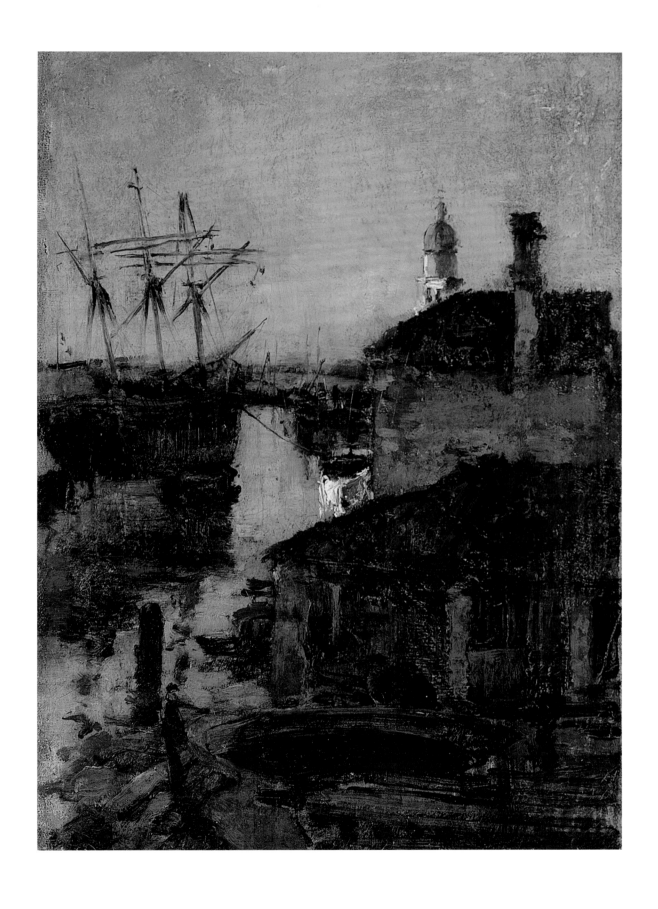

4.

Venetian Sailing Vessel 1878

Oil on canvas
15¼ × 10½ inches
Signed, dated, and inscribed lower right: *Venice / J. H. Twachtman 78*
Private Collection

PROVENANCE

The artist; to his son Godfrey Twachtman, Independence, Missouri; to his daughter Phyllis Twachtman, Brooklyn, New York; to (Ira Spanierman, Inc., New York, 1969); to present coll., 1969.

REFERENCES

Peters, "Twachtman: A 'Modern' in Venice," 1992, pp. 69–71 ill.
Peters, *John Twachtman (1853–1902) and the American Scene*, 1995, vol. 1, pp. xiv, 56; vol. 2, p. 603 ill. (Fig. 45).

THE VIEWPOINT in this Venetian scene appears to be looking west along the Fondamenta della Zattere from just beyond the eighteenth-century Church of the Gesuati, a common location at the end of the nineteenth century for cargo ships to anchor that were too large to pass through the Grand Canal.

Many artists painted from this spot, but generally their images are horizontal in format, accentuating the picturesque forms stretching into the distance along the Zattere.[1] By contrast, Twachtman used a vertical canvas, as a way of focusing our attention on the antiquated wooden sailing barque that had anchored at this spot.[2] The sense that he painted this scene as he saw it is suggested in his vantage point from the level of the wharf and the presence of the small figure walking casually toward us. Leaving the buildings in the distance sketchy, he devoted his attention to the forms of the boat, using an expressive handling to portray the faded green color of the boat's stern, the tilting qualities of its cross beams, and the simultaneous heaviness and translucency of its slack, drying sails. He would return to painting similar ships at the end of his career, when he spent three summers in Gloucester, Massachusetts (see Cat. 59).

A review by Susan Carter in the *Art Journal* of the second exhibition of the Society of American Artists, held in March 1879, suggests that this was one of two paintings that Twachtman exhibited in this show, both of which were entitled *Venetian Sketch*. Carter remarked that "the great hull of a vessel in one of the Venetian sketches was chiefly valuable as a study of colour in a scale of black-and-white into which were woven reds and yellows of sails."[3] That Twachtman went to the effort of inscribing this work *Venice* is further evidence that it was a work that he chose to exhibit.

Twachtman painted from the same angle in *Le Quai, Venice* (Cat. 20), probably in 1885.

1. See, for example, Francesco Guardi, *Vue de la Giudecca avec les Zattere* (ca. 1780; Musée du Louvre, Paris), and Guardi, *The Giudecca Canal with the Zattere* (ca. 1759; private collection).
2. Vertical formats were also used in Venetian scenes by William Merritt Chase, who, along with Duveneck, was Twachtman's roomate in Venice. See, for example, *Street in Venice* (ca. 1878; Lyman Allyn Museum, New London, Connecticut), illustrated in Margaretta M. Lovell, *Venice: The American View, 1860–1920*, exh. cat. (San Francisco: The Fine Arts Museums of San Francisco, 1985), p. 33.
3. S[usan] N. Carter, "Exhibition of the Society of American Artists," *Art Journal* 5 (March 1879), p. 157.

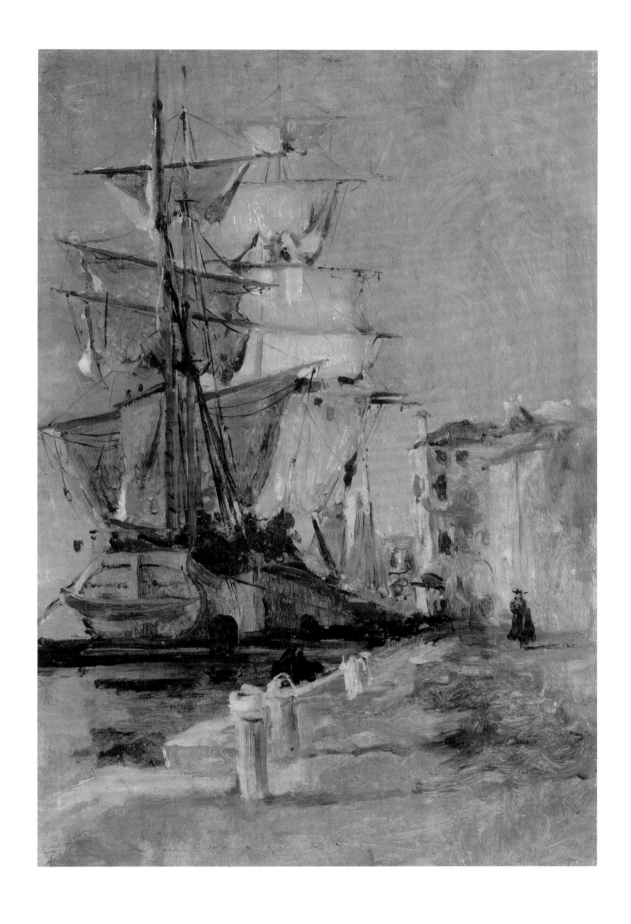

5.

View of Venice 1878

Oil on canvas
7¼ × 13¼ inches
Signed, dated, and inscribed lower left: *J. H. Twachtman / Venice 78*
Private Collection

PROVENANCE

(Newhouse Galleries, New York, by 1968); to present coll., 1980s.

EXHIBITED

1968 Ira Spanierman, no. 2 (as *Venice*, lent anonymously).
Danforth Museum of Art, Framingham, Massachusetts, *Explorations in Realism: 1870–1880: Frank Duveneck and His Circle from Bavaria to Venice*, April 21–July 2, 1989, no. 103 (as *Venice*).

REFERENCES

Peters, "Twachtman: A 'Modern' in Venice," 1992, pp. 66 ill., 67.
Peters, *John Twachtman (1853–1902) and the American Scene*, 1995, vol. 1, pp. xiv, 54–55; vol. 2, p. 598 ill. (Fig. 40).

THE BUILDINGS of Venice were described by the novelist Henry James and others as colored a faded pink, due to the reflected light in their weathered stone facades.[1] In this work, Twachtman captured this roseate quality in the famed structures along the Riva degli Shiavoni—the Doge's Palace is at the center of the shoreline and the domes of St. Mark's and the cathedral's campanile are cropped in the upper left. However, at the right, modern life intrudes on this timeless scene, in the form of a large, ungainly black steamship, a motif that other artists of the day routinely omitted from their Venetian images in their desire to capture the poetic essence of the city—despite the fact that such vessels were prevalent on the city's waterways by the 1870s.

Twachtman, by contrast, found this motif riveting, as he constructed his arrangement to direct our gaze to it, along a diagonal perspective and away from the shoreline. Beside it, a red buoy brings us into the work, and suggests the point at which Twachtman had focused his own gaze. Thus, through his composition he evoked his personal experience of this scene and perhaps sought to suggest his affinity for painting the new phenomena of his own time rather for retreating to an elegiac type of art linked with the past. He also signaled his desire for a fresh new kind of art through his asymmetrical arrangement.

1. See Henry James, "Venice," *Century Magazine* 25 (November 1882), p. 12. This essay was reprinted in James's *Italian Hours* of 1909 (London: Century, 1986), p. 12.

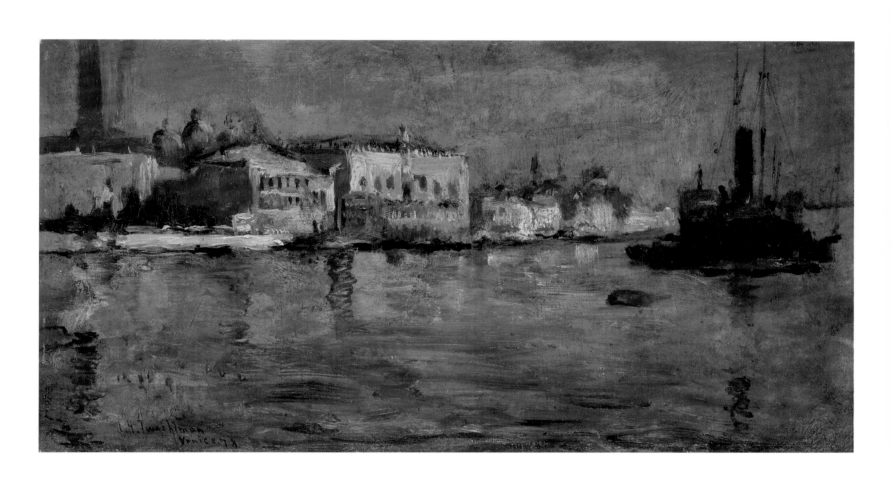

6.

End of the Pier, New York Harbor 1879

Oil on canvas
12⅛ × 18 inches
Signed, dated, and inscribed lower right: *J. H. Twachtman N.Y. 79*;
 signed lower left: *J. H. T.*
Ackerman Family Collection

PROVENANCE

(American Art Galleries, New York, *Sale of the Work of the Late John H. Twachtman*, March 24, 1903, lot 5, as *End of the Pier*); to J. Alden Weir; to his daughter G. Page Ely (née Caroline Weir), Old Lyme, Connecticut; by descent in the family; to (Peter Davidson, Inc., New York, 1988); to present coll., 1988.

EXHIBITED

1907 Lotos Club, no. 38 (as *New York Harbor*, lent by J. Alden Weir).
Lyman Allyn Museum, New London, Connecticut, *The Art of J. Frank Currier and Painters of the Munich School*, February 9–March 9, 1958, no. 67 (as *Waterfront in New York*, lent by Mr. and Mrs. Page Ely, Old Lyme, Connecticut).

REFERENCES

"Twachtman Pictures, $16,610," *New York Sun*, March 25, 1903, p. 5.
Hale, *Life and Creative Development*, 1957, vol. 2, pp. 454 (catalogue G, no. 240, as *New York Harbor*), 563 (catalogue A, no. 462, as *End of Pier*).
Peters, *John Twachtman (1853–1902) and the American Scene*, 1995, vol. 1, p. 81; vol. 2, p. 621 ill. (Fig. 66).

THIS PAINTING was listed as *End of the Pier* in the catalogue of Twachtman's 1903 estate sale, from which it was one of seven works acquired by J. Alden Weir, who purchased it for fifty dollars. When Weir sent the painting four years later to a memorial show of Twachtman's work held at the Lotos Club in New York, it was identified in the catalogue as *New York Harbor*. The painting was shown as *Waterfront in New York* in 1958, when Weir's daughter Caroline (Mrs. G. Page Ely) lent it to an exhibition at the Lyman Allyn Museum in New London, Connecticut. The work remained in the Weir family until 1988. This is the only New York scene to have been owned by Weir, and it represented the early phase of Twachtman's art in his friend's collection, along with *Ship and Dock, Venice* (Cat. 3).

Dated 1879, this painting probably depicts a site along the Hudson River near Tenth Street, where Twachtman created similar views of oyster boats and warehouses (see Figs. 33, 36). Painting the scene from water level, he worked his brush vigorously directing our gaze along the diagonal of the receding pier toward a red flag in the distance. Here the varied shapes of warehouses, figures at work, a tugboat smoking as it approaches the harbor, and the forms of furnaces, scaffolds, cranes, and debris evoke the bustling energy of New York City in an age of dramatic industrial growth.

In his New York scenes such as *End of the Pier*, Twachtman had begun to rein in the offhandedness of his Munich style. This change in his style was observed by William C. Brownell, who stated in 1880 that his images, including one of New York harbor (see Fig. 33), demonstrated his gain "in restraint and consequently in effectiveness." Brownell observed: "he sees things very directly and feels them very strongly, and furthermore very pictorially, noting their relations as well as themselves, and bringing out their picturesqueness with a good deal of sympathetic perception."[1] Indeed, in general, Twachtman's application of a Realist approach to New York scenes was welcomed by critics of his time, who felt that for American art to be strong, it was necessary for artists of the day to paint the actualities of the world around them, rather than depicting the sort of idealized views of pastoral and wilderness scenery popularized earlier by the Hudson River School.

1. William C. Brownell, "The Younger Painters of America," *Scribner's Monthly* 20 (July 1880), p. 334.

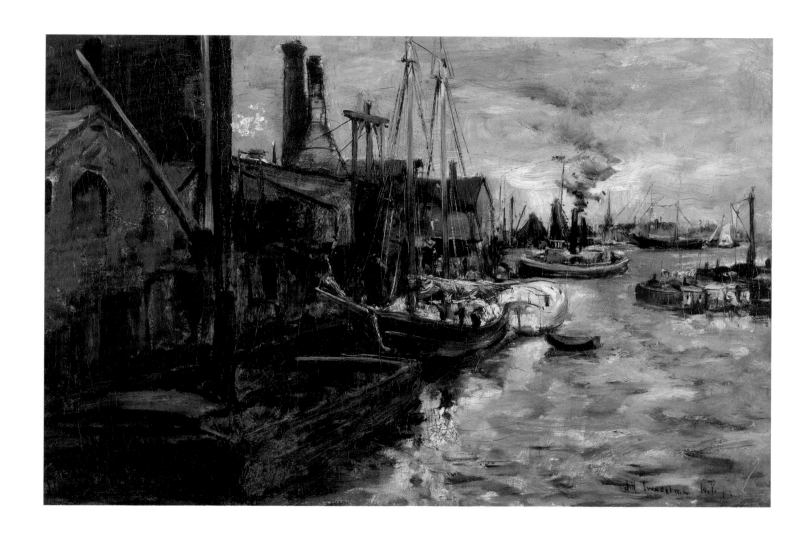

Dredging the Harbor ca. 1879

Oil on canvas
12 × 18 inches
Signed lower right: *J. H. Twachtman*
Private Collection

PROVENANCE

(Kleeman Galleries, New York, ca. 1920s); Chester J. Robertson, Pelham Manor, New York; by descent through the family, ca. 1927–82; to (Hirschl & Adler Galleries, New York); to (Christie's, New York, June 1, 1987, lot 117); to present coll., 1987.

EXHIBITED

Museum of the Borough of Brooklyn at Brooklyn College, New York, *"Crossing Brooklyn Ferry"—The River and Bridge*, April 12-May 10, 1983 (as *Dredging in the East River*).
Memorial Art Gallery of the University of Rochester, New York, *Impressionist New York* (as *Dredging in the East River*) (traveling exh.,1994–95).

REFERENCES

"Dredging in New York Harbor," *Harper's Weekly* 26 (June 10, 1882), p. 365 ill. (as wood engraving by Porin).
Hale, *Life and Creative Development*, 1957, vol. 2, p. 547 (catalogue A, no. 149, as *Dredging in the East River*).
John Grafton, *New York in the Nineteenth Century* (New York: Dover Press, 1977), p. 242 ill. of Porin wood engraving from *Harper's Weekly*, 1882.
Ulrich W. Hiesinger, *Impressionism in America: The Ten American Painters* (Munich: Prestel-Verlag, 1991), p. 75 ill. (as *Dredging in the East River*).
William H. Gerdts, *Impressionist New York* (New York: Abbeville, 1994), pp. 150–51 ill. (as *Dredging in the East River*).
Peters, *John Twachtman (1853–1902) and the American Scene*, 1995, vol. 1, pp. xvi, 84; vol. 2, p. 623 ill. (Fig. 68).
Peters, *John Henry Twachtman: An American Impressionist*, 1999, pp. 35 ill., 36, 40.

THIS PAINTING was reproduced in a wood engraving that was used as an illustration in *Harper's Weekly* in June 1882 with the caption "Dredging the Harbor." Despite this date, it seems most likely that Twachtman rendered the image three years earlier, when he was living in New York and painting similar scenes of the city's harbor, rather than while he was residing in Cincinnati in 1881–82. The painting was known under the title *Dredging in the East River* when it was at Kleeman Galleries in New York, probably in the 1920s. Although dredging certainly took place in the East River, especially near Hell Gate, it is just as possible that the subject is the Hudson River near Tenth Street, which was the focus of Twachtman's attention in his 1879 harbor scenes (see Cat. 6 and Figs. 33, 36).

The article accompanying the illustration of *Dredging the Harbor* focused on "a battered old man with a grizzly beard," a treasure hunter who "sat at the edge of a dredging scow," his legs dangling over the edge and smoking "a worn cob pipe with great gravity and satisfaction as he kicked his heels in the sunshine and talked with a drawl."

Twachtman's depiction does not follow this description precisely, but the scow's bucket has salvaged the sorts of miscellaneous ship parts and debris from the water that interested the speculator described in the article. In the painting, a figure standing on the edge of the vessel's deck has dropped a line into the river, perhaps attempting to snare a prize from the depths; other figures on a nearby raft are similarly engaged in dredging or fishing.

Twachtman captured the dynamism of his subject matter by choosing a vantage point directly below the dredge, so that the vessel fills the picture plane and seems to move toward us, mud spewing from its bucket in the immediate foreground. Through and around the arm and bucket of the dredge, harbor craft of many types—from simple rowboats to oceangoing steamboats—may be glimpsed, suggesting the variety and vitality of this chaotic waterfront. Across the top of the dredge's cabin, its name, *America*, is clearly articulated, adding a symbolic and national element to the work.

That Twachtman was inspired by the energy of New York is suggested in a comment made by his fellow Tile Club member William MacKay Laffan, who wrote of approaching an artist who was painting on the New York waterfront (presumably Twachtman) and asking him if his picture was of "the entrance to the Grand Canal." Laffan recalled that the artist's reply was, "'Bosh! Venice never saw the day when it could present such a thing as that.'"[1] Other critics of the time bemoaned the fact that American artists shunned native subjects for European ones, and one cited James McNeill Whistler's views of "old warehouses and wharves on the Thames" and "bits about Wapping and the lower river" as exemplary, remarking that Whistler "would have found just as good material in the water front of this city."[2] Twachtman was one of the only American artists of his time to embrace the aesthetic possibilities of this subject matter. It would not be until the art of the Ashcan School in the early twentieth century that the portrayal of New York's harbors would again be addressed in such a forthright fashion.[3]

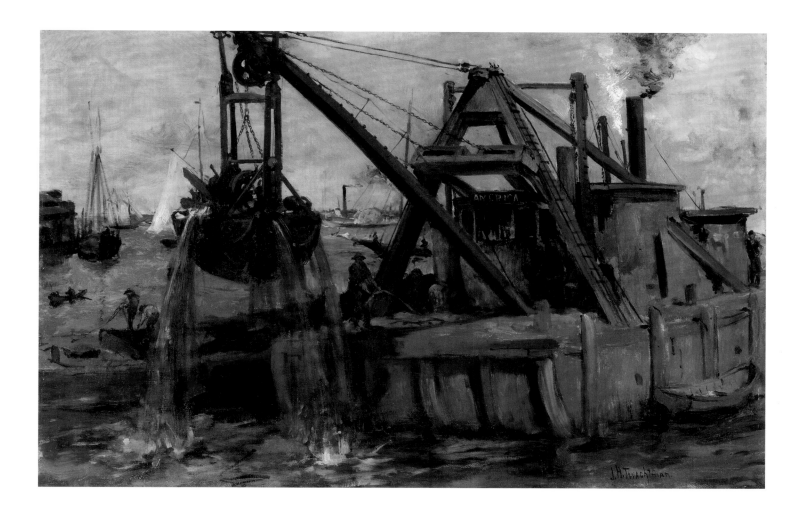

1. William MacKay Laffan, "The Material of the American Landscape," *American Art Review* 1 (July 1880), p. 32.

2. "The Society of American Artists," *New York Sun*, March 23, 1879, p. 2. This critic observed that when Arthur Quartley had exhibited a view of New York harbor at an exhibition in France, he had been "amazed" when the French critics "actually discovered real sentiment in it, and what appeared to be a true poetic quality in its general motive and treatment." The critic went on to note that, Quartley had "painted his ferryboats and ships and steeples and towers in the deepest humility and with a sort of resentful apology, because the result couldn't be given a Brittany name."

3. For a discussion of New York harbor views of Twachtman's era and those of the early twentieth century, see Gerdts, "The Waterfront and the Bridges," *Impressionist New York*, 1995, pp. 149–79.

8.

Coney Island: From Brighton Pier ca. 1879–80

Oil on canvas
14 × 24 inches
Signed lower left: *J. H. Twachtman*
Private Collection

PROVENANCE

F. W. Clarke; (Brooks Reed Gallery, Boston); to Charles Van Cise Wheeler, Washington, D.C., 1916; to (American Art Association—Anderson Galleries, New York, November 1, 1935, lot 14, as *Atlantic City*); to (Mr. and Mrs. David B. Findlay, New York, 1935); by descent in the family to the present.

EXHIBITED

1949 Milch Galleries, no. 3 (as *Atlantic City*, lent by a private collector).
1968 Ira Spanierman, no. 3 (as *Atlantic City*).

REFERENCES

William Bishop, "To Coney Island," *Scribner's Monthly* 20 (July 1880), p. 364 (illustrated as *From Brighton Pier*, in wood engraving by Evans).
Clark, "Art of John Twachtman," 1921, p. lxxviii.
Charles Van Cise Wheeler, *Sketches* (Washington, D.C.: privately printed, 1927), p. 113 (as *Atlantic City* by J. W. [*sic*] Twachtman).
Reed, "Twachtman's Sensitive Poetry," 1949, p. 17 (as *Atlantic City*).
Hale, *Life and Creative Development*, 1957, vol. 1, pp. 300–1 ill. (Fig. 66); vol. 2, pp. 441 (catalogue G, no. 132, as *Coney Island*), 539 (catalogue A, as *Atlantic City*).

Fig. 68
Twachtman, *Dunes, Back of Coney Island*, ca. 1879–80, oil on canvas, 13¾ × 20 inches, Frye Art Museum, Seattle, Washington.

THIS PAINTING was one of three works by Twachtman that were illustrated as wood engravings in an article by William Bishop entitled "To Coney Island" that appeared in *Scribner's Monthly* in July 1880. The article focused on the many available routes for traveling to the increasingly popular pleasure park on the Brooklyn shore. The article's caption for this image was "From Brighton Pier," indicating that the scene may be identified as a view from somewhere along the one-hundred-foot-long Iron Pier in West Brighton, constructed in 1878–79, a landing for steamboats traveling to and from Manhattan.

Twachtman created many of his illustrations from photographs, and this painting may not be an exception. Yet, whereas he did not always have firsthand experience of locales reproduced in many of his illustrations—such as the Trans-Siberian Railroad and the coast of Carmel, California—he could easily have visited Coney Island while living in New York in 1879.[1] Indeed, this work has an interesting relationship to one of the other images he created for the article. Captioned "Under the Iron Pier," it portrays a view from beneath the very site from which he rendered the present scene. The painting once associated with "Under the Iron Pier," known to have belonged to William T. Evans in 1911, is unfortunately unlocated, but for his other image of Coney Island included in the article (Fig. 68), Twachtman painted mostly in the grisaille manner typical of most of his other works that became the basis for illustrations, for which he seems to have used photographs or other secondary materials as sources.

In *Coney Island: From Brighton Pier*, Twachtman's angle is probably eastward along the beach, perhaps toward the Sea Beach Palace Hotel, set on the West Brighton beach and decorated with flags (as also were most of Coney Island's other hotels). Looking across a wide expanse of water washing over the beach, probably at high tide, Twachtman captured the opalescent glow of the water's surface, its light tones echoing the colors in the buildings and flags, while the tiny dots of figures, the flickering flags, and the pointed towers set at rhythmic intervals along the shore enliven the scene. The sense of light-heartedness and pleasure that exude from this work evoke the spirit of its subject.

Rendered a few years before the completion of the Brooklyn Bridge made Coney Island fully accessible to the masses, Twachtman's images capture a place that was still largely natural, its

dunes and waterfront not yet subsumed into a
fully humanized landscape of thrills and crowds.

Although Eliot Clark mentioned this work as
Coney Island in 1921, describing its "unusually
effective spacing,"[2] inexplicably this painting
began to be called *Atlantic City* by 1927, when the
businessman Charles Van Cise Wheeler (who had
bought it in 1916) reproduced it with this title in
Sketches, a book he published himself, in which
he wrote about artists and featured works in his
own collection. The painting retained this title
until recently.

1. For details on Twachtman's illustrations, see Peters,
John Twachtman (1853–1902) and the American Scene,
1995, vol. 1, appendix 3, pp. 560–67.
2. Clark, "Art of John Twachtman," 1921, p. lxxviii.

9.

Landscape, Tuscany ca. 1880

Oil on canvas
16⅝ × 25¾ inches
Signed lower left: *J. H. T.*
Spanierman Gallery, LLC, New York

PROVENANCE

William Rutherford Mead, New York; bequest to Mead Art Museum, Amherst College, Massachusetts, 1936; to (Berry-Hill Galleries, New York, 1973); Robert P. Coggins, by 1977; (Berry-Hill Galleries); to private collection, 1979; to present coll., 2006.

EXHIBITED

Memorial Art Gallery, University of Rochester, New York, *Selections from the Robert P. Coggins Collection of American Paintings*, February 25–April 10, 1977 (traveled to High Museum of Art, December 3, 1976–January 16, 1977; Herbert F. Johnson Museum of Art, Cornell University, Ithaca, New York, May 4–June 12, 1977).

REFERENCE

Hale, *Life and Creative Development*, 1957, vol. 2, p. 557 (catalogue A, no. 331).

Iɴ ᴛʜᴇ fall of 1880 Twachtman left Cincinnati—where he had been teaching and working—for Florence, accepting an invitation from his old friend Frank Duveneck to teach in the school that Duveneck had started there the previous fall.[1] Reunited with friends from Cincinnati, Munich, and Polling,[2] Twachtman joined the lively gatherings of the artists that were fictionalized by William Dean Howells as the "Inglehart boys" in his novel *Indian Summer* (1886).[3]

Twachtman's instructional activities seem to have been limited to offering occasional criticism and using his "very sharp tongue and a keen sense of humor" to drive "home admonitions," as Oliver Dennett Grover recalled.[4] The emphasis of the students' work was figural rendering, but Twachtman, who had his own studio, continued to focus on landscape painting, portraying the hills of the city near Fiesole and perhaps working near the villa of the American sculptor Thomas Ball on the Porta Romana, which Julius Rolshoven mentioned was "a veritable home for all the artists."[5]

The rusts and browns in the landscape suggest that it was painted in the fall, indicating that Twachtman may have executed it shortly after his arrival in Florence. In the painting, he captured the feeling of this ideal time of year for wandering through the Tuscan hills. In the lower right, a figure wearing a red cap involves us in the scene, drawing our gaze upward along the gradual curve of the path through this cultivated countryside and toward the long horizontals of the red-roofed villas set on hillcrest terraces. These forms are echoed in the format of the canvas, creating a sense of harmony evoked by the imagery and the arrangement. Here Twachtman tempered his Munich handling in this scene in favor of a more versatile and nuanced approach that, while suggesting the influence of the French Barbizon School on his art, also reflects his delighted response to his subject matter.

The first known owner of this painting was the noted architect William Rutherford Mead (1846–1928), who became a member of the firm of McKim, Mead, and White in 1879, a time when his associate Stanford White and Twachtman were both members of the Tile Club. Mead may have been drawn to this painting owing to his study of architecture in Florence in 1871–72. The painting was part of Mead's bequest to the Mead Art Museum at his alma mater, Amherst College, which deaccessioned it in 1973.

1. In a letter to Weir of September 5, 1880, Twachtman wrote: "About a month ago Duveneck wrote me from Italy and offers me certain inducements to join him at Florence where he has sort of a private school and in which I am to teach. You will see me as I intend to sail on the second of October from N.Y." Twachtman, Cincinnati, to J. Alden Weir, September 5, 1880, Weir Family Papers, MSS 41, Harold B. Lee Library, Archives and Manuscripts, Brigham Young University, Provo, Utah.

2. The artists studying in Florence included John White Alexander, Otto Bacher, Charles Corwin, Joseph DeCamp, George Hopkins, Charles Mills, Louis Ritter, Julius Rolshoven, Ross Turner, and Theodore Wendel.

3. William Dean Howells, *Indian Summer* (1886; reprint, New York: Fromm International, 1985), p. 84.

4. Oliver Dennett Grover, "Duveneck and His School," typescript of lecture delivered to Woodlawn Woman's Club, New York, January 18, 1915, pp. 13–14.

5. Julius Rolshoven Memoirs, p. 72, Heerman Papers, Collection of Bruce Weber.

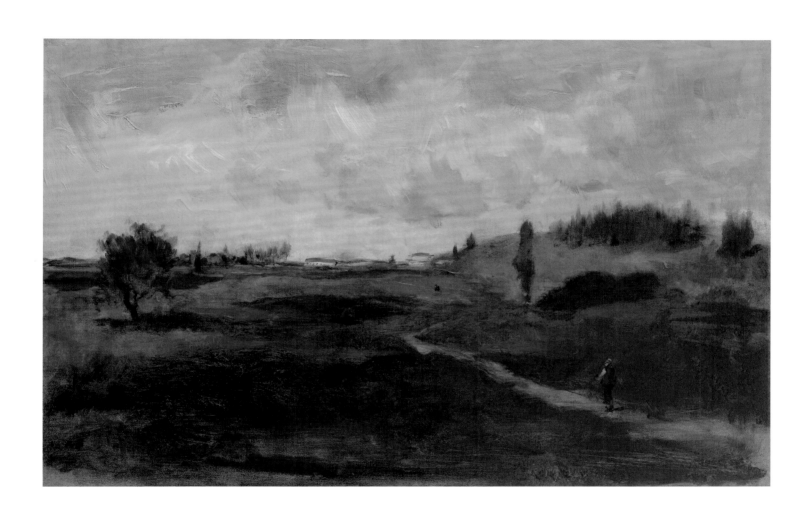

10.

Windmill in the Dutch Countryside ca. 1881

Oil on canvas
10¾ × 15¾ inches
Spanierman Gallery, LLC, New York

PROVENANCE

The artist; to John Ferguson Weir, ca. 1881; by descent in the family; to
(Christie's, New York, May 19, 2005, lot 56); to present coll., 2005.

EXHIBITED

(Probably) New Haven Paint and Clay Club, Connecticut, *Seventh Annual Exhibition*,
 March 21–April 13, 1907, no. 128a (as *Dordrecht, Holland*, loaned by Prof. J. F. Weir).

MARRIED IN Cincinnati on April 22, 1881, John Twachtman and his new wife, the Cincinnati artist Martha Scudder, spent most of their honeymoon that summer in Holland. Based in Dordrecht, they created paintings and etchings (see Cat. 74) while exploring an area of small, picturesque river towns so popular with visiting artists that it became known as the "Southern Sketching Grounds."

In August the couple was joined by J. Alden Weir and his half brother John Ferguson Weir. Writing home to his family, the latter pronounced: "We are in Holland! One can smell the salt air … a grassy slope is like an emerald; and all in low tone, the sky falling to a low horizon, the clouds scudding in flying skies."[1]

John Weir described "passing through several villages, whose picturesque tiled roofs look so beautiful in the landscape," a journey he is likely to have made with Twachtman. It was to Weir that Twachtman gave this painting, probably in the recognition that it typified the landscape that they enjoyed together. Using a palette devoid of the browns and blacks of his Munich art, Twachtman captured the landscape's warm yet diffused atmosphere, described by Weir as "almost palpable to the eye as it might be to the sense of touch," the "emerald" color of the ground, and the seemingly integral role of the windmill in the topography. His offcenter placement of this form creates a sense of informality and immediacy, suggestive of his pleasure in sharing with Weir what the latter described as "the most lovely landscape imaginable."[2]

This painting may have been among those that Twachtman showed during his time in Holland to the noted Hague School painter Anton Mauve, who offered him encouragement.[3] Along with other works that Twachtman created in Holland in 1881, *Windmill in the Dutch Countryside* is close to

examples by such Hague School artists as J. H. Weissenbruch, Jacob Maris, and Peter Gabriël.

Twachtman stayed in close touch with John Weir over the years, and communicated with him often during the period when his eldest son Alden studied under Weir at the Yale University School of Art, from 1897 through 1900. This painting is likely may have been the work that Weir lent to the New Haven Paint and Clay Club's seventh annual exhibition in 1907 as *Dordrecht, Holland*. It remained in the family of Weir until 2005.

1. John Ferguson Weir, "Typescript from John F. Weir's Memories," undated, J. Alden Weir Papers, Archives of American Art, Smithsonian Institution, Washington, D.C., roll 71, frame 1090.
2. Ibid.
3. Clark wrote that, in Holland, "Twachtman met Anton Mauve and was much pleased with the encouraging criticism of his work," and Twachtman's son Alden confirmed that the meeting had occurred. Clark, *John Twachtman*, 1924, p. 23, and Hale, *Life and Creative Development*, 1957, vol. 1., p. 45n.

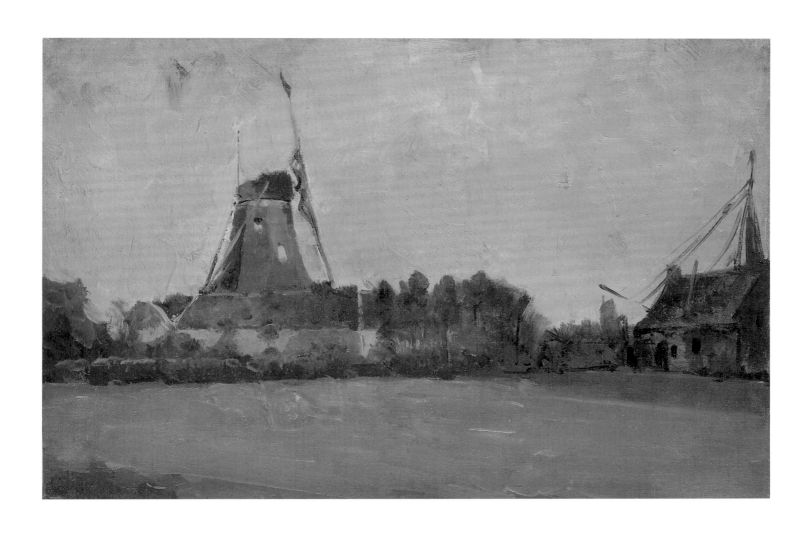

11.

Venice 1881

Watercolor on paper
13⅛ × 11 inches
Signed and dated lower right: *J. H. Twachtman / 1881*
Private Collection

PROVENANCE

The artist; to James Smith Inglis; to (American Art Galleries, New York, *The James S. Inglis Collection*, March 10, 1910, lot 58, as *Venice*); to Adolph Lewisohn, New York; (Milch Galleries, New York); (Victor D. Spark, New York); to present coll., 1961.

EXHIBITED

(probably) American Water Color Society, New York, *Fifteenth Annual*, January 23–February 25, 1882, no. 84 (as *San Giorgio, Venice*).

REFERENCE

(probably) Hale, *Life and Creative Development*, 1957, vol. 2, pp. 520 (catalogue G, no. 829, as *Venice*); (catalogue G, no. 830, as *San Giorgio, Venice*); (possibly) 521 (catalogue G, no. 832, as *Watercolor*).

ATED 1881, this watercolor was created by Twachtman at the end of his honeymoon, in the fall or early winter of the year, when he and his new wife, Martha, traveled to Venice, after slowly making their way south from Holland. There their arrival was recorded by Twachtman's former Over-the-Rhine neighbor Robert Blum, and Twachtman joined Blum, as well as Otto Bacher and Frank Duveneck, who were also in the city, on painting expeditions within Venice and to the island of Chioggia.[1]

Twachtman took a spontaneous approach in this work, using translucent washes in the sky and water and noting the different features of the boats, one in the left distance with its open sail coasting along while it catches a light breeze and the other at anchor in the right middleground, with its canopy rigged between masts.[2] However, it seems that this work was at least partly a product of the studio, as the artist appears to have conflated two scenes observed from opposing vantage points. While our view is toward San Giorgio, as seen from the Riva degli Schiavoni, Twachtman also included Santa Maria della Salute and its long wall, not visible from this vantage point, in the left background.

Probably Twachtman painted San Giorgio first, perhaps from a boat, but then added the Salute to offset the roseate tones of the buildings against the sparkling blue surface of the water. This was exactly the blend of colors that the novelist Henry James found resonant while sojourning in Venice in 1881, a time when he lived in an apartment on the Riva that overlooked San Giorgio, from which,

he remarked, "you see a little of everything Venetian." His account of Venice from this visit was published in *Century Magazine* in November of 1882 along with illustrations by Blum, among other artists. James wrote:

> Straight across, before my windows, rose the great pink mass of San Giorgio Maggiore, which has for an ugly Palladian church a success beyond all reason. I know not whether it is because San Giorgio is so grandly conspicuous, with a great deal of worn faded-looking brick-work; but for many persons the whole place has a suffusion of rosiness. Asked what may be the leading colour in the Venetian concert, we should inveterately say Pink.... It is a faint, shimmering, airy, watery pink; the bright sea-light seems flush with it and the pale whitish-green of the lagoon and canal to drink it.[3]

Although there is no record indicating that Twachtman and James were acquainted, it does not seem improbable that they met, enabling the writer and artist to share their similar pleasure in the light of Venice.

It is highly likely that this watercolor was the work that Twachtman exhibited at the American Water Color Society in March of 1882 with the title of *San Giorgio, Venice*. The work's price of $50 was noted in the exhibition's catalogue.

This watercolor's first known owner was the Scottish artist James Smith Inglis (1852–1907), who managed the prominent New York gallery of Cottier and Company. Perhaps he purchased it from the 1882 exhibition. The work was included in the sale of art from Inglis's collection in 1910, from which it was acquired by the New York philanthropist Adolph Lewisohn, who also owned *Venice* (Cat. 2). Only eleven other watercolors by Twachtman are known (see Cat. 19).

1. See Bruce Weber, *Robert Frederick Blum (1857–1903) and His Milieu*, 2 vols. Ph.D. dissertation, City University of New York, 1985 (Ann Arbor, Mich.: University Microfilms International, 1985), p. 141f.

2. Thanks are due to John Nelson for his observations of the nautical forms in this scene.

3. Henry James, "Venice," *Century Magazine* 25 (November 1882), p. 12. This essay was reprinted in James's *Italian Hours* of 1909 (London: Century, 1986), p. 12.

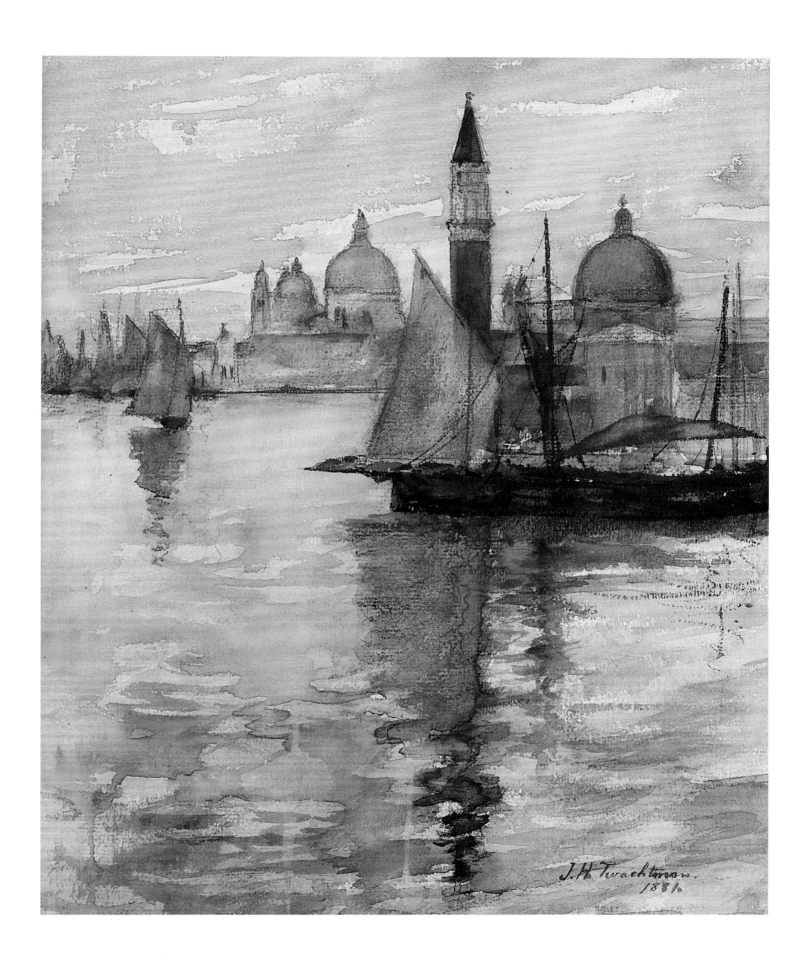

J.H. Twachtman.
1881.

Dark Trees, Cincinnati 1882

Oil on canvas
32 × 48 inches
Signed and dated lower left: *J. H. Twachtman 1882*
Collection of Mr. and Mrs. Stephen G. Vollmer

PROVENANCE

Martha Twachtman, the artist's wife, Greenwich, Connecticut; by descent to her son and his wife, Mr. and Mrs. Godfrey Twachtman, Independence, Missouri; to (Maynard Walker, New York, by 1967); (M. Knoedler & Co., New York, by 1969); to Mr. and Mrs. Richard Case, Baltimore, ca. 1969; to the estate of Mrs. Richard Case, Baltimore; to (Adelson Gallery, New York); to present coll., 2004.

EXHIBITED

1966 Cincinnati Art Museum, no. 18 (lent by Mr. and Mrs. Godfrey Twachtman).
Maynard Walker Gallery, New York, *Collectors' Finds*, February 20–March 11, 1967.
M. Knoedler & Co., New York, *American Paintings, 1750–1950*, May 20–June 20, 1969, no. 73.

REFERENCES

Hale, *Life and Creative Development*, 1957, vol. 2, p. 574 (catalogue A, no. 633).
Mahonri Sharp Young, "Letter from the USA: Fantastics and Eccentrics," *Apollo* 85–86 (June 1967), p. 466 ill.
Peters, *John Twachtman (1853–1902) and the American Scene*, 1995, vol. 1, pp. xxi, 161; vol. 2, p. 694 ill. (Fig. 155).

Most of the paintings Twachtman created while living in Cincinnati from 1880 through 1882 appear to be plein-air views in which he continued to use the bravura style typical of his Munich period. By contrast, for this painting as well as for *Landscape near Cincinnati* (ca. 1882; oil on canvas, 34¾ × 46 inches, Munson-Williams-Proctor Institute, Utica, New York), he chose to work on unusually large canvases and to create scenes in which he balanced Realism with idealized conceptions of nature.

With this view of a rural landscape, Twachtman created a symmetrical and carefully ordered design. While using a limited palette of greens, he was attentive to different values, setting the dark trees into relief against the warmer tones in the landscape. He conveyed a sense of the grandeur of these old trees, comparing the large tree on the far left, weighed down with heavy leaves, with a tree on the far right, its boughs of full, but softer leafage silhouetted against the gray-white sky. A path that runs horizontally through the break between the hills opens in a clearing directly in the center of the work. Here red wildflowers add a natural accent to the landscape, providing a point of orientation for the viewer from which we are led gradually upward through the rhythmic movement of interwoven green forms. Strato-cumulus clouds move in overhead, as if to provide shelter for this graceful and harmonious landscape.

Evoking classical ideals, Twachtman's structured arrangement in this painting was clearly purposeful, perhaps reflecting his desire to find a sense of permanence in a place that would soon change forever, as a wave of suburban development swept across Cincinnati's hills.

This culminating work of Twachtman's Munich period remained in the family of the artist until the 1960s. It was last exhibited in 1969 at M. Knoedler and Company in New York, and has remained inaccessible to the public since that time.

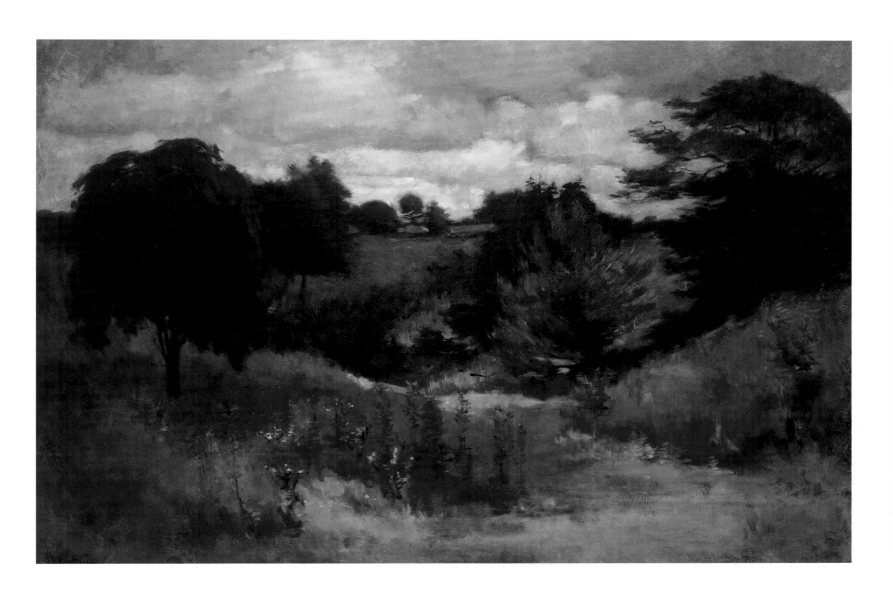

13.

Gray Day 1882

Oil on canvas
22¼ × 28 inches
Signed and dated lower right: *J. H. Twachtman–1882–*
Spanierman Gallery, LLC, New York

PROVENANCE

(Babcock Galleries, New York, by 1930–ca. 1942); private collection, Massachusetts;
to (Macbeth Gallery, New York); to (Parke-Bernet, New York, February 6–7, 1948, lot 81);
to Vera Boggs, Washington, D.C., until 1960; bequest to American News Women's Club,
Washington, D.C.; to (Richard York Gallery, New York, by 1986); to private collection,
Dallas, Texas, 1992; to (Richard York Gallery); to private collection, 1992; to present
coll., 2006.

EXHIBITED

Babcock Galleries, New York, *Paintings, Water Colors, Etchings by American Artists*,
 Summer 1930, no. 3.
Babcock Galleries, New York, *Paintings, Water Colors, Etchings by American Artists*,
 Summer 1931, no. 42.
Babcock Galleries, New York, *Paintings by American Masters*, March 1936, no. 13.
1942 Babcock Galleries, no. 3.

REFERENCES

Hale, *Life and Creative Development*, 1957, vol. 2, p. 452 (catalogue G, no. 224).
Peters, *John Twachtman (1853–1902) and the American Scene*, 1995, vol. 1, p. 164;
 vol. 2, p. 701 ill. (Fig. 162).

IN *Gray Day*, dated 1882, Twachtman depicted a quiet rural scene probably near Avondale in which our eye is drawn upward over a cleared hillside framed by trees to a small farmhouse. The sky is filled with heavy clouds that warn of a coming snowfall. Twachtman used an unusual method to paint this work, reflective of a time when he was seeking to liberate himself from the rough, slap-dash manner characteristic of the Munich School and searching for new expressive avenues. Here to convey a sense of palpability, in the landscape he applied an active layer of glossy paint onto the canvas that he then abraded, producing a textural surface effect against which the delicate silvery lines of bare trees seem to stand out in the space. He painted the sky with a more varied brush handling, leaving his strokes and the blue underlayer visible, thereby creating a sense of depth. The result is to make this serene scene appear filled with a sense of inner life.

It seems highly likely that this painting was the work that Twachtman exhibited as *Silver Poplars* at the sixth annual of the Society of American Artists, held in the spring of 1883. A review of the show in the *New York Sun* observed that the painting's "subject is a green field at the back of an ordinary farm house in early spring. There is a row of leafless poplars to the left and another to the right. The sky is filled with a mist of fine drifting snow, not formed into flakes and overhead the white snow clouds, all on a slant, are hurrying by."[1]

Critics of the show were drawn to the painting and debated its novel qualities. Some, such as a writer for the *Nation*, were perplexed by *Silver Poplars*, describing it as "mostly a flat space of dull green paint, with some dirty gray rarified brush lines drawn through it and a space of ungraduated leaden gray above for a sky."[2] The reviewer for the *New York Daily Tribune* felt that the work represented a superficial type of art that neglected thought and only tickled "fancy by the form."[3] By contrast, other critics felt that Twachtman's treatment, while original, was successful in capturing the essence of his subject. One, writing for the *Sun* observed that the painting was "more interesting than any other landscape in the room because it fixes for some years at least on the canvas a very transient and very beautiful natural effect which has not, to our knowledge previously been attempted."[4] Mariana Van Rensselaer remarked that the work was "very broad in treatment and low in tone," and noted that it demonstrated an "individuality," which she felt was reflected in "its poetry of sentiment, its harmony of color and tone."[5]

This painting was first recorded as *Gray Day* when it was exhibited at Babcock Galleries in 1930. The painting remained there until 1942, when it was included in the solo exhibition of Twachtman's art held at the gallery in February, in which *Venice* (Cat. 2), *The Cascade* (Cat. 57), and *Upland Pastures* (then known as *November Haze*) (Cat. 45) were also included.

1. "Art Exhibitions: The Society of American Artists," *New York Sun*, March 25, 1883, p. 5.
2. "The Sixth Annual Exhibition of the Society of American Artists," *Nation*, April 12, 1883, p. 327.
3. "The Society of American Artists: Sixth Annual Exhibition," *New York Daily Tribune*, March 25, 1883, p. 5.
4. Ibid.
5. Mariana G. Van Rensselaer, "Spring Exhibitions in New York—II," *American Architect and Building News* 3 (May 12, 1883), p. 221.

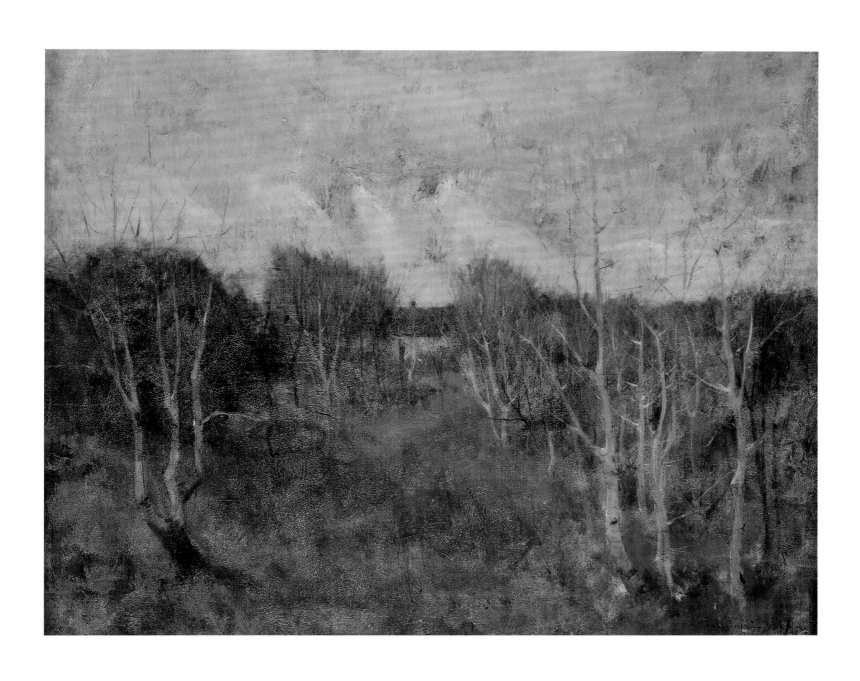

14.

An Early Winter ca. 1883

Oil on canvas
17 × 14 inches
Collection Villa America

PROVENANCE

William J. Baer, Cincinnati; to William T. Evans, New York; to (*Collection of American Painting Formed by the Widely Known Amateur, William T. Evans, Esq., of New York*, Plaza Hotel Ballroom, New York, March 31–April 2, 1913, lot 12); Ralph King; (Macbeth Gallery, New York); private collection, California; by descent through the family; to (Christie's, New York, December 4, 1997, lot 22); to present coll., 1997.

LITERATURE

Hale, *Life and Creative Development*, 1957, vol. 2, p. 512 (catalogue G, no. 735).
Peters, *John Twachtman (1853–1902) and the American Scene*, 1995, vol. 1, p. xxi, 163; vol. 2, p. 696 ill. (Fig. 157).

As was the case for *Dark Trees, Cincinnati* (Cat. 12) and *Gray Day* (Cat. 13), Twachtman probably found his subject for *An Early Winter* in or near the Cincinnati suburb of Avondale, where he lived from the winter of 1882 through the fall of 1883. Most likely, the painting is a product of the winter of 1883, when he had left behind the dark, painterly Realism of his Munich manner in favor of a limited palette of silvery and pale green tones and more fluid, almost imperceptible brushwork.

While his scene evokes a direct experience of a landscape that was being transformed into a suburb—the vertical, rectilinear houses seem to be two-storied dwellings set on small plots of land rather than long, horizontally oriented farmhouses—he gently structured the arrangement to create a sense of harmony between natural and man-made elements. In particular, the calligraphic forms of trees, on which a few leaves remain, mediate between the broad curve of the green ground before us and the forms of the houses in the middle ground, just as the delicate tree branches seem to connect the contours of the buildings.

This painting demonstrates a significant change in Twachtman's aesthetic from the views of Cincinnati he had rendered a year before (Figs. 44–45), suggesting that he had begun to turn away from an emphasis on recording new aspects of modern life in favor of producing peaceful, contemplative images through the use of soft tonal harmonious and gracefully structured arrangements. Twachtman's aesthetic in *An Early Winter* provides a clear indication that he had fully conceived the approach usually associated with his French period before leaving Cincinnati for Paris in the fall of 1883.

The first known owner of this painting was Twachtman's childhood friend and former classmate from Cincinnati's McMicken School of Design, the artist William J. Baer (1860–1941), who became a noted painter of miniatures in the 1890s. Baer either gave or sold this painting to the collector William T. Evans. It is easy to see why this work would have appealed to Evans, whose chairmanship of the art committee at the Lotos Club beginning in 1892 would be crucial to the promotion of just this sort of evanescent, tranquil art under the rubric of Tonalism.

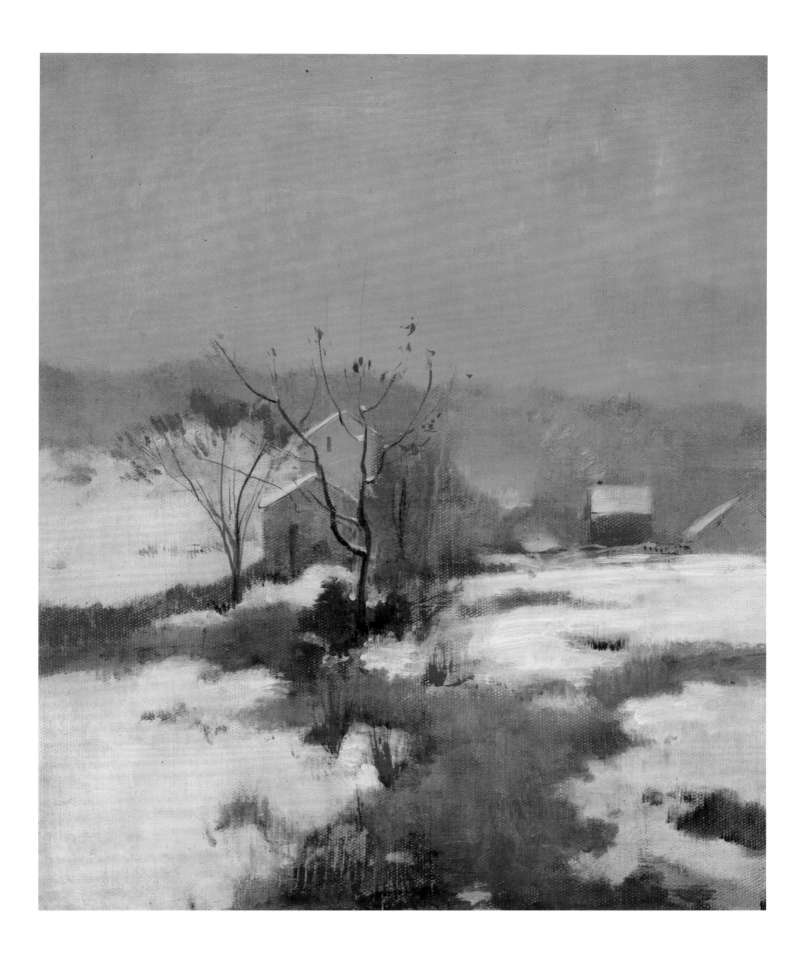

15.

Near Paris ca. 1885

Pastel on paper
7½ × 10¾ inches
Spanierman Gallery, LLC, New York

PROVENANCE

J. Alden Weir; by descent to his daughter G. Page Ely (née Caroline Weir), Old Lyme, Connecticut; by 1945; by descent in the family; to (art market); to present coll., 2002.

EXHIBITED

Lyman Allyn Museum, New London, Connecticut, *Work in Many Media by Men of the Tile Club*, March 11–April 23, 1945, no. 155 (as *Spanish Walls*, 7½ × 11 inches, lent by Mr. and Mrs. G. Page Ely, Old Lyme, Connecticut).

REFERENCE

Hale, *Life and Creative Development*, 1957, vol. 2, p. 591 (catalogue A, no. 1006, as *Near Paris*).

THE REVIVAL in popularity of pastels that had begun among the French Impressionists during the 1870s spread to America in the following decade. Among the leading artists to generate interest in the medium were Twachtman's close friends William Merritt Chase, with whom he had first associated in Munich, and Robert Blum, his childhood companion from Cincinnati. In the early 1880s Chase and Blum initiated the idea for the American Society of Painters in Pastel and organized its first exhibition, held in 1884. In Paris at the time, Twachtman did not participate in this show, but during the following summer he began to explore pastels. His interest in doing so may have been spurred by a pastel exhibition held in Paris in April 1885 that he mentioned visiting in a letter to J. Alden Weir.[1] Chase may also have encouraged him to try pastels when they spent time together in Holland at the end of the summer.[2] That the medium quickly absorbed Twachtman's energy is reflected in his decision to include eight pastels among the twenty-three works in his second solo exhibition, held at J. Eastman Chase's Gallery in Boston in 1886.[3]

In his pastels of 1885, most of which can be identified as scenes of Holland and Venice, Twachtman's method was closely allied to that of his oil paintings at the time. He applied his crayons in a painterly fashion, rubbing smooth, thin layers of gradually modulated color across his surfaces to create harmonious tonal arrangements in the manner of James McNeill Whistler. *Near Paris*, the only known pastel that he is thought to have rendered in France, is among the most spare of his early pastels, demonstrating one of first instances in which he used the Whistlerian technique of incorporating the tone of his paper into his design. The bluish green color in the foreground seems less to cover the surface of the paper than to suggest sparse vegetation rising from dry ground. Twachtman also left his paper exposed to convey the subtle color within the stone facades of Norman homes and their fortifying walls; he added the minimal details of windows and dormers with pale rusts and greens that brought out these undertones within the paper itself. He similarly blended his light blue crayon into the sky to suggest a thin cloud cover. A pastel entitled *The Rosy Morn* that Twachtman exhibited at the Inter-State Industrial Exposition in Chicago in September 1889 may well have been similar to this work. A critic for the *Chicago Tribune* wrote that in it "the effect is good. Houses the color of his paper frankly for the body tone, and dashes on a landscape in a dozen strokes or two."[4]

In contrast to the abrupt arrangement of forms into space in the art of his Munich period, here a swift yet smooth recession of forms along a diagonal reflects the control that Twachtman had gained by studying in Paris. He had written to Weir in December 1883 of how much he needed the lessons in drawing from the figure that he was receiving at the time, because he thought his training in drawing in Munich had been insufficient.[5] In fact, the first known owner of this pastel was Weir. Although it cannot be verified that Twachtman gave this image to Weir, it seems likely that he did so, perhaps as a way of demonstrating that he had achieved the goals that he had set out to accomplish during his European sojourn.

This work was inexplicably exhibited with the title of *Spanish Walls* when it was lent to the Lyman Allyn Museum in 1945 by Weir's eldest daughter Caroline Ely, but it was still in Ely's collection when John Hale catalogued it in his 1957 dissertation with the title *Near Paris*. Indeed, Twachtman is not known to have visited Spain. This work remained in the Weir family until 2001.

1. Twachtman, Paris, to Weir, April 6, 1885, Weir Family Papers, MSS 41, Harold B. Lee Library, Archives and Manuscripts, Brigham Young University, Provo, Utah.

2. Twachtman, Chase, and Walter Launt Palmer (1854–1932) signed the guest book of the Halsmuseum in Haarlem on September 5, 1885. See Annette Stott, "Documentation of American Artists' Activities in Holland from Dutch Archives," in *Holland Mania: The Unknown Dutch Period in American Art and Culture* (Woodstock, N.Y.: Overlook Press, 1998), pp. 267, 273, 276.

3. 1886 J. Eastman Chase's.

4. "Whistler's Audacity . . . Other Works," *Chicago Tribune*, September 29, 1889, p. 32.

5. Twachtman wrote to Weir from Paris on December 7, 1883, Weir Family Papers: "I am studying from the figure, nude, this winter and you know how much I need drawing. I don't know a fellow who came from Munich that knows how to draw or ever learned anything in that place."

16.

Sailing Boats, Dieppe Harbor ca. 1883–85

Oil on panel
13½ × 15½ inches
Signed lower left: *J. H. Twachtmann*; lower right: *J. H. Twachtman*
Collection Villa America

PROVENANCE

(Ortgies and Company, New York, *Paintings in Oil and Pastel by J. A. Weir and J. H. Twachtman*, February 7, 1889, lot 46, as *Harbor of Dieppe*); (Parke-Bernet, New York, January 24, 1973, lot 108, as *Boats at Dieppe*); to (Ira Spanierman Inc., New York, 1973); to (Schweitzer Gallery, New York); private collection, Massachusetts; (Hammer Galleries, New York); to George Albrecht, 1986; to (Sotheby's, New York, May 5, 2002, lot 30); to present coll., 2002.

EXHIBITED

1889 Fifth Avenue Galleries, no. 46 (as *Harbor of Dieppe*, 13½ × 15½ inches).

REFERENCES

"Paintings and Pastels by J. H. Twachtman and J. Alden Weir," *Studio* 4 (February 1889), pp. 43–44 (as *Harbor of Dieppe*).
"Pictures by Messrs. Weir and Twachtman," *New York Daily Tribune*, February 7, 1889, p. 7 (as *Harbor of Dieppe*).
"Weir and Twachtman Pictures." *New York Sun*, February 8, 1889, p. 3 (as *Harbor of Dieppe*).
"The Weir and Twachtman Exhibition," *Art Amateur* 20 (March 1889), p. 75 (as *Harbor of Dieppe*).
Hale, *Life and Creative Development*, 1957, vol. 2, p. 453 (catalogue G, no. 230, as *Harbor of Dieppe*).

Reviews of the exhibition and sale of the works of Twachtman and Weir held at the Fifth Avenue Galleries in New York in early February 1889 provide convincing evidence that *Sailing Boats, Dieppe Harbor* was the work included with the title *Harbor of Dieppe*. Not only do its dimensions match those of the painting listed in the catalogue, but critical commentaries also provide descriptions that accord with the image. The work's subject may also be linked with the cliff-walled waterfront of Dieppe, painted by a diverse range of artists, including Eugène Delacroix, Joseph Mallord Turner, Claude Monet, and, contemporaneously with Twachtman, by the American Stephen Parrish.[1]

Twachtman's *Harbor of Dieppe* was among the works that the reviewers of the 1889 show frequently singled out for praise. For the exhibition's critics, the painting exemplified the way that Twachtman was able to present the facts of his scene at the same time that he organized their forms into aesthetically conceived arrangements. That American critics understood this balancing act is reflected in the comments of a writer for the *New York Daily Tribune*, who, in discussing the "admirable little 'Harbor of Dieppe' at the end of the gallery," noted that "another artist in treating the . . . subject might have labored zealously to realize the water and or bring out the modelling

and even many details of the vessel at anchor, but Mr. Twachtman has omitted nothing of genuine pictorial value, and nothing essential to the general truthfulness of his picture."[2]

The reviewer for the *Studio* noted that "the 'Dieppe'" along with a few of Twachtman's other coastal scenes—including works entitled *Snowbound, Boats on the Maas*, and *The Seine, near Paris*—"were all delightful in tone; the relations between the sky, the shore with its shipping, and the water were perfectly felt." This writer further observed that "along with this faithfulness to the facts of greatest importance—for no amount of truth to detail could atone for the want of this harmony—there was a decorative effect in these pieces that they shared with all work of true artistic value." Again turning to *Harbor at Dieppe*, the writer noted that the painting "gave the same pleasure as looking at a shell of mother-of-pearl; it was comforting to the eye as far as the eye could see it."[3] The reviewer for the *Art Amateur* remarked that the painting showing "a vessel at anchor" along with two other marine subjects, *Snow Bound* and *Bridgeport*, were "good examples of [Twachtman's] peculiar talent."[4]

What these commentators saw in Twachtman's scene of Dieppe is still apparent. Allowing the tone of his reddish panel to show through the surface, he focused on the subtle effect of the atmospheric light within the scene, differentiating the flatter tones in the sky from the reflective quality of the water. This painting exemplifies the way that Twachtman's works often call for us to take a second look at them. While at first we notice only one ship at dock, gradually we become aware that there are two vessels, both of which are moving slowly toward the land in quiet syncopation at the same time, a larger schooner maneuvered by a line on the shore, and a smaller one catching the breeze in a sail at its stern as it heads for a point just beyond the larger ship. The movement within the tranquil landscape suggests the character of a place in which such routinized patterns on the waterfront were so deeply ingrained as to be almost inconspicuous, a great contrast to the chaotic quality of New York City harbors that had drawn Twachtman's attention in the previous decade.

That Twachtman felt this painting was an important one is reflected in his decision to sign it twice, once with the double *n* at the end of his name, which was his common practice during the time he spent in France. The signature at the lower right might have been added by the artist at the time of the 1889 show and sale, as a way of indicating the way that he had chosen to represent

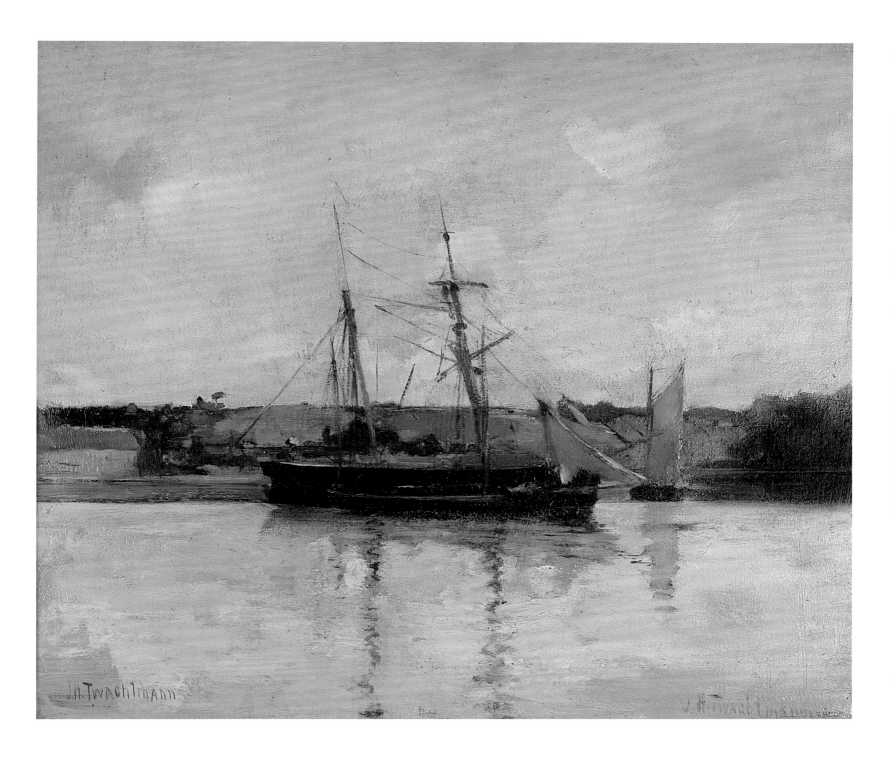

his name by that time (this was how he had chosen to use it for purposes of the catalogue for the show and sale), with only one *n* at the end.

According to a report in the *New York Sun*, *Harbor at Dieppe* sold for eighty dollars from the auction held on February 7, 1889, by Ortgies Gallery at the conclusion of the weeklong exhibition at the Fifth Avenue Galleries.

1. On Parrish, see Rona Schneider, *Stephen Parrish: Rediscovered American Etcher*, exh. cat. (Philadelphia: Woodmere Art Museum, 1999).

2. "Pictures by Messrs. Weir and Twachtman," *New York Daily Tribune*, February 7, 1889, p. 7.

3. "Paintings and Pastels by J. H. Twachtman and J. Alden Weir," *Studio* 9 (February 1889), p. 43.

4. "The Weir and Twachtman Exhibition," *Art Amateur* 20 (March 1889), p. 75.

17.

Scene along a Dutch River ca. 1885

Oil on canvas
9¾ × 14⅛ inches
Private Collection

PROVENANCE

The artist; by descent to his daughter Marjorie Twachtman Pell, New Canaan, Connecticut; by descent in the family to the present.

THE WINDMILL on the horizon at the far left identifies this painting as a scene of Holland, and it is also stylistically consistent with other Dutch views that Twachtman created during the summer of 1885, which he spent mainly in and around Dordrecht. As in works done during his time in France, here the space is deeper than in his Munich period works, for he portrayed the diminutive motifs of boats and buildings at the horizon line. Yet he countered this traditional construction by tilting up the foreground, so that the bank of reed-lined land directly below us bridges the pictorial space in the middle. The empty rowboat tied to a post at the near shore perhaps was used by the artist, who stopped to paint the view. Thus, his presence is suggested both through the image itself and through the immediacy of his perspective.

This painting was given at some point by the artist to his daughter Marjorie, who was born in Paris in June 1884. The painting remains in the family of Marjorie's descendants.

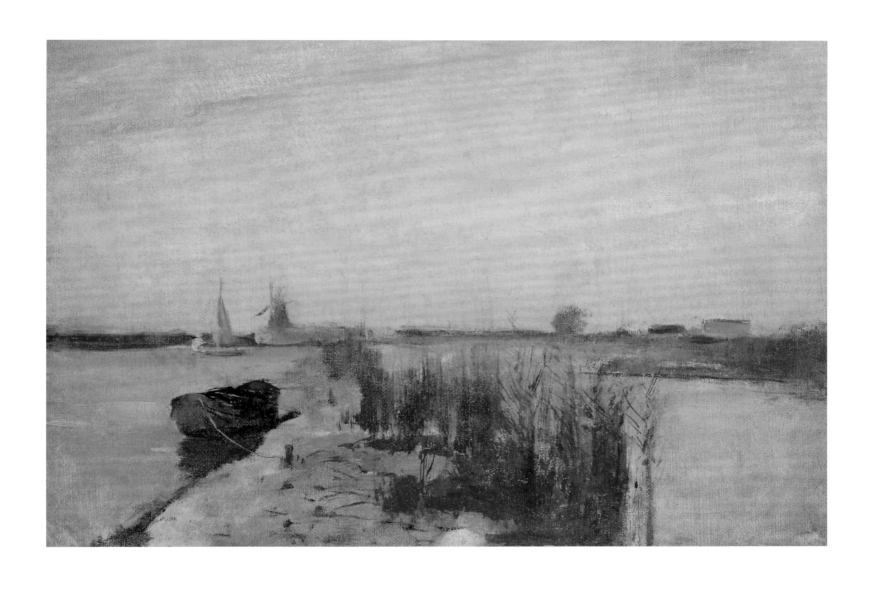

18.

View along a River ca. 1883–85

Oil on canvas
12 × 16 inches
Spanierman Gallery, LLC, New York

PROVENANCE
The artist; to Charles Adams Platt; by descent in the family to present coll., 2006.

TWACHTMAN and the artist, etcher, architect, and landscape designer Charles Adams Platt (1861–1933) were friends, had many friends in common, and crossed paths often.[1] Both began exploring etching in the early 1880s, participating in the same exhibition of the New York Etching Club in 1883. In the winter of 1884 the artists worked together—and similarly struggled with figural rendering—in the Parisian atelier of Gustave Boulanger and Jules Joseph Lefebvre at the Académie Julian. From 1883 through 1885 they each spent time in the Normandy town of Honfleur and the southern Dutch city of Dordrecht; both had a deep admiration for the art of the Hague School.[2] Twachtman and Platt became members of New York's Players Club in 1889. In the years that followed, they fraternized there often with their mutual friends, including the architect Stanford White and the artists Thomas Dewing and Edward Simmons. In 1900 Platt designed an addition for the home of Twachtman's close friend J. Alden Weir.

While it is unknown when Platt received this painting from Twachtman, it is tempting to think that it might have been while the artists were together in Paris. Twachtman's scene includes many of the features that appealed to Platt. The latter favored waterfront over inland subjects and was enamored of the atmospheric, tonal qualities in the overcast skies so common in Hague School art. Both artists thought that a work of art should not be akin to a window onto nature but instead a balanced and harmonious arrangement of forms. In *View along a River* Twachtman kept to this tenet, rendering forms indistinctly so that our attention is drawn to the rhythmic flow of the receding shore and the way that the greens and rusts in the land resonate within the atmosphere that suffuses the sky and water.

The site shown in the work is unknown, although a description in the *Boston Evening Transcript* of a Dordrecht scene entitled *Papendrecht* that Twachtman showed at Chase's Gallery in Boston in January 1886 matches it well.

The critic wrote that "The 'Parkendrecht' [*sic*] is a huge empty space of water and sky, with a line of tree-covered shore stretching out and away into the distance—a strong, bold thing that is entirely true."[3]

In addition to this painting, Platt also once owned Twachtman's *October* (ca. 1901; Chrysler Museum, Norfolk, Virigina), which he purchased about 1910 from Twachtman's wife Martha and lent frequently to exhibitions from 1910 through 1915. *October* was inherited at Platt's death in 1933 by his wife, who sold it through Milch Galleries, New York, about 1937.

1. An analysis of all facets of Platt's career is provided in Keith N. Morgan, *Shaping an American Landscape: The Art and Architecture of Charles A. Platt* (Hanover, N.H.: Hood Museum of Art, Dartmouth College in association with University Press of New England, 1995). In particular, see Erica E. Hirshler, "The Paintings of Charles A. Platt," in ibid., pp. 51–74.
2. Hirshler, "The Paintings of Charles A. Platt," p. 55.
3. "Paintings and Pastels by J. H. Twachtman," *Boston Evening Transcript*, January 23, 1886, p. 6.

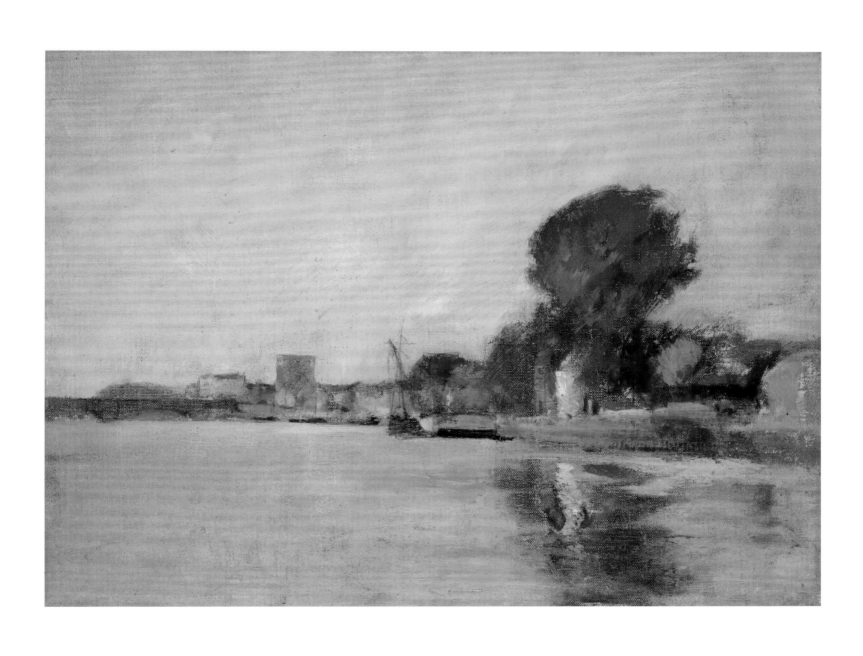

19.

French River Scene ca. 1884

Watercolor and gouache on paper laid down on board
6¾ × 11⅞ inches
Signed lower left: *J. H. Twachtman*
Spanierman Gallery, LLC, New York

PROVENANCE

(Macbeth Gallery, New York, ca. 1939); private collection, Florida; to (R. S. Greenbaum Antiques, Clearwater, Florida, 2001); to private collection, 2004; to present coll., 2006.

T HE DEGREE to which Twachtman used water-color is difficult to gauge, as only twelve of his works in the medium are extant today, and there are only a few recorded instances in which he exhibited watercolors. In 1882 he showed a Dutch watercolor at the Interstate Exposition in Chicago and one Dutch and three Venetian views at the American Watercolor Society, one of which, enti-tled *San Giorgio, Venice*, was probably *Venice* (Cat. 11). He participated in exhibitions of the society again in 1888, 1890, 1893, and 1894 and in shows of the New York Water Color Club in 1893 and 1895. A watercolor entitled *Winter* was one of the five works he sent to the Columbian Exposition in Chicago in 1893.

The subject matter in this watercolor, for which no early exhibition record can be determined, suggests that Twachtman made it while he was in France, studying in Paris and spending summers in the countrysides of Normandy and Holland (see Cats. 15–18 and Figs. 50–52). The tall cypress trees are similar to those portrayed in *Road near Honfleur* (ca. 1884; Art Institute of Chicago), and Twachtman's palette of low-keyed, closely modu-lated tones is characteristic of a time when the influences of the plein-air approach of Jules Bastien-Lepage and the color harmonies of James McNeill Whistler were converging in his art. His use of the medium in this image diverges from that in *Venice*, rendered a few years earlier. Instead of the translucent washes and pure colors of his earlier style, here he employed a dryer tech-nique in which he combined watercolor and gouache and left areas of paper free of color, defining forms through subtle textural and tonal differentiation.

In the lower right, Twachtman portrayed a blue boat angled so as to draw us into the scene and provide a point of reference, drawing our atten-tion to the faint outlines of a barge in the left mid-dle ground—noticeable more by its reflections in the water than by its own form—that is aligned

with the horizontal of an arched bridge just beyond. The open hull of the blue dinghy also directs our eye upward through the verticals of the cypress trees.

Drawing the gaze across the surface rather than into the distance, this work anticipates the art of Twachtman's Greenwich years, while capturing the refreshing feeling of summer in a Normandy village on the water. "What seems at first sight a space of pure and singularly pleasant color," wrote a reviewer of a work in Twachtman's February 1885 exhibition at Chase's Gallery in Boston, "proves to be a study in numberless tints—a fact which explains its qualities of singu-lar pleasure."[1] This statement could readily apply to *French River Scene*.

This work was possibly included as *The Harbour* in an exhibition entitled *American Water Colors: Past and Present*, held at Macbeth Gallery, New York, in 1939.[2]

1. "Art Notes: Mr. Twachtman's Landscapes," *Boston Evening Transcript*, February 17, 1885, p. 2.
2. The work was no. 26 in the show, whose dates were February 7–27, 1939.

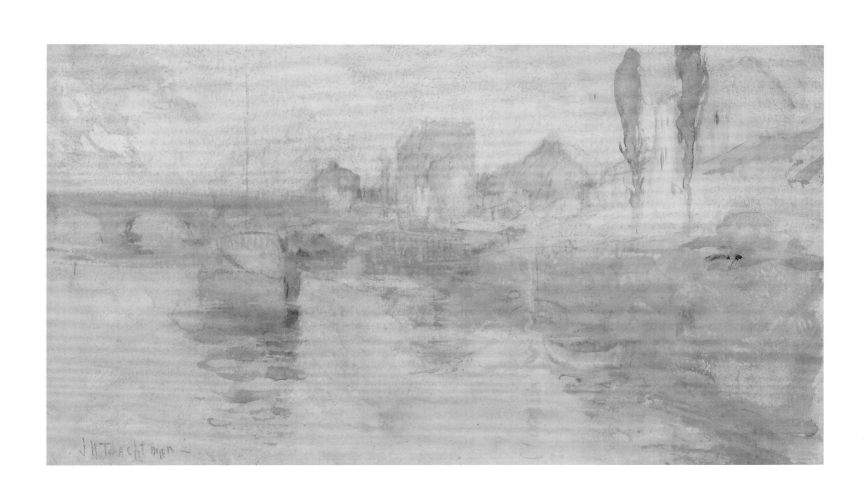

20.

The Quai, Venice ca. 1885

Oil on panel
4⅝ × 7⅛ inches
Signed lower right: *J. H. Twachtman*–
Spanierman Gallery, LLC, New York

PROVENANCE

A. Sommaruga, France; (art market, France); to present coll., 2005.

1. See Peters, *John Twachtman (1853–1902) and the American Scene*, 1995, vol. 1, pp. 205–7; and Bruce Weber, *Robert Frederick Blum (1857–1903) and His Milieu*, Ph.D. dissertation, City University of New York, 1985, 2 vols. (Ann Arbor, Mich.: University Microfilms International, 1986), pp. 278–79.

2. Robert Blum, Venice, to William Merritt Chase, New York, December 26, 1885, Chappellier Gallery Papers, Robert Blum Correspondence, Archives of American Art, Smithsonian Institution, Washington, D.C., roll N68-101, frames 28–29; Twachtman, Venice, to Chase, New York, December 26, 1885, Chappellier Gallery Papers, Robert Blum Correspondence, Archives of American Art, D.C., roll N68-101, frames 9–10. See Peters, *John Twachtman (1853–1902) and the American Scene*, 1995, vol. 1, pp. 206–7.

TWACHTMAN painted this scene from the same spot as *Venetian Sailing Vessel* (Cat. 4), although that work was a product of his 1878 trip to the city, while this painting probably dates from about 1885. In both, the perspective is from Venice's Fondamenta della Zattere just beyond the eighteenth-century Church of the Gesuati looking west. The sketchily rendered white posts at the left in *The Quai, Venice* were and are still today the guardposts on the railing for a bridge over a narrow canal. That *The Quai* dates from Twachtman's 1885 trip to Venice is suggested in the large and separated letters in his signature; earlier, he had usually signed his name in a tighter cursive hand. In addition, while his sketchy brushwork evokes his Munich approach, the succinct treatment of forms and lighter and more atmospheric palette are a departure from his earlier Venetian images.

Twachtman's 1885 trip to Venice was a joyful time. After sending his wife and children home from a Normandy port at the end of the summer, he headed south, concluding his European sojourn with a stay in Venice that lasted from September through December. His arrival in the city occasioned a reunion with several of his old friends. He stayed with Robert Blum in the Palazzo Contarini di Scrigni in the San Trovaso quarter on the Grand Canal[1] and was delighted when Frank Duveneck arrived in December. Other artists with whom Twachtman fraternized during his Venetian sojourn were William Gedney Bunce, George Clements, Oliver Dennett Grover, Ruger Donoho, Walter Launt Palmer, and Charles Ulrich. Twachtman and Blum wrote home to William Merritt Chase in the jovial, bantering tone that characterized the artists' friendships with each other.[2] Duveneck and Blum also created similar sketches of Venetian sites, clearly enjoying working together outdoors.

Until recently this painting was in a collection in France, suggesting that Twachtman may have left it in Europe when he returned to the United States in December 1885 or January 1886.

21.

Winter Landscape with Barn ca. 1885

Oil on canvas
12¼ × 18 inches
Signed lower left: *J. H. Twachtman–*
Private Collection

PROVENANCE

Mrs. Frank A. Scott, Hartford, Connecticut; (Kennedy Galleries, New York);
to present coll., 1973.

Fig. 69
Twachtman, *Along the River, Winter*, ca. 1885, oil on canvas, 15⅛ × 21¹¹⁄₁₆ inches, High Museum of Art, Atlanta, Georgia, J. J. Haverty Collection.

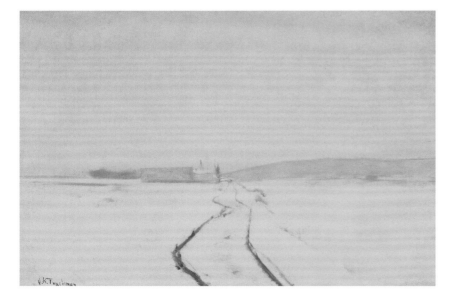

THIS PAINTING is similar in many respects to *Along the River, Winter* (Fig. 69). Both works are approximately the same size, horizontal, nearly all-white images in which a thin band of buildings and land forms are set in the middle ground. In both works Twachtman signed his name with thin black letters that stand out against the snow.

In *Along the River, Winter* the wheel tracks in the snow evoke the feeling of traveling across an empty snow-covered landscape, through which another traveler has recently passed, and moving toward a place of shelter and rest. In this painting, Twachtman's perspective is closer to the forms of human habitation, and the delicately rendered shapes of the gray-blue structures and the low hills are more in focus, their presence accentuated against the lighter silvery whites of the unbroken snow-covered ground and the overcast, atmospheric sky. A quiet feeling is evoked by the diminutive presence of the small farmhouse within the empty space of this still, frozen landscape, yet linked by long horizontals to the land, the farmhouse has a calm, stable presence suggesting that

its solitude is not one of loneliness, but of pleasure in such isolation. Choosing a vantage point from the level of the snow, Twachtman involves us in the work, evoking the sense of anticipation that is felt by the traveler whose destination has just come fully into view.

A recent reading of a review in the *Boston Evening Transcript* of Twachtman's one-man exhibition held in January 1886 at J. Eastman Chase's Gallery in Boston suggests that *Along the River, Winter* may have been included in the show as number 7, with the title *Winter*. The painting listed as *Winter, near Paris*, number 4 in the catalogue, may well have been this painting, as no other images of this type of landscape are known in Twachtman's oeuvre. The *Transcript* critic commented: "The effect of snowy air filling No. 7 is absolutely true, as is also the diffused light in No. 4. The first picture is very simple—a waste of white snow, a wheel track, deeper-rutted, sinuous, stretching away to a group of farm buildings, with low hills in the distance. A man who can paint the phase of atmosphere that is rendered in this picture can do nearly everything. Its very simplicity makes it triumphant."[1]

Although the site shown in this work and in *Along the River, Winter* cannot be pinpointed, it makes sense that Twachtman painted them both in the French countryside in the winter of 1885, during a break from his studies at the Académie Julian. The smooth, even surfaces of the works, in which Twachtman's brushwork is seemingly invisible, the paint seemingly bled into the canvas, and the controlled yet fluid lines used for the buildings, trees, and hills demonstrate the progress Twachtman had made in Paris toward bettering his drawing skills and gaining greater control. Both paintings suggest Twachtman's awareness of the popularity among American artists of white-on-white compositions in the years after James McNeill Whistler exhibited his *Symphony in White, No. 1: The White Girl* (1862; National Gallery of Art, Washington, D.C.) at the Union League Club in New York in 1881.[2]

With the exception of the possibility that this painting was included in Twachtman's 1886 exhibition in Boston, this is the first known instance in which it has been exhibited.

1. "Paintings and Pastels by J. H. Twachtman," *Boston Evening Transcript*, January 23, 1886, p. 6.
2. On this phenomenon, see Linda Merrill, "The Soul of Refinement: Whistler and American Tonalism," in Ralph Sessions et al., *The Poetic Vision: American Tonalism*, exh. cat. (New York: Spanierman Gallery, LLC, 2005), pp. 61–62.

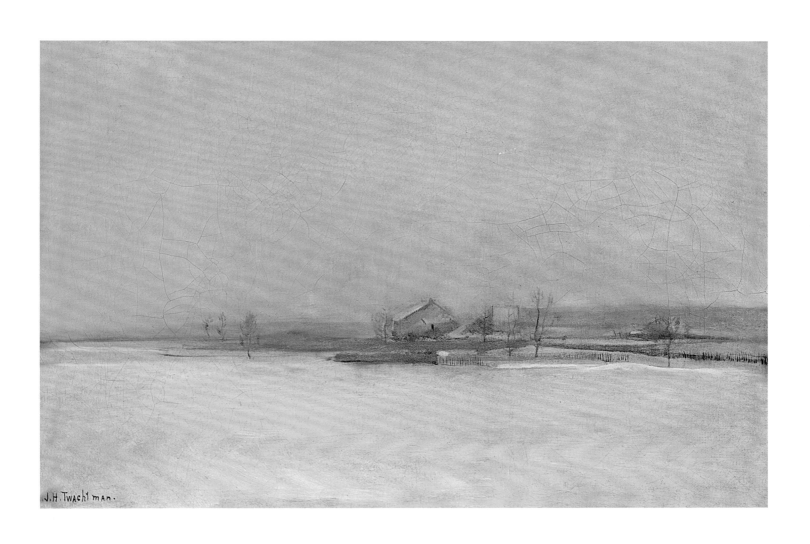

22.

Windmills ca. 1885

Oil on canvas
38 × 51½ inches
Signed lower left: *J. H. Twachtman*
Collection of Mr. and Mrs. Stephen G. Vollmer

PROVENANCE

The artist; to Smith College Museum of Art, Northampton, Massachusetts, before 1902; to (M. Knoedler & Co., New York, 1917); to Mr. and Mrs. Richard Case, Baltimore, 1960s; to estate of Mrs. Richard Case; to present coll., 2004.

EXHIBITED

(probably) 1886 J. Eastman Chase's, no. 1 (as *Hollandsch Diep*).
Yandell Galleries, New York, *Tenth Annual Exhibition, Society of American Artists*, April 9–May 5, 1888, no. 118.
Department of Fine Arts, San Francisco, *Panama-Pacific International Exposition*, February 20–December 4, 1915, no. 4059 (lent by the Hillyer Art Gallery, Smith College).
M. Knoedler and Co., New York, *Americans in Paris*, March 22–April 6, 1954, no. 49.
1966 Cincinnati Art Museum, no. 28 (lent by M. Knoedler & Co., Inc., New York).

REFERENCES

(Probably) "Paintings and Pastels by J. H. Twachtman," *Boston Evening Transcript*, January 23, 1886, p. 6 (as *Hollandsch Diep*).
"The Society of American Artists—II," *Nation*, May 3, 1888, p. 373.
"Fine Arts: Society of American Artists, First Article," *New York Sun*, April 15, 1888.
"Art Notes," *Art Interchange* 20 (May 5, 1888), p. 146.
Mrs. Schuyler [Mariana] Van Rensselaer, "Fine Arts: The Society of American Artists (Tenth Exhibition)," *Independent*, May 17, 1888, p. 7.
De Kay, "John H. Twachtman," 1918, p. 73 ill.
Clark, "Art of John Twachtman," 1921, pp. lxxviii–lxxxi ill.
Clark, *John Twachtman*, 1924, p. 39.
Hale, *Life and Creative Development*, 1957, vol. 1, pp. 58, 65, 207–8 ill. (Fig. 28), 209; vol. 2, p. 577 (catalogue A, no. 716).
Boyle, *John Twachtman*, 1979, p. 17.
Peters, *John Twachtman (1853–1902) and the American Scene*, 1995, vol. 1, pp. xxiii, 209, 214; vol. 2, p. 726 ill. (Fig. 194).
Annette Stott. *Holland Mania: The Unknown Dutch Period in American Art and Culture* (Woodstock, N.Y.: Overlook Press, 1998), p. 215 ill.
Peters, *John Henry Twachtman: An American Impressionist*, 1999, p. 68 ill.

IT HAS long been known that this important painting from Twachtman's French period won the Webb prize at the Society of American Artists tenth annual exhibition in 1888, awarded to the best landscape in the show by an American artist under the age of forty.[1] Only recently has it been determined that the work was also probably exhibited two years earlier, as it may with some certainty be identified with the highlight of Twachtman's solo exhibition at J. Eastman Chase's Gallery in Boston, held in January 1886. There a painting entitled *Hollandsch Diep* was listed as number one in the catalogue and given the premier position in the gallery. A review in the *Boston Evening Transcript* describes the work shown as "a large canvas hanging in the place of the 'Chateau Garden' of last year. In the centre of the picture rise the dark shapes of several windmills, vanish-

ing in the distance; the foreground is low, sandy marsh, with parts of gray water and harsh, rank rushes; a curve of slow river winds off on the right, and far away lies the dull blue line of the sea. The sky is full of vast, vaporous masses of clouds, and the air is wet and still, with faint light diffused through it."[2]

If *Windmills* was the painting entitled *Hollandsch Diep*, its subject can be identified as the area at the confluence of the Maas and Rhine rivers, just south of Dordrecht, the city in southern Holland where Twachtman spent the summer of 1885. Yet Twachtman may also have used many smaller images of the Dutch countryside as a basis for the work.[3] Two years after the 1886 exhibition at Chase's gallery, Twachtman may have felt that a Dutch title was too obscure for this culminating painting of his summer in Holland, and he sent it to the society as *Windmills*, by which title it has been known ever since.

Windmills was not the only important painting that Twachtman created in 1885. During the previous winter, he painted *Arques-la-Bataille* (Fig. 51) in his Paris studio, a signature work in his oeuvre, in which he portrayed the Normandy countryside where he had spent the summer of 1884. In that stark, minimalistic image, he reduced a river and the hills beyond it to bands of silvery green, resulting in a quietly sonorous vision that seems to speak to the emotions before the eye registers its forms. It is likely that *Arques-la-Bataille* was the painting that Twachtman submitted to and had rejected from the Paris Salon in 1885.[4] Perhaps the sense that his Normandy scene had retreated too far from a recognizable locale inspired Twachtman to return to a greater degree of detail and specificity in *Windmills*. Instead of treating his forms as abstract shapes and suspending the viewer within the space, as in *Arques-la-Bataille*, here the spatial recession is measured and convincing; we are drawn slowly from the foreground, where the reflective surface of the low water has gathered, across the flat terrain—shifting in tone from the sandy banks to the grassy distance— to the receding forms of the two windmills and toward a tree or mill on the horizon. This rhythmic movement draws us slowly in a circular direction through the arrangement, creating a deeply meditative experience. Thus, at the end of his French period, Twachtman merged the draftsmanship skills he had learned in Paris with a new kind of vision of art, as a vehicle for emotive expression, an approach that would be associated with American Tonalist art in the following decade.

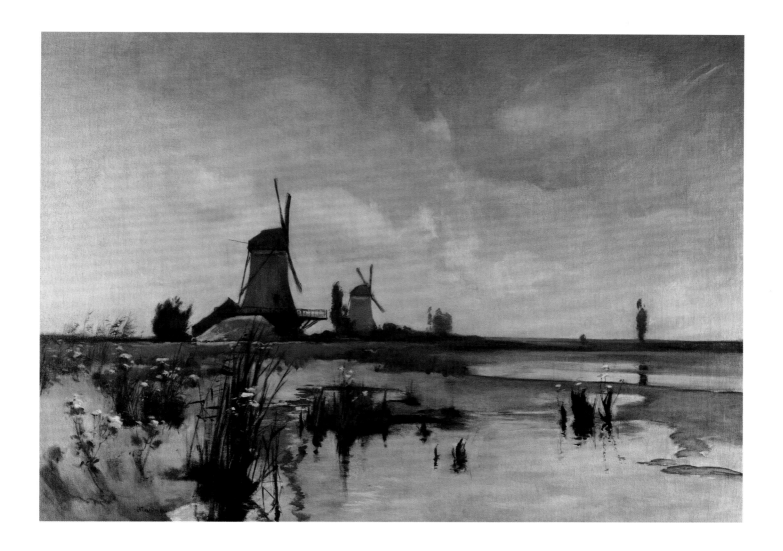

That Twachtman's objective was clear to audiences of his time is reflected in the commentary of the *Boston Evening Transcript* critic with respect to *Hollandsch Diep.* "[V]ery subtly the picture itself begins to exert its influences. This level waste, with its infinite distance, these silent and impressive windmills, the dull, gray water, and the great vacant, luminous sky combine to form a picture that has a distinct and decided influence; it is certainly impressive." The critic concluded with the statement that instead of "truth of form," Twachtman had conveyed the greater "truth of impression."[5]

The critics of the society's 1888 exhibition also recognized Twachtman's achievement. The most apt comment was that of the critic for the *Art Interchange*, who observed that Twachtman's "gray landscape" was more realistic than one by J. Francis Murphy, and yet was "not entirely unsentimental."[6]

The painting was often discussed in writings on Twachtman in the early twentieth century. Eliot Clark, who highlighted it in his article of 1921 and his monograph of 1924, commented in the latter that the work "is a most felicitous arrangement, wherein we find a very exact adjustment of the relative positions of masses and the division of areas."[7]

The records of Smith College, in Northampton, Massachusetts, indicate that *Windmills* entered the college's collection directly from the artist in 1902, the last year of his life. It was still in Smith's collection when it was included among the twenty-six works by Twachtman on view at the Panama-Pacific International Exposition in San Francisco in 1915. Two years later, the college deaccessioned the painting, selling it through M. Knoedler and Company in New York. Known to have been exhibited only five times until now, *Windmills* was last on view at the large retrospective of Twachtman's art held at the Cincinnati Art Museum in 1966.

1. From this award, the artist received $300.
2. "Paintings and Pastels by J. H. Twachtman," *Boston Evening Transcript*, January 23, 1886, p. 6.
3. For example, *Landscape with Windmill* (ca. 1885; pastel on paper, 19⅝ × 25⅛ inches, Smith College Museum of Art, Northampton, Massachusetts) and *Single Windmill with Reflection* (ca. 1885; oil on canvas, 12¾ × 17¼ inches, private collection).
4. A discussion of the evidence that this was the case may be found in Peters, *John Twachtman (1853–1902) and the American Scene*, 1995, vol. 1, pp. 215–17.
5. "Paintings and Pastels by J. H. Twachtman," 1886, p. 6.
6. "Art Notes," *Art Interchange* 20 (May 5, 1888), p. 146.
7. Clark, *John Twachtman*, 1924, p. 39.

23.

Middlebrook Farm ca. 1888

Oil on canvas
18⅛ × 29⅛ inches
Signed lower left: *J. H. Twachtman*
Private Collection

PROVENANCE

(Ortgies and Company, New York, *Paintings in Oil and Pastel by J. A. Weir and J. H. Twachtman*, February 7, 1889, no. 60, as *Middlebrook Farm*, 29 [width] × 18½ [length] inches); private collection, New Haven, Connecticut; to (Alexander J. Brogan & Son, New Haven, Connecticut, auction sale, May 30, 1958); to present coll., 1958.

EXHIBITED

1889 Fifth Avenue Galleries, no. 60.

REFERENCES

"Weir and Twachtman Pictures," *New York Sun*, February 8, 1889, p. 3.
"The Weir and Twachtman Exhibition," *Art Amateur* 20 (March 1889), p. 75.
Hale, *Life and Creative Development*, 1957, vol. 2, p. 445 (catalogue G, no. 165).

Fig. 70
Photograph, Middlebrook Farm, Ridgefield Road, Wilton, Connecticut, ca. 1970s, Wilton Historical Society, Connecticut. Records from the Wilton Historical Society indicate that this house, once a three-bay Federal dwelling, was extended and reworked probably by Frederick Middlebrook, who owned it from 1905 until 1929.

AFTER RETURNING to America from France in December 1885 or January 1886, Twachtman began a peripatetic phase of his life and career. Presumably he initially went home to Cincinnati, but by June 1886 he had relocated to Pelee Island, in Lake Erie, where his wife's family owned property and where—probably under the coercion of his domineering father-in-law, Dr. John Scudder—he tried to "combine landscape painting with farming" on the Scudder cattle farm.[1] Although his name appears in the Pelee Island tax records in 1887,[2] at some point that year he left for Chicago, where he worked on cycloramas of the Civil War battles of Gettysburg and Shiloh.[3]

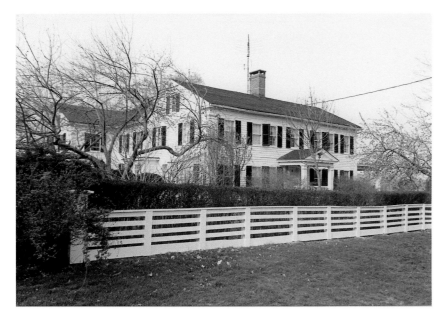

By the fall of 1887 or the winter of 1888, Twachtman was in New York, sharing a small apartment in the Benedick Building on Washington Square with the illustrator and painter William Langson Lathrop. He had probably left his wife and children (including Alden, born 1882; Marjorie born 1884; and Elsie, born 1886) in the care of the Scudder family in Avondale, but in the summer of 1888 they joined him in Branchville, Connecticut, where the family rented a house next to that of Twachtman's old friend Weir. The artists' children played together, and the two friends worked side by side, exploring pastels in the Branchville hills (see Cats. 24–25, 27, 29–30) and creating etchings on the printing press that Weir established in his Branchville barn (see Cats. 75–77).

Twachtman also traveled around the surrounding area in search of painting sites, as has been demonstrated by the determination that this painting, known in recent years with the descriptive title *Farmhouse in a Rural Landscape*, was without doubt the work Twachtman included in the February 1889 exhibition and sale of his works (along with those of Weir) held at the Fifth Avenue Galleries in New York with the title *Middlebrook Farm*. Not only do the dimensions in the catalogue match those of this painting exactly, but the house portrayed and its site exist today and concur with its image. The location can be pinpointed to Ridgefield Road in Wilton, Connecticut, four miles south of Weir's home in Branchville on Nod Hill Road. The records of the Wilton Historical Society indicate that the house, built probably in the early nineteenth century, was extended at the beginning of the following century and the shape of its chimney narrowed (Fig. 70). At the time Twachtman painted it, its owner was Samuel Bradley Middlebrook, a member of a old Wilton family of successful farmers, which had had a home on the site since 1755. Twachtman's vantage point on the scene was from the hill opposite the farmhouse looking west toward it, a view that captured the felicitous way that house was superbly positioned on the crest of a ridge paralleling Ridgefield Road, where its expanded version may be seen today.[4]

In the 1889 exhibition, the painting, which sold for seventy-five dollars, was described in the *Art Amateur* as portraying "a typical American landscape, raw, barren, and rocky, but delightful in its way as a page of description out of [Nathaniel] Hawthorne or [Ralph Waldo] Emerson."[5] Indeed, *Middlebrook Farm* evokes the essence of the New England countryside, showing a humanized landscape in which a small white farmhouse is nestled

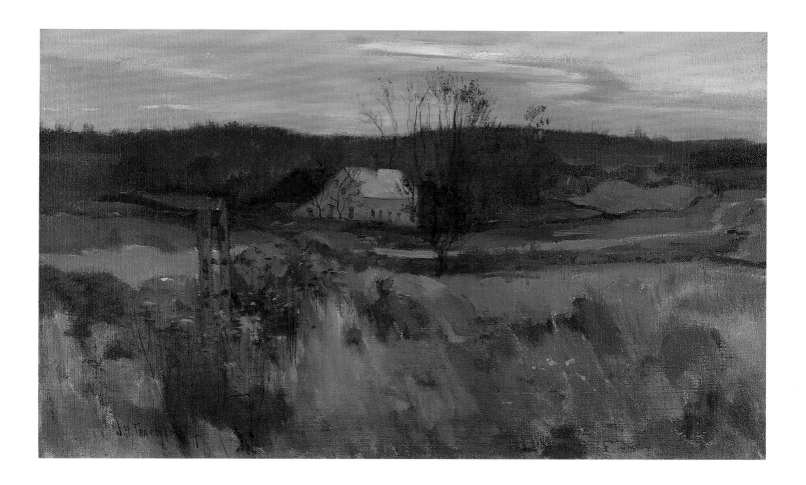

against dark hills, providing a beacon of security, while the presence of earlier occupants on the land is revealed in the form of an old gate, partly reclaimed by nature. Large rocks and boulders probably belong to old property lines, now intruded on by overgrown grass. The curving road, following the contours of the landscape, suggest that the locale is one that, while isolated, is not remote. Twachtman's image, painted with fluid strokes and subdued tones imbued with a pale luminosity, captures the feeling of just the kind of farmscape that Emerson felt instilled self-reliance and "an antagonism in the tough world for all the variety of our spiritual faculties," without which "they will not be born."[6]

In the collection of its current owner since 1958, this painting does not seem to have been exhibited since 1889. The verification of the painting's original title and location provide significant assistance in determining the character of Twachtman's art at a point in his career that has been little understood in the past.

1. Clark, *John Twachtman*, 1924, p. 6.

2. Archives, Pelee Island Heritage Center, Lake Erie, Ontario.

3. On the Gettysburg cyclorama, see *The Battle of Gettysburg as Exhibited by the Pittsburgh Cyclorama Co., Giving a Succinct and Accurate Account of the Great Battle, with Map and Key, Explanatory of the Painting*, booklet (Pittsburgh: H. H. Gross, [1887]). On the Shiloh cyclorama, see Bennard B. Perlman, *The Lives, Loves, and Art of Arthur B. Davies* (Albany, N.Y.: State University of New York), pp. 23–24.

4. Information on Middlebrook Farm was provided by the Wilton Historical Society, including a survey on the house from *Historic Resources Inventory Building and Structures, State of Connecticut, Connecticut Historical Commission*, compiled by Mary E. McCahon, architectural historian, April–May 1989, Wilton Historical Society, Connecticut. Another source on the house is *Wilton Historical Society, Eighteenth Century Dwellings in Wilton* (Wilton, Ct.: Wilton Historical Society House Files, 1976). Many features that Twachtman included in the painting either remain or have been recorded as once present, including the barn situated behind the farmhouse (now a private home), the house's wide chimney (now narrower, but evidence of an earlier wider chimney has been recorded), and a house in the hills at the upper right (known to have once been present). For help in identifying this site, I would like to thank Scotty Taylor, Wilton Historical Society.

5. "The Weir and Twachtman Exhibition," *Art Amateur* 20 (March 1889), p. 75.

6. Ralph Waldo Emerson, *A Lecture read before the Mechanics' Apprentices' Library Association, Boston, January 25, 1841, Man the Reformer*, from *Lectures*, published as part of *Nature; Addresses and Lectures* (Boston: J. Munroe, 1849).

Farm Scene ca. 1888–91

Pastel on academy board
17 × 21 inches
Signed lower right: *J. H. Twachtman–*
Private Collection

PROVENANCE
The artist; to his daughter Marjorie Twachtman Pell, New Canaan, Connecticut; by descent through the family to the present.

Rendered on a gray-beige academy board to which pumice was added, this pastel reveals a richer, more diverse treatment than in many of Twachtman's other works in the medium in which he used a sparer application. He offset the crisp lines of the farmhouse against the soft, full clouds that move in to cover the sky. While he allowed the color of the board to be present in the road, suggesting its uneven, reflective surface with light touches of white and pink, he layered his chalks thickly in the right middle ground to indicate dense foliage and its dark shadow. The result is a work that captures the rich animated qualities within this peaceful scene.

The large size of this pastel, the completeness of the image, and the clearly articulated signature in the lower right suggest that Twachtman intended it as more than a casual sketch. It may have been this pastel, or one similar to it, that he included in his 1891 exhibition at Wunderlich Galleries in New York with the title *The Farmer's House*. The critic for the *Art Amateur* considered this work to be one of the three finest of the thirty-one pastels on view, noting that in it, "summer light and color are treated with equal success."[1]

The subject in this work was perhaps one of the many abandoned farmhouses of New England that were idealized in the late nineteenth century as representing the perpetuation of the values and simplicity associated with an earlier time in American life. Real estate brokers provided lists of just such locales, noting that they were plentiful, affordable, and easily transformed into beautified country seats, offering refuge from the stresses of city life.[2] "Many of these old places have great possibilities," noted a writer for *Country Life in America* in 1901, advising, "Even the old houses are often capable of being made into comfortable homes with small expense."[3] Such thoughts may have been on Twachtman's mind during the period when he was searching for a home of his own, where he could settle in with his family, and perhaps he rendered this scene as a way of determining the qualities that best fit what he sought. Indeed, some of the aspects of this humble dwelling, consisting of two conjoined buildings, evoke the farmhouse in Greenwich that Twachtman would convert to a home for his family in the 1890s, modifying it so as to harmonize it with its landscape.

Farm Scene was given by Twachtman to his daughter Marjorie, and it remains in the family of Marjorie's descendants today. With the exception of its possible inclusion in Twachtman's 1891 exhibition, the present show is the first known time this work has been seen in public.

1. "My Notebook," *Art Amateur* 24 (April 1891), p. 116.
2. See, for example, William Bishop, "Hunting an Abandoned Farm in Connecticut," *Century Magazine* 47 (April 1894), p. 919. This author visited with Weir at his Branchville home while traveling through the Connecticut countryside.
3. "The Making of a Country Home: Being a Series of Practical Papers on the Possibilities of Home-Making by Persons of Moderate Means—I. Choosing the Site, and General Advice," *Country Life in America* 1 (April 1901), pp. 201–2.

25.

Path in the Hills, Branchville, Connecticut ca. 1888–91

Pastel on paper
10 × 12 inches
Signed lower left: *J. H. Twachtman*–
Spanierman Gallery, LLC, New York

PROVENANCE

Estate of the artist; to (Milch Galleries, New York, by 1928–ca. 1942); C. C. Gibson,
San Francisco, as of 1957; (Bernard and S. Dean Levy, New York, by 1979); to (art market,
New York, 1979–80); to private collection, 1980; to present coll., 2000.

EXHIBITED

1928 Milch Galleries, no. 2 (as *Cos Cob*).
1942 Babcock Galleries, no. 23 (as *Cos Cob, Conn.*).
Spanierman Gallery, LLC, New York, *Two Hundred Years of American Watercolors, Pastels,
and Drawings*, April 16–June 30, 2001, no. 26 (color ill.).
Spanierman Gallery, LLC, New York, *The Poetic Vision: American Tonalism*,
November 12, 2005–January 7, 2006, no. 38 (pp. 75, 170 color ill., 171).

REFERENCES

Hale, *Life and Creative Development*, 1957, vol. 2, p. 586 (catalogue A, no. 926,
as *Cos Cob*).
Lisa N. Peters, entry, "John Henry Twachtman," in Ralph Sessions et al., *The Poetic
Vision: American Tonalism* (New York: Spanierman Gallery, LLC, 2005), pp. 170
color ill., 171 (no. 38).
Peters, "'Spiritualized Naturalism,'" 2005, p. 75 (no. 38).

TWACHTMAN was most absorbed in working in pastel during the years 1888 to 1891. In his 1889 exhibition at the Fifth Avenue Galleries, he displayed ten pastels, and in 1891, when he had a solo show at Wunderlich Gallery in New York, thirty-one of the forty-three works included were pastels. Among the pastels in the Wunderlich exhibition was a work entitled *The Path across the Hills*, which may have been similar to *Path in the Hills, Branchville, Connecticut*. When this pastel was shown in 1928 at the Milch Galleries in New York, where it was included in a group of works from the artist's estate, it was assigned the title *Cos Cob, Connecticut*. This title seems to be wrong, however, as the scene closely concurs with the features of the Branchville countryside and with other pastels that Twachtman is known to have created there, often working in the company of J. Alden Weir.

Incorporating the oatmeal-grained paper's underlying tone into his arrangement, here Twachtman used his colors with extreme restraint. His subject, a spring day possibly just after a rainfall, is suggested by the effect of pressing the flat side of the crayon across the paper, evoking the delicacy of the damp earth and of new foliage barely covering the ground. Through this approach, as in *Gray Day* (Cat. 13), he created a sense of surface depth. He drew the trees with the "shorthand" method remarked on by critics of his time, using his pencil with light agility to convey the essence of their forms rather than to portray them in literal detail. Likewise, in the small area of sky that is visible, he rendered the thinness of the clouds with slight touches of pale whitish blue.

For the path in the scene, Twachtman used a thin, broken line to note its form curving upward across the hill. Typical of his willingness to depart from usual artist practices, he did go over this line to make it a more significant element in the image. Instead he used it to create a subtle sense of movement and structure, without allowing it to dominate the composition or distract from its subject, the light and feeling of nature stirring on this early spring day.

As one reviewer of his show at the Wunderlich Gallery remarked of Twachtman's pastels in this vein: "Emphatically these delicate trifles are objects to live with in peace and constantly fresh satisfaction. They should be looked at slowly or their shy charm will not be realized. The eye gradually plunges into their light tones and discovers new planes in the landscape, fresh points of interest to seize."[1]

1. "Art Notes," *New York Times*, April 12, 1891, p. 12.

Branchville ca. 1888–89

Oil on canvas
60 × 80 inches
Spanierman Gallery, LLC, New York

PROVENANCE

The artist; to J. Alden Weir; to Twachtman's son J. Alden Twachtman, Greenwich,
Connecticut, by 1957; to his son Dr. Eric Twachtman, Essex, Connecticut; to (Ira
Spanierman, Inc., New York, by 1966); to Mr. and Mrs. Harry Spiro, 1968; gift to
Columbus Museum of Art, Ohio, 1979; to (Christie's, New York, December 2, 2004, lot
57); to present coll., 2004.

EXHIBITED

1966 Cincinnati Art Museum, no. 33 (lent by Dr. Eric Twachtman, Essex, Connecticut, as
 Landscape, Branchville).
1968 Ira Spanierman, Inc., no. 13 (p. 12 ill., as *Landscape, Branchville*).
Mansfield Art Center, Ohio, *The American Landscape*, 1981.

REFERENCES

Hale, *Life and Creative Development*, 1957, vol. 2, p. 559 (catalogue A, no. 377, as
 Branchville Lane).
"Reviews and Previews," *Art News* 67 (March 1968), p. 56.
Norma J. Roberts, ed., *The American Collections: Columbus Museum of Art* (Columbus,
 Ohio: Columbus Museum of Art, 1988), p. 265.
Peters, *John Twachtman (1853–1902) and the American Scene*, 1995, vol. 1, pp. xxviii, 253;
 vol. 2, p. 784 ill. (Fig. 357).
Hildegard Cummings, "Art and Nature in the Landscapes of Nod," in Nicolai Cikovsky Jr.
 et al., *A Connecticut Place: Weir Farm—An American Painter's Rural Retreat* (Wilton,
 Conn.: Weir Farm Trust in collaboration with the National Park Service, Weir Farm
 National Historic Site, 2000), pp. 85–86 ill. (Fig. 77).

Fig. 71
Twachtman, *Tree by a Road*,
ca. 1889, pastel on paper,
18 × 21½ inches, Cincinnati Art
Museum, Museum purchase.

Just over one inch larger than *Arques-la-Bataille* (Fig. 51), which measures 60 by 78⅞ inches, *Branchville* is Twachtman's largest known painting. For most of the important works that Twachtman created during his mature career, he tended to use canvases that had dimensions in the twenty- or thirty-inch range, and only a few notable works extend to forty or fifty inches in width. Indeed, no other works in Twachtman's oeuvre come close to either of these paintings in scale. Since it is likely that *Arques-la-Bataille* was the painting Twachtman was referring to in a letter to Weir of April 1885, in which he mentioned taking a month off "from school" to paint "a large canvas for the Salon," its size can be explained. His disappointment when the painting was rejected by the Salon was undoubtedly predicated at least in part on his belief that such a large canvas could not fail to impress the jury.[1]

Twachtman's motivation to create a second work on a similarly grand scale about three years later is less clear. Yet the many ways in which this painting is antithetical to *Arques-la-Bataille* suggest that he made it as a way of rethinking and redirecting his art at a transitional point in his career. Whereas *Arques-la-Bataille* is a formal composition, in which Twachtman adjusted each shape and tone for purposes of balance and harmony, *Branchville*, which can be identified as a view looking west toward the hills from the front door of Weir's Branchville, Connecticut, farm, is casual, painted with a vigor consistent with a plein-air approach.

Rendered probably in 1888 or 1889 before he moved to nearby Greenwich, *Branchville* may reflect Twachtman's growing awareness of and interest in French Impressionist art, a knowledge of which had spread dramatically in America in the years following the 1886 exhibition of French works brought to New York by the Paris art dealer Paul Durand-Ruel. The painting also demonstrates the direction in which Twachtman was proceeding in his pastel work, as the portability of pastel materials encouraged his spontaneity. Yet, it seems likely that Twachtman used *Branchville* as the basis for a pastel. In the similar *Tree by a Road* (Fig. 71), for example, he synthesized and reduced his image to just a few discrete forms.

Branchville presents an informal view of an inconspicuous and intimate landscape subject on a monumental scale. With this combination Twachtman challenged the idea that an outsize canvas is synonymous with an impressive subject, contradicting, as it were, the large, richly detailed, theatrical productions of the Hudson River

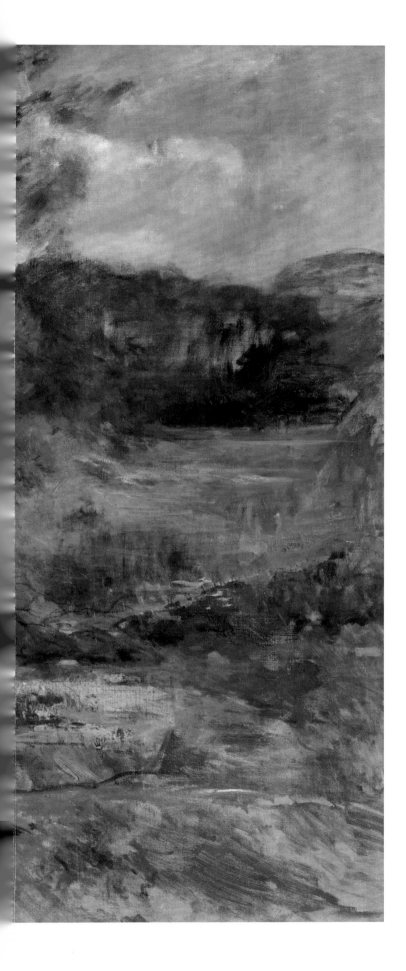

School. *Branchville* conveys a feeling of being life-size; with the path extending before us, there is a sense that we could walk into it.

Twachtman's execution of *Branchville* is sketchy and free. In the foreground the loose brushstrokes do not cover all of the underlying ground. While it is possible that he intended to fill in these areas later, his approach also concurs with the aim he had set for himself earlier in his career, of reducing detail in a work to emphasize a feeling of fresh experience.

Branchville passed directly from Twachtman to Weir, perhaps at the time that the two were living near each other in Branchville, beginning in the summer of 1888. By 1957 the painting was in the collection of Twachtman's son, Alden, suggesting that Weir or his descendants felt it was a work that should be returned to the artist's family, in whose possession it remained until 1968. The painting was exhibited in the large retrospective of Twachtman's art held at the Cincinnati Art Museum in 1966 and at the Twachtman exhibition held by Ira Spanierman, Inc., in 1968, from which it sold to the land developer and art collector Harry Spiro. Eleven years later, Spiro gave the work to the Columbus Museum of Art, Ohio, which deaccessioned it in 2004.

1. Twachtman, Paris, to Weir, April 6, 1885, Weir Family Papers, MSS 41, Harold B. Lee Library, Archives and Manuscripts, Brigham Young University, Provo, Utah.

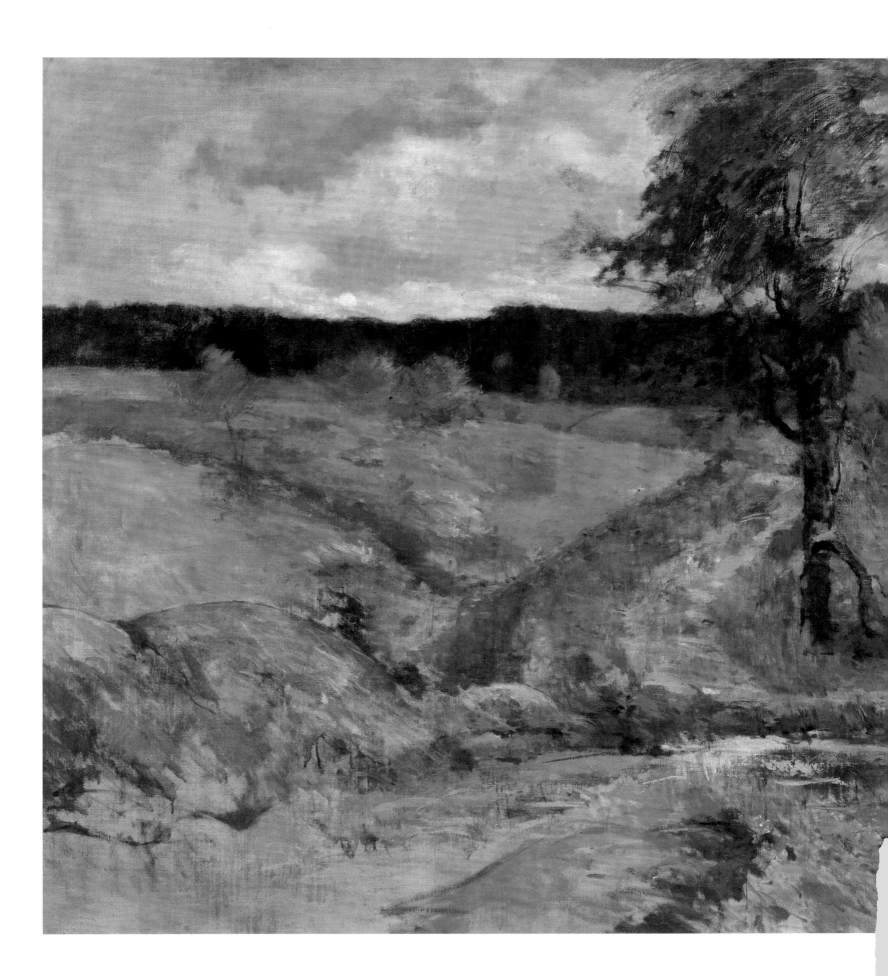

27.

Landscape ca. 1888–91

Pastel on paper
13¾ × 13 inches
Signed lower right: *J. H. Twachtman–*
Spanierman Gallery, LLC, New York

PROVENANCE

(M. Knoedler & Co., New York, as of 1957); Irving Mitchell Felt, New York; (Berry-Hill Galleries, New York, by 1980); to private collection, 1980; to present coll., 2006.

LITERATURE

Hale, *Life and Creative Development*, 1957, vol. 1, p. 412 ill. (Fig. 156); vol. 2, p. 589 (catalogue A, no. 982).

BY CONTRAST with the pastels he created in Europe, in which he emulated his oil painting technique of that time, applying his colors in thin layers that covered the surface of the papers, in his pastels of the late 1880s and early 1890s, Twachtman took his cue from the intrinsic nature of his medium, exploiting its suitability for sketching and recording his direct observations. His approach is illustrated in this work in which he applied his crayons in quick, broken lines and rubbed in patches of color with his hand or an available cloth. The result is an image in which he captured all the forms in the scene at once. Rather than differentiating the trees in the foreground from the trees and bushes behind them, he rendered near and far forms together, their discontinuous outlines making them seem animated in the air and sunlight. A back-and-forth movement is established by the placement of the forms; by leaving empty space on the left of this nearly square image, Twachtman created a sense of movement and flow that a narrower, more restrictive composition would not have allowed.

Wood interiors were among Twachtman's favorite pastel subjects, and a pastel entitled *Sunlight through the Trees* that was included in his 1891 exhibition at Wunderlich Gallery may have been similar to the present work. A writer for the *Critic* was undoubtedly including *Sunlight through the Trees* in his praise for Twachtman's ability to capture the essence of his subjects, noting of the show: "Thirty pastels reproduce with unequalled lightness of touch and daintiness of color every mood of the typical Eastern landscape—rolling hills, rambling stone walls, wandering brooks, wood-interiors green and sunny."[1]

The first record of this pastel is in John Hale's 1957 dissertation, where it is listed in the collection of New York's M. Knoedler and Company. It was owned, probably in the 1960s, by Irving Mitchell Felt, who at one point was the president of Madison Square Garden.

1· "The Fine Arts: Oil-Paintings and Pastels by Mr. Twachtman," *Critic* 18 (March 1891), pp. 146–47.

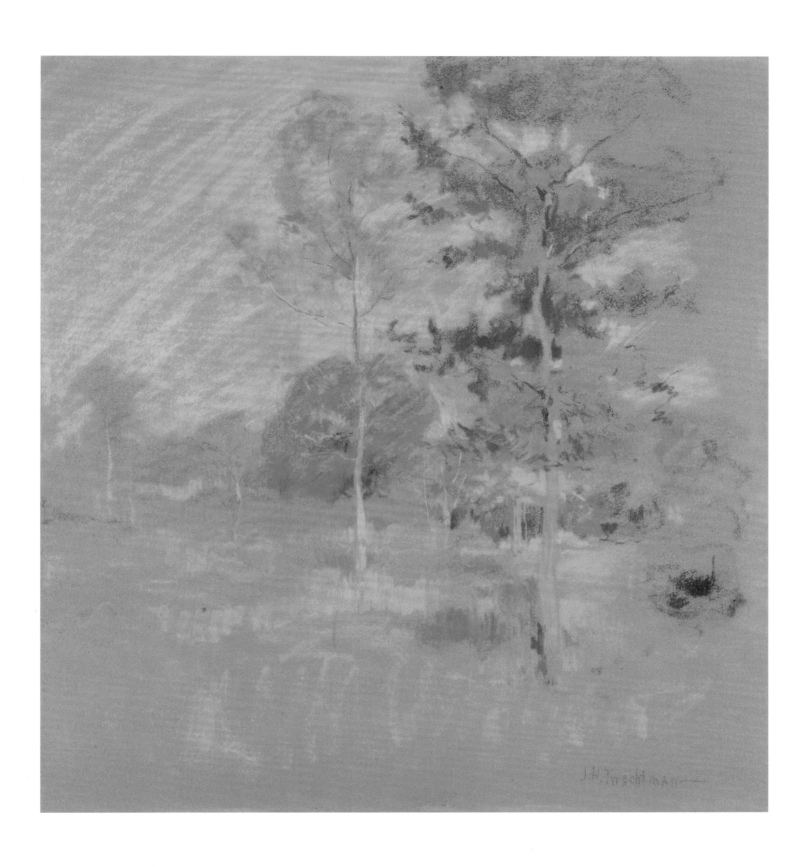

28.

Tulip Tree ca. 1889–91

Oil on canvas
43¼ × 30¼ inches
Spanierman Gallery, LLC, New York

PROVENANCE

The artist; to his daughter, Marjorie Twachtman Pell, New Canaan, Connecticut, until at least 1934; (M. Knoedler & Co., New York, by 1956); (Milch Galleries, New York, by 1959); (A.C.A. American Heritage Gallery, New York); (Christie's, New York, May 31, 1985, lot 245); (A.C.A. American Heritage Gallery, by 1987); to American Express Company, 1987; to present coll., 2002.

EXHIBITED

American Academy of Arts and Letters in conjunction with the National Institute of Arts and Letters, New York, *The Impressionist Mood in American Painting,* January 16–February 15, 1959, no. 36 (lent by Milch Galleries).
Spanierman Gallery, LLC, New York, *The Spirit of America: American Art from 1829 to 1970,* November 1, 2002–February 15, 2003, no. 42 (color ill.).

REFERENCE

Hale, *Life and Creative Development,* 1957, vol. 2, p. 574 (catalogue A, no. 634, as *Poplar Trees*).

It seems likely that Twachtman created this painting in the late 1880s or early 1890s, when he was most absorbed in pastel work and beginning to determine how best to incorporate Impressionist methods into his art. Here he used this scene as a way of studying the way that our attention on a subject makes it come into sharper focus than the forms around it. This may be seen

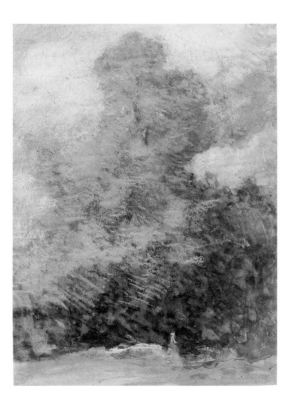

Fig. 72
J. Alden Weir,
The Tulip Tree, pastel
and watercolor on
paper, 13¼ × 9¼ inches,
private collection.

in this work in the way that the tree with its two clusters of feathery leaves in the near left foreground naturally draws our eye, and despite the uniformity of the subdued tones throughout the scene, we differentiate this form because it draws our interest. Twachtman's awareness of this process by which our awareness registers is reflected in the advice that he gave to his students in Cos Cob, as reported by a visitor to a summer class he held in 1899: "If you wish us to see the foreground most clearly, emphasize it and make the rest vague; sometimes it is the distance. In a study where each part is done with equal care the eye goes from one point to the other and never rests."[1]

In *Tulip Tree,* the radiating leaf formations, cropped at the top of the work, suggest a feeling of jubilation, which is yet tempered by the drooping leaves below, a presentation suggesting that Twachtman found in trees a reflection of his own state of mind. In this respect, he shared with Weir the sentiment that familiarity with a place and its features bred a love for and understanding of them, and both artists brought this sense of personal attachment into their work. Weir was quoted as telling Joseph McSpadden in 1917: "Now I had seen those old trees year after year until they had become a part of me, so to speak. One day the impulse seized me to paint them, and the picture instantly 'caught on.' This proves to my mind that you must make a subject a part of yourself before you can properly express it to others."[2] It is, in fact, interesting to note that in a work in pencil, watercolor, and pastel entitled *The Tulip Tree* (Fig. 72), Weir created a similar image of a poplar tree, set in the foreground of his scene, and it is intriguing to think of the two artists working side by side, discussing their deepening affection for the trees and landscape of which they were growing increasingly fond.

When John Hale catalogued this painting in 1957, the title he was given by its owner, New York's M. Knoedler and Company, was *Poplar Trees.* By 1959, when the painting was in the hands of New York's Milch Galleries, it had been reassigned the title *Tulip Tree,* a name that refers to yellow poplar trees.

1. "An Art School at Cos Cob," *Art Interchange* 43 (September 1899), p. 56.
2. J[oseph] Walker McSpadden, *Famous Painters of America* (New York: Dodd, Mead & Co., 1917), pp. 388–89.

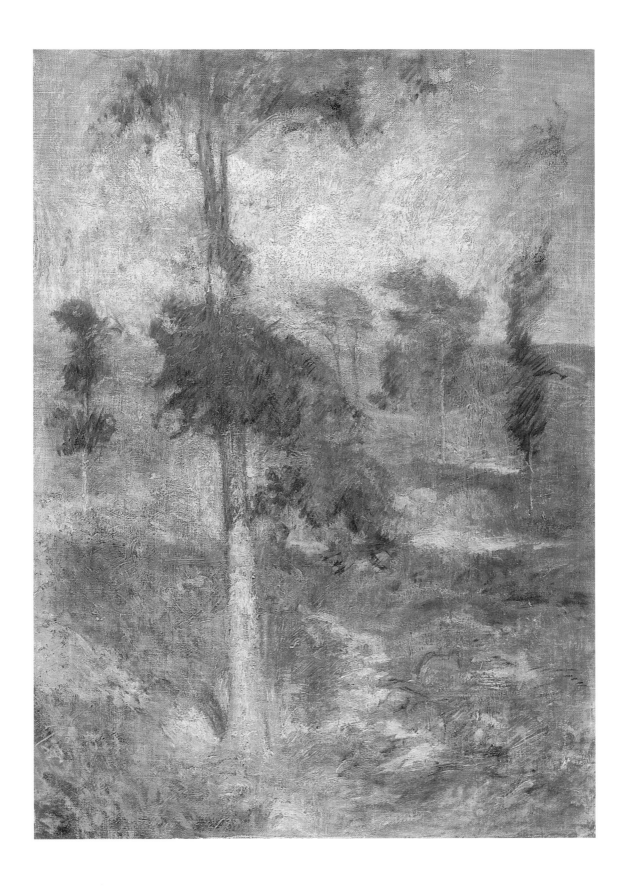

29.

Brook among the Trees ca. 1888–91

Pastel on paperboard
10⅛ × 8⅜ inches
Private Collection

PROVENANCE

The artist; gift to the Art Students League, New York; to (Hirschl & Adler, Inc., New York, 1978); to (Steven Straw, Newburyport, Massachusetts); to (Phillips, Boston, May 2–3, 1980, no. 58); to (Debra Force Fine Art, New York); to present coll., 2003.

Brook among the Trees is among a group of pastels that Twachtman is known to have given to the Art Students League, in New York, where he taught from 1889 through 1902, the last year of his life. At the league, Twachtman was in charge of the preparatory antique class, in which beginning students created charcoal drawings of plaster casts that consisted "of geometrical forms, 'block' feet and hands, Greek and Roman heads, and antique bas-reliefs," as John Van Dyke noted in an article of 1891.[1] This instruction, such a great contrast with his own artistic approach, was onerous for Twachtman. As one student observed, Twachtman's role at the league reduced him to "a poet made to drag a cart, heavy with blocks of dead plaster."[2] Nonetheless, Twachtman's ideas and his commitment to using art to find new routes to perceptual understanding were communicated to his students, whether they studied with him at the league or in the freer atmosphere of Cos Cob, Connecticut, where he taught during the summers of 1892–93 and 1895–99. His pupil Allen Tucker credited Twachtman with making him aware that nothing but what was within him should dictate what he put on canvas. Tucker's observation that Twachtman "opened the door for me" was typical of many of Twachtman's students, who felt that his art, vision, and individualism inspired their own creative potential.[3]

Perhaps Twachtman gave this pastel to the league as a way of representing his true self there—by contrast with his role as a teacher—among his greatest admirers, the art student population of his day. Brook among the Trees represents the subject matter that inspired Twachtman most during his Greenwich years, the brook winding through the undulating landscape of his property. His style here is also representative of his characteristic approach. Leaving much of the oatmeal-grained paper exposed, he incorporated its gray-brown tone and surface texture into his design, applying pale yellow and green shadings that seem to emerge from an atmospheric setting, represented by the paper itself. With his pencil, he sketched aspects of the brook, hills, and trees with a broken cursive, conveying their essential qualities rather than outlining them. The nervous verticals of trees create a rhythmic movement back and forth in the space. The resulting work expresses the feeling of the brook's sparkle and movement. The work was perhaps similar to a pastel entitled Brook in the Woods that Twachtman included in his 1891 exhibition at Wunderlich Galleries in New York, which a critic described as "a summer wood interior, full of various sunny greens."[4]

1. John C. Van Dyke, "The Art Students' League of New York," Harper's New Monthly Magazine 83 (October 1891), pp. 691–92.
2. Thorpe, "John H. Twachtman," 1921, p. 5.
3. Tucker, John H. Twachtman, 1931, pp. 7–8.
4. "My Notebook," Art Amateur 24 (April 1891), p. 116.

30.

Wildflowers ca. 1888–91

Pastel on paper
17½ × 13 inches
Signed lower right: *J. H. T.*
Private Collection

PROVENANCE

Martha Twachtman, the artist's wife, Greenwich, Connecticut; to her daughter Violet Twachtman Baker, New York; to her daughter Martha Baker, Italy; by descent through the family; to (Spanierman Gallery, 1988); to present coll., 1989.

EXHIBITED

1989 Spanierman Gallery, no. 17 (pp. 50 color ill detail, 88–89 color ill.).
Georgia Museum of Art, University of Georgia, Athens, *American Impressionism in Georgia Collections*, September 11–November 14, 1993, no. 55 (pp. 114–15 color ill.) (traveled to Museum of Fine Arts, St. Petersburg, Florida, December 5, 1993–March 6, 1994; Mint Museum of Art, Charlotte, North Carolina, April 16–June 19, 1994).
1999 High Museum of Art, no. 14 (pp. 83, 87, color ill.).

REFERENCES

Peters et al., *In the Sunlight*, 1989, pp. 50 color ill. detail, 88–89 col. ill. (no. 17).
Donald Keyes. *American Impressionism in Georgia Collections*, exh. cat. (Athens, Ga.: Georgia Museum of Art, University of Georgia, 1993), pp. 114–15 color ill.
Peters, *John Twachtman (1853–1902) and the American Scene*, 1995, vol. 1, pp. xxx, 267; vol. 2, p. 817 ill. (Fig. 293).
Peters, *John Henry Twachtman: An American Impressionist*, 1999, pp. 83, 87 color ill.

FROM THE mid-1880s onward, flowers were a theme of sustained interest for Twachtman, but few of his floral images are still lifes (see Cat. 39).[1] Neither are these works generally landscapes in which flowers are set within distinct garden plots. Instead, especially in the oils and pastels he rendered beginning in the late 1880s, Twachtman portrayed flowers growing freely in nature, integrated within their landscape settings and often shown in such a way that the viewer is thrust into a direct confrontation with their animate forms affected by fluctuations of wind and atmosphere. Painting blossoms and petals with strokes that approximate their colors and movement, he conveyed the essence of his subjects rather than detailing their forms. His approach is exemplified in *Meadow Flowers* (Fig. 57), in which we are drawn into the evanescent qualities of goldenrod and wild aster seen from above and filling the picture plane.

Wildflowers in situ also played a role in Twachtman's pastel works, probably beginning in 1889, when he exhibited a pastel entitled *Wildflowers* in his joint exhibition with Weir at the Fifth Avenue Galleries in New York. A pastel of wildflowers may also have been the basis for a work by Twachtman that was illustrated in a wood engraving in *Scribner's Magazine* in August 1890.[2]

In a letter to J. Alden Weir of 1892, he mentioned his fondness for observing wildflowers on his Greenwich property, noting: "The foliage is changing and the wild-flowers are finer than ever. There is greater delicacy in the atmosphere and the foliage is less dense and prettier."[3]

In his pastels of wildflowers, Twachtman did not portray his subjects with an eye to botanical detail, but neither was he interested in conveying the immediate coloristic splendor of flowers, as, for example, Childe Hassam did in his images of Appledore, on the Isles of Shoals, in which Hassam depicted the cultivated and even exotic varieties of blooms in the seaside garden of the poet Celia Thaxter. In pastels such as *Wildflowers*, showing three or four flowers, possibly phlox, rising from their stems, Twachtman's colors and forms are so restrained, faint, and delicate as to make the flowers seem spectral, their forms so pale and suffused in a soft, atmospheric light that the viewer has to strain to make out their features. Such an approach reveals his interest in rendering his subject in a way that coalesced with its essential nature, while bringing the viewer through the process of observing such images into awareness of the fragility of the motif portrayed. "The flower pieces in pastel which seem at first hardly more than a ghost of the blossoms, assume outline and consistency," wrote a reviewer for the *New York Times* of Twachtman's 1891 exhibition at Wunderlich Gallery, in which at least seven of the thirty-one pastels on view were of wildflowers.[4]

This critic went on to note that "such pictures are not fit for the 'struggle for life' in a general exhibition" and that "the artist was wise to look by himself."[5] The Darwinian overtones in this statement are unavoidable, and perhaps Twachtman saw a parallel in the amazing survival of wildflowers in the trials of New England's changeable climate with his struggle to maintain a belief in his own artistic direction in the increasingly cut-throat art market, in which artists often had to construct self-images and package their art to fit a certain profile to achieve recognition.

Wildflowers belonged to the artist's daughter Violet and remained with her descendants until 1987.

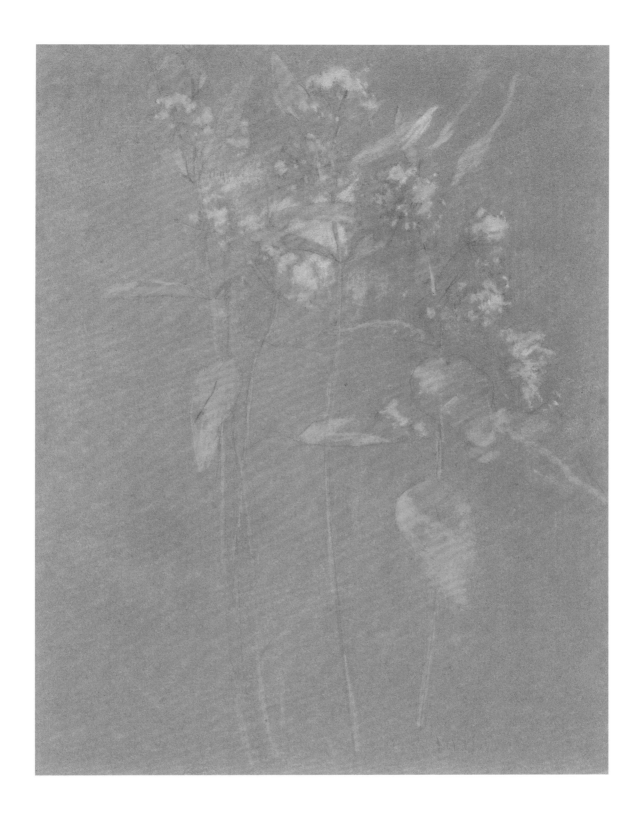

1. On Twachtman's treatment of this theme, see
William H. Gerdts, "'Like Dreams of Flowers,'" in Peters
et al., *In the Sunlight*, 1989, pp. 21–36.

2. G. Melville Upton, "The Season's Boon," *Scribner's
Magazine* 8 (August 1890), p. 223, engraved by Norman
William Kingsley.

3. Twachtman, Greenwich, to Weir, Chicago,
September 26, 1892, Weir Family Papers, MSS 41, Harold
B. Lee Library, Archives and Manuscripts, Brigham
Young University, Provo, Utah.

4. The titles of these works were *Rye Stubble, Red
Aggeratum, Wild Aster, Thoroughwort, Aggeratum, Fairy
Wand,* and *Tiger Lilies.*

5. "Art Notes," *New York Times,* April 12, 1891, p. 12.

31.

Paradise Rocks, Newport ca. 1889

Oil on canvas
31½ × 47 inches
Signed lower right: *J. H. Twachtman*
Spanierman Gallery, LLC, New York

PROVENANCE

Private collection, California; to Edward Pouch; Alice Carson, Greenwich, Connecticut; to Mr. and Mrs. F. Herbert Filley, Greenwich, Connecticut; by descent through the family; to present coll., 2005.

REFERENCES

Hale, *Life and Creative Development*, 1957, vol. 2, p. 567 (catalogue A, no. 517).
Peters, *John Twachtman (1853–1902) and the American Scene*, 1995, vol. 1, pp. 260–61; vol. 2, p. 801 ill. (Fig. 276).

NEWPORT had been a popular destination for artists for several decades when Twachtman traveled to the Rhode Island town in June 1889.[1] An invitation to teach may have been the reason for his visit; in her diary the amateur artist and school director Anna Falconnet Hunter (1855–1941) reported that Twachtman gave his first lesson on the fourth of the month, instructing Hunter and a few other pupils to draw from a model.[2] By June 21, he had taken his class into the open air, a teaching practice that would come into regular use only after William Merritt Chase began his summer school in Shinnecock, Long Island, in 1891.[3] Hunter reported: "Mr. Twachtman wishes us to begin big canvas out of doors."[4] Twachtman remained in Newport long enough to be listed in the 1889 directory of summer residents, and Hunter mentions his presence in the town in early August as well as in late October.

Fig. 73
John Frederick Kensett, *Paradise Rocks, near Newport*, 1859, oil on canvas, 14 × 24 inches, private collection.

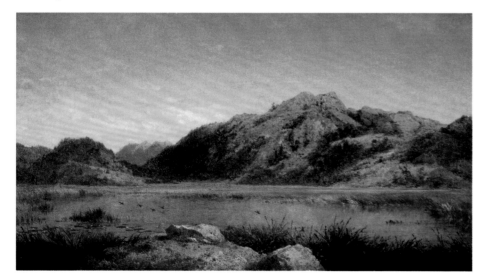

In the city directory, Twachtman's address was listed as "Longmeadow, Swinburne's."[5] While the latter name may have been a boardinghouse, the former likely refers to a road in Middletown, just east of Newport, from which Twachtman would easily have been able to walk east to Newport's harbor or west to Paradise, an approximately one-square-mile area marked by seven puddingstone ridges and encompassing two picturesque ponds: Nelson's and, to its east, the larger Gardiner's.[6] Most of Twachtman's Newport images are of the town's harbor, featuring boats and the waterfront. For these works, he primarily used pastels (Cat. 32), while also working in watercolor, and creating at least one etching (Cat. 78).[7]

This work is among few oils that Twachtman created in Newport, and the only one that is not a harbor view (see Fig. 94). Its subject is the landscape of Paradise, portraying what appears to be a view from the south end of Nelson's Pond looking east toward a small island at the east side of the pond, a location from which John Frederick Kensett (Fig. 73), John La Farge, and Homer Martin also are known to have painted.[8] Twachtman appears to have taken liberties with his subject, bringing the two shores closer together than they actually were, and his loosely painted image contrasts significantly with Kensett's view of 1859, in which each facet of the scene is carefully delineated.

Twachtman's aim appears to have been to capture the character of the landscape's richly varied natural forms without making any of them explicit. He painted the reeds at the water's edge with blurred lines, an approach antithetical to the crisply delineated reeds he had painted four years earlier in the foreground of *Arques-la-Bataille* (Fig. 51). He portrayed the foliage and rocks on the hills just as indistinctly as the reflections of their forms in the water. Using a low-keyed palette of grays, light greens, and pale browns, he established a tonal consistency throughout the work that plays down the differences between forms and enables the feeling and general sense of the whole scene to come across to the viewer more completely than does its imagery. Among Twachtman's most experimental and modern works, *Paradise Rocks, Newport* epitomizes the type of work for which he was most admired by his fellow artists, but not well understood by the art buyers of his time, who were interested in pictures with more obvious appeal.

In a Greenwich family for decades, this painting has only recently emerged from obscurity.

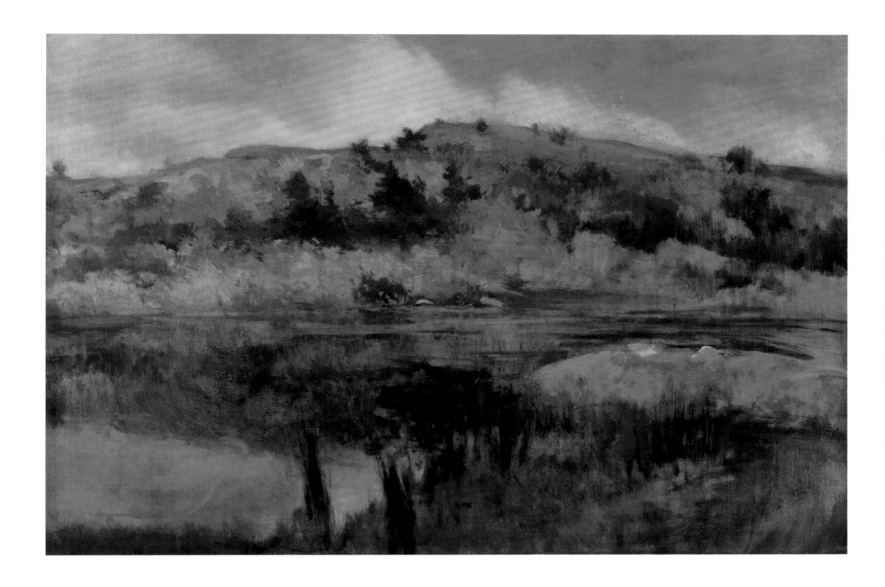

1. For a survey of artists who worked in Newport, see Robert G. Workman, *The Eden of America: Rhode Island Landscapes, 1820–1920*, exh. cat. (Providence, R.I.: Museum of Art, Rhode Island School of Design, 1986), and *The Artistic Heritage of Newport and the Narragansett Bay*, exh. cat. (Newport, R.I.: William Vareika Fine Arts, 1990).

2. See Hunter Family Diaries, Box 98, Vault A, Newport Historical Society, Newport, Rhode Island.

3. For a discussion of the development of outdoor painting in America, see William H. Gerdts, "The Teaching of Painting Out-of-Doors in America in the Late Nineteenth Century," in *In Nature's Ways*, exh. cat. (West Palm Beach, Fla.: Norton Gallery of Art, 1987), pp. 25–40.

4. Anna Hunter, journal entry, June 21, 1889, Hunter Family Diaries. Information on Twachtman's outdoor instruction in Newport is also included in *Retrospective Exhibition of the Work of Artists Identified with Newport*, exh. cat. (Newport, R.I.: Art Association of Newport, 1936), p. 28.

5. *The Newport Directory, 1889, Containing a Directory of the Citizens, Street Directory, the City Record, and Business Directory, also Directory of the Summer Residents* (Newport, R.I.: Sampson, Murdock, & Co., 1889), p. 363.

6. On Paradise and its history as an artist's site, see James L. Yarnall, *John La Farge in Paradise: The Painter and His Muse*, exh. cat. (Newport, R.I.: William Vareika Fine Arts, 1995).

7. Notable among Twachtman's Newport watercolors is *Waterside Scene* (ca. 1889; Mead Art Museum, Amherst College, Massachusetts).

8. I would like to thank James Yarnall for his help in identifying the site in this painting.

32.

Newport Harbor ca. 1889

Pastel on pumice paper
12¼ × 9¾ inches
Signed lower right: *J. H. Twachtman*
Spanierman Gallery, LLC, New York

PROVENANCE

(Maynard Walker, New York, by 1966); to Mr. and Mrs. Ralph Spencer, 1967;
to present coll., 1990.

EXHIBITED

1966 Cincinnati Art Museum, no. 110 (p. 31 ill.).
1968 Ira Spanierman, no. 34 (p. 19 ill.).
Spanierman Gallery, New York, *The Spencer Collection of American Art*, June 13–29, 1990,
 no. 25 (pp. 52–53 color ill.).
1993 Spanierman Gallery.
Spanierman Gallery, LLC, New York, *Two Hundred Years of American Watercolors, Pastels,
 and Drawings*, April 16–June 30, 2001, no. 46.

LITERATURE

Lisa N. Peters et al., *The Spencer Collection of American Art*, exh. cat. (New York:
 Spanierman Gallery, 1990), pp. 52–53 color ill. (no. 25).
Peters, *John Twachtman (1853–1902) and the American Scene*, 1995, vol. 1, pp. xxviii,
 258–59; vol. 2, p. 797 ill. (Fig. 271).
Peters, *John Henry Twachtman: An American Impressionist*, 1999, pp. 80–81 color ill.

Most of the works Twachtman created during his stay in Newport in the summer of 1889 were pastels of the piers and docks of the town's commercial harbor. Using this subject matter as an armature, he drew quickly and succinctly, recording effects of light and shadow with the same emphasis as he did boats and architectural structures. In *Newport Harbor* he restricted his scope to an anchored fishing vessel. Set broadly and obliquely within the picture plane, it fills the paper. Carrying a full load, the boat is weighed down, with the result that the line of its hull forms a thin curve that Twachtman made the emphasis of his image, its firmness contrasted with the sketchy horizontals of the warehouses in the distance. Against the sandy red pumice paper, the white of the boat and water subtly creates a sense of luminosity. He drew in the boat's hold and masts with a minimum of line, yet with a surety that demonstrates the mastery of draftsmanship he had achieved in Paris.

This work could easily have been among the Newport pastels that Twachtman showed at the fourth exhibition of the Society of Painters in Pastel, held in June 1890. Of the works on view, this image might be close to one entitled *Mary Ann*. Along with the pastels *Sailboats* and *Coal Dock* (both unlocated), the works were pronounced "delightful marines touched in with spirit, but not made tedious."[1]

1. "Painters in Pastel," *New York Times*, May 5, 1890, p. 4.

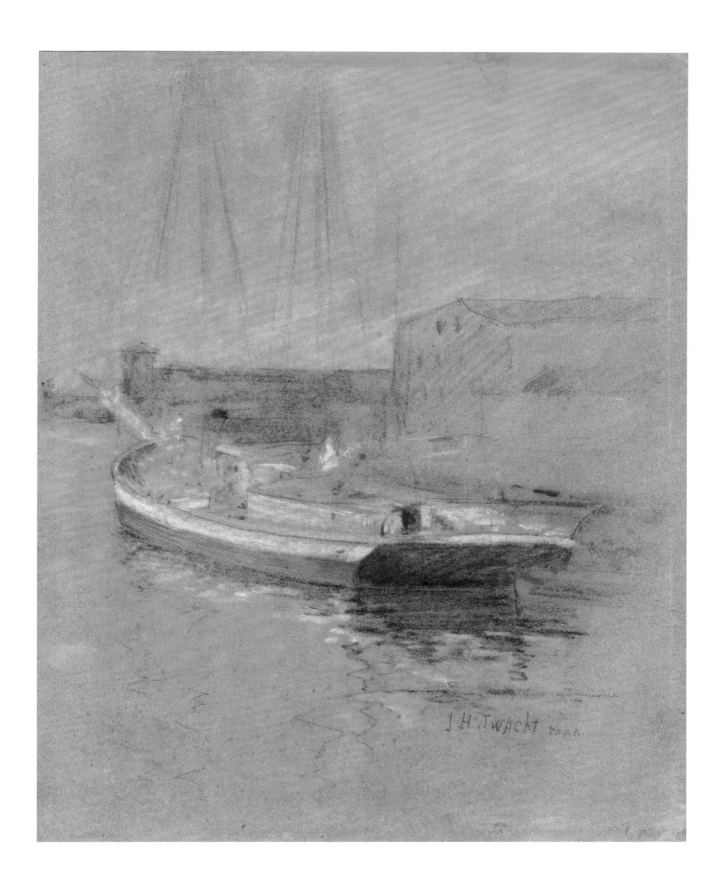

33.

Hollyhocks ca. 1892

Oil on canvas
29 × 24 inches
Signed lower right: *J. H. Twachtman*
Private Collection

PROVENANCE

(Macbeth Gallery, New York); to (Vose Galleries, Boston); to Harry W. Jones, Kansas City, Missouri, 1919; to Mr. and Mrs. David Findlay, New Canaan, Connecticut; by descent in the family to the present.

REFERENCE

Hale, *Life and Creative Development*, 1957, vol. 1, p. 337 ill. (Fig. 96); vol. 2, p. 554 (catalogue A, no. 277).

DURING THE years that he lived in Greenwich, Connecticut, from 1889 until 1900, Twachtman often painted the back of his house seen in conjunction with his garden or with flowers growing freely in his backyard. Here, instead of painting from the middle of the garden, as in *Greenwich Garden* (Cat. 34), his viewpoint was looking southeast from the grassy hillock situated about thirty feet behind the back of his house, just beyond the north end of the grass-covered root cellar (see Fig. 4). His interest in the artistic possibilities of every spot on his property is demonstrated by how he structured his subject to place the flowers in the forefront of the arrangement, a choice that accentuates the energy and great height of hollyhocks, a perennial bloom that grows with little tending. Twachtman often was drawn to wildflowers for how that they found their own way of harmonizing with their natural settings. Within the composition, the blossoms, painted with vigorously applied dabs of color, seem to reach as high as the house, their diffuse forms drawing our eye upward across the surface. The house, portrayed as a broad horizontal stretching almost across the upper register, by contrast, evokes a feeling of calm repose. Its position high in the pictorial field gives it a spiritual bearing.

The center point within the work is marked by a doorway with a small white pediment above it, located on back facade of the house. Even after a formal portico, thought to have been designed by the architect Stanford White, was added to the front of the house in the mid-1890s, this was the Twachtman family's preferred entry to their home: "Take the side path to the back of the house," a stranger was told by a hired worker on the property."[1] The doorway draws us into the scene, its role as mediator of the flow between the outdoors and the indoors suggested by way that the flowers reach up toward its opening.

In the painting, Twachtman evokes the popular idea of his era that a country house and its garden were to flow together, forming a unified arrangement. Sarah Cone described such a quality in an article in 1903 for *Country Life in America* magazine in which she described a home in Brookline, Massachusetts: "The whole garden is treated as an adjunct of the house ... [and] the grounds seem but to continue and expand from the house, and the house to concentrate the prevailing thought of its surroundings."[2]

Martha Twachtman, the artist's wife, noted about this work: "This was painted by my husband John H. Twachtman at our house in Greenwich about the year 1892." The painting was probably among the works that Martha Twachtman sold through Macbeth Gallery in the late 1910s or 1920s, but there is no evidence that it was exhibited during those years.

1. Goodwin, "An Artist's Unspoiled Country Home," 1905, p. 630.

2. Sara Cone Bryant, "A Suburban Place of Four Acres," *Country Life in America* 4 (August 1903), p. 267. For additional discussion of this subject, see Lisa N. Peters, "Cultivated Wildness and Remote Accessibility: American Impressionist Views of the Home and Its Grounds," in Peters, *Visions of Home: American Impressionist Images of Suburban Leisure and Country Comfort*, exh. cat. (Carlisle, Pa.: Dickinson College, 1997), pp. 9–33.

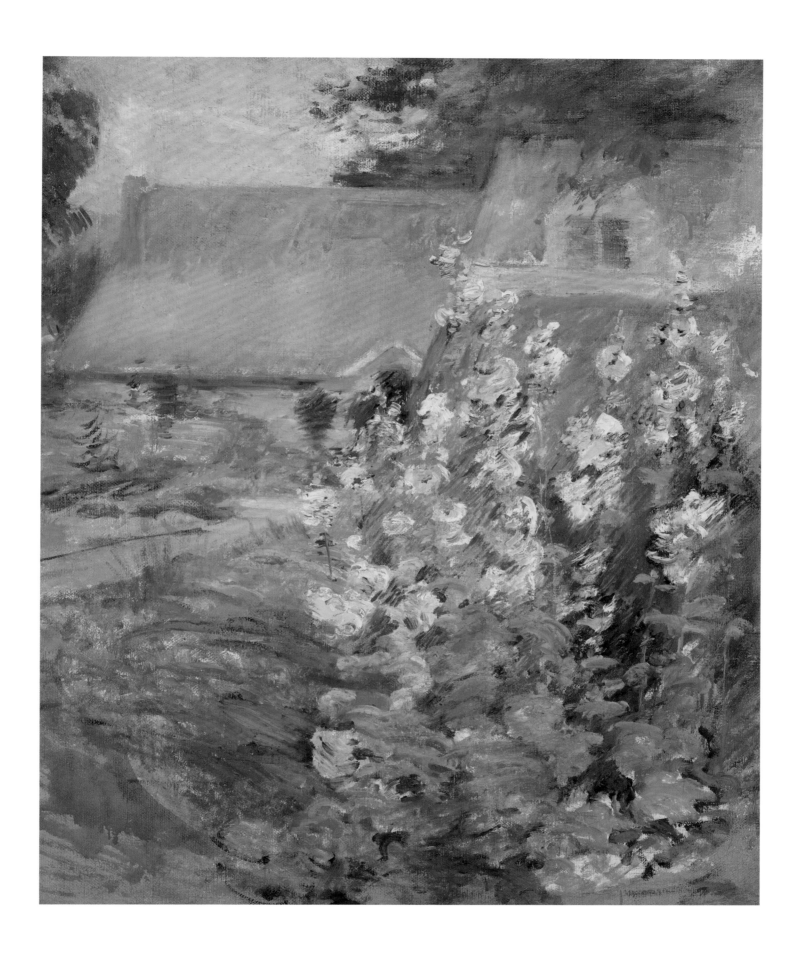

34.

Greenwich Garden late 1890s

Oil on canvas
30 × 30 inches
Signed lower left: *J. Alden Twachtman*
Spanierman Gallery, LLC, New York

PROVENANCE

J. Alden Twachtman, the artist's son, Greenwich, Connecticut; to his son, Dr. Eric Twachtman, Essex, Connecticut; by descent through the family; to present coll., 1990.

EXHIBITED

Bruce Museum, Greenwich, Connecticut, *Impressionist Painters of Connecticut*, June 23–September 29, 1996.
The Trout Gallery, Dickinson College, Carlisle, Pennsylvania, *Visions of Home: American Impressionist Images of Suburban Leisure and Country Comfort*, April 4–June 14, 1997, no. 20 (pp. 112–13 color ill.) (traveled to Florence Griswold Museum, Old Lyme, Connecticut, June 28–September 28, 1997; Indianapolis Museum of Art, May 23–August 8, 1999).

REFERENCES

Lisa N. Peters, *Visions of Home: American Impressionist Images of Suburban Leisure and Country Comfort*, exh. cat. (Hanover, N.H.: The Trout Gallery, Dickinson College, 1997), pp. 112–13 color ill. (no. 20).

Fig. 74
Twachtman, *Tiger Lilies*,
ca. 1890s, oil on canvas,
30⅛ × 25 inches,
location unknown.

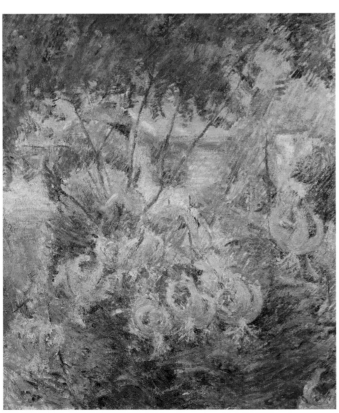

ALTHOUGH signed "J. Alden Twachtman," this painting seems primarily the work of John Twachtman, with a minimum of assistance provided by his eldest son, John Alden (1882–1974; named for his father and his father's close friend J. Alden Weir).[1] In many of his paintings of the back of his home, Twachtman stood on the hill to the north of it, portraying its relationship to its broader surroundings. In this painting, by contrast, the house is cropped, so that only a section of its back facade is seen in close up. The approach in this painting is similar to that in Twachtman's *Tiger Lilies* (Fig. 74). In both works the vivacious forms of the garden largely obscure the walls of the house, resulting in compositions that evoke Japanese prints in their lack of recession and in their flat, superimposed forms. In both paintings flowers seem interwoven with the forms of the house, their lines and shapes coalescing to form a unified arrangement. In *Greenwich Garden*, as in *Tiger Lilies*, the branches of a tree radiate from the middle ground, this movement countered by the cascading blossoms below that seem to spill outward beyond the limitations of the picture.

In his diary in 1894, Theodore Robinson had noted the "extraordinary combination of convention and reality" in "Japanese work," which provided "a new enjoyment."[2] Twachtman explored this combination in *Greenwich Garden*, revealing the way that seeing this familiar site in a new way could enhance his enjoyment of the locale itself.

As in *Hollyhocks* (Cat. 33), in *Greenwich Garden*, the pedimented doorway at the back of the house takes a central role. Here the flowers appear to nearly burst through to the indoors, while the leaves seem to replace the roof. The painting suggests Twachtman's feeling that nature was an integral part of his domestic experience in Greenwich. Perhaps the father took pleasure in involving his son in creating an image of an experience they shared, even going so far as to allow Alden to sign it. Only the somewhat mechanical clipped strokes in the upper leaves seem in keeping with Alden's style, comparable to a similar type of handling in paintings by him that are known.

Greenwich Garden remained in the family of artist's descendants until 1990.

1. Alden Twachtman studied at the Yale School of Art from 1897 through 1900, where one of his instructors was John Ferguson Weir. While at Yale, Alden received the Winchester Scholarship, enabling him to study in Paris. There he trained from 1901 to 1903 at the École des Beaux-Arts under Léon Bonnat. He received his B.F.A.

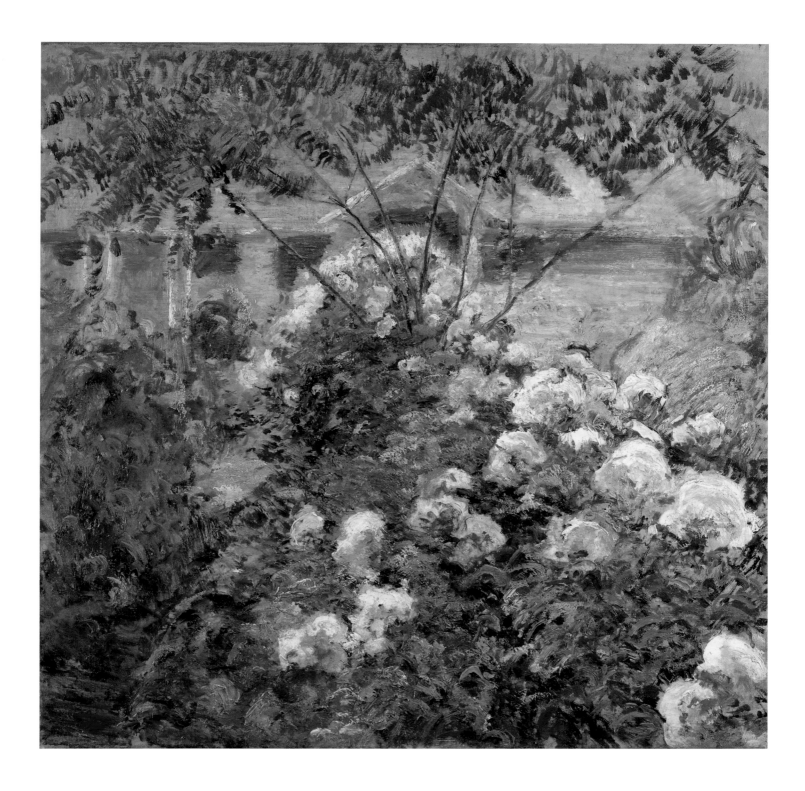

from Yale in 1905. After 1906 he became established as an architect and mural painter. His most significant project was a set of murals for the home of Henry Clay Frick, works that are now on the walls on a private floor of the Frick Collection. See William B. McCormick, "J. Alden Twachtman—Mural Painter," *International Studio* 75 (April 1922), pp. 91–96.

 2. Theodore Robinson diaries, February 17, 1894, Frick Art Reference Library, New York.

35.

House in Snow early 1890s

Oil on canvas
30 × 30 inches
Private Collection

PROVENANCE

Estate of the artist; (art market, by 1977); to (Terry De Lapp Gallery, Los Angeles, 1978); to (Hirschl & Adler Galleries, New York, 1978); to Steve Martin, Los Angeles; (Zabriskie Gallery, New York); to present coll., 1983.

TWACHTMAN portrayed his Greenwich home seen from the back in all seasons of the year, but he especially enjoyed depicting this subject during the winter, when snow blurred the boundaries between his house and land. Whereas *Snowbound* (early 1890s; Montclair Art Museum, New Jersey), *Snowbound* (ca. 1890s; Scripps College, Claremont, California), and *The Last Touch of Sun* (ca. 1893; Manoogian Collection) are midwinter scenes in which the ground is thickly covered with layers of old and new snow, *House in Snow* portrays a snowfall probably in the early spring. Here he captured the feeling of the conditions of this late snowfall by painting the ground with thin, translucent glazes in which he blended undertones of pinks, blues, and greens, creating a luminous surface from which color seems present but not apparent.

That Twachtman was fascinated by the presence of the one tree in his backyard that had already regained its leaves before the ground had cleared is suggested in this work, as he seems to have subtly organized his composition to emphasize this form and bring our attention to it. The opalescence of the snow and the lavenders in the stone wall that extends on a perpendicular from the house seem to accentuate, while harmonizing with, the glistening delicate greens of the new leafage. In addition, the tree's position in the work is not only central, but pivotal. It stands at the point where the diagonals of other, still bare trees converge with the diagonal of the stone wall. Its vertical form rises above and crosses over the horizontal shape of the house, while it is set as forward in the space as the house is set back within it. Thus, it balances the design both within its two-dimensional and three-dimensional aspects.

Twachtman seems to have purposefully simplified the form of his house in this work, smoothing its irregular lines and eliminating evidence of the dormers in its roof, the break between the new and old parts of the house

obscured by the tree, so as to further bring our gaze to the tree itself. *House in Snow* reveals the way that, no matter how many times Twachtman had observed and painted a site on his Greenwich property, he did not lose his ability to see it anew and to find a way to compose a work so as to bring out what had surprised and delighted him, without making his emphasis overly obvious. The perspective in this work is similar to that in his pen-and-ink drawing *Artist's House, Greenwich, Connecticut* (Cat. 72), in which the birdhouse that appears in other winter scenes from this angle is included. Its omission from this painting suggests that the work possibly predates the time that the birdhouse was erected or that Twachtman left it out for compositional reasons.

This is the first time that this painting is known to have been exhibited.

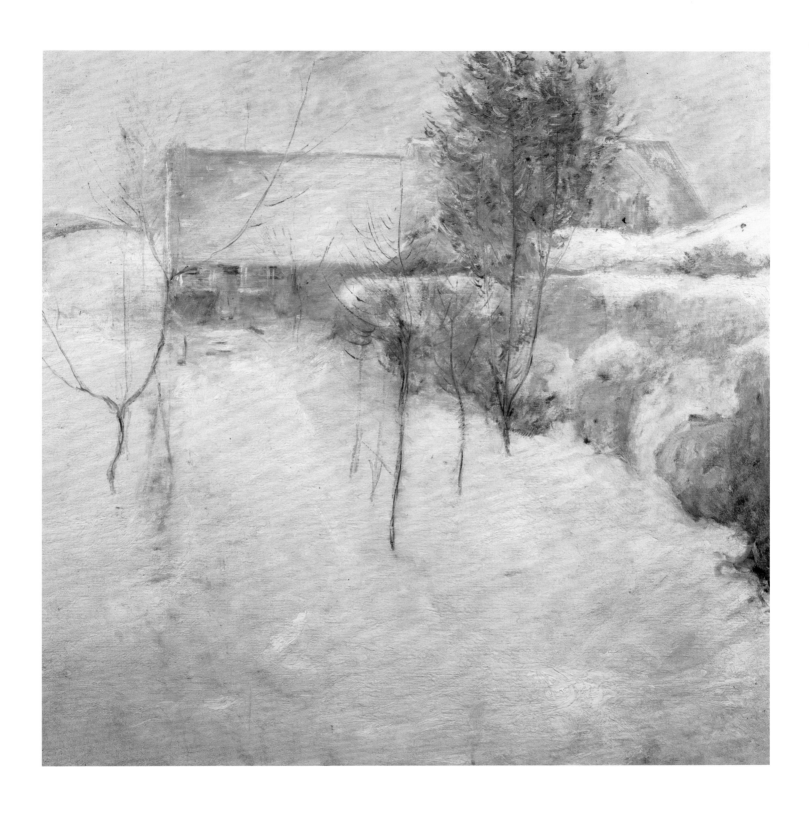

36.

Autumn Afternoon ca. 1894–95

Oil on canvas
20 × 16 inches
Signed lower left: *J. H. Twachtman*
Private Collection

PROVENANCE

(American Art Galleries, New York, *Modern Oil Paintings by American and Foreign Artists*, December 6–7, 1900, lot 162, as *Autumn Afternoon*); H. Wood Sullivan, Brooklyn; (American Art Association, New York, *Modern Paintings Principally by American Artists Collected by the Late H. Wood Sullivan*, Brooklyn, April 3, 1903, lot 48, as *Autumn Afternoon*); to A. A. Healy; John F. Braun, Philadelphia, as of 1919); to (Vose Galleries, Boston, 1919); to (Macbeth Gallery, New York, 1920); to George Horace Lorimer, New York); bequest to Cary William Bok, Camden, Maine; to Robert C. Vose Jr., Boston, 1969; to private collection, 1992; to (Christie's, New York, May 26, 1999, lot 60, as *Artist's House through the Trees*); to present coll., 1999.

EXHIBITED

1919 Vose Gallery II, no. 9.
Hurlbutt Gallery, Greenwich Library, Connecticut, *Connecticut and American Impressionism: The Cos Cob Clapboard School*, March 20–May 31, 1980, no. 68 (as *Twachtman's Home*).
Colby College Museum of Art, Waterville, Maine, *Friends Collect: Selections from Private Collections of Friends of Art at Colby*, August 5–October 18, 1987, no. 100 (as *Artist's House*).

REFERENCES

"Wood-Sullivan Pictures," *New York Times*, April 1, 1903, p. 8.
"Pictures at Auction: The H. W. Sullivan Collection of One Hundred Canvases Sold for $25,271," *New York Times*, April 4, 1903, p. 8.
"Some Recent Art Sales," *Brush and Pencil* 12 (1903), p. 119.
Hale, *Life and Creative Development*, 1957, vol. 2, p. 428 (catalogue G, no. 21).

TWACHTMAN's vantage point in this scene is looking from just west of his home over the uneven rises of his Greenwich property, marked with outcroppings of rocks, toward the side and the front of his house. The approximate date of this painting can be determined from its architectural features. The gabled western end of the house is higher than it would be after Twachtman extended this part of the house into the side of the hill in the mid-1890s. In addition, the curved projecting form of old bay front of the house can be discerned through the trees. He would also change this part of the house in the mid- or late 1890s, adding a columned portico, thought to have been designed by the architect Stanford White. Another painting by Twachtman probably dating from this time, *September Sunshine* (ca. 1894; Horowitz Collection), similarly shows the old projecting bay front, while including the "open-air" dining room that was the result of an earlier renovation in which Twachtman removed the stairs leading up to what had been an earlier front porch.

In *Autumn Afternoon*, our gaze is guided directly into the flickering leaves through which the house's color, described by Alfred Goodwin in

1905 as a "gentle white, not a blatant white" is in harmony with the landscape.[1] The house seems woven into nature, its sunlit western end culminating the upward line of the hill. In this painting Twachtman expressed the way that his house followed the contours of the land, illustrating Goodwin's observation that it flowed "up the hill" and "fit into the curves," continuing "on up to the crest.[2] By using a vivacious Impressionist approach, he conveyed his affection for this vision of comfort and harmony.

This painting has the distinction of being perhaps the only work by Twachtman to have been put in an auction during his lifetime in the years following the show and sale of his work along with that of Weir, held in February 1889 at the Fifth Avenue Galleries in New York. The sale in which this painting appeared, entitled *Modern Oil Paintings by American and Foreign Artists*, was held in December 1900 at the American Art Galleries in New York (listed with dimensions of 20 by 16 inches), and the painting was identified in the catalogue as *Autumn Afternoon*. Whether Twachtman himself put the painting into the auction is unknown, but this title may well have been chosen by him, as it is typical of the generic names he often assigned his works. The buyer of the painting from the sale was probably the Brooklyn leather merchant H. Wood Sullivan (1850–1903), as the work was included in an auction of works from Sullivan's estate, held in April 1903. The catalogue listed it again as *Autumn Afternoon* and provided a description, while the *New York Times* stated that the work "appears to be a view of [the artist's] house at Greenwich, Conn., seen through the rich foliage of Autumn from the front, with one gable end in the sunlight." As published reports of the sale indicate, the painting was purchased for $170 by A. A. Healy, who also bought works by Childe Hassam and J. Francis Murphy.[3]

By 1919 the painting belonged to the noted Philadelphia manufacturer, concert singer, and art collector John F. Braun (1866/67–1939),[4] who sold it to or placed it with Vose Galleries in 1919. While at Vose, the painting was set in a frame made by Hermann Dudley Murphy, bearing Murphy's inscribed monogram and the date 1919. The painting was shown, still entitled *Autumn Afternoon*, in the exhibition of Twachtman's art that the gallery held in February 1919.

Shortly after this show, the painting was sold, through the aegis of Macbeth Gallery, to George Horace Lorimer (1867–1937), the dynamic editor in chief of the *Saturday Evening Post*, who owned it

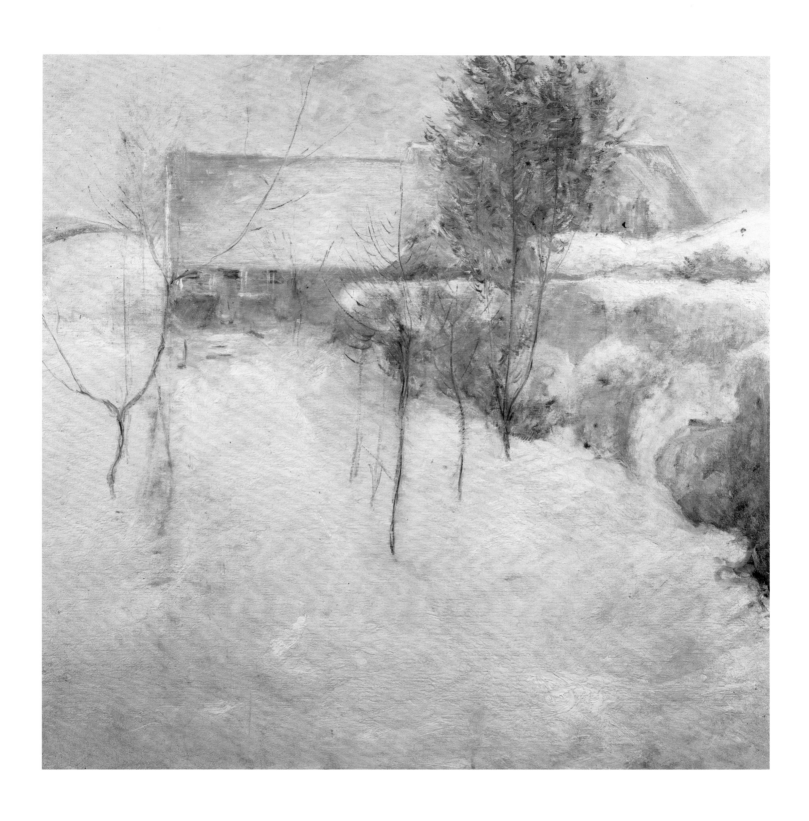

36.

Autumn Afternoon ca. 1894–95

Oil on canvas
20 × 16 inches
Signed lower left: *J. H. Twachtman*
Private Collection

PROVENANCE

(American Art Galleries, New York, *Modern Oil Paintings by American and Foreign Artists*, December 6–7, 1900, lot 162, as *Autumn Afternoon*); H. Wood Sullivan, Brooklyn; (American Art Association, New York, *Modern Paintings Principally by American Artists Collected by the Late H. Wood Sullivan*, Brooklyn, April 3, 1903, lot 48, as *Autumn Afternoon*); to A. A. Healy; John F. Braun, Philadelphia, as of 1919); to (Vose Galleries, Boston, 1919); to (Macbeth Gallery, New York, 1920); to George Horace Lorimer, New York); bequest to Cary William Bok, Camden, Maine; to Robert C. Vose Jr., Boston, 1969; to private collection, 1992; to (Christie's, New York, May 26, 1999, lot 60, as *Artist's House through the Trees*); to present coll., 1999.

EXHIBITED

1919 Vose Gallery II, no. 9.
Hurlbutt Gallery, Greenwich Library, Connecticut, *Connecticut and American Impressionism: The Cos Cob Clapboard School*, March 20–May 31, 1980, no. 68 (as *Twachtman's Home*).
Colby College Museum of Art, Waterville, Maine, *Friends Collect: Selections from Private Collections of Friends of Art at Colby*, August 5–October 18, 1987, no. 100 (as *Artist's House*).

REFERENCES

"Wood-Sullivan Pictures," *New York Times*, April 1, 1903, p. 8.
"Pictures at Auction: The H. W. Sullivan Collection of One Hundred Canvases Sold for $25,271," *New York Times*, April 4, 1903, p. 8.
"Some Recent Art Sales," *Brush and Pencil* 12 (1903), p. 119.
Hale, *Life and Creative Development*, 1957, vol. 2, p. 428 (catalogue G, no. 21).

TWACHTMAN's vantage point in this scene is looking from just west of his home over the uneven rises of his Greenwich property, marked with outcroppings of rocks, toward the side and the front of his house. The approximate date of this painting can be determined from its architectural features. The gabled western end of the house is higher than it would be after Twachtman extended this part of the house into the side of the hill in the mid-1890s. In addition, the curved projecting form of old bay front of the house can be discerned through the trees. He would also change this part of the house in the mid- or late 1890s, adding a columned portico, thought to have been designed by the architect Stanford White. Another painting by Twachtman probably dating from this time, *September Sunshine* (ca. 1894; Horowitz Collection), similarly shows the old projecting bay front, while including the "open-air" dining room that was the result of an earlier renovation in which Twachtman removed the stairs leading up to what had been an earlier front porch.

In *Autumn Afternoon*, our gaze is guided directly into the flickering leaves through which the house's color, described by Alfred Goodwin in 1905 as a "gentle white, not a blatant white" is in harmony with the landscape.[1] The house seems woven into nature, its sunlit western end culminating the upward line of the hill. In this painting Twachtman expressed the way that his house followed the contours of the land, illustrating Goodwin's observation that it flowed "up the hill" and "fit into the curves," continuing "on up to the crest.[2] By using a vivacious Impressionist approach, he conveyed his affection for this vision of comfort and harmony.

This painting has the distinction of being perhaps the only work by Twachtman to have been put in an auction during his lifetime in the years following the show and sale of his work along with that of Weir, held in February 1889 at the Fifth Avenue Galleries in New York. The sale in which this painting appeared, entitled *Modern Oil Paintings by American and Foreign Artists*, was held in December 1900 at the American Art Galleries in New York (listed with dimensions of 20 by 16 inches), and the painting was identified in the catalogue as *Autumn Afternoon*. Whether Twachtman himself put the painting into the auction is unknown, but this title may well have been chosen by him, as it is typical of the generic names he often assigned his works. The buyer of the painting from the sale was probably the Brooklyn leather merchant H. Wood Sullivan (1850–1903), as the work was included in an auction of works from Sullivan's estate, held in April 1903. The catalogue listed it again as *Autumn Afternoon* and provided a description, while the *New York Times* stated that the work "appears to be a view of [the artist's] house at Greenwich, Conn., seen through the rich foliage of Autumn from the front, with one gable end in the sunlight." As published reports of the sale indicate, the painting was purchased for $170 by A. A. Healy, who also bought works by Childe Hassam and J. Francis Murphy.[3]

By 1919 the painting belonged to the noted Philadelphia manufacturer, concert singer, and art collector John F. Braun (1866/67–1939),[4] who sold it to or placed it with Vose Galleries in 1919. While at Vose, the painting was set in a frame made by Hermann Dudley Murphy, bearing Murphy's inscribed monogram and the date 1919. The painting was shown, still entitled *Autumn Afternoon*, in the exhibition of Twachtman's art that the gallery held in February 1919.

Shortly after this show, the painting was sold, through the aegis of Macbeth Gallery, to George Horace Lorimer (1867–1937), the dynamic editor in chief of the *Saturday Evening Post*, who owned it

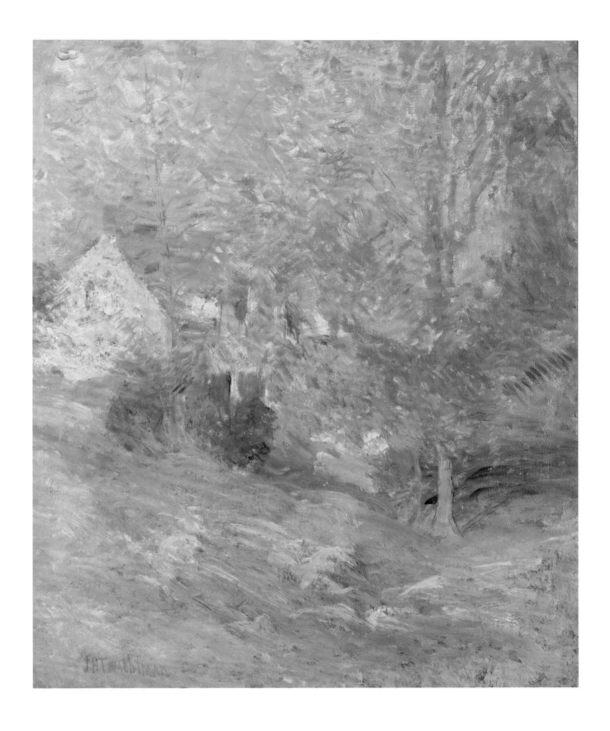

until 1937, when it went by Lorimer's bequest to Cary William Bok (1905–1970), the grandson of Cyrus Curtis, who had hired Lorimer and who owned the publishing company that produced *Saturday Evening Post*.[5] Perhaps aware of Vose Galleries' earlier ownership of the painting, Bok sold the painting to Robert C. Vose Jr. for his personal collection in 1969, and it was retained by Vose until 1992. At some point after the Vose exhibition of 1919, the title by which the painting had been known throughout its earlier history was forgotten, and it was exhibited with various other titles referring to its subject as the artist's home.

1. Goodwin, "An Artist's Unspoiled Country Home," 1905, p. 628.

2. Ibid., p. 625.

3. The three articles that appeared on this sale are listed above, in References. Works by Ralph Blakelock, Bruce Crane, Childe Hassam, George Inness, J. Francis Murphy, Henry Ward Ranger, and Theodore Robinson represented the American selections in the sale.

4. On Braun, see "John F. Braun Dead: A Patron of Arts, 72," *New York Times*, November 19, 1972, p. 39 and "John F. Braun, "Why Nationalism in Art?" *American Magazine of Art* 20 (October 1929), pp. 569–70.

5. Lorimer was made director of the Curtis Publishing Company in 1903 when Bok was its senior vice president.

Artist's Home Seen from the Back ca. 1893–95

Oil on panel
24 × 15 inches
Signed lower left: *J. H. Twachtman*
Private Collection

PROVENANCE

Possibly, Mr. Morrison, 1962; private collection, 1981; to (Sotheby's, New York, May 29, 1981, lot 27); to (Hirschl & Adler Galleries, New York, 1981–82); to private collection, 1982; through (Hirschl & Adler Galleries) to present coll., 1994.

TWACHTMAN chose yet another vantage point toward the back of his home in this work. Standing just above where he had painted *Hollyhocks* (Cat. 33), he looked in a northwesterly direction across the corner of the root cellar and the edge of the roof of his Greenwich house to Round Hill Road and the hills beyond. The steps in the right foreground are those that Alfred Goodwin reported had demonstrated the artist's handling of "native stone work," using "various sizes of stones," their irregular placement "fitted in, no mortar being used."[1] A vertical structure just below the steps were probably set in place by the artist to protect a new tree, demonstrating the attention he gave to even the smallest detail of his property. Near the edge of the road is the small building that contained a well, its gabled form a diminutive version of the larger house, as if announcing the presence of the young occupants of this domain.

In his winter scenes portraying his home from the back, Twachtman usually employed canvases that were horizontal, a format according with the shape of the house and expressing the quiet harmony he had achieved between it and the lay of the land, as it was both ensconced in and calmly presiding over its surroundings (see Cats. 35, 72). By contrast, in this vivid painting, he used a vertical format, evoking his study of Japanese pillar prints, and using this format to create an abstract design and evoke a feeling of uplift. The house seems allied with the dynamic feeling of this sunny summer day. Although the curved line of the top of the root cellar overlaps with the roof of the house, the house does not seem set back in space, as both forms seem to rise upward across the surface. This movement is continued in the chimney, which echoes the tree rising above the house. The lines of the road and hills at the left also form a flat pattern, extending horizontally across the surface. The vivacity of the heightened color and the tight, broken brushwork, reflecting

Twachtman's thorough absorption of Impressionist methods, comply with the dynamism of the arrangement.

In 1962 this painting was brought for inspection to the artist's son J. Alden Twachtman by an individual known only as "Mr. Morrison."[2] Alden identified the subject of the work and suggested that it was painted sometime between 1893 and 1895, a date that coincides with the time Twachtman was creating works that most fully employed Impressionist precepts.

An oil sketch on the verso features a tree and a sketchy landscape, in which the roof of a building appears at the right. The early history of this painting is unknown but will someday, with luck, be determined.

1. Goodwin, "An Artist's Unspoiled Country Home," 1905, p. 629.
2. See Alden Twachtman note, August 13, 1962, copy, Archives, Spanierman Gallery, LLC, New York.

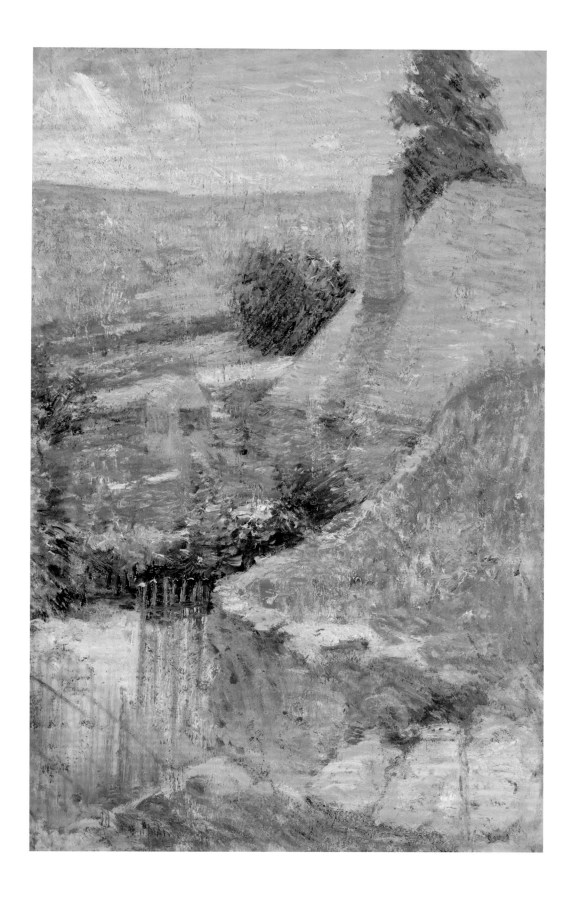

38.

Artist's Home in Autumn, Greenwich, Connecticut ca. 1895

Oil on canvas
25¼ × 30¼ inches
Signed lower right: *J. H. Twachtman*
Spanierman Gallery, LLC, New York

PROVENANCE

Robert E. Tod, New York; gift to Metropolitan Museum of Art, New York, 1930; to (Sotheby's, New York, October 25, 1979, lot 130, as *House in a Landscape*); to (Hirschl & Adler Galleries, New York, 1979); to Thomas Thompson, Houston, Texas; to Lacey Neuhaus, Houston, Texas; to (Berry-Hill Galleries, New York); to Saul Siegel, Memphis, Tennessee, 1980; to (Sotheby's, New York, May 18, 2005, lot 40, as *Landscape*); to present coll., 2005.

EXHIBITED

The Art Association of Newport, Rhode Island, *Retrospective Exhibition of the Work of Artists Identified with Newport, Rhode Island*, July 25–August 16, 1936, no. 96 (as *Landscape*, lent by the Metropolitan Museum of Art, New York).
1966 Cincinnati Art Museum, no. 43 (as *Landscape*, lent by the Metropolitan Museum of Art, New York).
Hathorn Gallery, Skidmore College, Saratoga Springs, New York, *Some Quietist Painters: A Trend toward Minimalism in Late Nineteenth-Century American Painting*, April 8–29, 1970, no. 22 (as *Landscape*, lent by the Metropolitan Museum of Art, New York).

REFERENCES

Albert Ten Eyck Gardner, *A Concise Catalogue of the American Paintings in the Metropolitan Museum of Art, New York* (New York: Metropolitan Museum of Art, 1957), p. 46 (as *Landscape*).
Hale, *Life and Creative Development*, 1957, vol. 2, p. 558 (catalogue A, no. 336, as *Landscape*).

WHEN THIS painting was in the collection of the Metropolitan Museum of Art, from 1930 until 1979, it was known simply as *Landscape* or *House in Landscape* and its site was considered unknown. Its location has since been identified as Twachtman's Greenwich property, looking eastward over the brow of the hill toward his house.[1] Its present title thus reflects its subject. The gabled side of the house belongs to a section that the artist added in the mid-1890s. Here, instead of leveling the ground, he lay the new foundation on the rise of the land. In his 1905 article on Twachtman's home, Alfred Goodwin commented on the result of this renovation: "so neatly does [the house] fit its little niche between the hills that the second story at the west opens by door and window to a ground level, so that one can step outdoors from upstairs as easily as from the front door."[2] This is the only known work in which Twachtman painted from this vantage point.

Here he accentuated the way that the house rested on the land. Its forms, aligned with the crests of the near and far hills, are anchored between these rises. The exaggerated size of the trees at either side of the house convey the way that the off-white structure not only fit into its site but was also embraced by it. He also appears to have broadened the span of the near hill, so that our eye is drawn over the patterns of light and shadows on the uneven ground, where the land is already tinted with the golden browns of autumn, while the color of summer light remains. As in other works, he set the house high in the canvas, its spiritual presence suggested in the way that it presides over the landscape.

1. I would like to thank John Nelson for his help in identifying this site.
2. Goodwin, "An Artist's Unspoiled Country Home," 1905, p. 628.

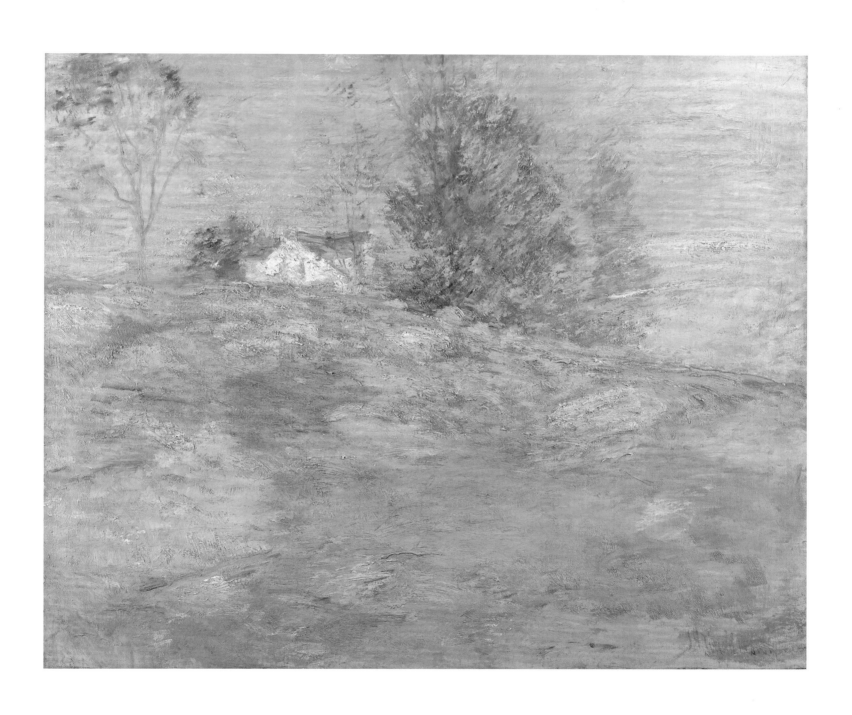

39.

Flower Still Life ca. 1890s

Oil on canvas
20½ × 14½ inches
Spanierman Gallery, LLC, New York

PROVENANCE

Violet Twachtman Baker, the artist's daughter, New York; by descent through the family;
to present coll., 1987.

EXHIBITED

Spanierman Gallery, New York, *The American Still Life: From the Antebellum Era to the
Roaring Twenties, 1850–1930*, July 8–September 27, 1991.

TWACHTMAN rendered flowers mostly in situ, whether in pastels and oils of wildflowers growing freely in fields and meadows (Cat. 30 and Fig. 57) or oils portraying his own loosely tended garden.[1] For only two works is he known to have brought these blossoms indoors, portraying them in a traditional still-life format. In *Flowers* (ca. 1892; Pennsylvania Academy of the Fine Arts, Philadelphia), he painted tall gladioli rising from a glass vase set on a table.[2] Using lively Impressionist handling throughout the work, he broke from still-life conventions, rendering floral forms with a flickering dabs of color so that they seem suffused into the atmospheric light of their surroundings. *Flowers* was probably included as *Gladiolus* in the 1893 exhibition at the American Art Galleries, in which Twachtman's and Weir's works were shown alongside those of Claude Monet and Paul-Albert Besnard, demonstrating that Twachtman felt that it exemplified his achievement as he gained renown as one of America's leading Impressionists.

By contrast, *Flower Still Life* is a casual oil sketch that Twachtman probably created to please himself and his family. The red and white flowers, maybe salvia and phlox picked from his backyard, are set in a simple earthenware pitcher, perhaps used on the dining table. Twachtman painted the blossoms with thick, blotted dabs of color, conveying their vivacity rather than their particular features. He left the background largely undifferentiated, painting it with layered effects of greens blended with yellows and oranges, against which the brightness of the flowers is heightened. In its rustic simplicity and lack of sentimental appeal, *Flower Still Life* evokes the images of just such humble subjects by the French still life master of the eighteenth century Jean Baptiste Siméon Chardin.

This unsigned work remained in the hands of the descendants of the artist's daughter Violet until 1987.

1. On Twachtman's floral works, see William H. Gerdts, "'Like Dreams of Flowers,'" in Peters et al., *In the Sunlight*, 1989, pp. 21–36.
2. See Peters et al., *In the Sunlight*, 1989, pp. 70–71.

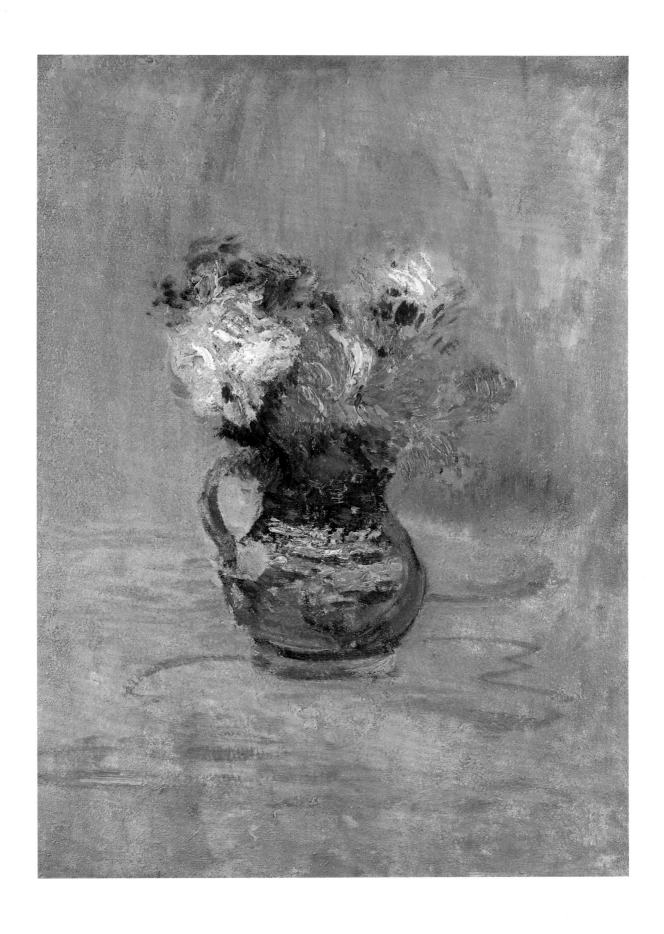

40.

Barn in Winter, Greenwich, Connecticut early 1890s

Oil on canvas
18 × 26 inches
Signed lower left: *J. H. Twachtman*
Spanierman Gallery, LLC, New York

PROVENANCE

Private collection, Boston; (Vose Galleries, Boston, 1967); private collection, Minnesota, 1968; to (Spanierman Gallery, New York, 1986); to private collection, 1990; to (Sotheby's, New York, May 18, 2005, lot 22 as *Winter Harmony*); to present coll., 2005.

EXHIBITED

Spanierman Gallery, LLC, New York, *The Poetic Vision: American Tonalism*, November 12, 2005–January 7, 2006, no. 39 (pp. 171 color ill., 172).

REFERENCES

Chotner, Peters, and Pyne, *John Twachtman: Connecticut Landscapes*, 1989, pp. 26 ill., 37 (as *Winter Harmony*).
Peters et al., *In the Sunlight*, 1989, pp. 13, 16 color ill. (as *Winter Harmony*).
Peters, *John Twachtman (1853–1902) and the American Scene*, 1995, vol. 1, p. 347; vol. 2, p. 882 ill. (Fig. 368, as *Winter Harmony*).
Lisa N. Peters, entry, "John Henry Twachtman," in Ralph Sessions et al., *The Poetic Vision: American Tonalism*, exh. cat. (New York: Spanierman Gallery, 2005), pp. 171 color ill., 172 (no. 39).

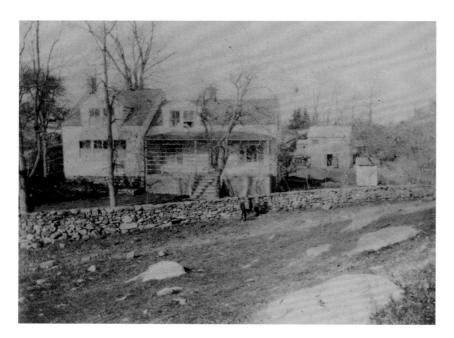

Fig. 75
Photograph, Twachtman's house, south/front facade, Greenwich, Connecticut, ca. 1889, private collection.

THIS PAINTING was entitled *House on Round Hill Road* when it arrived at Vose Galleries in Boston in 1967. When the gallery sold the work in the following year, it had been retitled *Winter Harmony*, the same name as a view by Twachtman of the hemlock pool on his Greenwich property that had entered the collection of the National Gallery of Art, Washington, D.C., three years earlier. Yet the title *Winter Harmony* was of recent vintage, since it does not appear to be associated with any works that Twachtman exhibited during his lifetime or that belonged to his estate. To distinguish it from the National Gallery's hemlock pool scene, and to assign it a title relevant to its subject, this painting has been renamed *Barn in Winter, Greenwich, Connecticut*. The scene portrayed is one that Twachtman depicted often, a view looking north from the back of his Greenwich house toward his barn, just west of Round Hill Road. This view may be seen in a photograph looking north past both the artist's house and the barn that was taken shortly after Twachtman settled in Greenwich in 1889 (Fig. 75). This square, high-roofed barn, where the artist and his family stabled ponies and donkeys, still stands today. Although it was expanded and its roofline lowered, its original shape may still be discerned.

Twachtman featured his barn in eight paintings that are known today. Of these, seven are similarly composed winter scenes on canvas, while the eighth is a smaller, sketchy oil on panel rendered in the spring.[1] Twachtman seems to have been fascinated by the compositional possibilities of the square-shaped building in relation to its snow-covered surroundings, creating arrangements that have a quiet trancelike effect on the viewer.

As a comparison of this painting with *Winter Landscape* (Cat. 41) reveals, Twachtman was interested in the how subtle differences in shape, light, atmosphere, and angle produced unique images. In *Barn in Winter, Greenwich, Connecticut*, the light rose-orange-toned barn, set high in the space, draws our eye upward across the surface of the painting, through the curving lines created by wet and melting snow and the patterns of blue and lavender shadows and reflections from a diffused emerging sunlight. The barn is linked with its site through the repetition of its tones in the landscape and in the lines of the road, which Twachtman rendered by leaving the primed canvas exposed, an aspect of the work that a conservator once misunderstood and filled in. The trees in the left distance are similarly rendered by leaving bare canvas visible, making them seem to blend into the atmospheric distance.

Whereas in another barn scene, *Winter* (ca. 1890; Phillips Collection, Washington, D.C.), the barn fades into the landscape, here it seems to rest gently within its setting, taking neither a commanding nor a retreating role, thus exuding a sense of presence and humility at the same time. The result is a feeling of harmonious balance that one could receive either from nature and or from within oneself.

This work may well have been one of the two barn scenes that Twachtman included in his solo exhibition at the Wunderlich Gallery in 1891 in New York, one of which was entitled *The Barn—Winter* and the other of which was entitled *Snow in Sunlight*. For the critics' discussions of these works, see Cat. 41.

1. All the winter scenes are oil on canvas and rendered presumably in the 1890s. They are *Winter* (21⁵⁄₁₆ × 26⅛ inches; Phillips Collection, Washington, D.C.); *Winter Landscape* (Cat. 41); *Winter Landscape* (24¾ × 15¾ inches; private collection); *Winter Landscape* (25½ × 32 inches; private collection); *Snow* (26 × 32 inches; private collection); and *Snow* (30 × 30 inches; Pennsylvania Academy of the Fine Arts, Philadelphia). The spring scene is *Barn in Greenwich* (oil on panel, 12 × 14¾ inches; private collection). The barn may also be seen in *Round Hill Road* (Fig. 55).

41.

Winter Landscape early 1890s

Oil on canvas
22⅛ × 30 inches
Signed lower left: *J. H. Twachtman*
Private Collection

PROVENANCE

(Frank K. M. Rehn Gallery, New York); to J. K. Newman, 1925; to (American Art Association, New York, *Important Paintings: The Private Collection of J. K. Newman*, December 6, 1935, lot 17); Michael Taradash, New York; to (Ira Spanierman, Inc., New York, by 1968); to private collection, 1968; by descent in the family.

EXHIBITED

1968 Ira Spanierman, no. 19.

W*inter Landscape* portrays the same subject as *Barn in Winter, Greenwich, Connecticut* (Cat. 40), depicting a view looking north from the back of Twachtman's house toward his barn (see Fig. 75), at the side of Round Hill Road. As in *Barn in Winter*, here the reddish-peach building is set high in the canvas, its tone similar to that of the sky, which seems to be in the process of darkening as a storm approaches from the north. Rendered more crisply than in *Barn in Winter*, the building in this painting is set more distinctly apart from the landscape. Thus, it seems a beacon of security and strength, by contrast with its more wraithlike presence in *Barn in Winter* and in *Winter* (ca. 1890; Phillips Collection, Washington, D.C.). Contrasting with the color of the sky, the broad blue shadows running lengthwise across the snow in the canvas's lower register evoke a feeling of the day's chill and gathering shadows as a front moves in. Against this frosty landscape, the steadfast barn seems to provide protection, its small door guarded by high walls. More isolated in the space than in *Barn in Winter*—with distance between it and the hill at its left—the barn also evokes a feeling of isolation, the sense that it has barricaded itself against the elements. This may have been a feeling with which Twachtman was familiar, as collectors of his time paid little attention to his work.

The critics of Twachtman's day grasped his objectives and praised the two barn scenes that were among the twelve oils he exhibited at Wunderlich Gallery in 1891. A writer for the *New York Evening Post* observed: "'The Barn—Winter,' No. 10, with the pale sunshine falling on the white walls of the barn and the broad expanse of snow that covers the ground, is truthfully observed, and the motive is interpreted with a great deal of refinement and distinction in the color scheme." This critic also found *Snow in Sunlight*, the other barn scene, to be "real and good."[1] The reviewer for the *Art Amateur* saw how Twachtman had interpreted his subject in different ways, noting:

> Twelve of the sketches were in oils, several of them being snow scenes of extraordinary brilliancy. "Snow in Sunlight" and "The Barn Winter" were among the best. The scene is the same in both—a rocky bit of ground on the confines of a small wood, with a yellow barn in the middle distance. Nothing could be more prosaic as to its associations, yet the painter has obtained from it two studies, which may be compared for poetic feeling to Whittier's "Snow-Bound." The changes of the shadows on the snow make them two different pictures.[2]

Although Twachtman's barn scenes have seemingly little to do with John Greenleaf Whittier's idyll of 1866, which focuses on a community taking refuge from a cruel and harsh winter storm in indoor storytelling, the sense of the metamorphic impact of winter and the refuge of home is suggested in both. Whittier's description of sun shining "through dazzling snow-mist" and of "woodland paths that wound between / Low drooping pine-boughs winter-weighted" can be associated with Twachtman's transformation into dreamlike visions of his own root-filled, rockbound, and unleveled backyard and of the barn where he kept ponies and donkeys for his children to ride. Twachtman's barn scenes similarly evoke Ralph Waldo Emerson's poem "The Snow Storm" of 1835, the inspiration for Whittier's poem, in which Emerson described the arrival of snow: "Seems nowhere to alight: the whited air / Hides hill and woods, the river, and the heaven / And veils the farmhouse at the garden's end." That critics often related Twachtman's works to the writings of Emerson and Henry David Thoreau reflects just this sort of awareness of the parallel sensitivity to the vicissitudes of nature in New England on the part of Twachtman and his Transcendentalist predecessors.

This painting was last exhibited in 1968.

[1.] "Art Notes: Pictures by J. H. Twachtman at Wunderlich," *New York Evening Post*, March 9, 1891, p. 7.
[2.] "My Notebook," *Art Amateur* 24 (April 1891), p. 116.

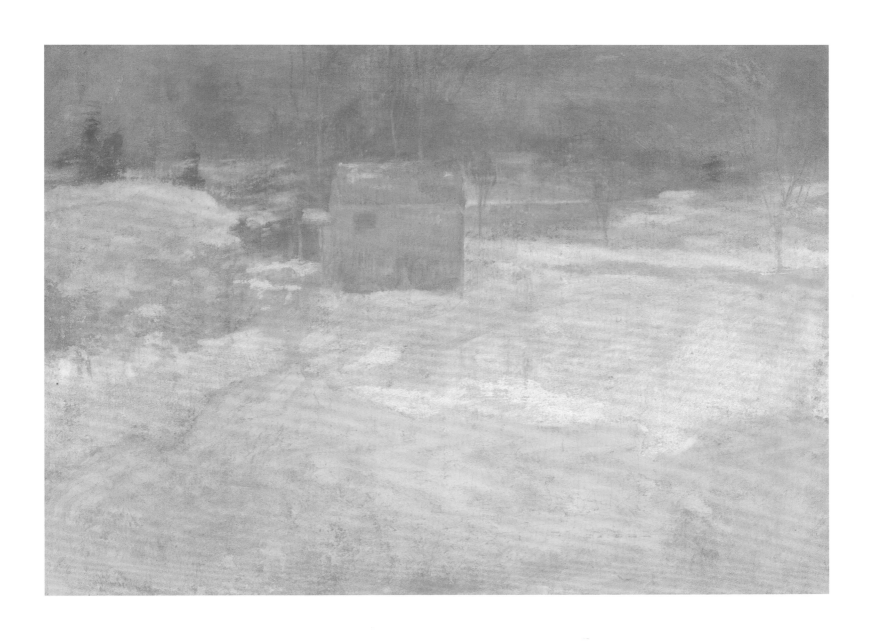

42.

Road over the Hill ca. 1890s

Oil on panel
19 × 20 inches
Stamped lower left: *Twachtman Sale*
Private Collection

PROVENANCE

(American Art Galleries, New York, *Sale of the Work of the Late John H. Twachtman*, March 24, 1903, lot 48, as *Road over the Hill*); to Edward A. Rorke; (Frank Rehn Gallery, New York); to Dr. Diane Tannenbaum, New York, 1970; to Robert Austin, 1992; through (Jordan-Volpe Gallery, New York); to present coll., 1999.

TWACHTMAN'S view for this work is probably looking at some point along Round Hill Road, near his Greenwich home. His high angle of vision reflects the influence of Japanese prints, as does the way the line of the road draws our eye across the surface rather than into depth. The time of year appears to be spring, and Twachtman portrayed this season of renewal by treating forms in a generalized, indistinct manner, suggestive of their nascent, tentative character. He limited his palette mostly to lavender and green, along with touches of blue, yellow, and peach, expressing the feeling of a light that is neither too bright nor too subdued, while the deeper rust red tone of the panel is used as a color in the composition that sets the lighter tones into relief, heightening their luminosity. Twachtman's handling is also in keeping with the gentle feeling in this scene, as he used energetic brushwork that was not overly forceful but also not too light.

The red stamp at the lower left indicates that it was in the 1903 sale of works from Twachtman's estate, in which its dimensions and subject matter match number 48 in the catalogue, identified as *Road over the Hill*. The work was purchased from the sale, along with nine others, by Edward A. Rorke (1856–1905), a painter of genre scenes and landscapes (among the other works Rorke bought was *The Hidden Pool*, now in the Freer Gallery of Art [Fig. 65]).[1] *Road over the Hill* was next known to have been in the hands of the dealer Frank Knox Morton Rehn (1886–1956), who promoted the works of American Scene painters in the 1920s and 1930s, including Edward Hopper and Charles Burchfield.[2]

1. Rorke was a member of group called the Brooklyn Ten in 1901–2. The other painters in this group were W. S. Barrett, Frederick Boston, Joseph Boston, Charles Burlingame, Paul Dougherty, Benjamin Eggleston, George McCord, Harry Roseland, and Gustave Wiegand. In 1903 the Brooklyn Ten became known as the Society of Brooklyn Painters.

2. The gallery remained in existence for twenty-five years after Rehn's death in 1956.

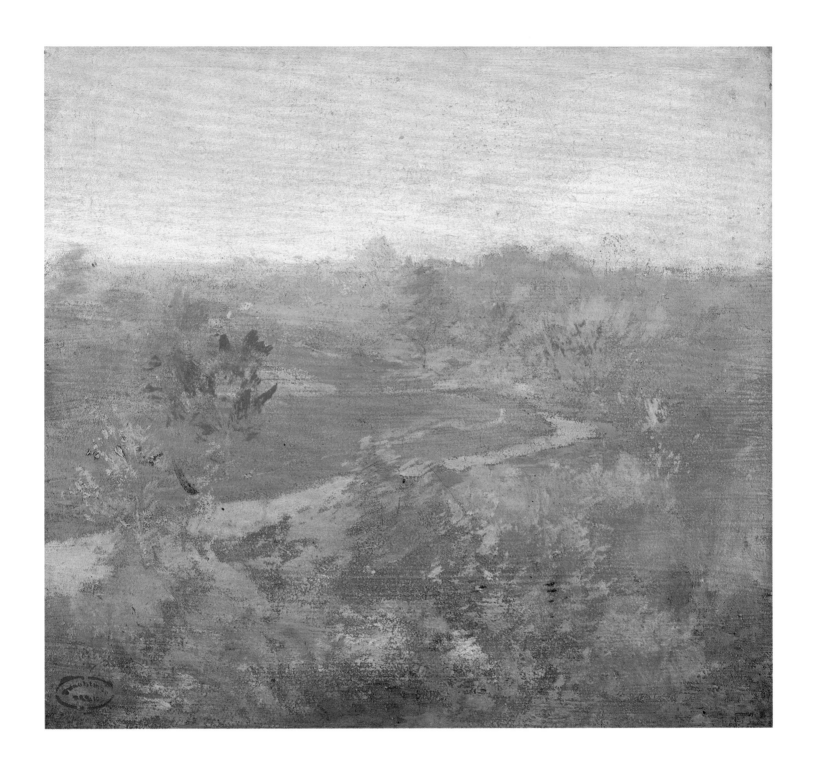

43.

Fountain, World's Fair ca. 1894

Oil on panel
7 × 10½ inches
Inscribed on verso: *Sketch by John H. Twachtman [1893]*
 Chicago, Martha S. Twachtman, 1918
The Orr Collection

PROVENANCE

Martha Twachtman, the artist's wife, Greenwich, Connecticut; to (Macbeth Gallery, New York, by 1918); private collection; (American Art Association, New York, February 2–3, 1928, lot 117); to A. E. Gallatin, New York; to (Rehn Gallery, New York); to Henry Sheafer, Pottsville, Pennsylvania; to (Babcock Galleries, New York); to Edward A. Grant, New York, 1954–ca. 1957; (Babcock Galleries); to present coll., 1958.

EXHIBITED

Macbeth Gallery, New York, *Second Exhibition of Intimate Paintings*, December 1918, no. 82 (as *Fountain, World's Fair*, 7 × 10½ inches).
Babcock Galleries, New York, *Important Paintings by American Artists of the 19th and 20th Century*, September 29–October 31, 1952, no. 20.

IN THE summer of 1892 Twachtman was expecting to receive an invitation from Frank Millet (1846–1912), director of decorations at the Columbian Exposition in Chicago, to create murals for the fair, an activity in which his friends J. Alden Weir and Edward Simmons were participating. However, Twachtman was relieved when this invitation did not arrive, and he expressed his disinterest in attending the fair, writing to Weir in Chicago from Greenwich on September 26, 1892: "I should like to see you," he wrote, "but the Fair buildings have no attraction for me."[1] Nonetheless, when Millet came through with a request that Twachtman, along with a number of other artists, create images of the fair's architecture that would be illustrated in a deluxe history of exposition, Twachtman accepted.[2] Also participating in this project, Theodore Robinson made his paintings of the fair's sites from photographs, and Twachtman probably followed the same procedure.[3] Reporting on his friend's struggles on the project, Robinson wrote in his diary on March 12, 1894: "Almost everyone has a finger in the pie. Poor Twachtman groans over his—half? done one and will do another."[4]

Twachtman created more views of the Columbian Exposition than would be expected from Robinson's comments. His images for this project known today are *Court of Honor, World's Columbian Exposition, Chicago* (Columbus Museum of Art, Ohio), *World's Fair* (Tweed Museum of Art, Duluth, Minnesota), *The World's Columbian Exposition, Illinois Building* (private collection), *Bridge: World's Fair* (private collection),

and *Fountain, World's Fair*. Yet, there is little consistency in the way that Twachtman treated this subject, suggesting that he faced a dilemma in trying to portray places he had not seen firsthand.

In *Court of Honor, World's Columbian Exposition, Chicago*, which measures 25 by 30 inches, he showed a broad, oblique view looking west toward Richard Morris Hunt's Administration Building, portraying this subject mostly according to how photographs present it, although softening the lines of the buildings. By contrast, in *Fountain, World's Fair*, he took greater liberties. His view seems to be looking west toward the Green Basin, where Frederick MacMonnies's Columbian Fountain was situated at the western end of the Court of Honor, just in front of Hunt's Administration Building. However, that Twachtman created this painting as a quick sketch suggests that he was approximating the look of the fountain from the reports of his friends rather than relying on photographs or other images of it. The low, horizontal form in the water is only vaguely like the shape of the grand Barge of State on which the Figure of Columbia was seated on a high pedestal. While the railing of the fence around the fountain is generally representative of the enclosure circling the basin, the decorative planters do not appear in any existing photographs of the site.

Rendering the work on a panel in which he used thin brushwork to fill in just enough detail to indicate his motif, Twachtman evoked the essence of the fair, which was conceived as a complete aesthetic environment in which the landscape, sculptural decorations, and the experience of the viewer moving past them, were taken into consideration. The soft greens and pinks give it a jewel-like quality, suggestive of a place meant for leisurely enjoyment.

In 1918 the artist's wife inscribed the back of the work, "*Sketch by John H. Twachtman [1893] Chicago, Martha S. Twachtman, 1918.*" Despite this notation, Twachtman probably made this painting in 1894, when Robinson reported that he was struggling with his depictions of the World's Fair. When this painting was sold at the American Art Association in 1928, the catalogue described it as "a green *bassin* at the World's Fair, Chicago, with fountains bordered by statuary, marble vases, and centered with a marble group." It was purchased from this sale by the noted dealer and modernist Albert E. Gallatin, who may have enjoyed the abstract qualities in Twachtman's sketchlike approach.

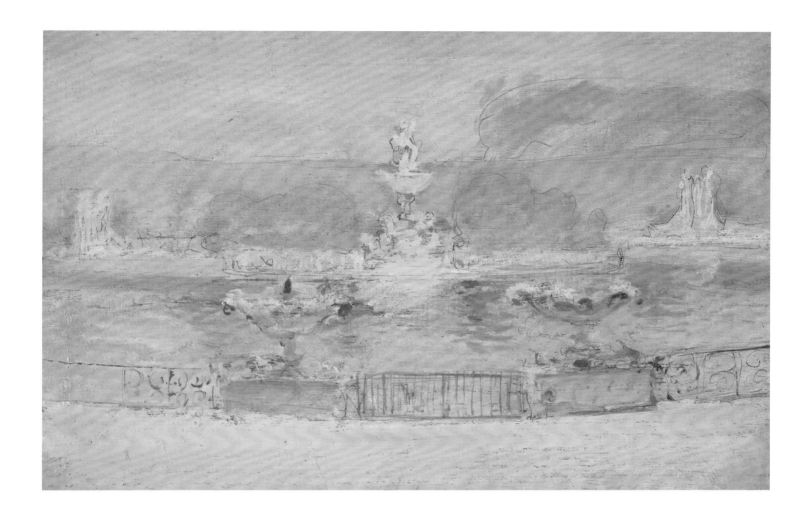

1. Twachtman, Greenwich, to Weir, September 26, 1892, Weir Family Papers, MSS 41, Harold B. Lee Library, Archives and Manuscripts, Brigham Young University, Provo, Utah.

2. The deluxe publication planned by Millet never came to fruition.

3. John Hale stated that Twachtman went to Chicago to see the exposition, receive his silver medal, and fulfill a speaking engagement at the Art Institute of Chicago. Hale, *Life and Creative Development*, 1957, p. 92. However, there is no evidence that Twachtman went to Chicago at the time of the fair. He did go in 1901 at the time of his one-man show at the Art Institute, as newspapers reported on his presence and on the lectures he gave. See "Say the Art Institute Falls Short of Mission," *Chicago Tribune*, January 15, 1901, clipping, Artist's Files, Ryerson Library, Art Institute of Chicago.

4. Robinson diaries, March 12, 1894, Frick Art Reference Library, New York.

44.

Autumn Mists ca. 1890s

Oil on canvas
25 × 30 inches
Signed lower left: *J. H. Twachtman*
Spanierman Gallery, LLC, New York

PROVENANCE

(Silas S. Dustin, New York, agent for the artist's estate, by 1905); Burton Mansfield, New Haven, Connecticut, by 1912); to (American Art Association—Anderson Galleries, Inc., *American Landscapes: The Private Collection of the Late Burton Mansfield*, April 7, 1933, lot 69); to (M. Knoedler & Co., New York): Leroy Ireland; Dr. and Mrs. T. Edward Hanley, Bradford, Pennsylvania, by 1957–ca. 1969; (Bernard Danenberg Galleries, New York, by 1969); Dr. Simon Joseph, White Plains, New York, 1969; (M. Knoedler & Co., by 1975–77); (Sotheby Parke-Bernet, New York, October 27, 1977, lot 37); (Galleries Maurice Sternberg, Chicago); (Hirschl & Adler Galleries, New York); (Sotheby's, New York, December 3, 1998, lot 27); to private collection, 1998; to (Christie's, New York, November 29, 2001, lot 68); to present coll., 2001.

EXHIBITED

(probably) Carnegie Institute, Pittsburgh, *Fifteenth Annual Carnegie Institute International Exhibition*, April 27–June 30, 1911, no. 13 (as *Autumn Freshet*).
Rhode Island School of Design, Providence, *Paintings from the Collection of Burton Mansfield, Esq., New Haven, Connecticut*, May 22–September 1, 1912, no. 43.
Morgan Memorial, Hartford, Connecticut, *Exhibition of Paintings, Pottery, and Glass Loaned by Honorable Burton Mansfield of New Haven*, April 13–November 1, 1920, no. 29.
Gallery of Modern Art, New York, *Selections from the Collection of Dr. and Mrs. T. Edward Hanley, Bradford, Pennsylvania*, January 3–March 12, 1967 (p. 60) (traveled to Philadelphia Museum of Art, Spring 1967; Denver Art Museum, February 22–April 30, 1968).
Hudson River Museum, Yonkers, New York, *Art in Westchester from Private Collections*, September 28–November 2, 1969, no. 36 (lent by Dr. Simon Joseph).
M. Knoedler & Co., New York, *A Selection of Recent Acquisitions from the American Department*, November–December 1975, listed in checklist.
M. Knoedler & Co., New York, *The American Impressionists*, February 3–March 6, 1976, listed in checklist.

REFERENCES

"Coming Auctions: American—Anderson Galleries—Mansfield Paintings," *Art News*, April 1, 1933, p. 11.
Hale, *Life and Creative Development*, 1957, vol. 2, p. 539 (catalogue A, no. 27).
Boyle, "John H. Twachtman," 1978, p. 77 color ill.
Peters, "'Spiritualized Naturalism,'" 2005, p. 85.

THE SUBJECT from which Twachtman derived *Autumn Mists* may be the brook or pool on his property in Greenwich, but his interest in this work was less in transcribing the features of his site than in using form and color to create an abstract conception that expresses its essence. Departing from stereotypical fall imagery in which rusts and oranges dominate, he depicted a landscape seen through a soft haze in which opalescent and luminous tones evoke the presence of the transitional season and of autumnal foliage. Indeed, undertones of rusts, purples, and pale browns throughout the work serve to heighten the shimmering qualities of the lighter hues.

Here Twachtman created a symmetrical arrangement in which the contours of the hills are reversed in their reflections, while a lavender-russet plant in the foreground, silhouetted against the light-blue surface of the water, is mirrored in a similarly toned tree on the far hillside, silhouetted against the sky. Indeed, this painting's composition would be almost unchanged if it were hung upside down. A tree at the far right further emphasizes the planarity of the arrangement, its vertical form set in the Japanese manner against the surface. Its lightly brushed leaves harmonize with the purples in the hillside on the far shore, while the richness of its color is emergent in wispy dabs of purple set against the paler sky.

As in the landscapes of Paul Cézanne, in this work, Twachtman arranged and modified elements of his scene to accord with his artistic conception. At the same time, he used formal means to express the feeling that this landscape evoked. The painting typifies the way that his works have a gradual impact on the viewer. Our first perception of this scene is of its static quietude, but gradually we become aware, through the subtle richness of the color and the variegated layered surface, of its vibratory and animated qualities, and the contemplative experience into which we are drawn is the true subject of the work. A sophisticated and understated painting, *Autumn Mists* stands as among the most modern of Twachtman's works.

Autumn Mists remained in the artist's estate in the years following his death, from which it was offered to potential buyers by Silas S. Dustin (d. 1940), who acted as an agent for Twachtman during the later years of his life and for the artist's family in the years following his death.[1] Born in Richfield, Ohio, the elusive Dustin was an artist who trained at the National Academy of Design and under William Merritt Chase. Dustin may have lent this painting under the title of *Autumn Freshet* to an exhibition at the Carnegie Institute in 1911, and it was probably Dustin who arranged the sale of *Autumn Mists* to the lawyer and noted collector of Tonalist works, Burton Mansfield of New Haven, Connecticut, who purchased Twachtman's *Beach at Squam* (ca. 1901; private collection) four years later.[2] *Autumn Mists* was included in the show of Mansfield's collection, held at the Rhode Island School of Design in 1912, and in the sale of works from Mansfield's estate, held at the American Art Association in 1933, from which it was purchased by M. Knoedler and Company, New York. Somewhat later, the painting was owned by the painter, art historian, and art

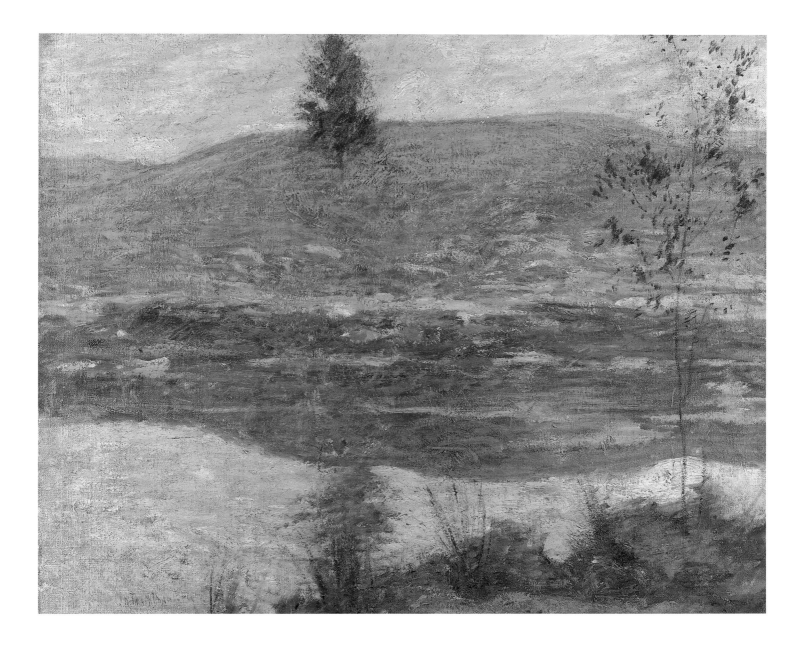

dealer Leroy Ireland (1889–1970), who prepared a catalogue raisonné of the work of George Inness. By 1957 it was in the collection of the oil and gas magnate T. Edward Hanley of Bradford, Pennsylvania, who donated his vast collection of books, manuscripts, paintings, and art to Harvard and Princeton universities along with the University of Texas. *Autumn Mists* was probably part of Hanley's estate at his death in 1969 and since then has changed hands several times.

Winter (Fig. 54) to the Museum of Fine Arts, Boston, in 1907. Dustin was responsible for Twachtman's inclusion in the Lewis and Clark Centennial Exposition in Portland, Oregon, in 1905 and in the Alaska-Yukon-Pacific Exposition in Seattle in 1909. From 1908 to 1912 Dustin also sent works by Twachtman to annual exhibitions at the Cincinnati Art Museum, the Buffalo Fine Arts Academy, the City Art Museum of St Louis (now the St. Louis Art Museum), and the Toledo Art Museum, Ohio. There is no evidence that Dustin owned works by Twachtman. Dustin was living in Los Angeles at his death in 1940.

2. On Mansfield, see *Modern History of New Haven and Eastern New Haven County*, 2 vols. (New York: S. J. Clarke Publishing Company, 1918), vol. 2, pp. 189–90. http://www.rootsweb.com/~ctnhvbio/Mansfield_ Burton.html.

1. In 1906 Dustin arranged the sale of Twachtman's *Sailing in the Mist* to the Pennsylvania Academy of the Fine Arts (Fig. 77). In the following year, he negotiated the sale of *Flowers* to the academy and of *Brook in*

45.

Upland Pastures ca. 1890s

Oil on canvas
25 × 30 inches
Stamped lower left: *Twachtman Sale*
Spanierman Gallery, LLC, New York

PROVENANCE

(American Art Galleries, New York, *Sale of the Work of the Late John H. Twachtman*, March 24, 1903, lot 42, as *Upland Pastures*, oil on canvas, 25 × 30 inches); possibly to George Frederick Munn, 1903 (recorded as the purchaser of *Upland Pastures*); possibly (Vose Galleries, Boston, by 1919); (Robert C. Vose, Boston, by 1932); (Babcock Galleries, New York, as of 1942); Mr. and Mrs. A. Kornfield; to (Ira Spanierman Gallery, New York, 1978); to (R. H. Love Galleries, Chicago, 1979); private collection, Villanova, Pennsylvania, by 1994; to present coll., 2003.

EXHIBITED

(possibly) 1919 Vose Galleries II, no. 10 (as *October Haze*).
The Brooklyn Museum, New York, *Exhibition of Paintings by American Impressionists and Other Artists of the Period, 1880–1900*, January 18–February 28, 1932, no. 113 (as *November Haze*, lent by Robert C. Vose).
1942 Babcock Galleries, no. 17 (as *November Haze*).
Hirschl & Adler Galleries, New York, *Lines of Different Character: American Art from 1727–1947*, November 13, 1982–January 8, 1983, no. 72 (p. 17 color ill., as *November Haze*).
Smithsonian Institution Traveling Exhibition Service, *Impressionistes Américains*; traveled to Musée du Petit Palais, Paris, March 30–May 18, 1982, no. 72 (as *November Haze*) (traveled to Germany, Austria, Romania, and Bulgaria, 1982–83).
Columbus Museum of Art, Ohio, *Triumph of Color and Light: Ohio Impressionists and Post-Impressionists*, February 6–May 15, 1994 (pp. 23, 159 ill., as *November Haze*).
Kunstforum, Vienna, *Impressionismus: Amerika—Frankreich—Russland (Impressionism: America—France—Russia)*, October 25, 2002–February 23, 2003, no. 28 (pp. 100–101 color ill., as *November Haze*) (traveling exh.).
Spanierman Gallery, LLC, New York, *The Spirit of America: American Art from 1829 to 1970*, November 1, 2002–February 15, 2003, no. 41 (color ill., as *November Haze*).
Spanierman Gallery, LLC, New York, *The Poetic Vision: American Tonalism*, November 12, 2005–January 7, 2006, no. 40 (pp. 85, 172–73 color ill., as *November Haze*).

REFERENCES

"Art Exhibitions: The Twachtman, Colman and Burritt Collections," *New-York Daily Tribune*, March 21, 1903, p. 9.
Hale, *Life and Creative Development*, 1957, vol. 2, p. 455 (catalogue G, no. 250, as *November Haze*; no. 251, as *November Haze*; possibly no. 252, as *October Haze*); p. 480 (catalogue G, no. 457, as *Upland Pastures*).
Lisa N. Peters, "John Henry Twachtman," in Ralph Sessions et al., *The Poetic Vision: American Tonalism*, exh. cat. (New York: Spanierman Gallery, LLC, 2005), pp. 172–73 color ill. (no. 40, as *November Haze*).
Lisa N. Peters, "'Spiritualized Naturalism,'" 2005, p. 85 (no. 40, as *November Haze*).

THE STAMP at the lower left of this work indicates that it was included in the 1903 sale of works from Twachtman's estate. Although it has been known since the 1930s as *November Haze*, the title it was given in the estate sale, *Upland Pastures*, has been returned to it, as *Upland Pastures* was the only oil in the sale with these dimensions. Like many of the works in the sale, *Upland Pastures* was purchased by a fellow artist, the painter George Frederick Munn (1852–1907), who was known for reductive and refined landscapes and floral works.[1] By 1932 the painting belonged to Robert C. Vose, who lent it to an exhibition at the Brooklyn Museum that year, but it is possible that it was in the hands of Vose Galleries of Boston as early as November 1919, when the gallery included a work entitled *October Haze* in an exhibition of Twachtman's art held that year.

At first glance, this painting seems composed entirely of misty undifferentiated forms. Gradually, however, the view begins to materialize, as we become aware of the hillock rising from the rocky, terrain in the right foreground, while beyond, a dip in the land may indicate the presence of a pond. Farther, the land curves upward at a gradual pitch, its upper reaches fading into the atmosphere in the distance. The general topography suggests that Twachtman might have painted it from the hill to the east of his home, looking southwest toward the pond in which his children enjoyed their small sailboats.

Although the painting is rendered with a spontaneity associated with Impressionism, its evocation of a sense of mystery in nature, which we can only partly understand, associates it with Tonalism, a mode in which such artists as Dwight Tryon, Henry Ward Ranger, and Birge Harrison sought to capture the effect of nature on the artist's mind and emotions, seeking a spiritual plane of existence beyond the limitations of mere visual experience.[2]

1. On Munn, see Margaret Crosby Munn and Mary R. Cabot, eds., *The Art of George Frederic Munn* (New York: E. P. Dutton Co., 1916). Munn also purchased a watercolor from the Twachtman estate sale entitled *Village Inn*.
2. On Tonalism, see Ralph Sessions et al., *The Poetic Vision: American Tonalism*, exh. cat. (New York: Spanierman Gallery, LLC, 2005). For further sources on Tonalism, see Ralph Sessions, "Selected Bibliography," in ibid., p. 195.

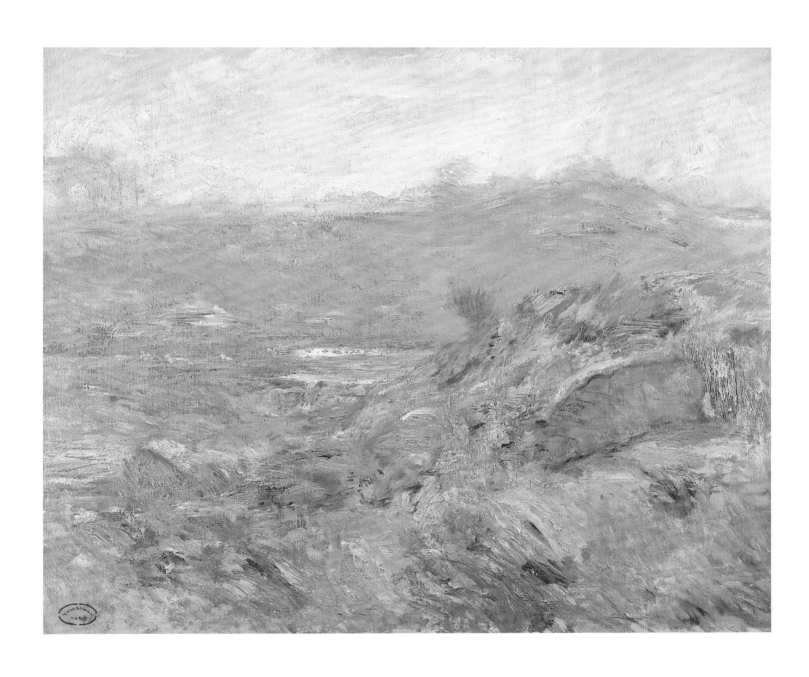

46.

Spring ca. 1890s

Oil on canvas
30⅛ × 25⅛ inches
Signed lower right: *J. H. Twachtman–*
Private Collection

PROVENANCE

The artist; to George F. Of, New York, by 1901; (Kennedy Galleries, New York, by 1966); (Campanile Galleries, Chicago); Dr. and Mrs. Robert B. Smythe, New Orleans, by 1971; (Christie's, New York, December 3, 1982, lot 158); to present coll, 1982.

EXHIBITED

(probably) Durand-Ruel Galleries, New York, *First Exhibition: Ten American Painters*, March 30–April 16, 1898, no. 36 (as *Early Spring*).
(probably) St. Botolph Club, Boston, *An Exhibition of Ten American Painters*, April 25–May 14, 1898 (as *Early Spring*).
1901 Art Institute of Chicago, no. 13.
1901 Durand-Ruel Gallery.
1901 Cincinnati Art Museum, no. 36.
1966 Cincinnati Art Museum, no. 45 (lent by Kennedy Galleries, New York).
New Orleans Museum of Art, *New Orleans Collects: A Selection of Works of Art Owned by New Orleanians*, November 14, 1971–January 9, 1972, no. 179 ill. (lent by Dr. and Mrs. Robert B. Smythe).
Museum of Art, Inc., Fort Lauderdale, Florida, *In the Eye of the Beholder: South Florida Collectors' Choice*, December 11, 1986–January 25, 1987 (incorrectly dated ca. 1920).
Orlando Museum of Art, Florida, *Hidden Treasures: American Paintings from Florida Collections*, January 4–February 23, 1992, no. 57 (p. 43 color ill.).

REFERENCES

(probably) "The Art World: Ten American Painters at the Durand-Ruel Gallery," *New York Commercial Advertiser*, March 30, 1898, p. 7 (as *Early Spring*).
(probably) "American Painters' Display," *New York Times*, March 30, 1898, p. 6 as (*Early Spring*).
"Painting: The Quiet American," *Time* (October 14, 1966), p. 91 color ill.

Fig. 76
Illustrated letter,
Twachtman, The Players,
New York, May 14, 1901,
to Joseph Gest, Archives,
Cincinnati Art Museum.

IN HIS Greenwich landscapes, Twachtman enjoyed referencing his domestic experience, because then he could draw inspiration both from the landscape and from his personal experience of it. He took this approach in *Spring*, showing one of his daughters in the flat-bottomed boat that his children used to row in the small pond containing "assorted tadpoles of extraordinary size"[1] and to travel along Horseneck Brook, when the water was high enough to permit it. Here, the brook along which the boat has already traveled rises upward through the composition, the energy of its wavering diagonal creating a feeling of ambling movement, while its seeming to travel out of the scene evokes the pleasure of the child's further journey of discovery. The willow tree in the left foreground—probably among those Twachtman planted along the brook for aesthetic purposes—is laid over the landscape in the Japanese fashion. He painted its leaves with tight, Impressionist flecks, capturing the effect of the sparkling sunlight and the buoyant feeling of a spring day, a sense also conveyed by the interweaving of pinks and greens. Flattening the picture plane by tilting it up, Twachtman produced an iconic and eternal image from a very personal one, showing the joys of childhood conjoined with the liberating and pleasurable experience of outdoor life in Greenwich.

It seems likely that *Spring* was the painting that Twachtman exhibited as *Early Spring* in 1898 at the first exhibition of the Ten American Painters at both Durand-Ruel Galleries in New York and at the St. Botolph Club in Boston. A critic reviewing the show for the *New York Commercial Advertiser* wrote of *Early Spring* as well as of *Baby's Reflection* (Fig. 21) and *On the Terrace* (Fig. 61) that "it was unusual to find J. H. Twachtman attacking the figure," and observed: "In an Early Spring there is a queer anatomical construction of nature, for a boat on a stream seems to be running uphill." A reviewer for the *New York Times* commented that of the works on view, the best were "'New Bridge' [identity unknown], 'Early Spring,' and 'On the Terrace.' The two former canvases have the artist's characteristic delicate and delicious color scheme, and the last has an atmosphere and sentiment which almost recalls Jules Breton."

Twachtman included the painting, this time with the title simply of *Spring*, in his 1901 exhibitions in Chicago, New York, and Cincinnati. The artist George F. Of (1876–1954) purchased this painting from the Cincinnati exhibition, possibly having seen it in New York. On May 14 of that year, Twachtman sent a letter to Joseph Gest (1859–1935), assistant director of the Cincinnati Art Museum, stating: "Dear Mr. Gest, will you please send picture called Spring to Geo. T. [*sic*] Off [*sic*], 66 East 8th Street, New York City? It is a picture 25 × 30 upright and something like this. There is a small boat with a child in it off in the middle ground.... Before sending the picture take all prices off the back and mark in good sized figure $500" (Fig. 76).[2] Gest replied on May 20 that he had sent the work per Twachtman's request.[3] Of's interest in the progressive qualities of Twachtman's art is not surprising, as he would later become a noted collector of modernist works by American and European artists and would create his own Fauvist-inspired landscapes that were admired by such discerning critics as Walter Pach, Willard Huntington-Wright, and Charles Caffin as well as by the influential photographer and art dealer Alfred Stieglitz.

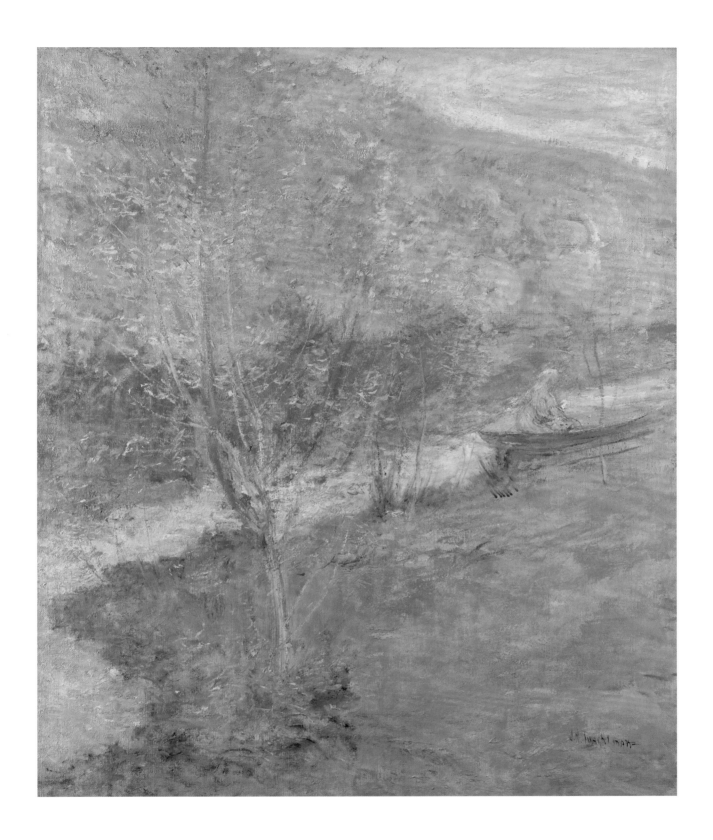

1. Goodwin, "An Artist's Unspoiled Country Home," 1905, p. 630.

2. Twachtman, The Players, New York, May 14, 1901, to Joseph Gest, assistant director, Cincinnati Art Museum. Archives, Cincinnati Art Museum. Gest was director of the art museum from 1902 to 1932. For his biography, see Virginia Raymond Cummins, *Rookwood Pottery Potpourri I* (Silver Spring, Md.: C. R. Leonard and D. Coleman, 1980), p. 6. For information on Gest, I would like to thank Mona L. Chapin, head librarian, Mary R. Schiff Library and Archives, Cincinnati Art Museum.

3. Joseph Gest, assistant director, Cincinnati Art Museum, May 20, 1901, to Twachtman, 16 Gramercy Park, New York, Archives, Cincinnati Art Museum.

47.

Sailing in the Mist ca. 1895

Oil on canvas
30 × 21 inches
Private Collection

PROVENANCE

Estate of the artist; by descent to the artist's granddaughter Phyllis Twachtman, Brooklyn, New York; to (Ira Spanierman, Inc., New York, ca. 1968); to Jacqueline Getty, Los Angeles; to the Geneva Marie Washburn Trust, Newport Beach, California, after 1974; to (Butterfield & Butterfield, Los Angeles, November 12, 1987, lot 2263); to private collection, 1987; by descent to present coll., 2005.

EXHIBITED

Los Angeles County Museum of Art, *American Paintings in Los Angeles Collections*, May 7–June 30, 1974 (lent by Mrs. Jacqueline Getty).

Fig. 77
Twachtman, *Sailing in the Mist*, ca. 1895, oil on canvas, 30³⁄₁₆ × 30⅛ inches, Pennsylvania Academy of the Fine Arts, Philadelphia, Joseph E. Temple Fund.

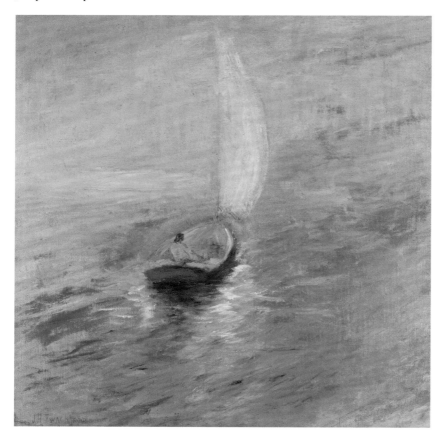

IN LATE December 1894, scarlet fever struck Twachtman's family. Two-year-old Quentin was sent to stay with the family of Childe Hassam, and Twachtman and his eldest son Alden (then twelve)—who were free of infection—were separated from the rest of the family. Marjorie, then ten, and Elsie, eight, and perhaps their mother, Martha, were ill. On January 2 Theodore Robinson reported in his diary: "Twachtman and Alden called a few minutes—T spoke despairingly of Elsie—the others are better."[1] Weir also wrote to his wife, Ella, reporting that "the doctor had given up all hope for Elsie's recovery." Of Twachtman he wrote, "the poor fellow was completely broken up."[2] Three days later, when Elsie died early in her ninth year, Twachtman was at her side. Robinson wrote: "Twachtman has returned to his family, after his long quarantine—he went back Sat. in time to see the little one die."[3] A funeral was held in Greenwich, attended by both Weir and Robinson.[4]

That Twachtman created *Sailing in the Mist*, now in the Pennsylvania Academy of the Fine Arts (Fig. 77), as an expression of his grief at the loss of his beloved daughter is well known, but what is less often mentioned is that he created several versions of this motif, of which four are extant today. In each, he used a different format. In *Sailing* (25¼ × 30¼ inches; private collection), two figures in the boat head downstream. As the journey is not a solitary one, this version is perhaps less melancholy than the others. The other three, in portraying a single figure in just the type of catboat or dinghy that the artist's children used for play on Horseneck Brook (see Cat. 46), emphasize the association of the anonymous child with the painter's daughter. In *Sailing* (30⅛ × 25⅛ inches; private collection) the figure and boat are treated in a generalized manner, and the boat moves toward us, its future unclear as it heads toward a rocky shore.

The work in the present exhibition, also entitled *Sailing in the Mist*, is closely related to the Pennsylvania Academy's painting but represents a more intimate image. In the work in the academy, Twachtman portrayed the scene from a high vantage point, tilting the picture plane up to create a sense of the boat's movement into the distance. The perspective draws our eye toward a hazy zone in which the division between water and sky is blurred. Here, by contrast, the vertical canvas creates a narrower space, making the boat take on a larger presence within the scene. We look directly at the vessel, from the rear, rather than seeing it from above, so that we seem to accompany the figure on her journey. In the present painting, the boat also heads into a mysterious atmospheric realm lacking a horizon line and spatial differentiation, while the way that the figure is bent suggests that she has given in to the will of the boat. Painted with thick, broad strokes that do not fully cover the canvas, this painting seems a direct expression of Twachtman's feelings, as he faced this unspeakable loss.

The Pennsylvania Academy's painting, which entered the museum's collection in 1906, has been

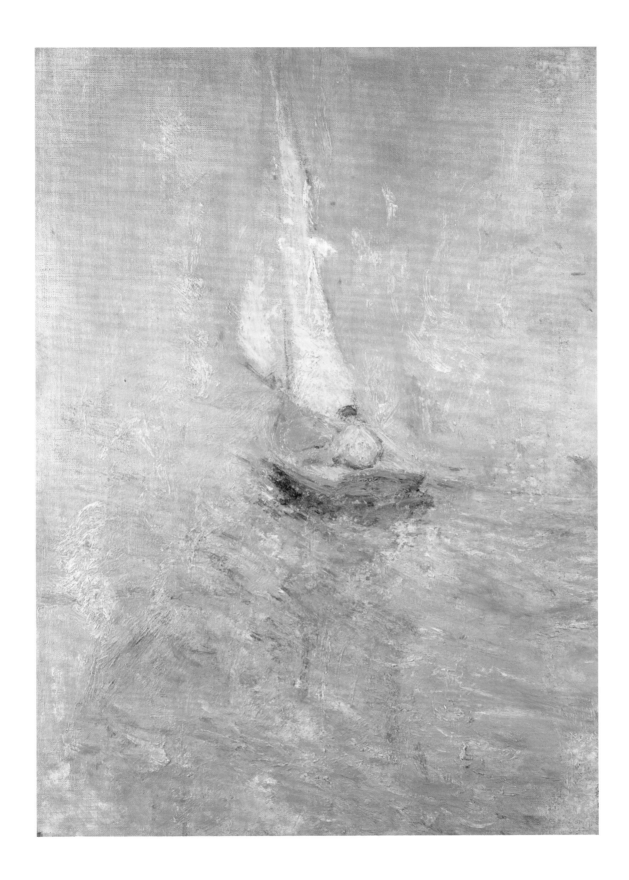

among the most frequently exhibited of Twachtman's works. By contrast, this painting is known to have been shown only once, in 1974. It stayed within the artist's family until 1968 and since then has been in private hands.

1. Theodore Robinson diaries, January 2, 1895, Frick Art Reference Library, New York.

2. J. Alden Weir to Ella Baker Weir, January 10, 1895, J. Alden Weir Papers, Archives of American Art, Smithsonian Institution, Washington, D.C., roll 71, frame 64.

3. Robinson diaries, January 14, 1895.

4. Ibid.

48.

Summer Afternoon ca. 1900

Oil on canvas
26 × 16 inches
Signed lower right: *J. H. Twachtman*
Private Collection

PROVENANCE

(Newhouse Gallery, New York); (M. Knoedler & Co., New York); present coll., ca. 1980s.

EXHIBITED

1987 Spanierman Gallery, no. 14 (pp. 82–83 color ill.).

REFERENCES

Peters et al., *In the Sunlight*, 1989, pp. 82–83 color ill. (no. 14).
Peters, "Suburban Aesthetic: John Twachtman's *White Bridge*," 1994–96, pp. 51–53, 55 ill.

Fig. 78
Twachtman, *The White Bridge*, late 1890s, oil on canvas, 30¼ × 30¼ inches, Minneapolis Institute of Art, Gift of the Martin B. Koon Memorial Fund.

IN THE LATE 1890s Twachtman painted several views of a white footbridge crossing Horseneck Brook on his Greenwich property, six of which, including *Summer Afternoon,* are known today.[1] In each, the bridge appears to have a different form, suggesting that he rebuilt it each year, when the brook reached so high that it could not be forded by foot. Like Claude Monet, who used the arched Japanese bridge that he constructed over his lily pond in Giverny as an aesthetic form within his paintings, Twachtman created images expressing

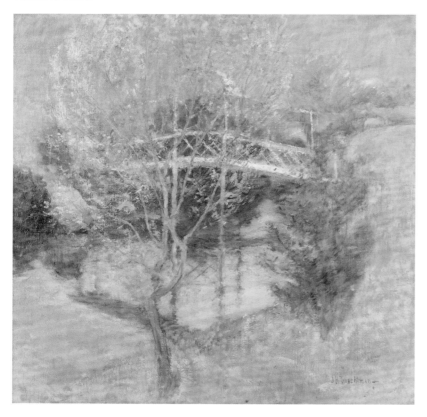

the way that the bridge enhanced the beauty of the existing landscape, which he had also augmented by planting willows along the sides of the brook, seen in *Spring* (Cat. 46).

In three of his bridge paintings (see Fig. 78), probably created in the late 1890s, he created decoratively composed arrangements in which the influence of Japanese prints is suggested in the overlaid patterning of the lines of the bridge and trees and in the use of diagonals to create asymmetrically balanced designs.[2] By contrast, in *The White Bridge* of about 1900 (30¼ × 25⅛ inches; Memorial Art Gallery, University of Rochester, New York), he moved the bridge closer to the picture plane and used the more direct, painterly approach typical of his Gloucester period, generalizing the landscape and using a vibrant contrast of complementary purples and greens.

Probably also executed at the turn of the twentieth century, *Summer Afternoon* was painted with a similarly spontaneous method, but the work is a casual and personal image, rather than a study of relationships of color and form. Observing the bridge from the shore of the brook, the artist directs our eye upward to the white figure with her back to us, presumably a view of his wife. Her tentative movement combined with the rough appearance of the bridge—by contrast with its more refined aspect in other works—suggest that the bridge might not have been finished at the time that the work was painted. The small catboat docked on the far shore is ready for the arrival of the artist's children. The light, dry greens of the opposite shore, indicative of summertime, and the dappled light and shadow on the water, rendered in an active, sketchy fashion, hint that the artist's aim was to convey his immediate response to the scene rather than to craft an aesthetically considered arrangement.

1. For Twachtman's White Bridge paintings, see Peters, "Suburban Aesthetic: John Twachtman's *White Bridge*," 1994–96. Twachtman may have begun to paint the white bridge in 1897, as it was probably portrayed in a work entitled *The New Bridge* that he exhibited at the Pennsylvania Academy in January–February 1898 and at the first exhibition of the Ten American Painters in March–April 1898 in both New York and Boston. At the Carnegie Institute annual of 1899, he again showed a work entitled *The White Bridge*. A view of a white bridge was also included in Twachtman's 1901 show at Durand-Ruel, while a work entitled *The Little White Bridge* appeared in his 1901 show in Cincinnati.

2. The others are *The White Bridge* (29½ × 29½ inches; Art Institute of Chicago) and *The Little White Bridge* (25 × 25 inches; University of Georgia, Georgia Museum of Art, Athens).

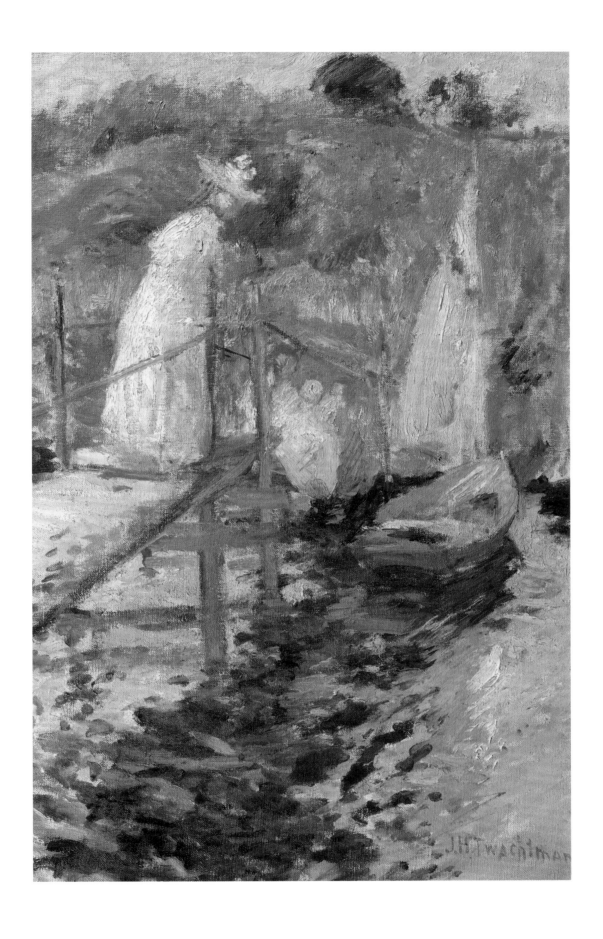

49.

Niagara Gorge ca. 1894

Oil on canvas
30 × 30 inches
Private Collection

PROVENANCE

Dr. and Mrs. Charles Cary, Buffalo, New York, ca. 1890s; to Mrs. Charles [Evelyn Rumsey] Cary, Buffalo, as of 1913; Lawrence Goodyear, Buffalo; (Christie's, New York, May 22, 1980, lot 100); (Berry-Hill Galleries, New York); to David Warner Foundation, Tuscaloosa, Alabama, 1980–93; to (Christie's, New York, May 26, 1993, lot 132); to (Raymond and Dottie N. Fortier, West Hartford, Connecticut); to present coll., 1998.

EXHIBITED

City Art Museum, St. Louis, *Fifth Annual Exhibition of Selected Paintings by American Artists*, September 15–November 15, 1910, no. 229.
1913 Buffalo Fine Arts Academy, no. 22 (lent by Mrs. Charles Cary).
Charles Burchfield Center, Buffalo State College, New York, *Our Legacy of Art in Western New York*, September–October 1971, no. 99.
Wadsworth Atheneum, Hartford, Connecticut, *Masterworks from Private Connecticut Collections*, October 1993–January 1994 (lent by The Fortier Collection).

REFERENCES

"Gallery and Studio Chat…Twachtman's Art, Canvases Marvelously in Tune With Spirit of Nature," *Buffalo Express*, March 17, 1913, p. 14.
"Memorial Exhibition of the Works of John H. Twachtman," *Albright Academy Notes* 8 (April 1913), p. 65.
Hale, *Life and Creative Development*, 1957, vol. 2, p. 477 (catalogue G, no. 444).

THE DETAILS of Twachtman's activities in Niagara Falls are just beginning to be understood. Previously it was believed that he visited the falls once, but it is now clear that he made two trips to the famed natural wonder, the first time in the winter of 1894 and the second time that summer.[1] Eliot Clark wrote: "While visiting Mr. Charles Carey [*sic*] of Buffalo, [Twachtman] made several pictures of Niagara Falls."[2] However, it seems that Twachtman's connection could well have been as much with Cary (1852–1931), a Buffalo physician

Fig. 79
Postcard, Maid of the Mist, Niagara Falls, ca. 1910s.

and professor of anatomy, as with his wife, the artist Evelyn Rumsey Cary (1855–1924). Evelyn Cary is known to have studied at the Art Students League with Alfred Q. Collins, a painter whom Theodore Robinson often mentions in his diaries as a companion of both himself and Twachtman.[3]

Only two of the winter views of Niagara that Twachtman painted on his first trip are known, *Niagara in Winter* (Fig. 63) and *Horseshoe Falls, Niagara* (Parrish Art Museum, Southhampton, New York), both painted from just north of the Canadian Horseshoe Falls, where staircases leading down below the falls to boardwalks would have given Twachtman easy access to his site.[4] It was certainly one of these works that he exhibited at the National Academy of Design in April–May 1894 with the title *Horseshoe Falls, Niagara— Afternoon*, which was described by the critics as a view of the cataract in winter.[5]

Twachtman's second trip to Niagara seems to have taken place sometime shortly before July 1, 1894.[6] Indeed, the other seven extant paintings that Twachtman rendered of Niagara appear to be summer- or springtime views. It was during this trip that he probably painted *Niagara Gorge*. Its site is possibly also located below Horseshoe Falls, rendered near the departure point for the ferry, The Maid of the Mist, still operating today (Fig. 79).[7] Turning his back on the tourists waiting for the ferry, Twachtman created one of his most mesmerizing works. Painting from the level of the water, he limited his palette to white, turquoise-white, and pale pink, applying his paint in thin layers overlaid with dragged strokes of dry pigment in these same tones, while allowing the priming of the canvas to serve as the lip of the ground and as an overall undertone. We are drawn into a realm in which boundaries between surface and depth, mist and clouds, cliffs, water, and foam seem to dissolve and shift. Although Twachtman departed from the famous panoramic view by Frederick Church, *Niagara* (1857; Corcoran Gallery of Art, Washington, D.C.), and those who followed his lead, in *Niagara Gorge*, Twachtman expressed the ineffable experience of this stunning site in his own way. It was possibly *Niagara Gorge* that Robinson mentioned in his diary entry of March 9, 1895, noting he had seen "one of [Twachtman's] Niagara's done last summer—a charming thing and very complete— light, mysterious."[8]

Niagara Gorge is the only painting of Niagara that is known to have been owned by Charles and Evelyn Cary, who, contrary to some reports, did not commission Twachtman's Niagara works.[9] In 1913 Evelyn Cary lent this painting to an exhibition

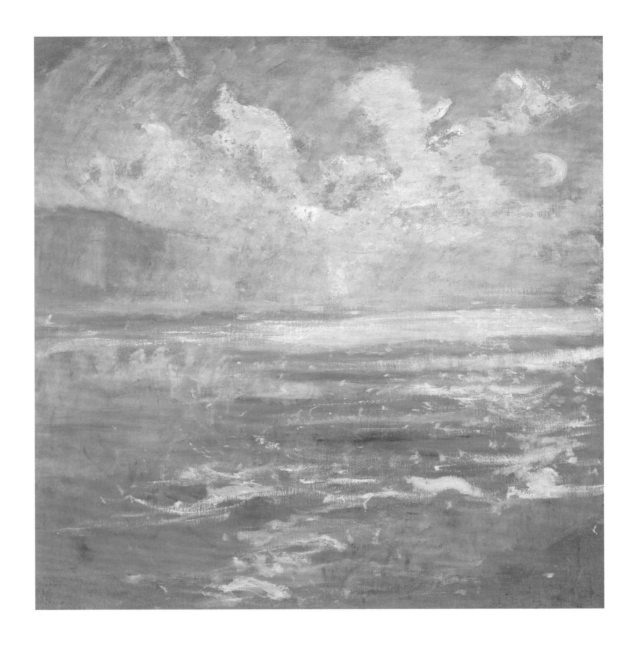

of Twachtman's works at the Buffalo Fine Arts Academy (now the Albright-Knox Art Gallery). Of *Niagara Gorge* and two other views by Twachtman of Niagara that were on view, a critic for the *Buffalo Express* wrote in March: "The elusive loveliness that escapes like a breath of truth and poetry, from these pictures, cannot be put into words without being fundamentally altered. In these pictures, while the dramatic note is not missing, it seems subordinated to an astonishingly delicate vision. Ethereal color and form seem to have been blown onto canvas. Never does one find an opaque shadow, a harsh edge, the pressure of a heavy hand." (This article was reprinted in *Albright Academy Notes* of April 1913.) The Carys introduced Twachtman to William Wadsworth, who financed the artist's trip to Yellowstone in the fall of 1895 (see Cats. 50–54).

1. In his diary on April 14, 1894, Theodore Robinson mentioned seeing "Twachtman's frozen 'Niagara.'" Robinson diaries, Frick Art Reference Library, New York.

2. Clark, *John Twachtman*, 1924, p. 28. See Peters, *John Twachtman (1853–1902) and the American Scene*, 1995, vol. 1, pp. 362–63.

3. On Evelyn Cary, see William H. Gerdts, *Art Across America: Two Centuries of Regional Painting, 1710–1920,* 3 vols. (New York: Abbeville, 1990), vol. 1, pp. 216–17.

4. I would like to thank Andrew Porteus, manager of Adult Reference and Information Services, Niagara Falls Public Library, Ontario, for his assistance in identifying Twachtman's Niagara sites. Email correspondence, January 30, 2006.

5. For example, see "Academy Prices and Prizes," *New York Times*, April 9, 1894, p. 2, describing Twachtman's "'Niagara in Winter'" as "a partial view of the Horseshoe taken in the afternoon."

6. Robinson wrote on July 1, 1894 that Twachtman had shown him "some canvases done at Niegara [sic]." On March 9, 1895, he mentioned seeing one of Twachtman's "Niagara's done last summer." Robinson's diaries.

7. The identification of the site has been suggested by Andrew Porteus, Niagara Falls Public Library. Email correspondence, January 30, 2006.

8. Robinson diaries.

9. See Boyle, *John Twachtman*, 1979, p. 19, and Peters, "Twachtman's Greenwich Paintings: Context and Chronology," in Chotner, Peters, and Pyne, *John Twachtman: Connecticut Landscapes*, 1989, pp. 31–32.

50.

Yellowstone Park ca. 1895

Oil on canvas
30 × 28½ inches
Signed lower right: *J. H. Twachtman*–
Private Collection

PROVENANCE

(Vose Galleries, Boston); (Howard Young Galleries, New York); J. K. Newman, New York; to (American Art Association—Anderson Galleries, New York, *Important Paintings: The Very Private Collection of J. K. Newman*, New York, December 6, 1935, lot 20); to Mr. and Mrs. David B. Findlay, New York, by 1957; by descent in the family to the present.

REFERENCE

Hale, *Life and Creative Development*, 1957, vol. 1, p. 404 (Fig. 149); vol. 2, p. 581 (catalogue A, no. 768).

SNOW WAS a subject that had fascinated Twachtman since at least the early 1880s, when he painted the snow-covered hills of Cincinnati. In Greenwich, the painting of snow was a passion for him, and he used an expressive technique to capture different conditions of snow softening the irregularities of his rambling farmhouse and blanketing the wooded hillsides and overgrown pastures of a countryside that Eliot Clark described as having "a peculiarly intimate charm."[1] However, Twachtman was unprepared for the experience of snow in the dramatic countryside of Yellowstone Park, which he visited in the fall of 1895. He wrote to Major William A. Wadsworth, who had provided the funds for his trip and probably commissioned a certain number of works, on September 22, thanking him for his "liberality" and expressing his feeling of being "overwhelmed with things to do that a year would be a short stay." Noting that "the scenery . . . is fine enough to shock any mind," he went on to tell Wadsworth: "We have had several snow storms and the ground is white— the cañon looks more beautiful than ever. The pools are more refined in color but there is much romance in the falls and the cañon."[2]

Twachtman's amazement at the effect of snow in Yellowstone is fully evident in this view of the Grand Canyon of the Yellowstone. Whereas the snows of Greenwich inspired him to record transitory qualities of light and atmosphere on a variegated ground cover, here he captured the extraordinary effect of light reflecting from the snow-blanched, high canyon walls. Arranging his composition with the flat balance of forms that he admired in Japanese prints, he brought out the ashen lavender tones in the sheer rises of the canyon through their decorative contrast with the

blue-greens of the trees lining the ridges and the mauve tints of the natural color of the volcanic rock, visible beneath and emerging from the light snow cover. The almost square format of this work accentuates its diagonal lines, which seem to crisscross back and forth on its surface.

The early history of this painting is not known, and it is possible that it was among the four views of Yellowstone Park that William Wadsworth lent to an exhibition at the Buffalo Fine Arts Center in 1913, where it would have been shown along with *Yellowstone Park* (Cat. 51) and *Niagara Gorge* (Cat. 49), lent by Evelyn Cary. Later the painting was part of an important collection of works by European and American artists owned by J. K. Newman.[3]

1. Clark, *John Twachtman*, 1924, p. 42.
2. Twachtman, Grand Canyon Hotel, Yellowstone National Park, Wyoming, September 22, 1895, to William A. Wadsworth, Geneseo, New York, Wadsworth Family Papers, College Libraries, State University of New York College of Arts and Sciences at Geneseo.
3. On the sale of Newman's estate, see "Van Gogh Painting is Sold for $15,000," *New York Times*, December 7, 1935, p. 15.

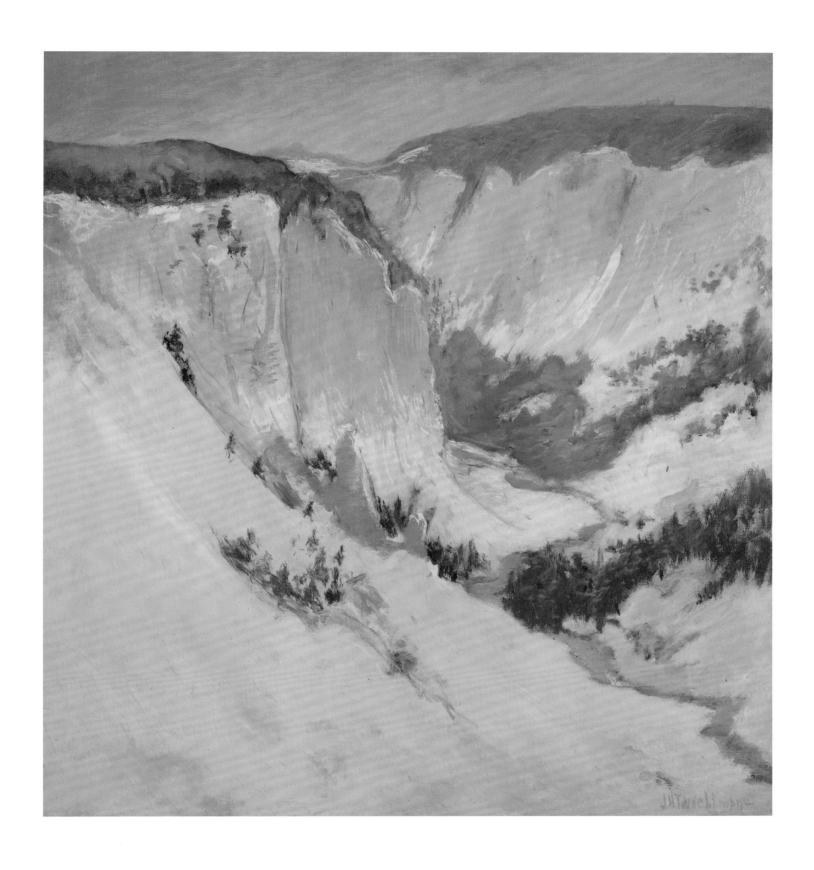

51.

Yellowstone Park ca. 1895

Oil on canvas
30 × 25 inches
Signed lower right: *J. H. Twachtman–*
Spanierman Gallery, LLC, New York

PROVENANCE

Mrs. Charles Cary, Buffalo, New York; Anson Conger Goodyear, Buffalo and New York, after 1913; (James Goodman Gallery, New York, by 1964); to (Hirschl & Adler Galleries, New York, 1964–65); to Thomas Mellon Evans, Kentucky, 1965; to his sister Eleanor Evans Norman, Louisville, Kentucky; to (Christie's, New York, May 25, 1989, lot 236); to William DeWitt, Cincinnati; to (Sotheby's, New York, November 28, 2001, lot 76); to present coll., 2001.

EXHIBITED

Albright Art Gallery, Buffalo, New York, *Seventh Annual Exhibition of Selected Paintings by American Artists*, May 21–September 2, 1912, no. 114 (lent by Mrs. Charles Cary).
1913 Buffalo Fine Arts Academy, no. 21 (lent by Mrs. Charles Cary).

REFERENCES

Hale, *Life and Creative Development*, 1957, vol. 2, p. 515 (catalogue G, no. 769).
Peters, *John Twachtman (1853–1902) and the American Scene*, 1995, vol. 1, pp. xxxvii, 372–73; vol. 2, p. 914 ill. (Fig. 400).

W HEN STEPPING from *Yellowstone Park* (Cat. 50) to this painting, one has the sensation of the artist's amazement at seeing the powerful, transformative effect of sunshine suddenly falling on a landscape recently shrouded in the atmospheric haze of an autumnal snowstorm. Here, portraying the same locale within the Grand Canyon of the Yellowstone as in Cat. 50, he focused on the luminescent pinks and yellows spreading upward over the sandstone cliffs, sending out resonances in tones of lavender and mauve. By using more of a narrower format than in the previous painting, Twachtman accentuated the radiating movement of the light. The canyon wall on the opposite side of the gorge remains cool toned under low stratus clouds, its dusty lavender color perhaps reflecting the transition between the recent blizzard and the effect of the sun's brilliance piercing the chilly mountainous air.

Reporting to William Wadsworth, who was underwriting his Yellowstone venture, Twachtman remarked that visiting the park was "like the outing of a city boy to the country for the first time," and went on to note: "I was too long in one place."[1] His feeling of excitement at the newness and novelty of Yellowstone can be felt in this work, as well as in his other paintings of the Wyoming park (Cats. 50, 52–54). Although these works are very different from the panoramic Yellowstone views by Thomas Moran, Twachtman expressed a wonder similar to that of Moran in experiencing the strange and stunning beauty of this unique landscape.

In 1913 Evelyn Cary lent this painting, along *Niagara Gorge* (Cat. 49), to an exhibition of Twachtman's works at the Buffalo Fine Arts Academy (now the Albright-Knox Art Gallery), a show that possibly included the previous painting. The date at which the painting entered Evelyn Cary's collection is unknown, but it is likely that she purchased it from the artist through the connection she and her husband had made in Buffalo with Twachtman and Wadsworth (see Cat. 49), while Twachtman was painting Niagara Falls. The next known owner of the work was Anson Conger Goodyear (1877–1964), a Buffalo-born industrialist, who served as president of the Museum of Modern Art, New York, from 1929 to 1939, and who donated his large collection of late-nineteenth- and early-twentieth-century American and European art to the Albright-Knox Art Gallery.

1. Twachtman, Grand Canyon Hotel, Yellowstone National Park, Wyoming, September 22, 1895, to William A. Wadsworth, Geneseo, New York, Wadsworth Family Papers, College Libraries, State University of New York College of Arts and Sciences at Geneseo.

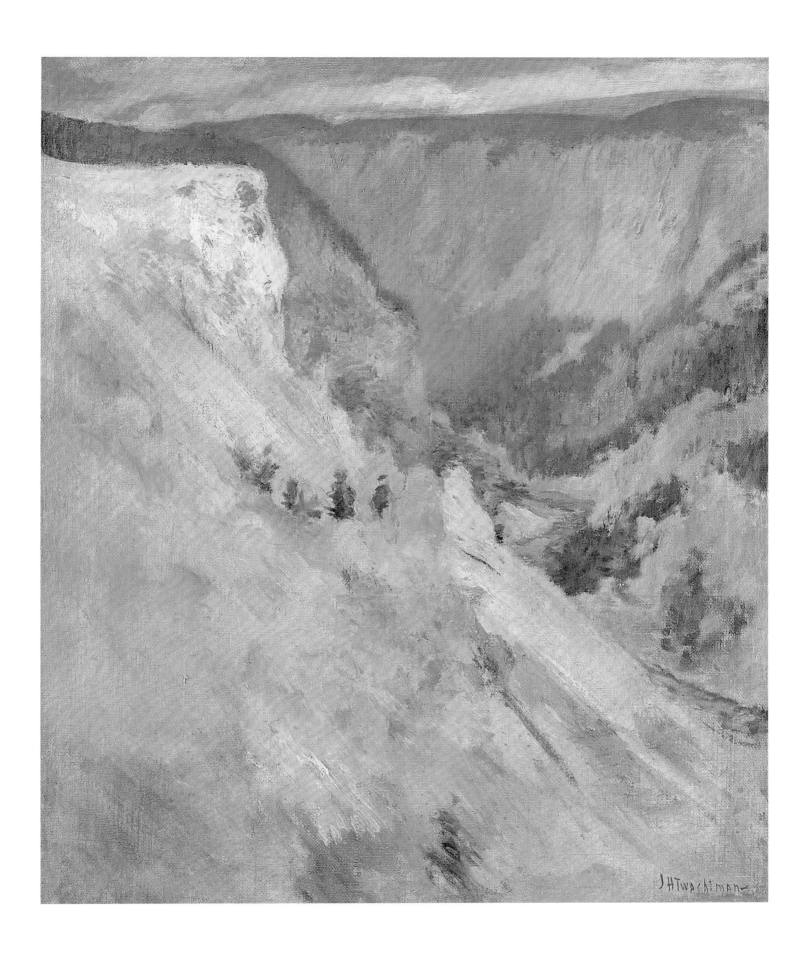

52.

Waterfall, Yellowstone ca. 1895

Oil on canvas
30¼ × 25 inches
Signed lower right: *J. H. Twachtman–*
Spanierman Gallery, LLC, New York

PROVENANCE

Samuel T. Shaw, New York; to (American Art Association, New York, *Sale of the Collection of Samuel T. Shaw*, January 22, 1926, lot 177); to (Frank K. M. Rehn Galleries, New York); to Arthur G. Altschul, New York, 1953; to (Chapellier Gallery, New York, 1959); to Joseph H. Hirshhorn, New York, 1959; gift to Hirshhorn Museum and Sculpture Garden, Smithsonian Institution, Washington, D.C., 1966; to (Sotheby's, New York, December 4, 2002, lot 25); to present coll., 2002.

EXHIBITED

Hirshhorn Museum and Sculpture Garden, Washington, D.C., *Inaugural Exhibition*, October 1974–September 1975 (as *Hemlock Pool: A Waterfall*).
The White House, Washington, D.C., June 1975–April 1978 (on loan).
Terra Museum of American Art, Evanston, Illinois, *Treasures from the Hirshhorn*, July 29–September 30, 1980, no. 6 (as *Hemlock Pool: A Waterfall*).
The White House, Washington, D.C., April 1981–April 1988 (on loan).
U.S. Department of Housing and Urban Development, Washington, D.C., June 1997–January 2001 (on loan).

REFERENCES

"New York Auctions: Samuel T. Shaw Paintings," *Art News*, January 30, 1926, p. 12.
"Collector Acquires Three Paintings by American Masters," *Art News* 21 (March 31, 1923), p. 1 (as *Lower Falls, Yellowstone Park*).
"Paintings Sold at Auction," *American Art Journal* 23 (1927), p. 364.
Hale, *Life and Creative Development*, 1957, vol. 1, pp. 254, 258 ill. (Fig. 52); vol. 2, p. 581 (catalogue A, no. 778).
Abram Lerner et al., *The Hirshhorn Museum and Sculpture Garden* (New York: Abrams, 1974), pp. 46 ill., 755 (Fig. 52, as *Hemlock Pool: A Waterfall*).

WHEN Twachtman wrote to his patron William Wadsworth from Yellowstone Park on September 22, 1895, he mentioned a recent snowstorm and noted: "I want to go to Lower Falls, they are fine."[1] As this comment reveals, he had not yet made the journey to see the falls up close. That he did so between its date and his departure from the park after a two-week sojourn there, which he told Wadsworth would be on the first of the month (presumably October), is demonstrated in the two paintings that he created from directly below the falls: *Lower Falls of the Yellowstone* (30 × 30 inches; private collection) and *Waterfall, Yellowstone*. It is likely that his other two known views of the falls, showing it from a greater distance (possibly from the location now called Artist's Point), *Lower Falls, Yellowstone* (30 × 30 inches; private collection) and *Waterfall in Yellowstone* (25⅝ × 16½ inches; Buffalo Bill Historical Center, Cody, Wyoming), were created before he corresponded with Wadsworth. Indeed, Twachtman could have seen the falls from near the Grand Canyon Hotel,

where he stayed, which was at the edge of the Grand Canyon of the Yellowstone, the location of the Lower Falls.[2]

Twachtman wrote in the same letter to Wadsworth that whereas the pools of Yellowstone, which he painted in a number of extraordinary works (Cats. 53–54), were "refined in color," there was "much romance in the falls and the cañon."[3] His images of the falls from a distance, which place the falls at the center of fantastic rock formations, contrast with the paintings he created below the falls themselves. These focus on the vivid colors of the waterfall reflecting sunlight and interacting with the volcanic rock walls over which they cascade with powerful force.

In *Waterfall, Yellowstone*, Twachtman limited his scope to the falls and their immediate surroundings. That he was portraying his subject directly, probably having carried his canvas to the site, is suggested in the spontaneity of his handling. He painted with a brusque energy, not taking the time to compose the scene as carefully as he did the more distant views. His aim seems to have been to express his fresh, direct impressions of the subject. The animation with which he worked is still apparent in the painting today and conveys the delight that Twachtman found in a landscape that he told Wadsworth was "fine enough to shock any mind."[4]

It was perhaps one of Twachtman's close-up images of the Lower Falls that he exhibited at the Society of American Artists in March–April 1896 with the title *Water-Falls*. One critic remarked that the work showed how Twachtman had kept "his tones very high" and thus had "achieved much brilliancy of opalescent qualities with his pigment."[5] Another reviewer commented that his view of a waterfall "gives us some idea of how that country looks to the eye of a modern painter. It is very charming in color."[6]

The first owner of this painting was the noted real estate magnate and art collector Samuel T. Shaw (1861–1945), who provided yearly prizes at many New York artists' clubs and organizations. Shaw, who knew many artists—including Theodore Robinson—may have purchased this painting directly from Twachtman.[7] After it entered the collection of Joseph Hirshhorn in 1959, it began to be known by the title of *Hemlock Pool: A Waterfall*, perhaps due to a belief that its waterfall subject somehow tied the work to Twachtman's Greenwich property (and perhaps because Hirshhorn lived in Greenwich and desired the painting to be of his surroundings). This title remained with the painting through the 1990s.

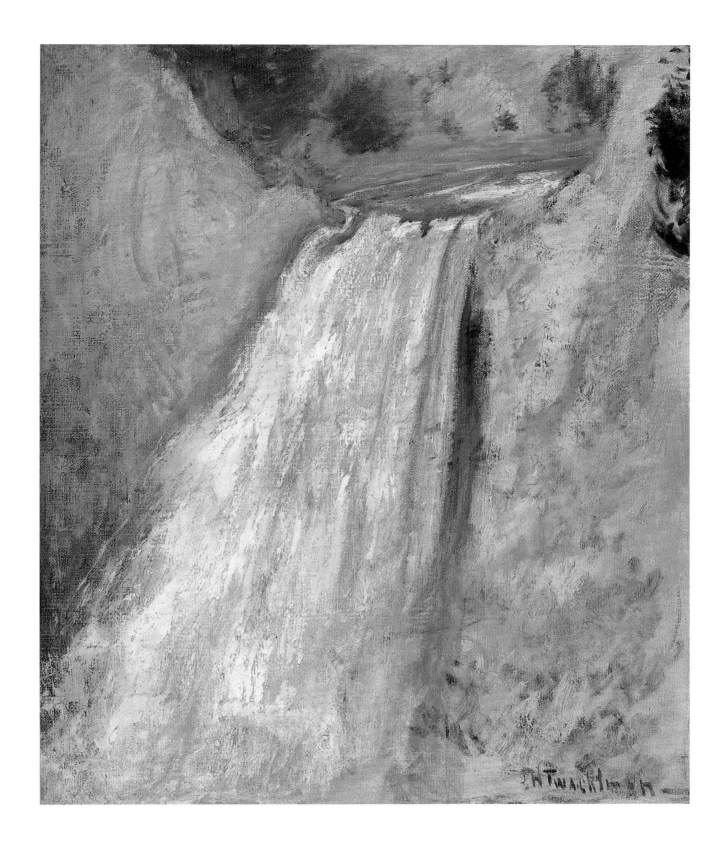

1. Twachtman, Grand Canyon Hotel, Yellowstone National Park, Wyoming, September 22, 1895, to William A. Wadsworth, Geneseo, New York, Wadsworth Family Papers, College Libraries, State University of New York College of Arts and Sciences at Geneseo.

2. Despite some reports that Twachtman painted both the Lower and the Upper Falls of the Yellowstone, he probably depicted only the Lower Falls, creating images of it both from afar and from his journey to its brink.

3. Twachtman to Wadsworth, September 22, 1895.

4. Ibid.

5. "Society of American Artists—The Landscapes," *New York Times*, April 4, 1896, p. 4.

6. "Society of American Artists," *New York Evening Post*, April 9, 1896, p. 7.

7. Robinson mentioned Shaw several times in his diaries. Frick Art Reference Library, New York.

53.

Edge of the Emerald Pool, Yellowstone ca. 1895

Oil on canvas
25 × 30 inches
Signed lower right: *J. H. Twachtman*–
Spanierman Gallery, LLC, New York

PROVENANCE

Major William A. Wadsworth, Geneseo, New York, ca. 1895; (M. Knoedler & Co., New York); (Milch Galleries, New York, by 1966); private collection, Texas, 1967; to (Sotheby's, New York, November 30, 2000, lot 20); to present coll., 2000.

EXHIBITED

1966 Cincinnati Art Museum, no. 78 (as *Near the Emerald Pool, Yellowstone*, lent by Milch Galleries, New York).

Kunstforum, Vienna, *Impressionismus: Amerika—Frankreich—Russland (Impressionism: America—France – Russia)*, October 25, 2002–February 23, 2003; no. 27 (pp. 98–99 color ill.) (traveling exh.).

Museum of the American West (formerly Autry Museum of Western Heritage), Los Angeles, *Drawn to Yellowstone: Artists in America's First National Park*, September 4, 2004–January 23, 2005 (traveled to Buffalo Bill Historical Center, Cody, Wyoming, Spring–Summer 2005).

REFERENCE

Impressionismus: Amerika—Frankreich—Russland (Impressionism: America—France—Russia) (Vienna: Palace Editions, 2002), pp. 98–99 color ill. (no. 27).

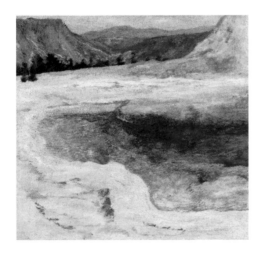

Fig. 80
Twachtman, *Emerald Pool*, ca. 1895, oil on canvas, 25 × 25 inches, Phillips Collection, Washington, D.C.

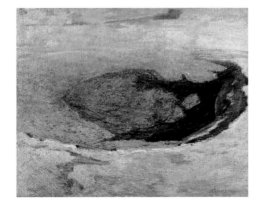

Fig. 81
Twachtman, *Emerald Pool, Yellowstone*, ca. 1895, oil on canvas, 25¼ × 30¼ inches, Wadsworth Atheneum, Hartford, Connecticut, Bequest of George A. Gay, by exchange, and the Ella Gallup Sumner and Mary Catlin Sumner Collection Fund.

IN ADDITION to painting the Grand Canyon of the Yellowstone and its Lower Falls, another subject that held Twachtman's attention during his trip in the fall of 1895 to the Wyoming park were its stunning geysers and thermal pools. Five of his images of this subject works are known today: *Geyser Pool, Yellowstone* (private collection); a view of an unknown site; *Morning Glory Pool, Yellowstone* (Cat. 54); and three views of the Emerald Pool, located in the Black Sand Basin, just to the west of Old Faithful: *Emerald Pool* (Fig. 80), *Emerald Pool, Yellowstone* (Fig. 81), and *Edge of the Emerald Pool*. Cooler than other Yellowstone pools, the Emerald Pool is distinguished by its rich, deep, sparkling greens and turquoises, a result of algae and bacteria that can grow there because of its fluctuating temperature.

Twachtman's scenes of the Emerald Pool are among his most striking works for the brilliance of their color and the abstract nature of their designs. Whereas in Greenwich, he had explored various ways of arranging forms within the picture plane, in these views, he departed further from traditional perspective. In the Phillips painting (Fig. 80), his vantage point was from the edge of the pool. Tilting the picture plane upward, he ignored the actual topography and cropped the pool and hills beyond to concentrate on the dynamic color relationships arrayed across the surface. The curving contours evoke a sense of energy, as the viewer's eye is naturally drawn to the movement that is implied by their sinuosity. In the Wadsworth painting (Fig. 81), the elliptical pool is placed in the center of the composition. The white surroundings, possibly reflecting the remnants of a recent snowfall, keep our gaze focused on the patterns of light and shadow within the blue pool, and as our eye is drawn into the curving rhythms of the depths and surface, the pool serves as a vehicle for meditation.

Edge of the Emerald Pool evokes a similar experience. Here Twachtman cropped the scene so that a partial view of the pool dominates the picture, and the vantage point—not as frontal as in the Wadsworth painting—draws us across the lip of the sun baked volcanic rock into a realm of mist and shimmering turquoises and blues. With more of the picture taken up with the pool than the ground itself, we feel urged over the edge, where we are left suspended above the water. Whereas in his Greenwich images Twachtman used compositional means to express the security and comfort of a place with which he was intimately familiar, in his Emerald Pool scenes, his use of almost perilous angles and daring reductive arrangements

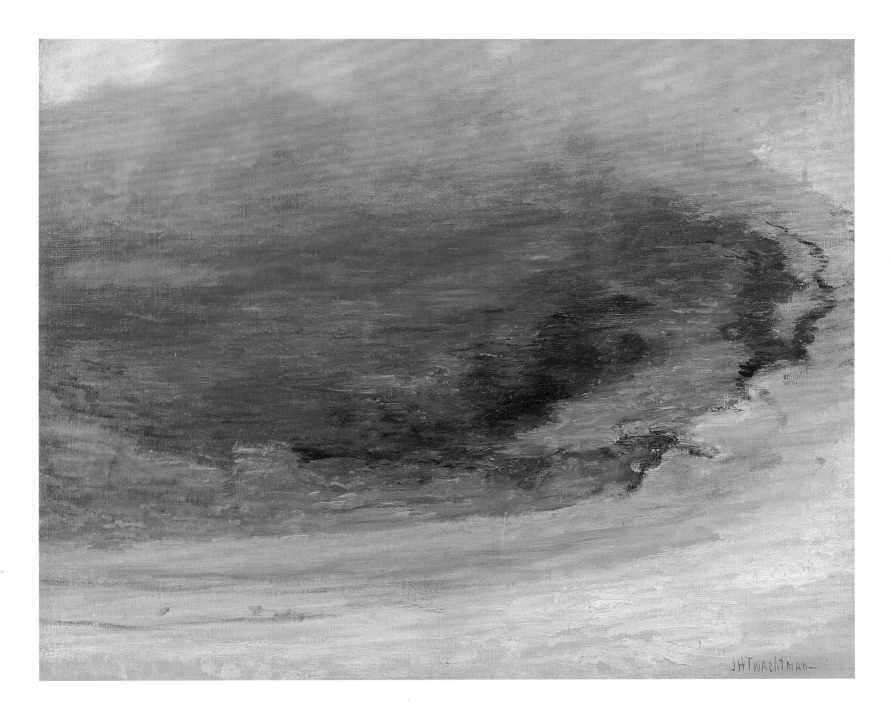

express his amazement at a locale he found exotic and utterly unique. Viewed close up the pool itself becomes almost unrecognizeable as we are drawn into a direct confrontation with it. It is easy to see why such an abstract image was radically modern in its day.

This painting was among the views of Yellowstone that were owned by William Wadsworth, who funded Twachtman's trip to the park, presumably remaining with Wadsworth until his death in 1918.

Morning Glory Pool, Yellowstone ca. 1895

Oil on canvas
29¾ × 24½ inches
Signed lower left: *J. H. Twachtman–*
Private Collection

PROVENANCE

(probably) (American Art Galleries, New York, *Sale of the Work of the Late John H. Twachtman*, March 24, 1903, no. 49, as *A Pool—Yellowstone Series*, oil on canvas, 30 × 25 inches); (probably) to W. M. Clancy; (Macbeth Gallery, New York); to H. L. Warner; to (Ferargil Galleries, New York); to (American Art Association, Inc., New York, *Oil Paintings by Representative European and American XVII and XIX Century Masters*, February 23, 1928, lot 158, as *Misty Morning*); private collection; to (Vose Galleries, Boston, 1977); to present coll., 1978.

EXHIBITED

Villa Favorita, Thyssen-Bornemisza Foundation, Lugano-Castagnola, Switzerland, *Masterworks of American Impressionism*, July 22–October 28, 1990, no. 33 (pp. 88–89 color ill.)

REFERENCES

Hale, *Life and Creative Development*, 1957, vol. 2, p. 475 (catalogue G, no. 423, as *Misty Morning*), possibly, p. 482 (catalogue G, no. 475, as *Emerald Pool*).
William H. Gerdts, *Masterworks of American Impressionism*, exh. cat. (Lugano-Castagnola, Switzerland: Fondazione Thyssen-Bornemisza, 1990), pp. 88–89 color ill. (no. 33).

IN HIS LETTER to William Wadsworth, who paid for his trip to Yellowstone in the fall of 1895, Twachtman mentioned that a recent snowfall had made the color in the park's pools "more refined."[1] Of his five extant paintings of pools in Yellowstone, Twachtman expressed this sense of refinement best in *Morning Glory Pool, Yellowstone*. Located in the Upper Geyser Basin, north of Old Faithful, this pool was named for its resemblance to the shape of the corolla of the morning glory flower, while its hot temperature is responsible for its dazzling ultramarine color. It is still one of Yellowstone's main attractions.

By contrast with the intimate angle at which *Edge of the Emerald Pool* (Cat. 53) was painted, Twachtman took an aerial perspective for this picture and tilted the ground plane forward, so that a broad expanse of the landscape could be seen, stretching far into the distance, although its exact scale is ambiguous. He recorded the subtle range of delicate tints within the rocky landscape, the result of snow or sun or both. With a flickering brushwork, he captured the crystalline turquoise of the pool, its great depth denoted by the deepening of its tones beneath its clear surface. As in *Edge of the Emerald Pool*, the feeling in the work is akin to that in the floral and canyon scenes of Georgia O'Keeffe. By bringing the viewer directly into the subject, *Morning Glory Pool, Yellowstone* verges on the abstract, representing what Twachtman saw combined with an expression of his feeling of wonder at this spectacular, seemingly unreal subject.

It is conceivable that this was the painting entitled *The Pool* that Twachtman exhibited in December 1896 at the eighth annual exhibition of the Art Club of Philadelphia. It was the subject of widespread controversy on the part of the critics and public alike, as suggested by the comment of a writer for the *Philadelphia Press*, who stated that it was "the riddle of the gallery" as well as its "gathering point of doubt, challenge, and discussion." In an attempt to explain how to understand the work, this critic observed, "nothing could be made out of it" without study, but he or she advised that, with such study, the painting revealed "a picture clear, distinct, accurate, and unmistakable of the fashion in which sandstone cliffs in an early stage of erosion in an atmosphere considerably elevated above the surface of the sea, present themselves the chill vision of quiet air which succeeds the first light snow of the season when it has come to stay." The critic felt that such an image was "worth doing and worth seeing," but wondered if it was a good idea for the artist "to present the unusual in an obscure fashion for the infrequent admirer."[2]

Such an opinion reflects the problem that plagued Twachtman throughout his career: the value of his art was undermined by the fact that only a limited number of admirers—mainly fellow artists—could see and appreciate it. Among the few who respected Twachtman's efforts were a critic for the *Philadelphia Daily Evening Telegraph*, who called *The Pool* "a striking work," portraying "a snow-filled crevance [*sic*] in which the pool is conspicuous by its silence,"[3] and one for the *Philadelphia Inquirer*, who stated that the painting was "aglow with that delicious light and play of color which Twachtman alone of our landscape painters beholds in nature."[4]

Although the identification of this painting as a view of Yellowstone's Morning Glory Pool seems assured, when this correlation was made is unknown. The first recorded title for it seems to have occurred in 1928 at an auction at the American Art Association, at which it was called *Misty Morning*. It is probable that it was listed in Twachtman's 1903 estate sale as number 49: *A Pool—Yellowstone Series* (oil, 30 × 25 inches), which sold to an individual named W. M. Clancy. Confusingly, John Hale catalogued the work with the title *Emerald Pool*.

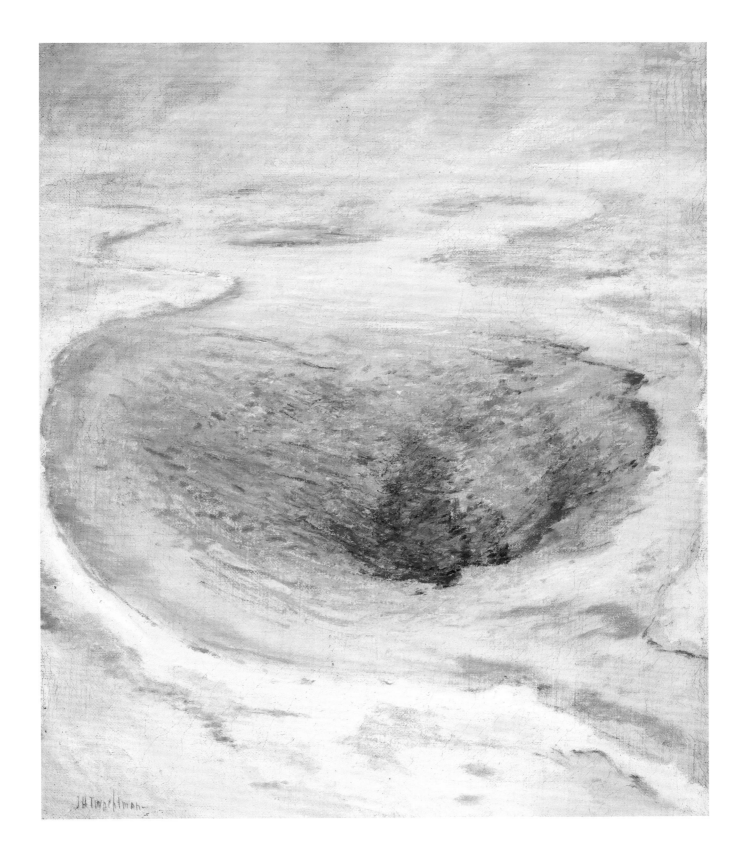

1. Twachtman, Grand Canyon Hotel, Yellowstone National Park, Wyoming, September 22, 1895, to William A. Wadsworth, Geneseo, New York, Wadsworth Family Papers, College Libraries, State University of New York College of Arts and Sciences at Geneseo.

2. "The Art Club Exhibition," *Philadelphia Press*, November 22, 1896, p. 11.

3. "Pictures at the Art Club," *Philadelphia Daily Evening Telegraph*, November 21, 1896, p. 7.

4. "The Art Club Show Is Now the Thing," *Philadelphia Inquirer*, November 22, 1896, p. 22.

55.

The Cascade in Spring ca. 1890s

Oil on canvas
22 × 30¼ inches
Stamped lower right: *Twachtman Sale*
Spanierman Gallery, LLC, New York

PROVENANCE

(American Art Association, New York, *Sale of the Work of the Late John H. Twachtman*, March 24, 1903, lot 85, as *The Cascade in Spring*); to M. Mott; Arthur B. Davies, Congers, New York, before 1928; to (Ferargil Galleries, New York, 1928); to Virginia and Niles Davies, Congers, New York, 1935; to (Parke-Bernet Galleries, New York, February 26, 1947, lot 94); to (Ferargil Galleries, New York); to (James Graham & Sons, New York); to Joseph H. Hirshhorn, New York, 1962; gift to Hirshhorn Museum and Sculpture Garden, Smithsonian Institution, Washington, D.C., 1966; to (Sotheby's, New York, December 4, 2002, lot 4); to present coll., 2002.

EXHIBITED

Ferargil Galleries, New York, *19th and 20th Century American Paintings*, February 11–March 1, 1928 (as *The Waterfall*).
Anderson Galleries, New York, *Exhibition of Works by American Artists Selected by the Associated Dealers in American Paintings, Inc.*, February 21–March 10, 1928, no. 109 (as *The Waterfall*, lent by Ferargil Galleries).
San Francisco Museum of Art, *American Forerunners of Contemporary Painting*, October 25–November 30, 1936 (as *The Brook*).
Hirshhorn Museum and Sculpture Garden, Smithsonian Institution, Washington, D.C., *Inaugural Exhibition*, October 1, 1974–September 15, 1975 (as *The Waterfall*).
Hurlbutt Gallery, Greenwich Library, Connecticut, in association with the William Benton Museum of Art, University of Connecticut, Storrs, *Connecticut and American Impressionism: The Cos Cob Clapboard School*, March 20–May 31, 1980, no. 151, as *The Waterfall* (pp. 104, 112 ill.).
Vatican Museums, Vatican City State, Italy, *A Mirror of Creation: 150 Years of American Nature Painting*, September 1980–March 1981, no. 25 (ill., as *The Waterfall*) (traveled to the Terra Museum of American Art, Evanston, Illinois, December 20–March 15, 1981).
Nassau County Museum of Art, Roslyn Harbor, New York, *Landscape of America: The Hudson River School to Abstract Expressionism*, November 10, 1991–February 9, 1992 (pp. 32–33 ill., 77, as *The Waterfall*).

REFERENCES

"Twachtman Pictures, $16,610," *New York Sun*, March 25, 1903, p. 5.
"Paintings by American Artists: Ferargil Galleries," *Art News* (March 2, 1929), p. 10 (as *The Waterfall*).
Hale, *Life and Creative Development*, 1957, vol. 2, pp. 440 (catalogue G, no. 122, as *The Cascade in Spring*), 576 (catalogue A, no. 679, as *The Waterfall*).
Abram Lerner et al., *The Hirshhorn Museum and Sculpture Garden* (New York: Abrams, 1974), pp. 88 color ill., 755 (Fig. 111, as *The Waterfall*).
Louise Bruner, "Religious Themes in American Art," *American Artist* 44 (December 1980), p. 76 color ill. (as *The Waterfall*).
Judith Zilczer, "Arthur B. Davies: The Artist as Patron," *American Art Journal* 19 (1987), pp. 73, ill., 74 (Fig. 20, as *The Waterfall*).
Lisa N. Peters, "John H. Twachtman (1853–1902): *The Torrent*, late 1890s," in William H. Gerdts et al., *Ten American Painters*, exh. cat. (New York: Spanierman Gallery, LLC, 1990), p. 167 ill. (as *The Waterfall*).

THIS PAINTING depicts Horseneck Falls, a focus of Twachtman's attention throughout his years in Greenwich. Looking northwest, Twachtman showed the cascade in his backyard from below, so that the rock positioned above it, which is featured prominently in many other works, is only suggested. He used a similar vantage point in *Horseneck Falls* (early 1890s; Metropolitan Museum of Art, New York) and *The Torrent* (ca. 1900; Smithsonian American Art Museum, Washington, D.C.).

The result of recent runoff, the water has just begun to gather force. Its meager flow allows the mauve and sandy tan tones in the ground to show through the grayish silver of the water. In keeping with this transitional time of year, the colors throughout the work are light and delicate, and hints of the emerging ground vegetation can be seen. Within the softly subdued landscape, the pastel, reflected color within the waterfall is allowed to shimmer in a way that will soon be lost when the foliage returns. Clearly Twachtman delighted in this gentle landscape, vulnerable in its raw state, yet full of the promise of the coming season. The work epitomizes the sort of refined image that appealed to businessmen in the late nineteenth century, who sought a soothing type of art that was calming to the nerves. Yet, due to its asymmetrical composition and lack of decorative elements, such as the dreamy figures that Thomas Dewing put in his paintings, it may not have closely enough fit the ideal that such patrons desired.

The title of this painting has changed a number of times. It was included in the artist's estate sale with the title *The Cascade in Spring*. This title has now been returned to it after a period of more than one hundred years. The buyer of the painting from the estate sale was identified in an article on the sale as M. Mott. Its next owner was the painter Arthur B. Davies, who worked with Twachtman on a cyclorama in Chicago about 1887 and created a landscape at the time that is close in style to works by Twachtman (*Landscape*, 1887, Sheldon Memorial Art Gallery, University of Nebraska-Lincoln).[1]

When it was in Davies's possession, the work appears to have been referred to as *The Brook*, according to the recollections of his daughter-in-law in a letter of 1965.[2] When Davies died in 1928, his family sold the painting to Ferargil Galleries in New York. Over the next several years, the gallery lent the painting and referred to it as both *The Waterfall* and *The Brook*, but in 1935 the gallery gave the painting back to the Davies estate "in full settlement of all debts and obligations to date."[3] The Davies family lent it to an exhibition in San Francisco the following year with the title *The Brook*. In 1947, when Davies's widow Virginia was eighty-five, the family called on Ferargil again to help sell the painting, and it was included in a sale at Parke-Bernet that February, in which it was listed as *The Waterfall*.[4] However, the buyer of the

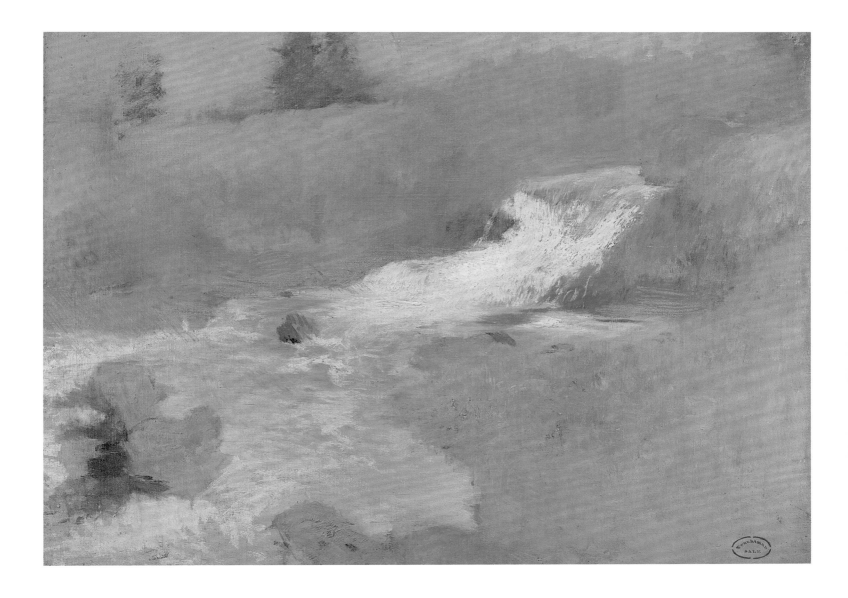

painting was none other than Ferargil. In a letter to the Davies family, Frederic Newlin Price of Ferargil stated that the gallery had purchased the painting for $225, by contrast with the $2,500 it had first paid for the work, when it bought the painting from the Davies family in 1928. James Graham and Sons Gallery in New York purchased the painting from Ferargil, retaining it until 1962, when it was sold to the New York financier and collector Joseph Hirshhorn (1899–1981). Hirshhorn lived on John Street in Greenwich, Connecticut, which intersects with Round Hill Road, on which Twachtman's home was located. Hirshhorn's purchase of this work and of the painting now called *Waterfall, Yellowstone* (Cat. 52), which Hirshhorn renamed *Hemlock Pool: A Waterfall*, reflected his taste both for modern American art and for paintings that he associated with his home.

In 1966 Hirshhorn gave this painting and *Waterfall, Yellowstone* to the new Hirshhorn Museum, a part of the Smithsonian Institution that had been mandated in the 1930s but was not created until Hirshhorn helped pay for the construc-

tion of its building. The museum catalogued the painting as *The Waterfall*, and this name was thereafter associated with the work, so that even after scholarship at the museum revealed the painting's original title, this name was kept, until now.

1. This project, portraying the Civil War Battle of Shiloh, was financed by H. H. Gross and built adjacent to the B&O passenger depot on Chicago's Michigan Avenue. The other artists who carried out the job included Charles Corwin, Warren Davis, Joseph P. Birren, Oliver Dennett Grover, and Frank C. Peyraud. See Bennard Perlman, *The Lives, Loves, and Art of Arthur B. Davies* (Albany, N.Y.: State University of New York, 1999), pp. 23–24. Davies's *Landscape* is illustrated in Perlman, p. 25.

2. Erica R. Davies (Mrs. Niles M. Davies Sr.) to Doreen Bolger, Metropolitan Museum of Art, New York, March 6, 1965, Artist File, Hirshhorn Museum and Sculpture Garden, Washington, D.C.

3. Frederick Newlin Price, Ferargil Galleries, New York, to Dr. Virginia Davies, Congers, New York, April 10, 1935, Artist File, Hirshhorn Museum.

4. Frederic Newlin Price, Ferargil Galleries, New York, to Dr. Virginia Davies and Niles Davies, Congers, New York, [1947], Artist's File, Hirshhorn Museum.

56.

Waterfall ca. 1898

Oil on canvas
30 × 30 inches
Signed lower right: *J. H. Twachtman–*
Private Collection

PROVENANCE

The artist; to Mr. and Mrs. Charles Deering, Evanston, Illinois, 1902; by descent to their son and daughter-in-law, Mr. and Mrs. Charles Deering, Boston; by descent to Mr. and Mrs. Richard E. Danielson, Boston; by descent to Mr. and Mrs. Richard E. Danielson Jr., ca. 1950; to estate of Mrs. Richard E. Danielson; to present coll., 1997.

EXHIBITED

(Possibly) 1901 Art Institute of Chicago, no. 12.
(Probably) 1901 Cincinnati Art Museum, no. 451.
Art Institute of Chicago, *A Century of Progress: Exhibition of Paintings and Sculpture lent from American Collections*, June 1–November 1, 1933, no. 486 (The Charles Deering Collection, lent by Mr. and Mrs. R. E. Danielson).

REFERENCE

"Twachtman, the Smiler," *Chicago Post*, August 2, 1932, newspaper clipping, Ryerson Library Scrapbook, Art Institute of Chicago.

IT IS generally believed that all of the waterfalls that Twachtman painted in Greenwich are views of Horseneck Falls, a cascade with a drop of about ten feet that was situated on the artist's property to the southwest of his house (Cats. 55, 57–58). However, winding over the uneven terrain of the artist's land, Horseneck Brook passes over many rocky outcroppings, and it produces a number of smaller waterfalls. One of these is probably portrayed in this painting. Its location is likely a spot south of Horseneck Falls, between the two pools that formed the subjects of Twachtman's Hemlock Pool paintings (see Figs. 59, 62, 65). Here the brook's course narrows through a cut between a

Fig. 82
Illustrated letter, Twachtman, Players Club, New York, March 13, 1902, to Joseph Gest, Archives, Cincinnati Art Museum.

high rocky ledge on one side and a steep bank of land on the other and then opens out over a wide stretch of more open land. The time of year in the painting is probably late spring or early summer, when heavy overgrowth wrapped over the brook and its rocky embankment, while the foliage of the trees limited the amount of the day's brilliant sunlight that could reach the water, producing a dappled pattern in the shaded enclosure.

Taking his inspiration from this subject, Twachtman structured the painting to capture the feeling of its protective, cloisterlike feeling. Closely cropping the scene to bracket the waterfall and the rocks above it, the greens and yellows of the trees filling the background, he enhanced the sense of privacy and seclusion evoked by his subject. Choosing a vantage point level with the water, Twachtman draws our eye toward the lightest area in the work, represented by the gleaming reflections; this line of vision locates us within the safe and secluded retreat.

The year "1898" has been penciled on the stretcher bar of this work. It is not clear if Twachtman wrote the date, but it could well be correct, as he often turned his attention to broadly treated waterfall subjects at the end of the 1890s.

This painting has the distinction of having been identified in a sketch Twachtman included in a letter he sent on March 13, 1902, from the Players Club in New York to Joseph Gest, the director of the Cincinnati Art Museum (Fig. 82).[1] In it, Twachtman asked Gest to send the work called "Waterfall, with spots of sunshine on the grass and rocks surrounding it," to "Mr. Charles Deering, Evanston, Illinois."[2] Twachtman indicated the dimensions of the work as "30 by 30" inches. That the painting was in Cincinnati suggests that it may have been the work entitled *Waterfall* that had been included in the show of Twachtman's art held at the museum the previous April, and perhaps Gest—a fellow painter and a friend to many contemporary artists—had offered to retain it in the hopes of selling it locally. The letter further suggests that the painting was shown in an earlier version of the exhibition, held in Chicago in January 1901, in which a work entitled *Waterfall* was on view. It seems more than likely that Charles Deering (1852–1927) would have seen the painting in Chicago and perhaps had written to Twachtman to ask if it was still available more than a year after Twachtman's show in Chicago. It also seems probable that Deering met Twachtman in Chicago (if not before), as the artist made a trip to the city at the time of the show, where he spoke to an audience at the Art Institute.

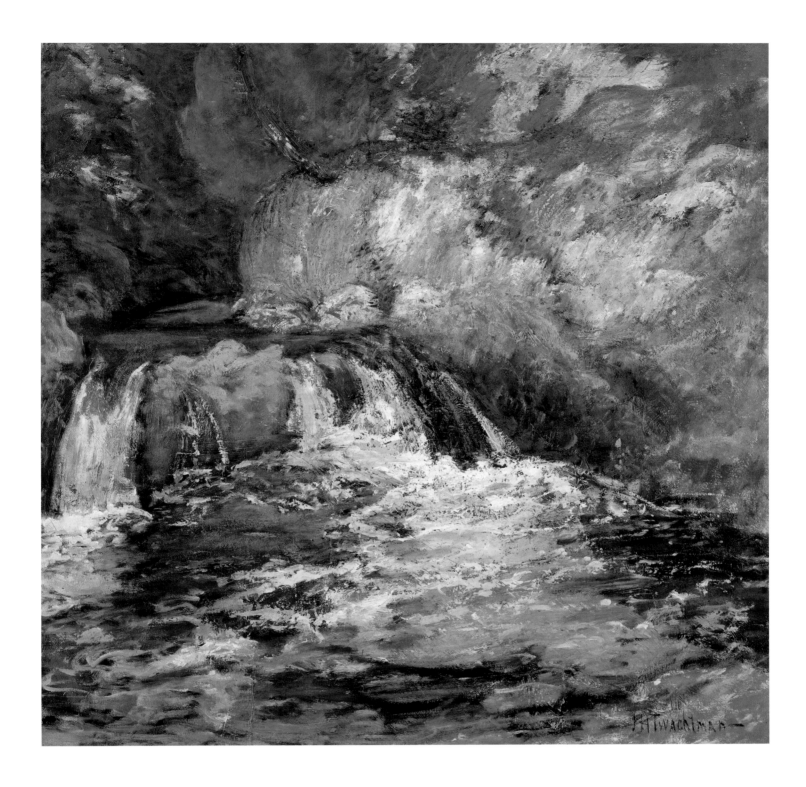

Deering was a prominent figure in both the business and art worlds of Chicago. Although heir to a textile mill and machine manufactory that produced harvesters, in the 1870s he had studied painting in Paris, where he had become a close friend of John Singer Sargent, who encouraged his painting career and remained a lifelong friend. After turning from art to business in the mid-1890s, Deering devoted himself to supporting young artists and served in his role as a trustee of the Art Institute of Chicago from 1904 to 1910.

The painting was inherited from Deering by his daughter Barbara, who married Richard Ely Danielson. The Danielsons lent the work to the important *Century of Progress Exhibition*, held in Chicago at the Art Institute in 1933. The painting remained in the Danielson family into the 1990s.

1. On Gest, see Cat. 46, pp. 170–71.
2. Twachtman, The Players, New York, to Joseph Gest, Cincinnati Art Museum, March 13, 1902, Archives, Cincinnati Art Museum.

57.

The Cascade late 1890s

Oil on canvas
30 × 30 inches
Signed lower left: *J. H. Twachtman*
The Cummer Museum of Art, Jacksonville, Florida

PROVENANCE

(Macbeth Gallery, New York, by 1919); Horatio S. Rubens, by 1931; (Babcock Galleries, New York, by 1942); (Milch Galleries, New York); (Grand Central Art Galleries, New York); to IBM International Corporation, Armonk, New York, 1944; to (Sotheby's, New York, May 25, 1995, lot 35); to The Fortier Collection; to (Spanierman Gallery, LLC, New York, 1998); to present coll., 2005.

EXHIBITED

1919 Macbeth Gallery, no. 13.
Brooklyn Museum, New York, *Leaders of American Impressionism: Mary Cassatt, Childe Hassam, John H. Twachtman, J. Alden Weir*, October 17–November 28, 1937, no. 68 (lent by Horatio S. Rubens, New York).
1942 Babcock Galleries, no. 18.
Grand Central Art Galleries, New York, *Sixty American Artists since 1800*, November 19–December 5, 1946, no. 18.
1989 National Gallery of Art, no. 22 (pp. 34 color ill. [detail], 35, 36, 110, color ill.).
Spanierman Gallery, LLC, New York, *110 Years of American Art: 1830–1940*, October 15–December 31, 2001.

REFERENCES

Tucker, *John H. Twachtman*, 1931, pp. 24–25 ill.
Hale, *Life and Creative Development*, 1957, vol. 2, pp. 544–45 (catalogue A, no. 121).
James Thomas Flexner, *Nineteenth Century American Painting* (New York: G. P. Putnam's Sons, 1970), pp. 248–49 color ill.
Chotner, Peters, and Pyne, *John Twachtman: Connecticut Landscapes*, 1989, pp. 34 color ill. (detail), 35, 36, 110 color ill.
Paul Richard, "John Twachtman's Scenes of Silence: At the National Gallery, Meditations on the Landscape," *Washington Post*, October 22, 1989, p. G10 ill.
May, "Twachtman at the Wadsworth," 1990, p. 9.
Peters, *John Twachtman (1853–1902) and the American Scene*, 1995, vol. 1, p. 381; vol. 2, p. 927 ill. (Fig. 413).

ALTHOUGH many American Impressionists painted their own home grounds, few were lucky enough to have a waterfall in their backyards. Indeed, the falls were one of the main features that attracted Twachtman to his Greenwich property. Alfred Goodwin recalled in his 1905 article that on his first visit to this countryside, Twachtman had followed "up a stream" that "bent and curved, and deepened into pools, and dashed itself to foam in miniature vociferous falls." Goodwin noted that "at the point where [the brook] spread itself with an added vivacity [the artist] walked away from it over the hill to the house that owned it to investigate the possibility of a transfer."[1] The stream was called Horseneck Brook and its falls, the cascade that dropped ten feet over a double ledge of rock, located down the hill and to the northwest of Twachtman's house. At the top of the falls, a large boulder, seen in many of his works, enhanced the energy of the water.

Twachtman painted views of the falls throughout his years in Greenwich, but it is nearly impossible to identify which waterfall picture he showed in a particular exhibition. In addition, many of the images of cascades that he exhibited in the mid-1890s were works he had created on his trips to Niagara Falls in 1894 and Yellowstone in 1895. The approximately twenty oils by Twachtman known today that appear to portray Horseneck Falls reveal that he was interested in approaching the subject from many angles and in all seasons. Among his earliest views of it is probably *Horseneck Falls* (early 1890s; Metropolitan Museum of Art, New York), in which his vantage point is from below, looking northwest, at some distance downstream below the falls. In other works, he portrayed the falls seen obliquely from their eastern bank, while in still others he showed them, as in *Horseneck Falls*, from below, looking northwest (see Cats. 55 and 58).

Among the waterfalls, there are four paintings that belong to a distinct group of images that Twachtman is thought to have created at the end of the 1890s: *Waterfall, Blue Brook* (Cincinnati Art Museum), *The Waterfall* (Worcester Art Museum, Massachusetts), *Falls in January* (Wichita Art Museum, Kansas), and *The Cascade*. In these works, he brought the forms of the water and the rocks and hills that formed their banks up to the picture plane, making these elements themselves establish the structure and design of the works. The decorative nature of their arrangements transforms these paintings from images capturing the liveliness of a rushing cascade to iconic representations in which the dynamism of the elements themselves—with the diagonals of the falls countering the diagonals of our line of vision—express the nature of the subject. With no sense of the landscape's scale, our attention is drawn to relationships of color and varying rhythms of brushwork, evoking Twachtman's view of a waterfall as defined by its effect on the eye and mind rather than by its specific placement within a landscape.

Each of the four works is different. While they do not constitute a series, each seems to capture a different mood. *Falls in January* has a somnolent quality, as our eye is drawn around the seemingly continuous curves of the icy falls set against white snowbanks. In *Waterfall, Blue Brook*, the waterfall seems almost relaxed, the ledge of its lower drop extending a longer distance than in the other works, while a warm light flickers across the image. In *The Waterfall* the falls are more upright and awake, their white foamy surface illuminated sharply against the darker purples and greens in

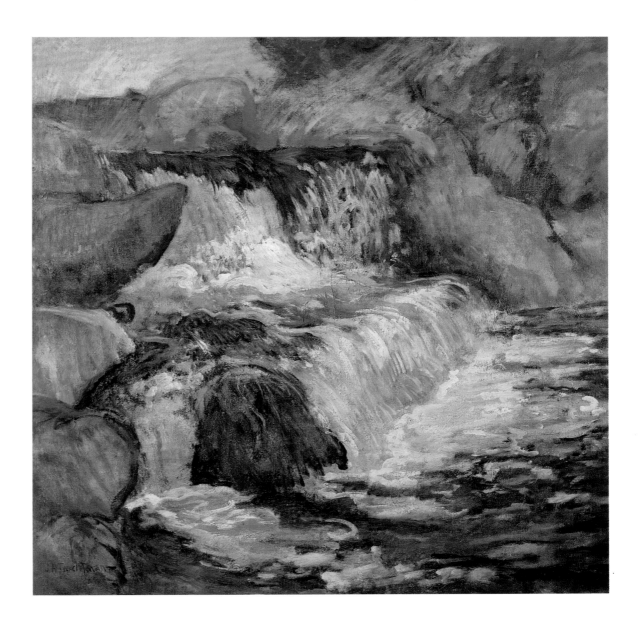

the background. In *The Cascade*, there is a sense of a melancholy calm in the decreased light of late afternoon, against which the white and blue reflective water holds onto the day's remaining luminescence.

One interpretation of these waterfalls is that they were Twachtman's swansong to Greenwich, works in which he wanted to encapsulate his feelings about the landscape and his artistic involvement in it. He seems to have he left his Greenwich home at some point in 1900, renting it out and staying in nearby Cos Cob at the Holley House or at the Players Club, in New York, and spending summers in Gloucester, while his family left him behind when they left for Europe in 1901, remaining there through the time of his death in August of 1902.

The Cascade is possibly the work with this title that Twachtman included in his 1901 exhibition, held in March at Durand-Ruel Gallery in New York. A critic for the *New York Tribune* remarked that the work with this title was one "in which land and water seem hopelessly confused."[2] The

painting probably remained in the artist's estate until about 1920, when it was either sold or consigned to New York's Macbeth Gallery. It is likely that it was purchased shortly thereafter by the New York lawyer Horatio S. Rubens (1869–1941), who acquired three other works by Twachtman about the same time.[3] Rubens lent the painting to the exhibition organized in 1937 by John Baur at the Brooklyn Museum of the works of Mary Cassatt, Childe Hassam, J. Alden Weir, and Twachtman, in which Baur sought to showcase the artists he considered the leading American Impressionists. *The Cascade* was in the collection of the IBM Corporation from 1944 until 1995.

1. Goodwin, "An Artist's Unspoiled Country Home," 1905, p. 625.
2. "Art Exhibitions," *New York Tribune*, March 6, 1901, p. 6.
3. These works are *Reflections* (ca. 1893; Brooklyn Museum of Art, New York), *Willows* (ca. 1890s; location unknown), and *Winter Landscape* (ca. 1890s; private collection).

58.

Waterfall, Greenwich late 1890s

Oil on canvas
25 × 30 inches
Spanierman Gallery, LLC, New York

PROVENANCE

Alden Twachtman, the artist's son, Greenwich, Connecticut; to private collection, 1970s; to present collection, 2000.

In 1910, Alden Twachtman, John Twachtman's eldest son, built a house on Round Hill Road just north of the farmhouse that had been his home during his youth. It was there several years after Alden's death in 1974, that this unfinished painting was found. Portraying a view of Horseneck Falls seen from below looking northwest, the painting relates closely to the images of the falls that John Twachtman painted about 1900, in which he framed the falls closely within his pictures and painted them with his inimitable dynamic strokes, their energy sustained throughout his works.

Indeed, this painting provides a fascinating glimpse into John Twachtman's working methods. As can be seen, he began, not by working in sections or even by focusing on his primary motifs, but by blocking in the entire structure at once, using broad hatchings to indicate tonal values. He also used the changing rhythms of his brushwork to indicate the basic lines and shapes of forms and to accentuate the points at which they had particularly interesting relationships with each other, such as the rounded curves of rocks meeting and the downward slope of the hill concurring with the movement of the falls. In the next phase of his work, Twachtman would have built these forms up with thicker layers of pigment and more pronounced lines, but he surely would have retained the underlying relationships and interconnections between the forms.

If this painting had been completed, we can conjecture what it would have looked like. It would have staked a middle ground between Twachtman's more dynamic views of the falls, such as *Waterfall* (ca. 1890s; Yale University Art Gallery, New Haven, Connecticut), in which the movement and rhythmic qualities of the subject were emphasized, and the more iconic images of about 1900 (see Cat. 57). In the latter category, the waterfall is painted both for its intrinsic qualities and for the symbolism its considered placement within the arrangement gave it.

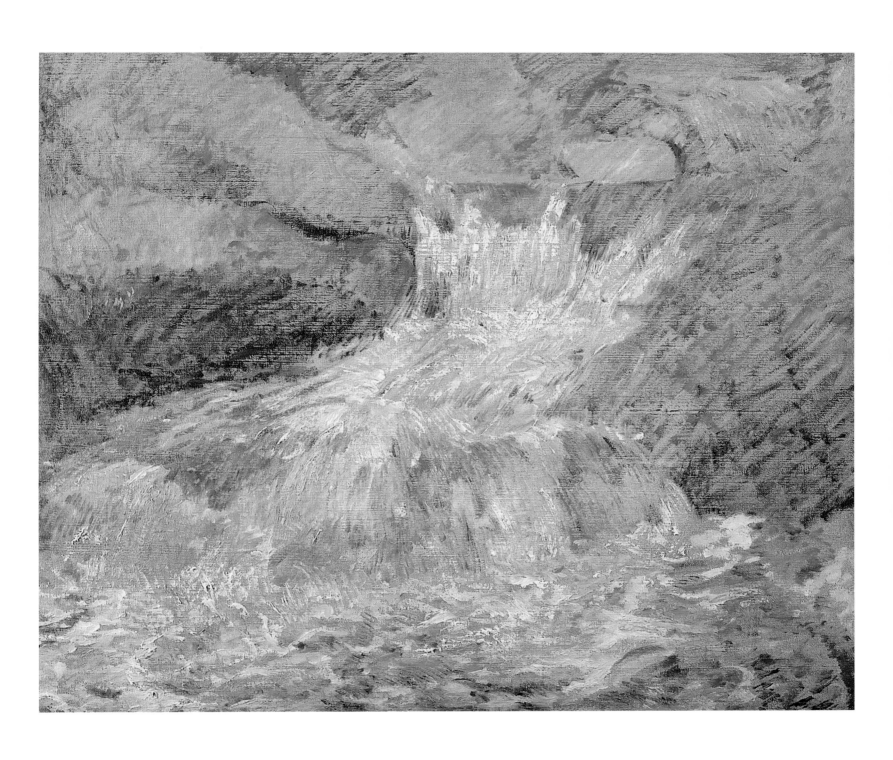

59.

Gloucester Schooner ca. 1900

Oil on canvas
30 × 25 inches
Private Collection

PROVENANCE

Martha Twachtman, the artist's wife, Greenwich, Connecticut; to her son Quentin Twachtman, 1936; by descent in the family to the present.

DURING the last three summers of his life, from 1900 through 1902, Twachtman painted in Gloucester, Massachusetts, where he joined the lively artists' colony that had been gaining strength in the Cape Ann town for several years. His decision to go to Gloucester had probably been at the urging of his old friend Frank Duveneck, who had been summering there since 1890. Twachtman must have been delighted to be greeted in Gloucester not only by Duveneck but also by a coterie of old friends that included several from his youth in Cincinnati, many of the Duveneck "boys" from Munich and Florence, and colleagues from the New York art world.

His first summer in the town may have been his longest and the most productive. His family was with him during his stay from early June through the end of September.[1] In 1901 Twachtman's family was in Europe and he joined them for a month in June or July in Honfleur, and probably went directly to Gloucester on his return, where he taught summer sessions organized there by the Art Students League. The family lived in Paris during the year that followed, but Marjorie, then twenty, sailed with an escort from Europe to join her father in Gloucester in mid-July 1902. She was the only family member with him when he died of a brain aneurysm at a Gloucester hospital on August 8, 1902, after a short illness, four days after his forty-ninth birthday. With his family away, funeral arrangements were not made, and he was laid to rest in Gloucester's Oak Grove cemetery, where his simple grave marker may be found today.

This painting of a schooner suggests the way that Gloucester energized and revitalized Twachtman. The three-masted, square-rigged cargo ship must have caught Twachtman's eye in part because it was an exotic and rare sight. Such sailing vessels, bringing salt from Spain and Italy for the curing of fish, were becoming obsolete in the early twentieth century, as steam lighters were increasingly used for transatlantic trips, their loads brought to shore by smaller sailing vessels. For Twachtman such a motif may have evoked his days in Venice, when he had painted similar antiquated ships (see Cat. 4), and being in the company of friends from those times may have heightened his pleasure in this relic of bygone days, seen sidling up to the unembellished, practical forms of Gloucester warehouses. Indeed, it appears that his friend and fellow Ohioan Albert Fauley (1859–1919), who was staying in Gloucester in the summer of 1900, may have portrayed the same ship in *Sailboat* (Columbus Museum of Art, Ohio).[2] The site in this work is probably in or near Wonson's Cove in East Gloucester, where Twachtman painted views of warehouses such as those seen here in the background.

Gloucester Schooner relates to two other paintings that Twachtman created in Gloucester, *Bark and Schooner* (ca. 1900; Sheldon Memorial Art Gallery, University of Nebraska-Lincoln) and *Drying Sails* (ca. 1900; Freer Gallery of Art, Washington, D.C.), in which he showed antiquated sailing barques as the dominant forms in his compositions, studying their formal and reflective qualities. In *Bark and Schooner* the daylight is fading and the forms of the ship seem softened in the low light, their reflections glimmering across the darkening surface of the water. In *Drying Sails* a brilliant sunlight illuminates the scene, making the boat shimmer similarly to its reflections. In *Gloucester Schooner* the light seems to be that of morning and its soft prismatic glow resonates in the ship's sails, its reflection, and in the buildings on the shore. The black hull of the boat, recalling the dark boats in *Sailing Boats, Dieppe Harbor* (Cat. 16) is set at a slight diagonal, offsetting the scene's stillness with a suggestion of movement.

This painting remains today in the collection of a descendant of Twachtman's son Quentin and has never before been exhibited.

1. "East Gloucester...," *Gloucester Daily Times*, June 6, 1900, p. 5: "Mr. Twachtman and family of New York, who have been stopping at the Pilgrim House, awaiting an available cottage for their occupancy, have secured apartments in the 'Amenity cottage,' the new Rockaway annex, for the season." "East Gloucester...," *Gloucester Daily Times*, September 24, 1900, p. 5: "Mr. J. H. Twachtman's family have joined him at the Rockaway, among them his eldest son, who won the Yale College scholarship of $2,000 for future study abroad."

2. Illustrated in William H. Gerdts, "John Twachtman and the Artistic Colony in Gloucester at the Turn of the Century," in Hale, Boyle, and Gerdts, *Twachtman in Gloucester*, 1987, p. 37.

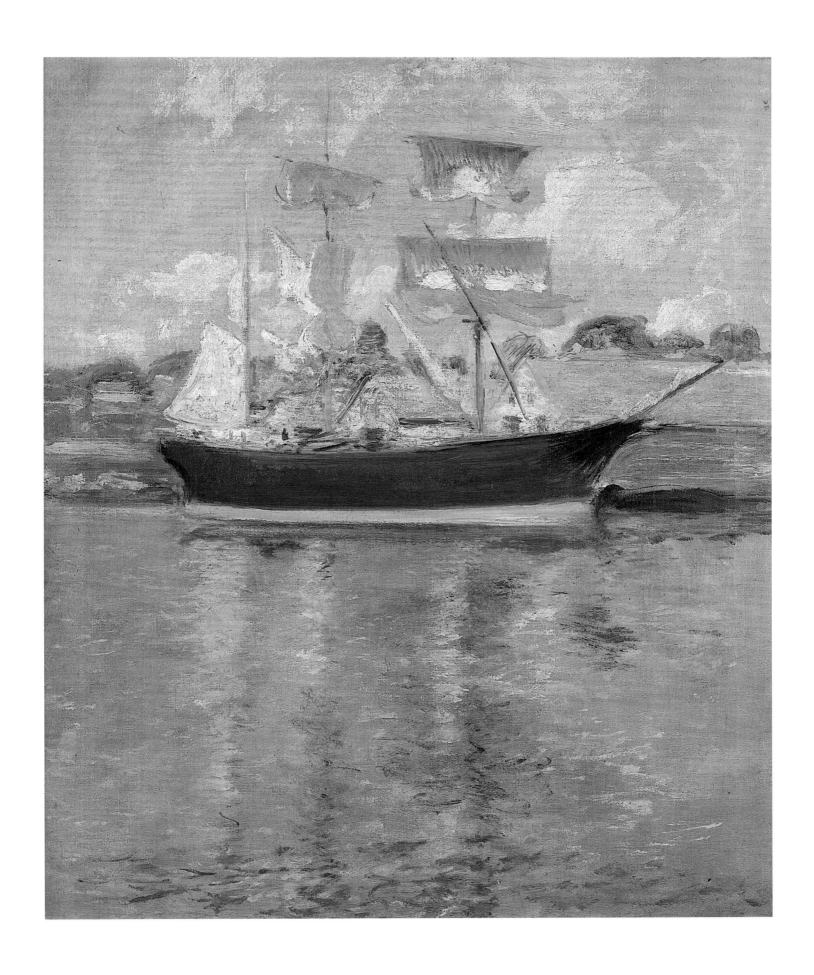

60.

Gloucester Harbor ca. 1900

Oil on panel
13¼ × 22¼ inches
Signed lower right: *J. H. Twachtman–*
Spanierman Gallery, LLC, New York

PROVENANCE

Colonel Charles Erskine Wood and Sarah Bard Field Wood, Los Gatos, California, by 1915;
by descent to the estate of Katherine Field Caldwell Administrative Trust, Berkeley,
California; (Christie's, New York, December 4, 2004, lot 31); to private collection; to
(Spanierman Gallery, LLC, New York, 2004); to (private collection); to present coll., 2005.

EXHIBITED

Department of Fine Arts, San Francisco, *Panama-Pacific International Exposition*,
 February 20–December 4, 1915, no. B4061 (as *Sketch*).
M. H. de Young Memorial Museum, San Francisco, *San Francisco Collector*, September
 21-October 17, 1965, no. 13 (lent by Mrs. James Caldwell).

REFERENCE

Arthur B. Clark, *Significant Paintings at the Panama-Pacific Exposition: How to Find
 Them and How to Enjoy Them* (Palo Alto, Calif.: Stanford University Press, 1915), p. 11
 (as *The View of Gloucester*, entitled *Sketch*).

L IKE MANY artists who gathered in Gloucester, Massachusetts, at the turn of the twentieth century, Twachtman delighted in painting the view looking down from Banner Hill in East Gloucester. This vantage point offered an array of compositional possibilities that were especially delightful to an Impressionist eye. Beyond the roofs of the white vacation homes on the rock-strewn hillside, the irregular forms of warehouses and the skeleton-like lines of piers stretched down to the water's edge. Looking across the Inner Harbor, dotted with sailboats, the hills of Gloucester itself, punctuated with pointed church spires of the town, rose against the horizon. Although other artists such as Childe Hassam painted this view, Twachtman's images of it are the most varied. They allowed him to explore the way that a change in angle or viewpoint created an utterly different picture and involved the viewer in a different way of seeing.

This subject seems to have been a particular focus for Twachtman in the summer of 1900, as he exhibited several views of it in his 1901 exhibitions in Chicago (January), New York (March), and Cincinnati (April–May). In addition, he created a group of charcoal sketches after works he had produced in the summer of 1900 that include several images of this site (see Cat. 61 and Fig. 83), a number of which can be linked to paintings known today.

Perhaps his most elaborate view of this subject is *Gloucester Harbor* (Canajoharie Library and Art Gallery, New York), which was almost certainly the work he exhibited as *The Ferry Landing* in all three of his 1901 exhibitions. In this work, he carefully organized the shapes and lines within the scene, creating an image that the critics hailed as "Japanese and charming in arrangement,"[1] a scene of "exquisite color and atmosphere and capital tendering of the twinship of water and boats,"[2] and a picture that was "thoroughly entertaining in arrangement and execution."[3]

By contrast with the Canajoharie painting, this view of the harbor is clearly a plein-air scene in which Twachtman almost purposefully seems to have wanted to paint freely without concerning himself too much with issues of construction. Whereas he rendered the forms in the Canajoharie painting with brushes of varying width to differentiate the different elements in the scene, here his effort seems to have been on working quickly in an alla prima fashion, noting forms rapidly so as to privilege their basic shapes and lines over their placement within the space or even within the composition. He clearly enjoyed creating this work, placing pearly dots of white for distant sailboats and flicking his brush with agile yet lithe force to record the patterns of light and shape that caught his eye as he scanned the buildings and harbor below him. Indeed, his motivation in this work seems to have been to engage the viewer in this process of taking in a scene from side to side, as if to browse over the forms rather than to focus in on them. He enhances this effect of glancing horizontally through the use of broad, intersecting diagonals, represented by the long pier that served as a ferry dock and a swath of paint indicating the East Gloucester road that followed the shoreline. Our angle of vision, guides us to the right, where the gable of the Wonson Factory warehouse stands at the water's edge.

This painting's first known owner was the noted Portland, Oregon, collector Colonel Charles Erskine Scott Wood (1852–1944), a poet, soldier, and corporate lawyer, who was close to many notable literary figures of his day, including Mark Twain, Emma Goldman, Ansel Adams, Robinson Jeffers, Clarence Darrow, and John Steinbeck. He also was a friend of several artists, including Childe Hassam and J. Alden Weir, whose works he collected. It is possible that Wood purchased the painting directly from the artist, or that Weir or Hassam brought it to his attention. The painting was lent by Wood to the Panama-Pacific

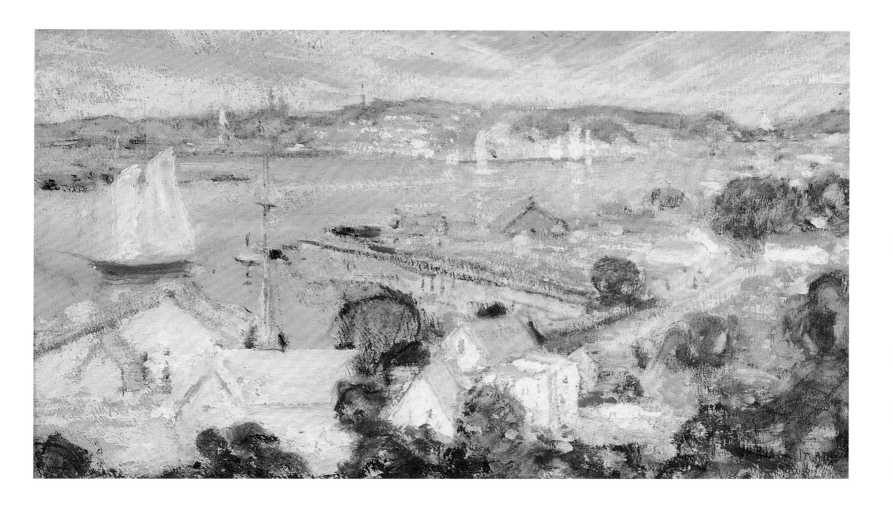

Exposition in San Francisco in 1915, where it was
exhibited with the title *Sketch*, but described in
Arthur Clark's *Significant Paintings at the
Panama-Pacific Exposition* as "The View of
Gloucester," a work that "is powerful in its values."

1. "Exhibitions Next Week," *Chicago Post*, January 5,
1901, unpaginated newspaper clipping, Archives,
Ryerson Library, Art Institute of Chicago.
2. "Exhibitions of the Week," *Chicago Times Herald*,
December 30, 1901, unpaginated clipping, Archives,
Ryerson Library, Art Institute of Chicago.
3. "The Art-World: Mr. Twachtman at Durand-Ruel's,"
New York Commercial Advertiser, March 5, 1901, p. 4.

Boats at Anchor ca. 1900

Oil on panel
7½ × 9⅝ inches
Signed lower left: *J. H. Twachtman–*
Spanierman Gallery, LLC, New York

PROVENANCE

(American Art Galleries, New York, *Sale of the Work of the Late John H. Twachtman*, March 24, 1903, lot 55, as *Boats at Anchor*); to Benjamin Ames Kimball; (Stephen Score, Essex, Massachusetts); to private collection, 1979; to present coll., 2005.
exhibited

REFERENCE

Hale, *Life and Creative Development*, p. 433, vol. 2, p. 433 (catalogue G, no. 64b).

RENDERED on what was probably one of the cigar box tops that Twachtman used often in Gloucester, *Boats at Anchor*, like *Gloucester Harbor* (Cat. 60), is a plein-air oil painted from Banner Hill in East Gloucester looking west toward Gloucester. The difference between the two paintings demonstrates that, as in many other instances, not only did Twachtman derive different compositional ideas from the same scene, but he also adjusted his range and focus as he took a new perspective on a subject, somewhat like changing the angle from which a photograph is taken, to see in new ways. Here, instead of encompassing a broad view across the near shore, he looked downward, so that the gables of houses below him loom large in the foreground, forming the outer contour of the shoreline that takes on a distinct angular shape. The boats also seem organized, one shown slotted between the foreground buildings and another with profiled sails repeating the triangles of the house gables.

This painting is among the twenty-four Twachtman created in Gloucester in 1900 for which he drew small charcoal sketches that he sent to his son Alden, probably in the fall of 1900 (Fig. 83). Twachtman notated the back of the sketch for this work: "8 × 10, Gray day, very cool in color." Indeed, throughout the image Twachtman sought to capture the color on a day of subdued light. He did this by using a few white sailboats to establish points of brightness that make the pinks of the houses and the silvery blues of the water paler by contrast.

When Twachtman participated in a group exhibition at the Rockaway Hotel in East Gloucester in August 1900, toward the end of his stay in the town that summer, a critic referred to his contribution as "very small pictures" "marked "$100 each," which "the artist termed 'postage stamps.'"[1] *Boats at Anchor* is likely to have been among such works on view. The painting remained with the artist until his death. It was included in his 1903 estate sale with the title *Boats at Anchor*, from which it was purchased by Benjamin Ames Kimball (1833–1920) for $70. A label on the back of the work, perhaps placed there at the time of the sale, indicates Kimball as the buyer, notes the title and number of the work in the estate sale, and identifies the scene as depicting Gloucester harbor. Kimball was a leading figure in the railroad industry in New Hampshire, serving as president of the Concord and Montreal Railroad, beginning in 1895. As noted in a memorial article of 1920, Kimball "was one of the first to comprehend the magnitude of the possible development of New Hampshire as a state of summer resorts and summer homes, and for that purpose, as well as for the benefit of the farms and factories of the state, he brought about the construction of various branch lines and extensions without which the Granite State could hardly have won and merited its title of the Switzerland of America."[2]

Although Twachtman reused and changed titles, it is possible that *Boats at Anchor* was the work with this title that was included in his 1901 exhibitions in Chicago (no. 31) and Cincinnati (no. 16). The New York show lacked a catalogue, but it is likely that the painting was shown at that venue as well.[3]

1. "East Gloucester . . . ," *Gloucester Daily Times*, August 10, 1900, p. 6.
2. On Kimball's biography, see "Benjamin A. Kimball," *Granite Monthly* (September 1920), pp. 343–54. Quote appears on page 347.
3. See Selected Exhibitions, p. 244 for 1901 Chicago; 1901 New York; and 1901 Cincinnati.

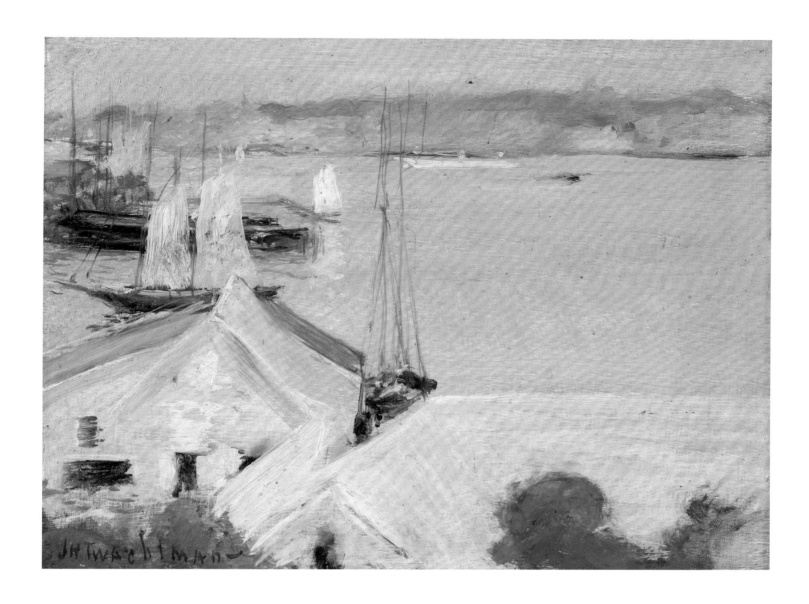

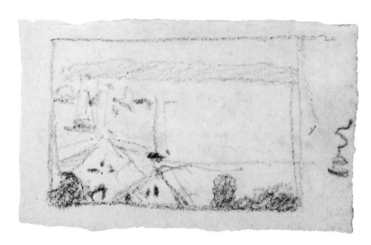

Fig. 83
Twachtman, charcoal
sketch, recto (left) and
verso (right), after *Boats
at Anchor*, ca. 1900,
private collection.

62.

Little Giant ca. 1900–1902

Oil on canvas
20 × 24 inches
Spanierman Gallery, LLC, New York

PROVENANCE

Martha Scudder Twachtman, the artist's wife, Greenwich, Connecticut; to her son and his wife, Mr. and Mrs. Godfrey Twachtman, Independence, Missouri; (Milch Galleries, New York); private collection; (David Findlay, Inc., New York); to private collection; to present coll., 1987.

EXHIBITED

1913 New York School of Applied Design, no. 18 (as *Ferry at East Gloucester*).
1913 Buffalo Fine Arts Academy no. 13 (as *Ferry at East Gloucester*).
1966 Cincinnati Art Museum no. 89.
1987 Spanierman Gallery, no. 7 (pp. 62–63 col. ill.)
Art Students League of New York, *League Masters Then,* November 3–26, 2000.
Bruce Museum of Arts and Science, Greenwich, Connecticut, *American Impressionism: The Beauty of Work*, September 24–January 8, 2006, no. 24 (pp. 120–1 color ill.).

REFERENCES

Hale, *Life and Creative Development,* 1957, vol. 2, p. 446 (catalogue G, no. 167, as *Ferry at East Gloucester*), p. 550 (catalogue A, no. 201, as *Little Giant*).
David Findlay Jr., *On the Spot: American Painting, 1865–1930* (New York: David Findlay Jr., Inc., 1985), color ill.
Hale, Boyle, and Gerdts, *Twachtman in Gloucester,* 1987, pp. 62–63 color ill. (no. 7).
Peters, *John Twachtman (1853–1902) and the American Scene,* 1995, vol. 1, pp. 485–86; vol. 2, p. 1001 ill. (Fig. 501).
Susan G. Larkin, *American Impressionism: The Beauty of Work*, exh. cat. (Greenwich, Conn.: Bruce Museum of Arts and Science, 2006), pp. 120–21 color ill. (no. 24).

FOUNDED in 1623, Gloucester, Massachusetts, was a center for the fishing trade in colonial days. At the end of the nineteenth century, it was still the largest fishing port in the country, and even after vacationers discovered the area, its fishing industry did not decline. The artists who painted in Gloucester at the time were drawn to this combination of its rugged, workaday element and its recreational side, described by a writer in 1897 as "land of rackets and golf clubs, summer girls, novels, and hammocks, water-color kits, and white umbrellas."[1]

Gloucester's many facets seem to have been inspiring to Twachtman, and in works including *Little Giant,* he explored the coalescence of the town's unlikely mix of qualities. His vantage point in this scene was from the dock at Rocky Neck, and he painted a view of the end of the pier that extended across the East Gloucester shore; in many other works, he showed the long diagonal of this pier from above (see Cat. 60). By placing this dark form, painted with a few vigorously dragged strokes, in the immediate foreground, Twachtman evokes the sense that we are standing with him, about to descend the steep ramp, its guardrails necessary to keep our balance, and begin a journey across the harbor. Our view is gradually drawn into the distance, its hazy softness evoking the sense of a trip that is anticipated but not yet real. Rendering this part of the work by blending his colors on the canvas as he had in works painted in France, Twachtman made the canvas itself seem to be made of atmosphere. Thus Twachtman communicates his sense of direct involvement in the experience of summer life in Gloucester, capturing both the present moment and the feeling of looking forward with pleasure to what is to come.

The ferryboat seems to mediate between the industrial and recreational aspects of Gloucester life. Stout and hardy, this coal-driven vessel, built of timberyard scrap in 1878, ran from 6:30 am until 6:30 pm, making a round trip every twenty minutes between Parkhurst's Wharf, at the head of Gloucester harbor, and Rocky Neck Marine Railways, with a stop at Robinson's Landing in East Gloucester.[2] With two cabins—a ladies' forward and a gentlemen's aft—the Little Giant afforded a refreshing trip across the water. Such a trip was far more pleasant than the alternative of encircling it in an uncomfortable, slow, and dusty ride in an omnibus.[3] The Little Giant was converted to a tugboat in 1917 and made her last trip in 1925, when she was crushed between two larger tugs in Boston harbor.

Little Giant remained in the possession of the artist's wife in the years following his death. She lent it to the two shows of Twachtman's work held in 1913 in New York City and Buffalo. The painting was handed down to the artist's son Godfrey, who still owned it in 1966, when he lent it to the Twachtman retrospective held at the Cincinnati Art Museum.

1. Edmund Garrett, *Romance and Reality of the Puritan Coast* (Boston: Little Brown, 1897), p. 185.
2. Information on the history of *Little Giant* was provided by Stephanie Buck, Librarian/Archivist, Cape Ann Historical Association, Gloucester, Massachusetts, letter, February 24, 2006. The boat's construction history is noted by Charles Rodney Pittee, Steamship Historical Society of America, "Ferry Boat Little Giant was Once Potent Factor in Gloucester Transport, *Gloucester Daily Times*, March 25, 1950, clipping file, Cape Ann Historical Association, and in John Lester Sutherland, *Steamboats of Gloucester and the North Shore* (Charleston, S.C., 2004, appendix III.
3. Larkin quotes a description of this omnibus ride in *American Impressionism: The Beauty of Work*, p. 120. The quote is from Joseph E. Garland, *Boston's North Shore* (Boston: Little, Brown and Co., 1978), p. 316.

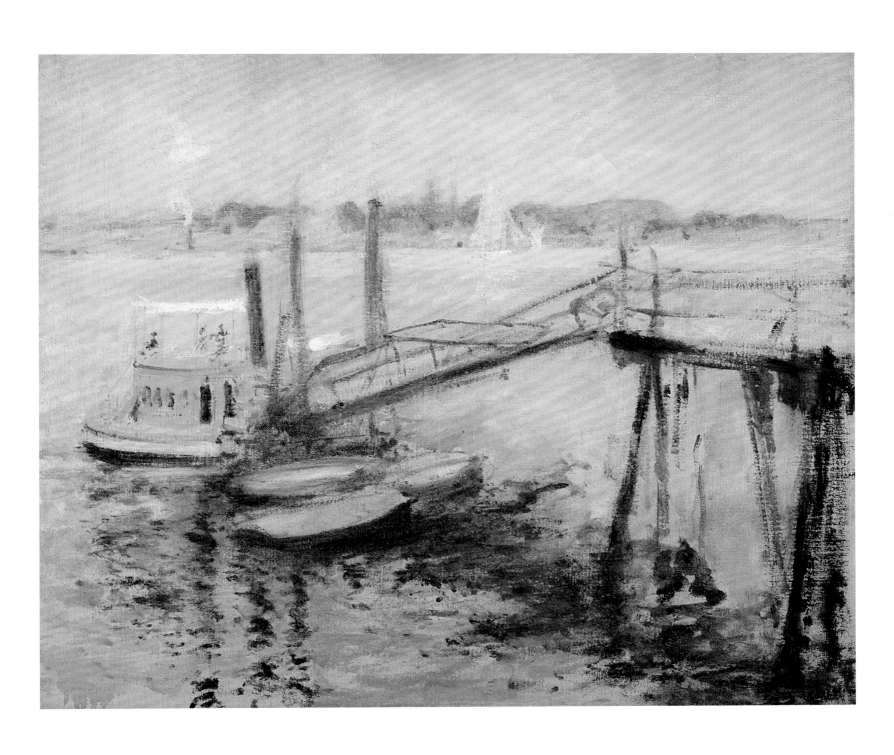

63.

Under the Wharves ca. 1900

Oil on panel
5⅛ × 9¼ inches
Signed lower right: *Twachtman*
Collection of Mr. and Mrs. Stephen M. Sessler

PROVENANCE

(American Art Galleries, New York, *Sale of the Work of the Late John H. Twachtman*, March 24, 1903, lot 17, as *Under the Wharves*); to J. Alden Weir; to his daughter Mrs. G. Page Ely (née Caroline Weir), Old Lyme, Connecticut; to her daughter, Anna Ely Smith; to her son Alexander G. Smith, California; to (Joseph Szymanski Gallery, Pasadena, California, 1997); to (Spanierman Gallery, LLC, New York); to present coll., 1998.

EXHIBITED

1901 Chicago, no. 41.
1901 Cincinnati, no. 31.

REFERENCE

"Twachtman Pictures," *New York Sun*, March 25, 1903, p. 5.

TWACHTMAN was able to paint on the spot in Gloucester because he procured many small wood panels that he could carry easily as he traveled around the harbor and up to the ridges of Banner Hill in East Gloucester. To this end, he often made use of cedar-wood cigar box tops, probably readily available in a day when cigars, evenings of fraternal socializing, and art went together. For this small work, he used not just one box lid but attached it to two others, demonstrating his creativity with materials available in Gloucester.

Here Twachtman found inspiration in a seemingly readymade artist's composition, a view seen in passing of a dark boat, enframed above and below by a Gloucester wharf. To capture the inherent aesthetic possibilities of this scene, Twachtman arranged his forms as in a Japanese print to achieve a delicate balance across the surface of alternating dark and light areas, and he painted with a lithe touch to express the elongated lines and graceful qualities of the forms. The inward tilt of the sailboat in the water implies its movement—with its jibs left loose on its deck, it may well be soon heading out into the harbor, suggesting the sense of freedom of movement that Twachtman felt during his Gloucester summers.

Under the Wharves was among the twenty-four works that Twachtman created in the summer of 1900 in Gloucester that he documented in charcoal sketches that he sent to his son Alden (Fig. 84). On the back of the sketch for this painting he wrote: "I am getting sleepy." This probably does not refer to the work itself but to the effort of drawing the sketches, while the casual remark points to the closeness he felt to his son. The painting was exhibited with its current title in Twachtman's 1901 exhibitions in Chicago (January) and Cincinnati (April–May). It may also have been included in the New York venue of the show, held at Durand-Ruel Gallery in March, for which no catalogue was produced.

The painting was one of six works purchased by J. Alden Weir from Twachtman's 1903 estate sale. The others that Weir bought included *End of the Pier* (Cat. 6) and *Pink Phlox* (ca. 1890s; Brigham Young University Museum of Art, Provo, Utah). The painting was inherited by Weir's eldest daughter Caroline (see Cat. 3) and remained in the Weir family until 1988. When this painting was cleaned, the *J. H.* in the signature was rubbed off, but it is present in earlier photographs of the work.

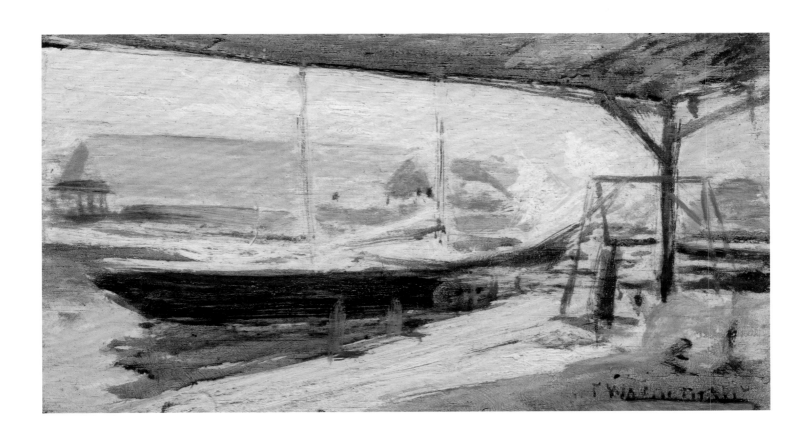

Fig. 84
Twachtman, charcoal
sketch, recto (left) and
verso (right), after *Under
the Wharves,* Gloucester,
ca. 1900, private collection.

64.

Fog and Small Sailboats ca. 1900

Oil on panel
6⅜ × 5⅛ inches
Signed lower left: *J. H. Twachtman*
Private Collection

PROVENANCE

J. Alden Weir; by descent in the family to the present.

RENDERED on a small wood panel made from a cigar box top, *Fog and Small Sailboats* epitomizes Twachtman's interest in capturing the spirit of a subject rather than in portraying the subject itself. As in other cases in which he moved from a direct transcription of a subject to a more iconic image, here he used abstract means to sum up a sight that caught his eye, in which fog and sunlight converged over the harbor in Gloucester. Painting quickly with only shades of grayish blue, he observed the way that sailboats in the fog were close in tone to their surrounding atmosphere, while he painted lines radiating from the center of the work with long, thin strokes, allowing the red-orange to serve as the color of the sun rays penetrating the fog. The short horizontal stroke of black at the center, which in this context must be a boat, provides a fulcrum from which the energy of the scene seems to generate. The work anticipates the art of such painters as Arthur Dove and Georgia O'Keeffe, who painted motifs for the sake of their essence.

Fog and Small Sailboats is depicted in one of the charcoal sketches that Twachtman sent to his son Alden, created after the works he had produced in Gloucester in the summer of 1900 (Fig. 85). A simplification of the forms in the painting, the drawing emphasized how the abstract arrangement in this work was Twachtman's focus, conveying a pure sense of energy.

This painting was part of the group of works by Twachtman owned by J. Alden Weir and remains in the collection of one of his descendants.

Fig. 85
Twachtman, charcoal
sketch after *Fog and
Small Sailboats*, ca. 1900,
private collection.

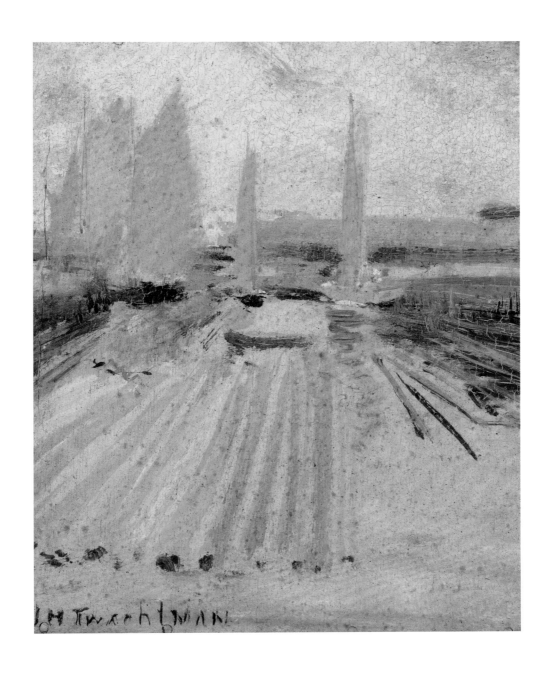

65.

View from the Holley House, Cos Cob, Connecticut ca. 1901

Oil on canvas
30 × 30 inches
Signed lower left: *J. H. Twachtman*
Private Collection

PROVENANCE

Estate of the artist; to (Macbeth Gallery, New York, by 1908); Schultze family, Chicago, as of 1945; Dr. Charles Barlow; W. David Lindholm; to (Spanierman Gallery, New York, 1985); to present coll., 1986.

EXHIBITED

Macbeth Gallery, New York, *Exhibition of Paintings by A Group of American Artists (Deceased), Copley to Whistler*, March 11–24, 1908, no. 30 (as *Bridge in Spring*).

Macbeth Gallery, New York, *A Group of Selected Paintings by American Artists*, opened April 21, 1914 (no closing date appears in the catalogue), no. 63 (ill., as *Holly House Porch, Cos Cob*).

(probably) Department of Fine Arts, San Francisco, *Panama-Pacific International Exposition*, February 20–December 4, 1915, no. 4066 (as *Bridge in Spring*).

1919 Macbeth Gallery, no. 15 (pp. 17, 19).

Hurlbutt Gallery, Greenwich Library, Greenwich, Connecticut, *Connecticut and American Impressionism: The Cos Cob Clapboard School*, March 20–May 31, 1980, no. 62 (p. 18 color ill.).

1989 National Gallery of Art, no. 25 (pp. 10 color ill. detail, 37, 113 color ill.).

1999 High Museum of Art, no. 54 (pp. 148 color ill. detail, 150, 153 color ill.).

National Academy of Design, New York, *The Cos Cob Art Colony: Impressionists on the Connecticut Shore*, February 13–May 13, 2001, no. 47 (pp. 81, 84 color ill.) (traveled to Museum of Fine Arts, Boston, June 17–September 16, 2001; Denver Art Museum, October 27, 2001–January 20, 2002).

REFERENCES

"Art and Artists," *Boston Globe*, April 12, 1908, p. 44.

Watson, "John H. Twachtman," 1920, p. 422 ill. (as *View from the Holly House*, courtesy Macbeth Galleries).

Hale, *Life and Creative Development*, 1957, vol. 2, p. 436 (catalogue G, no. 87, as *Bridge in Spring*), 460 (catalogue G, no. 299, as *From the Holley House*).

Patricia Jobe Pierce, *The Ten* (Concord, N.H.: Rumford Press, 1976), p. 142 color ill.

Doreen Bolger Burke, *J. Alden Weir: An American Impressionist* (Newark: University of Delaware Press, 1983), p. 208 (as *From the Holley House*).

Chotner, Peters, and Pyne, *John Twachtman: Connecticut Landscapes*, 1989, pp. 10 color ill. detail, 37, 113, color ill.

May, "Twachtman at the Wadsworth," 1990, p. 9.

Peters, *John Twachtman (1853–1902) and the American Scene*, 1995, vol. 1, p. 469; vol. 2, p. 980 ill. (Fig. 480).

Susan G. Larkin, "*A Regular Rendezvous for Impressionists*": The Cos Cob Art Colony 1882–1920, Ph.D. dissertation, City University of New York, 1996 (Ann Arbor, Mich.: University Microfilms, 1996), pp. xii, 59, 321 ill.

Peters, *John Henry Twachtman: An American Impressionist*, 1999, pp. 148 color ill. detail, 150, 153 color ill.

Susan G. Larkin, "The Cos Cob Art Colony," *American Art Review* 13 (February 2001), pp. 81, 84 color ill.

Susan G. Larkin, *The Cos Cob Art Colony: Impressionists on the Connecticut Shore*, exh. cat. (New York: National Academy of Design, in association with Yale University Press, 2001), pp. 81, 84 color ill. (no. 47).

William H. Gerdts, *The Golden Age of American Impressionism* (New York: Watson-Guptill, 2003), pp. 13, 67, 71 color ill.

BY THE TIME Twachtman settled in Greenwich in 1889, the Holley House on Strickland Road in Cos Cob, about four miles southeast of his home on Round Hill Road, had already been in operation for several years as an inn for summer visitors and a boardinghouse for a few longer-term residents (Figs. 86, 96).[1] Constructed in 1732, the two-story saltbox had been gradually expanded to become what the journalist Lincoln Steffens affectionately referred to as "a great, rambling, beautiful old accident."[2] Its proprietors were Edward Payson Holley and his wife, Josephine, both from old New England families. They appreciated the charm of the "old building" and offered its rooms at affordable rates, welcoming artists and writers who similarly prized its picturesque qualities, its informality, and its proximity to many paintable subjects. These last were attractive for their varied forms as well as for their historical resonances, since many of the buildings of Cos Cob dated from colonial times.

Twachtman may have met the Holleys as early as 1879, when he stayed at the farm they operated then several miles to the north, where J. Alden Weir was also known to have boarded occasionally in his youth.[3] Twachtman resumed contact with them during his Greenwich years, and in the early 1890s he began teaching summer classes with Weir at the inn, mostly for pupils who studied with the artists at the Art Students League during the school year.[4] Twachtman's years of teaching privately in Cos Cob continued through 1897, when he was hired by the league to conduct summer classes in Norwich, Connecticut. Finding the surroundings there distinctly unappealing, he returned to teach for the league at the Holley House in 1899, the last summer he would do so. Gloucester, Massachusetts, would be his destination during his last three summers, from 1900 to 1902.

Although Twachtman had certainly painted scenes of Cos Cob during the many summers he spent there as a teacher, the area, along with Gloucester, became his main subject matter during 1901 and 1902. He focused on Cos Cob at this time because he was often living at the Holley House after he and his family had vacated their house in Greenwich, having become overwhelmed with the responsibilities, financial and otherwise, of caring for it. (See Chronology, pp. 242–43 for details of the artist's whereabouts during his last years.) His family was not with him in 1901, as his wife and children went to Paris that year when Alden, the eldest son, began to study there at the École des Beaux Arts. Only his daughter Marjorie was with him when he died on

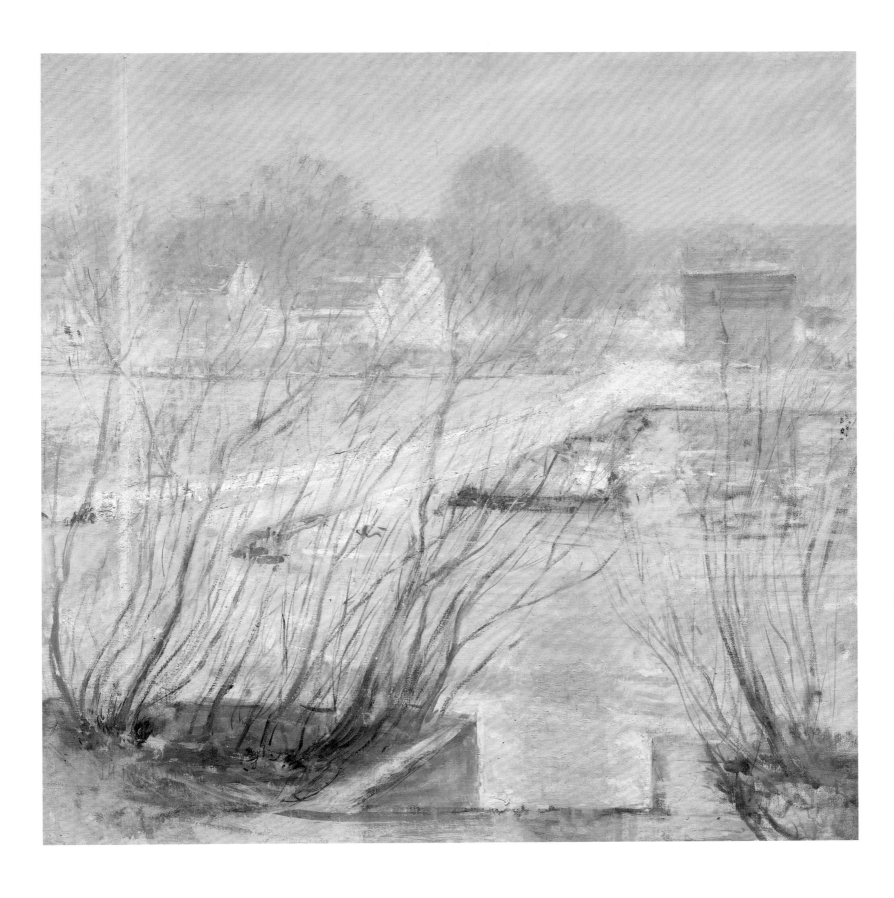

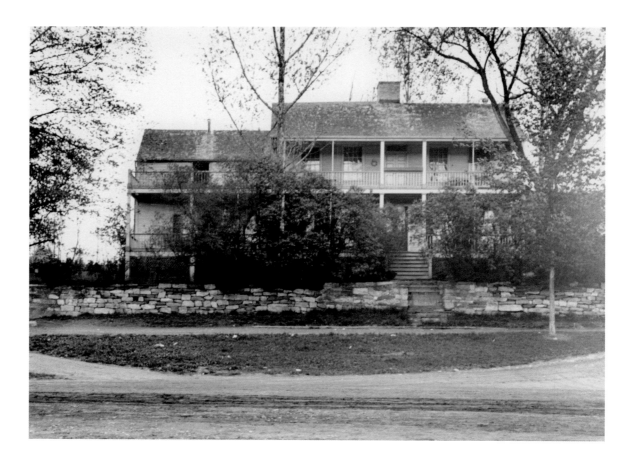

Fig. 86
Photograph, Exterior of
Holley House, ca. 1890s,
Historical Society of the
Town of Greenwich,
Cos Cob, Connecticut.

August 8, 1902, as she had sailed from Europe to join him in mid-July.

Twachtman's Cos Cob subjects include the houses and other buildings in the town, the warehouses on the Lower Landing of the Mianus River, and the view looking east from inside the Holley House and from its front porch (Figs. 86, 96). Opened up after the tide-powered grist mill run by Edward Holley was destroyed by a fire in 1899, this vista provided a vantage point across the millpond, where a bridge that doubled as a dam crossed to the opposite shore (Fig. 89). There to the north, houses, probably mostly fronting the Mianus River (east of the millpond) could be seen, while to the south, just across the millpond, stood the Palmer & Duff Shipyard, consisting of warehouses, a store, and other shipbuilding structures and armatures (Fig. 87). As noted by Susan Larkin, the shipyard had lost business over the years as the packet boat trade declined and its owners became elderly, and by the turn of the twentieth century, it looked ghostly and empty.[5]

Twachtman was clearly mesmerized by this view, and there are seven works known today in which he depicted it, including *Balcony in Winter* (Cat. 68), *Bridge in Winter* (Fig. 88), *View from the Holley House* (Cat. 67), *View from the Holley House, Winter* (Cat. 66), and this painting.[6] These are all wintry snow scenes with the exception of this painting, which appears to be a view in early spring. Snow is still on the ground in the distance and lines the sides of the bridge, but the trees have begun to develop leaves, and the warm, glowing light is indicative of the change in the seasons.

Whereas for his winter scenes, Twachtman stood inside the Holley House looking out its windows, for this painting he positioned his easel in the front yard of the inn, standing just to the side of the open staircase that led up to it from the shore of the millpond. In other views, he included the lilac bushes that rose up in front of the windows. Here, he stood directly behind the bushes, and the projecting corners of the stone wall below the house make the placement of these bushes clearer.

Twachtman used his arrangement to express the animated feeling of spring. Throughout the work, forms seem to move in a lively fashion both forward and back in the space. The angle of the bridge is more acute here than in most of his winter scenes; it imbues the scene with vitality because it counters the direction of our gaze,

OCT-14-06

Fig. 87
Photograph, Frank
Seymour, Palmer & Duff
Shipyard seen from the
Holley House, 1906,
Historical Society of the
Town of Greenwich, Cos
Cob, Connecticut.

which is from the lower right toward the white houses that glow through the soft, atmospheric haze at the far left. The wispy new leaves of the lilac bushes merge with the forms in the distance, while the red color of the shipyard's store makes this square form appear to advance. The colors throughout the work glow without being brilliant, and the interplay of shimmering pinks and blues creates the feeling of newness associated with the season. Yet to some degree, there is also a feeling of tension in the off-centered and dynamic arrangement, which is perhaps a result of this time in Twachtman's life when he was enjoying living in Cos Cob but missed his home and family.

View from the Holley House, Cos Cob is thought to have gone from the artist's estate directly to Macbeth Gallery in 1908, where it was included in an exhibition that March. However, this painting, measuring 30 by 30 inches, might have been the work in the artist's 1903 estate sale with these measurements, listed in the catalogue as *First Leaves*. *First Leaves* was mentioned in conjunction with *Balcony in Winter* (Cat. 68), also included in the sale, by a critic for the *New-York Daily Tribune*, who wrote: "Witness the tenderly painted 'First Leaves,' with its beautiful effect of atmos-

phere subtly emerging from details brushed in broadly and hastily."[7] *First Leaves* was the only painting purchased from the sale by an individual named J. L. Eddy. Perhaps it was Eddy who sold the painting to Macbeth; the gallery may have retained it until 1919, exhibiting it at the 1915 Panama-Pacific International Exposition in San Francisco.

1. On the history of the house and on Cos Cob as an art colony, the most recent and complete source is Susan G. Larkin, *The Cos Cob Art Colony: Impressionists on the Connecticut Shore*, exh. cat. (New York: National Academy of Design, in association with Yale University Press, 2001). See especially chap. 1, "The Genteel Bohemians of Cos Cob," pp. 7–35.
2. Lincoln Steffens, *The Autobiography of Lincoln Steffens* (New York: Harcourt, Brace & World, 1931), p. 437.
3. This visit was recalled by the Holley's daughter Constant; reported in Larkin, *The Cos Cob Art Colony*, 2001, p. 35.
4. On Twachtman's teaching activities in Cos Cob, see Peters, *John Twachtman (1853–1902) and the American Scene*, 1995, vol. 1, pp. 324–29.
5. Noted by Larkin, *Cos Cob Art Colony*, 2001, pp. 77–86.
6. The others are *Bridge in Winter, Cos Cob, Connecticut* (private collection) and *Lilacs in Winter* (Toledo Museum of Art, Ohio).
7. "Art Exhibitions: The Twachtman, Colman and Burritt Collections," *New-York Tribune*, March 21, 1903, p. 9.

66.

View from the Holley House, Winter ca. 1901

Oil on canvas
25⅛ × 25⅛ inches
The Hevrdejs Collection

PROVENANCE

Quentin Twachtman, the artist's son, Philadelphia; to his daughter, Mary Charlotte T.
Soutter; bequeathed to her husband, Peter M. Soutter; (Christie's, New York, December
2, 1988, lot 214A); to (Spanierman Gallery, New York, 1988); to (Allan Kollar, Seattle, 1989);
to present coll., 1990.

EXHIBITED

1989 National Gallery of Art, no. 26 (pp. 37, 70 color ill., 114 color ill.).
Metropolitan Museum of Art, New York, *American Impressionism and Realism: The
 Painting of Modern Life, 1885–1915*, May 10–July 24, 1994, no. 82 (pp. 75–76 color ill., 367)
 (traveled to Amon Carter Museum, August 21–October 30; Denver Art Museum,
 December 3–February 5, 1995; Los Angeles County Museum of Art, March 12–May, 14,
 1995).
National Academy of Design, New York, *The Cos Cob Art Colony: Impressionists on the
 Connecticut Shore*, February 13–May 13, 2001, no. 46 (pp. 81, 83 color ill.) (traveled to
 Museum of Fine Arts, Boston, June 17–September 16, 2001; Denver Art Museum,
 October 27, 2001–January 20, 2002).
Bruce Museum of Arts and Science, Greenwich, Connecticut, *American Impressionism:
 The Beauty of Work*, September 24–January 8, 2006, no. 23 (pp. 50, 118–19 color ill.).

REFERENCES

Chotner, Peters, and Pyne, *John Twachtman: Connecticut Landscapes*, 1989, pp. 37, 70,
 color ill. detail, 114 color ill.
H. Barbara Weinberg, Doreen Bolger, and David Park Curry, *American Impressionism
 and Realism: The Painting of Modern Life, 1885–1915*, exh. cat. (New York: Metropolitan
 Museum of Art, 1994), pp. 75–76 color ill., 367.
Peters, *John Twachtman (1853–1902) and the American Scene*, 1995, vol. 1, pp. 468–69,
 vol. 2, p. 970 ill. (Fig. 471).
Peters, *John Henry Twachtman: An American Impressionist*, 1999, pp. 150, 155 ill.
Susan G. Larkin, *The Cos Cob Art Colony: Impressionists on the Connecticut Shore*, exh.
 cat. (New York: National Academy of Design, in association with Yale University Press,
 2001), pp. 81, 83 color ill. (no. 46).
Susan G. Larkin, *American Impressionism: The Beauty of Work*, exh. cat. (Greenwich,
 Conn.: Bruce Museum of Arts and Science, 2006), pp. 50, 118–19 color ill. (no. 25).

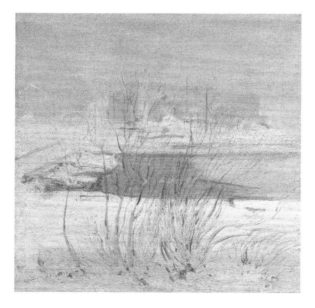

Fig. 88
Twachtman, *Bridge in
Winter*, ca. 1901,
oil on canvas,
30⅛ × 30⅛ inches,
private collection.

EVEN THOUGH Twachtman had painted snow
scenes at least since the early 1880s, he was
still fascinated by snow at the end of his career.
When he was living at the Holley House in Cos Cob
in the winter of 1901, the view from the windows of
the inn on snowy days gripped him. His student
Carolyn Mase recalled his compulsion to paint
them. Mase wrote of his arriving in the "breakfast
room of the Holley House" and his saying with "a
sense of good fellowship" to the maid: "'Hurry …
and bring me—well, a half dozen eggs, a rasher or
two of bacon, several cups of coffee, and a dozen or
so cakes. I am hungry!'" However, when the maid
went to fill his order, he had "sauntered toward the
window, and stood silent for a few minutes." After
remarking, "but Nature is fine this morning!" he
had forgotten his breakfast order and stood outside
in the snow, "painting like mad, utterly forgetful of
the breakfast, ordered but not eaten."[1] Mase
described him as "painting under the stress of the
emotion produced by the sight of his beautiful
Mother Nature that morning."[2]

Of the views that Twachtman painted from the
Holley House in the winter (see Cat. 65), *Bridge in
Winter* (Fig. 88) and this painting are extremely
close in their subject matter, but they demon-
strate how Twachtman, working in the inspired
fashion described by Mase, created images that
are quite different in their qualities and in the
feelings they evoke. It is fascinating to consider
that he may have painted these two works on the
same day in late winter or early spring, *Bridge in
Winter* in the morning, when the snow was deep
on the ground, and this painting in the afternoon,
when warmer temperatures had begun to clear
the air, thinning the snow on the ground and leav-
ing broad patches of melting ice and slush.

In both works, a patch of blue-gray at the near
edge of the millpond, probably representing a boat,
seems to be a guidepost for the artist, the point at
which he was most directly focused. In both, the
two vertical lines in front of the warehouse of the
Palmer & Duff shipyard (see Fig. 87) (probably
representing a smokestack and possibly a tall
scaffolding) and their reflections are in the same
position, although more accentuated here, while
both include a sailboat with bare masts docked at
the far side of the mill pond, further suggesting that
spring has or is about to arrive and indicating the
closeness in time in which the works were painted.

Although it seems that Twachtman stood far-
ther away to paint *Bridge in Winter* than for this
painting, it is more likely that he painted both
from the same spot, simply cropping the view in
this work to make it seem that he was closer to it.

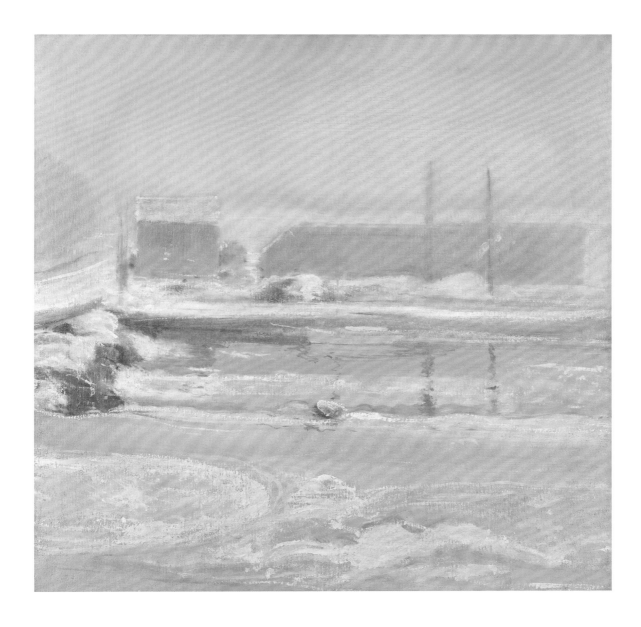

His different treatment in the two suggests the change in mood that the different conditions of the snowfall occasioned. Whereas stillness characterizes the misty forms and horizontal emphasis of *Bridge in Winter*, a feeling of growing warmth emerges in this painting, as the blue of the water sets off the mauve tones of the buildings, which is the same color as the ground layer of the canvas, visible beneath the thinly painted surface. He painted this scene in a summary fashion, letting just a few broad strokes in the foreground suggest the pattern the snow left as it thawed. His strokes are visible in the pond, indicating the liquidity of its surface as the snow and ice were melting. To suggest the clearing atmosphere, he painted the buildings with stronger tones and more firmly etched forms than in *Bridge in Winter* and rendered the sky with softer, more fluid paint.

Susan Larkin has observed of Twachtman's winter views looking toward the Palmer & Duff shipyard that "the ghostly shipyard seems to inhabit a time removed from that of the painter and viewer."[3] The differences between *Bridge in Winter* and this painting perhaps also suggest Twachtman's interest in exploring how things in the past fade as they become memories but can be evoked through a process of concentration and reflection.

This painting was in the collection of the artist's son Quentin, remaining in the hands of his descendants until 1988. It is possible that this painting was the work entitled *The Ship-Yard, Cos Cob* that was lent by Martha Twachtman, the artist's wife, to the two exhibitions of her husband's work held in 1913, at the Buffalo Fine Arts Academy and the New York School of Applied Design for Women.

1. Mase, "John H. Twachtman," 1921, p. lxxii.
2. Ibid.
3. Larkin, *Cos Cob Art Colony*, 2001, p. 81.

67.

View from the Holley House ca. 1901

Oil on panel
8¼ × 9½ inches
Signed lower left: *J. H. Twachtman*; inscribed lower right: *To Mrs. E. L. Holley*
Private Collection

PROVENANCE

The artist; to Mrs. Edward L. Holley (Josephine), Cos Cob, Connecticut; (Sotheby's, New York, April 20, 1979, lot 40); (Ara Danikian); to (Spanierman Gallery, New York, 1986); to present coll., 1990.

EXHIBITED

Danforth Museum of Art, Framingham, Massachusetts, *The Ten American Painters: An Impressionist Tradition*, May 5–June 30, 1985 (lent by Ara Danikian).

Fig. 89
Photograph, Palmer & Duff Store from Strickland Road, Lower Landing, ca. 1900, Historical Society of the Town of Greenwich, Cos Cob, Connecticut.

INSCRIBED "To Mrs. E. L. Holley," this painting was a gift from Twachtman to his dear friend Josephine Holley, who along with her husband, Edward, ran the Cos Cob inn and boardinghouse known as Holley House, where Twachtman taught in the 1890s, stayed in 1901 and 1902, and enjoyed the companionship of fellow artists and writers (see Cat. 65). Twachtman and "Joe" became close friends during the years that he boarded at the inn, and she cared for him when he was staying there alone. He bemoaned in a letter he sent to

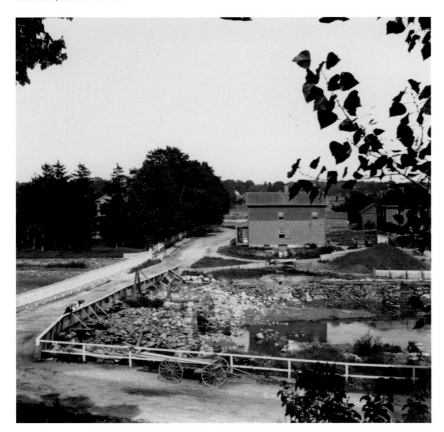

her from the Players Club on January 17, 1902, "I wonder why Joe does not bring me my pitcher of water."[1] In a letter of February 4, 1902, he signed a letter to her, "Your Johnie."[2]

This is the only work that Twachtman is known to have given to Joe. The scene is the view from the Holley House looking across the mill dam (Fig. 89) that he painted on a larger scale in works including *View from the Holley House, Cos Cob* (Cat. 65), *Bridge in Winter* (Fig. 88), and *View from the Holley House, Winter* (Cat. 66). Probably rendered about the same time as these other paintings, during the winter of 1901, here he created a quick sketch of the subject on a rust-red panel, possibly the top of one of the cigar boxes he often used for his Gloucester works. The mill dam-bridge is the main form in this small image, and by tipping up the ground plane, Twachtman showed this energetic diagonal extending up and across the surface rather than creating a sense of recession. A light snow has fallen but has begun to melt on the surface of the millpond, while the roof of the red building belonging to the Palmer & Duff shipyard store is already free of snow. The bright red-salmon color of this structure and the visible tone of the panel intensify the colors and suggest the imminent arrival of spring.

Although he painted quickly, on the spot, Twachtman captured the different qualities of his forms, noting the fluttering leaves of the trees on the far shore and rendering the atmospheric background with a broad, more fluid application of paint.

Overall this work has a less meditative, more cheerful feeling than his larger renditions of the subject. The red store, lower and flatter than in his other scenes of it, is more friendly here, and the diagonal of the bridge takes us directly to the building. The freedom of Twachtman's handling evokes his pleasure in painting it.

When this work left Josephine Holley's possession is not known, and its owner before its sale at Sotheby's, New York, in April 1979 is a mystery.

1. Twachtman, The Players, New York, to Josephine Holley, Cos Cob, Connecticut, January 17, 1902, Archives, Historical Society of the Town of Greenwich, Cos Cob, Connecticut.
2. Twachtman, The Players, New York, to Josephine Holley, Cos Cob, Connecticut, February 4, 1902, Archives, Historical Society of the Town of Greenwich, Cos Cob, Connecticut.

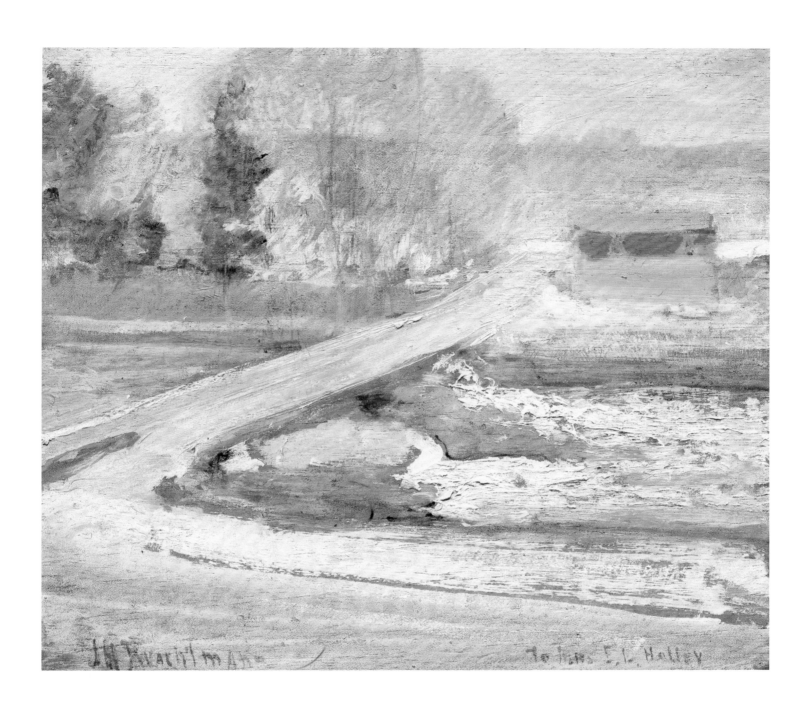

J H Twachtman To Mrs E. C. Holley

68.

Balcony in Winter ca. 1901–2

Oil on canvas
30 × 30 inches
Stamped lower left: *Twachtman Sale*
Private Collection

PROVENANCE

(American Art Galleries, New York, *Sale of the Work of the Late John H. Twachtman*, March 24, 1903, lot 72); to (Cottier and Company, New York); (Macbeth Gallery, New York); Charles Sterling, Philadelphia; to (Jordan-Volpe Gallery, New York, 1989); to present coll., 1995.

REFERENCES

"Twachtman Pictures, $16,610," *New York Sun*, March 25, 1901, p. 5.
"Art Exhibitions: The Twachtman, Colman, and Burritt Collections," *New York Daily Tribune*, March 21, 1903, p. 9.
"Twachtman Picture Sale," *New York Times*, March 25, 1903, p. 5.
Roof, "Work of John H. Twachtman," 1903, p. 244.
Doreen Bolger, "American Artists and the Japanese Print: J. Alden Weir, Theodore Robinson, and John H. Twachtman," in *American Art around 1900: Lectures in Memory of Daniel Fraad* (Washington, D.C.: National Gallery of Art, 1990), pp. 20, 23 ill.
Mary Lublin, *19th and 20th Century Painting* (New York: Jordan-Volpe Gallery, 1990), pp. 32–33 color ill.

IN MARCH 1901 Twachtman sent a letter to his eldest son, Alden, from the Players Club in New York, telling him of his recent work: "Yesterday I painted all day looking from a window at the blizzard and it recalled the one we had at home, but not so fierce. But it was beautiful and I could not stop painting and painted until it was too dark to see and I was tired out. It seemed to be a fifty round go and I got knocked out at about the

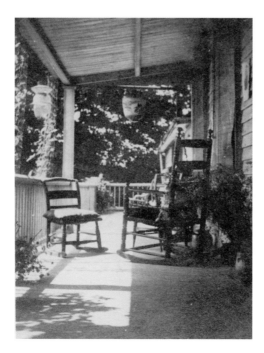

Fig. 91
Photograph, Exterior view of the Holley House, ca. 1900s, Historical Society of the Town of Greenwich, Cos Cob, Connecticut.

eleventh round."[1] In the letter, he included two sketches, one of the painting *Old Holley House, Cos Cob* (ca. 1901; Cincinnati Art Museum) and the other portraying *Balcony in Winter* (Fig. 90). The window to which he refers in the letter is clearly one of those on the lower floor of the Holley House in Cos Cob (see Figs. 86, 96), looking out across the millpond. This is the only view Twachtman made from this vantage point, however, that includes the porch in front of the house, seen in a photograph of it during the summer (Fig. 91). Here he focused on the porch itself, featuring the planters of evergreens, tended by Josephine Holley and her daughter Constant, and the netting from which clematis grew in the summer, hanging down at either side.

Snow covers the balcony, but warmer temperatures had created some open water on the millpond. Against the opalescent whites tinted with pale greens and pinks, the green-blues of the planted evergreens and the gray-greens of the netting create a delicate harmony like a Whistlerian Symphony. As in his paintings of his Greenwich home, in which Twachtman delighted in showing the way that natural and man-made realms merged, here he similarly captured the way that evergreens, belonging to a wild context, had become decorative elements for a domestic space, while the clematis netting connected the house with its natural surroundings. At the same time, the painting evokes a sense of nature displaced, perhaps reflecting Twachtman's own feeling of disconnection after he had severed ties with his home in Greenwich and while he was apart from his family.

This painting was included in Twachtman's 1903 estate sale with its current title. A writer for the *New-York Daily Tribune* remarked that Twachtman's work was often more suggestive than beautiful, and that at his best, "and this exhibition presents him at his best more frequently than has been the case on any other occasion, he produced work exquisite and distinguished. Witness, for example, the superb 'Balcony in Winter,' with its snow covered plants, its cold but living atmosphere, its sense of intimacy with nature." In a review of the same sale, Katharine Metcalf Roof also took notice of the painting, stating that Twachtman's "interpretation of snow effects was particularly sympathetic. In this posthumous exhibition there was one canvas with a foreground of piazza and the irregular lines of a frozen vine, snow-touched, that was as indefinable yet deep in its appeal as a Chopin nocturne or a Paul Verlaine verse, a picture one could never forget." The painting was purchased from the sale by

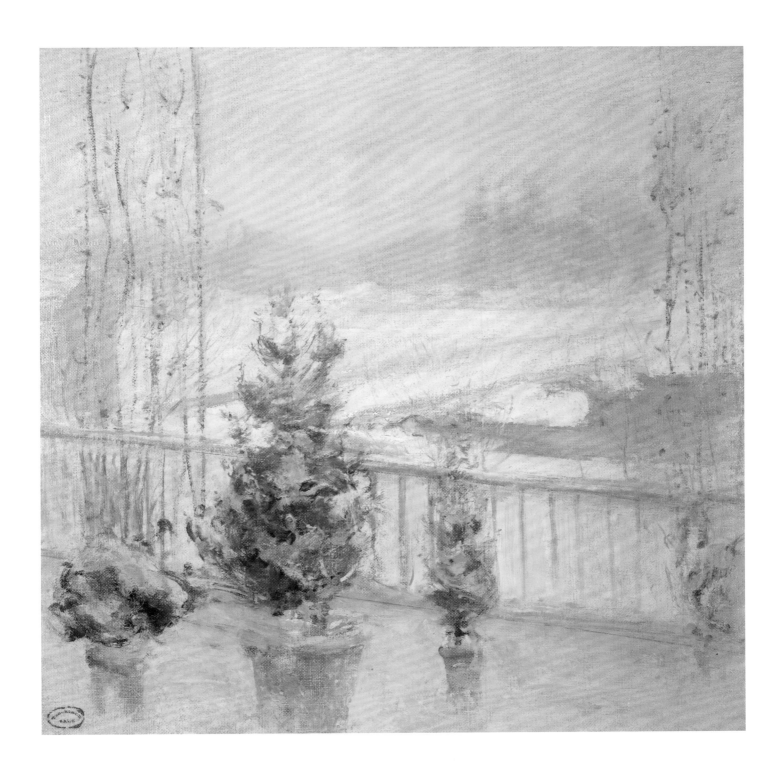

the New York gallery and department store Cottier & Company, probably on the advice of its manager, the Scottish artist James Inglis (1852–1907), who acquired Twachtman's watercolor *Venice* (Cat. 11) probably at about the same time. Its next owner was probably Macbeth Gallery, which placed a label on its stretcher bar identifying the work as *Winter, Holly House, Cos Cob*.

1. Twachtman, to J. Alden Twachtman, ca. March 1901, private collection, copy, Archives, Spanierman Gallery, LLC, New York.

Fig. 90
Illustrated letter,
Twachtman,
ca. March 1901, to
J. Alden Twachtman,
private collection.

69.

Boat Landing ca. 1902

Oil on panel
13½ × 9½ inches
Stamped lower left: *Twachtman Sale*
Private Collection

PROVENANCE

(American Art Galleries, New York, *Sale of the Work of the Late John H. Twachtman*, March 24, 1903, lot 3, as *Boat Landing*); to Charles M. Kelley; private collection, by 1959; to (Hirschl & Adler Galleries, New York, 1959–61); to (Main Street Gallery, 1961); (Sloan & Roman, New York, by 1968); to Mr. and Mrs. Ralph Spencer, Morristown, New Jersey, 1968; to (Spanierman Gallery, New York, 1990); to present coll., 1990.

EXHIBITED

1987 Spanierman Gallery, no. 15 (pp. 78–79 color ill.)
Spanierman Gallery, New York, *The Spencer Collection of American Art*, June 13–29, 1990, no. 27 (pp. 56–57 color ill.).

REFERENCES

Lisa N. Peters, "Boat Landing," in *The Spencer Collection of American Art*, exh. cat. (New York: Spanierman Gallery, 1990), pp. 56–57 color ill. (no. 27).
Hale, Boyle, and Gerdts, *Twachtman in Gloucester*, 1987, pp. 78–79 color ill. (no. 15).

THERE IS no charcoal sketch of this work among the twenty-four drawings that Twachtman made after paintings he did in Gloucester that he sent to his son Alden, probably in the fall of 1900. Although which summer in Gloucester Twachtman painted it cannot be determined, its abstract qualities suggest that it might have been among the last works he created in the Cape Ann town, possibly during the last few months of his life, in the summer of 1902. At first the work seems a straightforward plein-air harbor view, but on closer inspection, the image seems to veer between realism and abstraction in a new way.

In the left foreground, the dark boat's stern is toward us. It is tilted a little too far to the right, as if to suggest that it has a will of its own. In the right foreground, a corner of the dock on which the artist stood to make the picture inclines upward at a steep angle that does not correspond with the perspective controlling the rest of the image. A band of yellow and mauve paint at the far right seems to be situated simultaneously in both the middle- and background. The clouds eerily become less cloudlike as they get closer to the horizon; there, they seem to resemble the blots of white in the landscape and harden into architectural or nautical forms. The light, too, seems somewhat too hard, as the brilliance of the sky, with its pink clouds, stands in sharp contrast with the dark shadow under the boat.

If *Boat Landing* was a product of Twachtman's last summer, it suggests that at the end of his career, he was paying less attention to his perceptions of his scenes and than to his subjective responses to them, rendering them with greater antinaturalism in their colors and arrangements than in the past. Perhaps the process of painting gripped him as much as he was gripped by it. This may have been in Eliot Clark's mind when he described Twachtman in Gloucester at the end of his life: "There was something gnawing at the soul of the man, and for one who was approaching fifty something curiously uncertain and restless."[1]

Boat Landing was included in Twachtman's 1903 estate sale, from which it was purchased by an otherwise unknown buyer named Charles M. Kelley for $45.

1. Clark, *John Twachtman*, 1924, p. 28.

70.

Gloucester Boats ca. 1901–2

Oil on panel
12⅞ × 9¼ inches
Signed lower right: *J. H. Twachtman–*
Spanierman Gallery, LLC, New York

PROVENANCE

Mr. and Mrs. Hugh C. Wallace, by 1983; (Christie's, New York, June 3, 1983, lot 207); Mr. and Mrs. Henry D. Clark Jr., Greenwich, Connecticut, 1983–88; private collection, Washington, D.C., 1988; to (Spanierman Gallery, New York); to private collection, 1990; to present coll., 2006.

EXHIBITED

Delaware Art Museum, Wilmington, *Eight Delaware Collectors*, October–November 1973.

THROUGHOUT his career, Twachtman often incorporated the tones of the grounds of his canvases and panels into his works as coloristic and textural elements. In Gloucester, at the turn of the twentieth century, he used this approach with even greater consistency, as he traveled around the docks and up to Banner Hill, working quickly to record his immediate impressions of the sites. This method also suited the direction in which his art was tending, in which he focused less on recording his perceptual responses to his motifs and more on abstract conceptions of his subjects.

This approach may be seen in *Gloucester Boats*. Not included among the twenty-four charcoal sketches after Gloucester paintings that Twachtman sent his eldest son, Alden, in 1900, this work may date from the summer of 1901 or from the last few months of his life, spent in Gloucester from late June through his death there on August 8. That he wanted to work as unencumbered by compositional concerns as possible is reflected in his decision to limit his palette to a few blue tones and to paint with such a small number of strokes that it seems almost possible to count the times he lifted his brush. The rough surface of the primed panel facilitated this directness, enabling him to apply his paint broadly to produce variegated textural effects. While the mottled tones in the primed panel harmonize with the similarly softly shifting blues, he painted the near boat's hull and shadow with black mixed with blue to provide contrast.

Unconcerned with a spatial differentiation of forms, here Twachtman seems to have been interested primarily in using this subject to focus our attention on the animated qualities of the surface. Although textural and formal properties had been part of the expressive vocabulary of his art since much earlier in his career, he placed more emphasis on revealing his process of painting in these late Gloucester works, as if to suggest that painting itself was less about what was represented and more about the involvement of the artist in the act of creation.

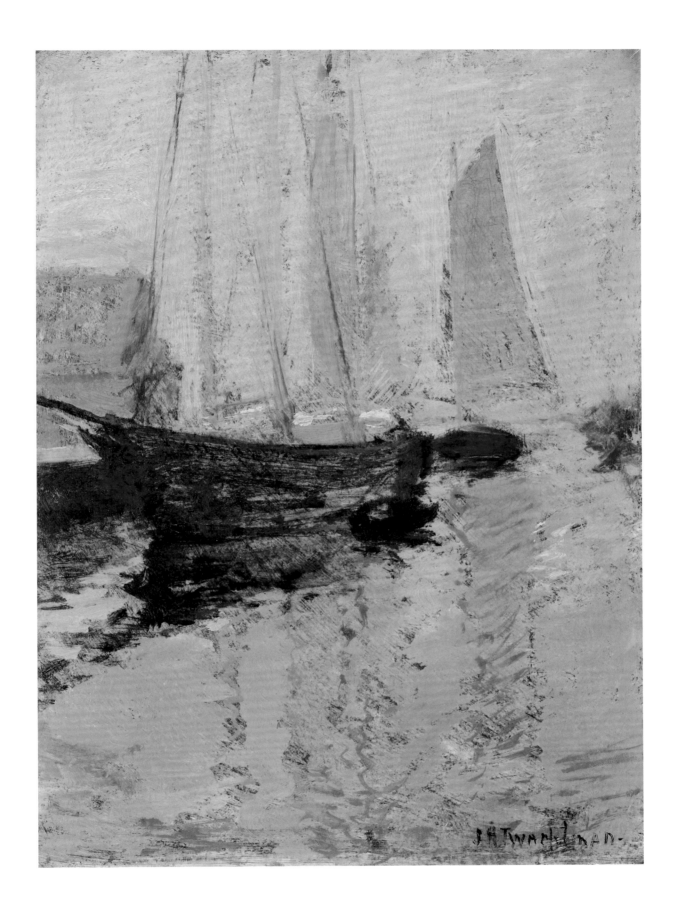

71.

Boat at Bulkhead ca. 1878

Pencil on paper
11¼ × 15¼ inches
Signed lower right: *J. H. T.*
Spanierman Gallery, LLC, New York

PROVENANCE

Private collection; to present coll., 1998.

THIS PENCIL drawing was probably rendered in Venice in 1878. By contrast with the general sketchiness of most of Twachtman's drawings, here he attempted to portray this dockside subject in greater detail than usual.

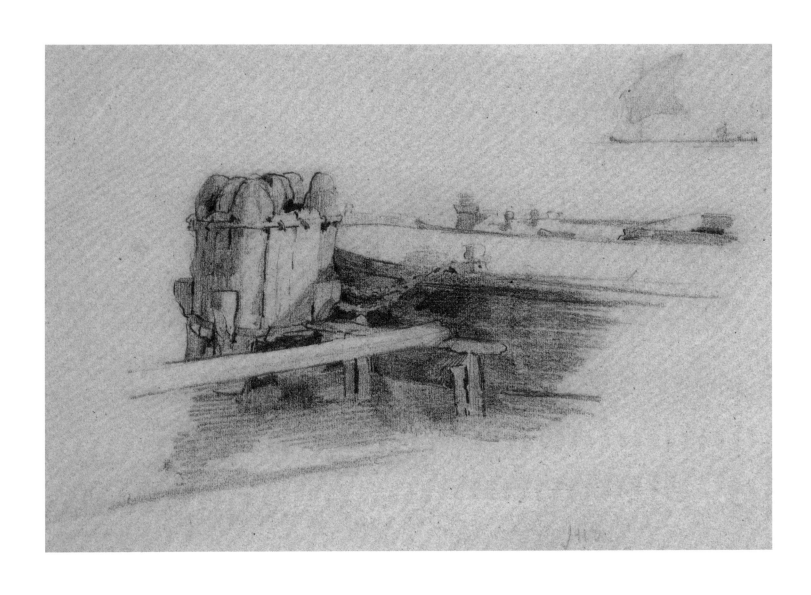

72.

Artist's House, Greenwich, Connecticut ca. 1893

Pen and ink on paper
3 × 8½ inches
Signed lower left: *J. H. Twachtman–*
Spanierman Gallery, LLC, New York

PROVENANCE

Francis Oakes Hunnewell and/or Mary Oakes, Wellesley, Massachusetts; by descent to
Elisabeth Oakes Colford, Manchester by the Sea, Massachusetts; by descent to private
collection; to present coll., 2001.

ALTHOUGH Twachtman created a few ink sketches as the basis for illustrations, this is his only known image in pen and ink of a Greenwich subject. It portrays a view looking toward the back of his house from a perspective similar to that in his *The Last Touch of Sun* (ca. 1893; Manoogian Collection). As in that work, here snow appears to be on the ground, indicated by the way that the base of the home is obscured, by the curved horizontals indicating the accumulation at the left, by the break in the linework at the top of the stone wall and the hill behind it that rose over the roof of the root cellar, and by the contrast between the shading in the sky and the open space of the ground. The birdhouse that appears in many of the artist's paintings is a prominent feature in this drawing, its small gable echoing that of the dormer in the house roof. The well house is indicated at the left, and beyond it, Round Hill Road curves southward.

Twachtman's rhythmic use of line, his integration of the paper into the design, and his awareness of his elongated horizontal format in the design of this image reflect his distinctive approach and evoke the method that he had used in his etchings, which he appears to have stopped making in about 1889 (see Cats. 74–78).

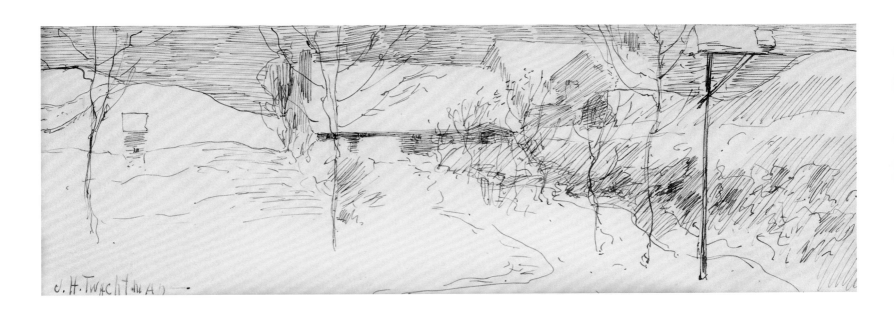

73.

Road Scene ca. 1890s

Pastel and charcoal on paper
7 × 10¼ inches
Spanierman Gallery, LLC, New York

PROVENANCE

J. Alden Weir; to his daughter, G. Page Ely (née Caroline Weir), Old Lyme, Connecticut;
by descent through the family to the present.

PROBABLY a view in either Branchville or
Greenwich, Connecticut, this drawing in
pastel and charcoal typifies the way that
Twachtman liked to carry his materials with him
and to record his quick impressions of the places
that caught his eye during walks in the country-
side. Here he suggested the presence of sunlight
on the open road by portraying the shadow of a
tree falling across the exposed paper. Twachtman's
use of light, sketchy lines and shading gives this
drawing a freshness and immediacy that are
matched by its direct perspective, in which the
road rises before us, the presence of a farmhouse
and a gate adding to its sense of welcome.

74.

Evening ca. 1881

Etching on thin, translucent paper
Etching: 4¹³⁄₁₆ × 7⁷⁄₁₆ inches
Sheet: 7¾ × 9¾ inches
Signed lower right in margin: *J. H. Twachtman*
Spanierman Gallery, LLC, New York

Lifetime impression, printed ca. 1881.

PROVENANCE

J. Alden Weir; to his daughter G. Page Ely (née Caroline Weir), Old Lyme, Connecticut; by descent in the family; to (Peter Davidson, New York, ca. 1988); to private collection; to present coll., 1992.

REFERENCE

Baskett, *John Henry Twachtman: American Impressionist Painter as Printmaker*, 1999, pp. 82–83 ill. (no. 11).

PRINTED on a thin, translucent tissue or tracing paper, this etching is listed as number 11, *Evening*, in the 1999 catalogue raisonné of Twachtman's etchings by Mary Baskett. It is one of six lifetime impressions that are known. Of these, it is the only one remaining in private hands; in addition, it is the only one known to bear the artist's signature, which appears in pencil in the margin, below the image. The others belong to the Art Institute of Chicago; Brigham Young University Museum of Art, Provo, Utah; Cincinnati Art Museum; Cleveland Museum of Art; and Honolulu Academy of Arts, Hawaii. As noted by Baskett, there are fifteen known posthumous prints of *Evening*, produced in 1921 for Frederick Keppel and Company, New York.

The etching was created by Twachtman during his honeymoon in Holland in 1881 (see Cat. 10). He used his plates to sketch his subjects directly, an approach that, of all his etchings, is best represented in this one. The cross-hatching blends aspects of the windmills, the atmosphere, and the landscape, creating a sense of the day's fading light. The composition is asymmetrically balanced, drawing our eye sideways across the surface. As Baskett notes, "while proofs of several etchings have been located that are printed with plate tone giving the feeling of different times of day, and *Harbor at Night* shows the deepening darkness after nightfall, *Evening* is the only etching that was created specifically to depict twilight."[1]

1. Baskett, *John Henry Twachtman: American Impressionist Painter as Printmaker*, 1999, p. 82.

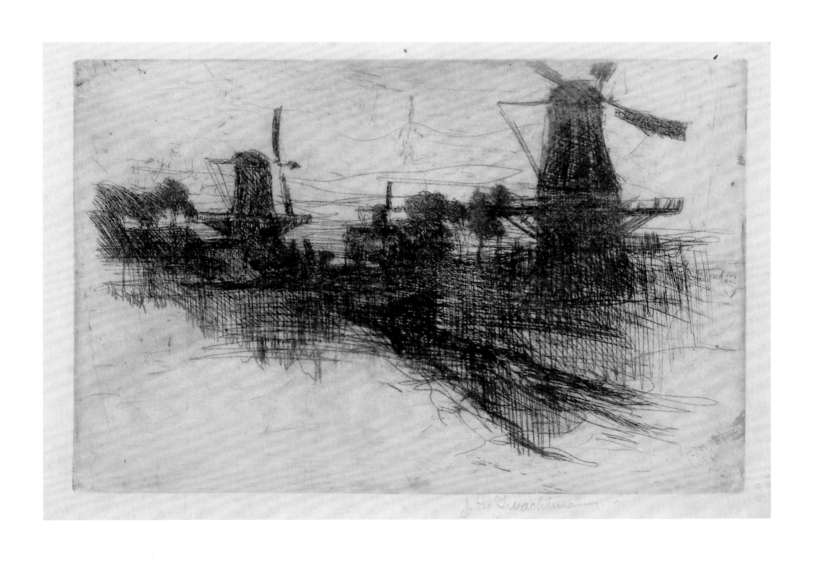

J. H. Twachtmann

75.

Abandoned Mill ca. 1888

Etching on heavy cream wove paper
Etching: 5 × 3½ inches
Sheet: 11⅞ × 8¾ inches
Signed in plate lower left: *J. H. T.*
Spanierman Gallery, LLC, New York

State II. Fifth Avenue Galleries, large-paper edition, printed ca. 1889.

PROVENANCE

J. Alden Weir; to his daughter G. Page Ely (née Caroline Weir), Old Lyme, Connecticut; by descent in the family; to (Peter Davidson, New York, ca. 1988); to private collection; to present coll., 1992.

REFERENCE

Baskett, *John Henry Twachtman: American Impressionist Painter as Printmaker*, 1999, pp. 100–101 ill. (no. 20).

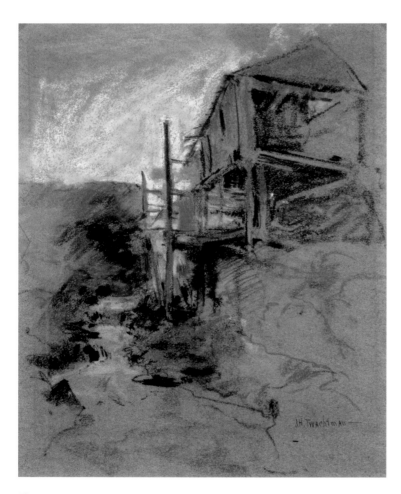

Fig. 92
Twachtman, *Abandoned Mill, Branchville, Connecticut*, ca. 1888, pastel on paper, 15 × 12 inches, The Jane Voorhees Zimmerli Art Museum, Rutgers, The State University of New Jersey, New Brunswick, Gift of the John C. Van Dyke Collection.

INCLUDED as number 20, *Abandoned Mill*, in Mary Baskett's 1999 catalogue raisonné of Twachtman's etchings, this was one of four etchings used to illustrate works in the catalogue for the show of Twachtman's and J. Alden Weir's art held at the Fifth Avenue Galleries in New York in early February 1889 (see Cat. 77). The etching belongs to the large-paper edition printed by the Fifth Avenue Galleries; the small-paper edition consists of the etchings that were actually part of the catalogue itself.[1] According to Baskett's catalogue raisonné, there are five other known Fifth Avenue impressions of this image: one is in a private collection, and the others belong to the Boston Public Library; the Cincinnati Art Museum; the Metropolitan Museum of Art, New York; and the New York Public Library. There are twenty-three known posthumous impressions of this image, printed in 1921 for Frederick Keppel and Company, New York.[2]

The work that this etching illustrated was a pastel, *Abandoned Mill* (Fig. 92), which was number 12 in the exhibition. However, the etching and the pastel are quite different, suggesting that Twachtman created both independently and directly on-site. In the pastel, he used a looser handling and blended tones, obscuring structural aspects of the subject to create a more atmospheric setting. In the etching, the form of the mill is clearer and larger, while shading produced through cross-hatching offsets the unfilled supports of the mill, conveying a sense of sunlight falling across the scene. His approach concurs with the view of Mariana Van Rensselaer, who advised in an 1883 article in *Century Magazine* that "painter-etchings" be produced with "an economy of labor." She wrote: "Work done with few lines and vital ones, its meaning suggested by subtile [*sic*] 'short-hand' methods, which leave the white paper to play an important part in the general result, appeals to most lovers of the art with especial force and charm."[3]

1. The paper sizes in the Fifth Avenue Galleries edition are noted in Baskett, *John Henry Twachtman: American Impressionist Painter as Printmaker*, 1999, p. 44.
2. Ibid., 1999, p. 100.
3. Mariana G. Van Rensselaer, "American Etchers," *Century* 25 (February 1883), p. 486.

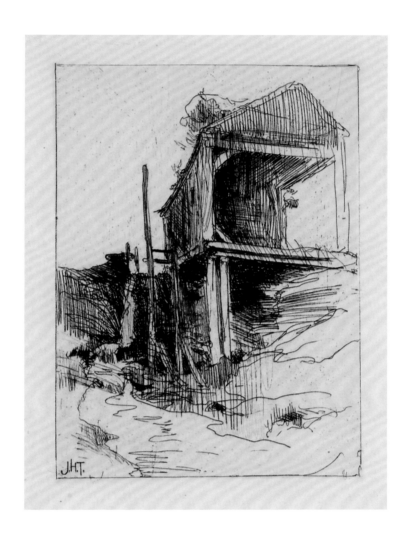

76.

Branchville Fields ca. 1888

Etching on heavy cream wove paper
Etching: 6⅝ × 10 inches
Sheet: 10 × 11¼ inches
Signed and inscribed in pencil in plate by G. Page Ely (née Caroline Weir) lower right: *J. H. Twachtman / C. W. E. imp.*
Inscribed in margin lower left: *This plate found among those of J. Alden Weir / and was first printed under his name—in Dec. 1942 / plate and several prints given to Alden Twachtman / Not in Z / Sketch Fields*

Printed by Caroline Weir Ely between 1919 and 1942, in an edition of 25; not in Baskett.

PROVENANCE

J. Alden Weir; to his daughter G. Page Ely (née Caroline Weir), Old Lyme, Connecticut; by descent in the family; to (Peter Davidson, New York, ca. 1988); to private collection; to present coll., 1992.

Fig. 93
Twachtman, *Spring Landscape*, ca. 1888, pastel on paper, 12 × 20 inches, Huntington Museum of Art, West Virginia, gift of Ruth Woods Dayton.

THE INSCRIPTION on this work by Caroline Weir Ely (see Cat. 3), the eldest daughter of J. Alden Weir, indicates that this etching was initially printed as a work by her father, but that it should instead be attributed to Twachtman. An edition of twenty-five impressions was made from this plate by Ely at some point between the time of her father's death in 1919 and 1942. Of these, thirteen belong to Brigham Young University

Museum of Art, Provo, Utah, which were received by the museum in about 1957 from the children of Mahonri Young (1877–1957), who had been married to Weir's daughter Dorothy (1890–1947). One impression was given in 1972 by Brigham Young University to the Smithsonian American Art Museum, Washington, D.C. As noted in the inscription on this etching, several impressions of it were given to Twachtman's eldest son Alden. This impression was kept by the Weir family, in whose hands it remained until 1988, along with the other etchings in this catalogue (Cats. 74–75, 77–78).

It is not clear as to when and why Caroline Weir Ely discovered that a mistake had been made. Yet her realization is borne out by the existence of a pastel by Twachtman, entitled *Spring Landscape* (Fig. 93), which concurs fully with the image in the etching. Perhaps Ely saw this pastel, which had been purchased in 1934 from Macbeth Gallery by Arthur Spencer Dayton, who in 1948 gave it to the Daywood Art Gallery, Lewisburg, West Virginia. (His collection was turned over to the Huntington Museum of Art, West Virginia, in 1966.)

It is not clear if Twachtman made the etching or the pastel first. His treatment of the motifs is much closer in these two works than it is in his

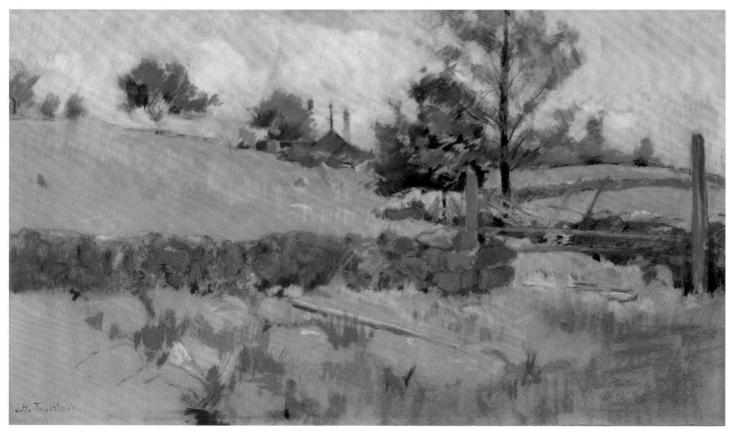

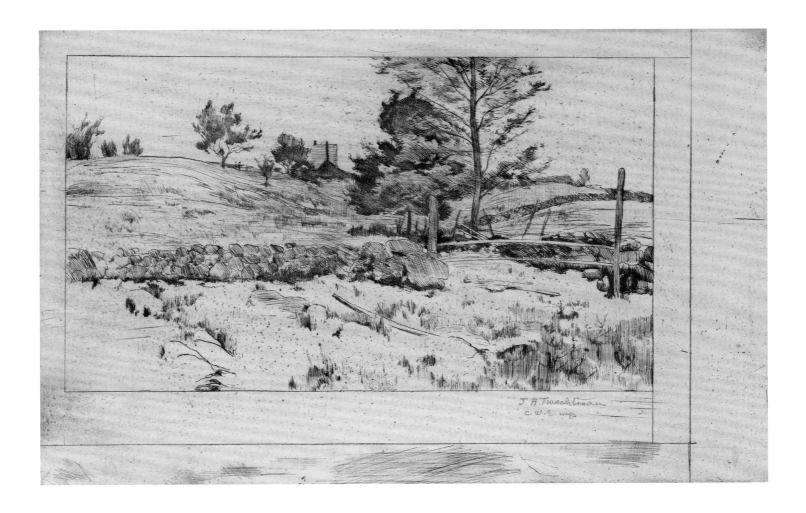

etching *Abandoned Mill* (Cat. 75) and its related
pastel (Fig. 92). Whereas Weir followed Twachtman
in creating more loosely rendered pastels,
Twachtman may have been taking his cue from
Weir in his approach in this image. The site of
both the etching and pastel is probably some-
where near Weir's farm in Branchville, and the
countryside is similar to that portrayed in
Middlebrook Farm (Cat. 23) and *Farm Scene* (Cat.
24), as well as in Weir's *Lengthening Shadows*
(1887; private collection). The etching and pastel
are characteristic of a period when Twachtman
repeatedly portrayed the motifs of low walls of
propped-together stones, gates of bent wood,
curving roads, and the rooflines of old farm-
houses rising from hillcrests, capturing the
Arcadian essence of a still-rural New England. A
similar subject matter appears in Twachtman's
etching *Windy Day* (Baskett 21) and a painting,
Spring Landscape (ca. 1888; Tweed Museum of Art,
University of Minnesota, Duluth).

That the Huntington pastel is signed suggests
that it might have been among the thirty-one
pastels that Twachtman included in his 1891
Wunderlich exhibition in New York.

77.

Bridgeport ca. 1888–89

Etching on heavy cream wove paper
Etching: 3⅞ × 6 inches
Sheet: 7⅞ × 9½ inches
Signed in plate at lower left: *J. H. T.*
Spanierman Gallery, LLC, New York

State II. Fifth Avenue Galleries, large-paper edition, printed ca. 1889.

PROVENANCE

J. Alden Weir; to his daughter G. Page Ely (née Caroline Weir), Old Lyme, Connecticut; by descent in the family; to (Peter Davidson, New York, ca. 1988); to private collection; to present coll., 1992.

REFERENCE

Baskett, *John Henry Twachtman: American Impressionist Painter as Printmaker*, 1999, pp. 108–9 ill. (no. 24).

As in the case of *Abandoned Mill* (Cat. 75), this etching, listed as number 24, *Bridgeport*, in Mary Baskett's 1999 catalogue raisonné of Twachtman's etchings, was one of four reproduced in the catalogue for the show and sale of the work of Twachtman and J. Alden Weir held at the Fifth Avenue Galleries in New York in February 1889. The etching belongs to the large-paper edition printed by the Fifth Avenue Galleries; the small-paper edition consists of the etchings that were actually part of the catalogue itself.[1] According to Baskett's catalogue raisonné, there are five other known Fifth Avenue impressions of this image: one in a private collection, and the others belonging to the Boston Public Library; the Cincinnati Art Museum; the Metropolitan Museum of Art, New York; and the New York Public Library. Baskett notes the existence of eleven known posthumous impressions of this image, printed in 1921 for Frederick Keppel and Company, New York.[2]

The painting that this etching illustrated, also entitled *Bridgeport*, is not known today. It was described by a reviewer for the *Critic* as "a view of wharves and old buildings in which [Twachtman's] customary greys and blues were varied by the dull yellows and reds of the weather-worn houses."[3] Most of Twachtman's extant images of Bridgeport portray a footpath that was part of an old bridge that was being replaced by the new Stratford Avenue Bridge, an iron bridge constructed across the Pequonnock River.[4] He featured the tollhouse on this bridge in a painting in the 1889 exhibition (location unknown) that was also reproduced in an etching (Baskett 22) in the catalogue. Twachtman showed this scene of Bridgeport's Inner Harbor,

on the Pequonnock River, in reverse in two other etchings: *Inner Harbor, Bridgeport* (small-plate) (Baskett 25) and *Inner Harbor, Bridgeport* (large-plate) (Baskett 26). Along the harbor were grain elevators and factories that produced salts, textiles, brass, and valves.

In the introduction to the 1921 catalogue produced by Frederick Keppel, Robert J. Wickenden, who had studied in Paris with Twachtman in the 1880s, wrote that this etching "is an example of the rectangular composition often employed by Twachtman in dock motives, the squareness of the buildings being relieved by the diagonals of roofs and a mast with sail that breaks the horizon at the extreme right. The lightly touched reflections of the water that fills the foreground contribute to the effect by a contrary mobility."[5]

1. The paper sizes in the Fifth Avenue Galleries edition are noted in Baskett, *John Henry Twachtman: American Impressionist Painter as Printmaker*, 1999, p. 44.

2. Ibid., p. 108.

3. "Paintings by Weir and Twachtman," *Critic* 2 (February 1889), p. 69.

4. These include *Footbridge at Bridgeport* (ca. 1888; pastel on paper, Washington County Museum of Fine Arts, Hagerstown, Maryland) and *Bridgeport* (watercolor; private collection). For information on this site, see Peters, *John Twachtman (1853–1902) and the American Scene*, 1995, vol. 1, pp. 246–50.

5. Wickenden, *Art and Etchings of John Henry Twachtman*, 1921, p. 37.

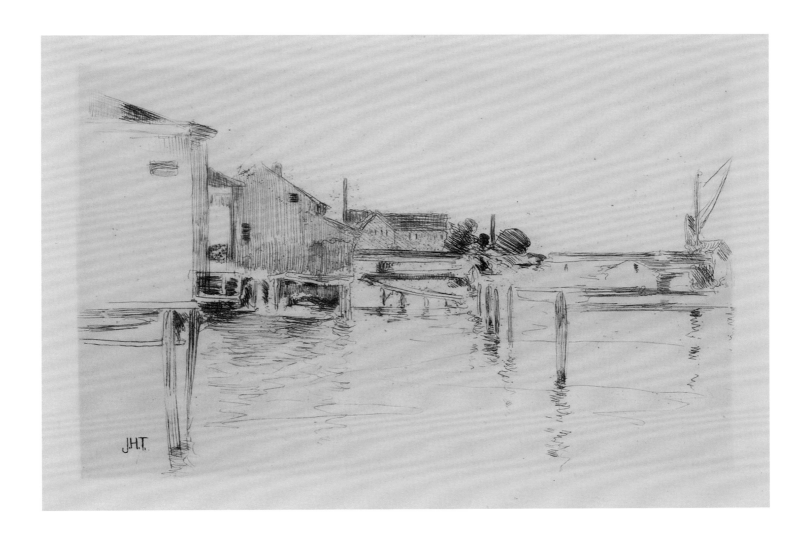

78.

Dock at Newport ca. 1889

Sepia etching on thin cream wove paper
Etching: 5 × 7 inches
Sheet: 7⅞ × 9½ inches
Signed in plate lower right: *J.* [in reverse] *H. T.* and below *J. H. T.* [in reverse]
Inscribed on label: *Artist's proof*
Spanierman Gallery, LLC, New York

Unique artist's proof, printed ca. 1889–93.

PROVENANCE

J. Alden Weir; to his daughter G. Page Ely (née Caroline Weir), Old Lyme, Connecticut; by descent in the family; to (Peter Davidson, New York, ca. 1988); to private collection; to present coll., 1992.

REFERENCE

Baskett, *John Henry Twachtman: American Impressionist Painter as Printmaker*, 1999, pp. 118–19 ill. (no. 29).

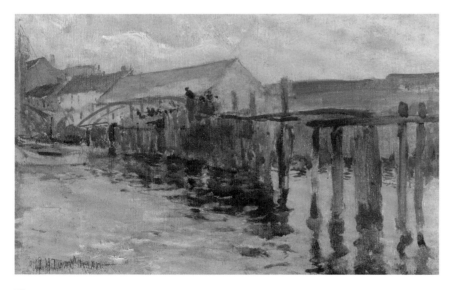

Fig. 94
Twachtman, *The Landing, Newport*, ca. 1889, oil on wood panel, 8⅛ × 12⅛ inches, private collection.

THIS ETCHING, number 29 in Mary Baskett's 1999 catalogue raisonné of Twachtman's prints, is known to exist in two editions, the first printed by Kimmel and Voight at the Devinne Press, New York, for the 1893 New York Etching Club catalogue, and the second in 1925 by the artist and printmaker Arion Mueller, who Baskett notes owned the plate at that time, probably in an edition of about twenty-five.[1] This impression, printed in sepia ink on thin cream paper, is a unique artist's proof. Here Twachtman softened the image overall, giving it the quality of an oil. The differences between this version and those in the other editions are notable especially at the lower level of buildings in the middle distance, where Twachtman added a few details, and in the dock in the left foreground, where he reduced the crispness of the outlining of the pilings, omitted some of them and fading others out. The doorways and windows in the building at the left are rendered with tonal shading rather than cross-hatching.

As in the case of many of his other etchings, this one relates to a painting, *The Landing, Newport* (Fig. 94), which portrays this subject in reverse. Of Twachtman's etching *Dock at Newport*, Robert J. Wickenden remarked:

[W]ith a few bravely drawn lines and well chosen accents, the artist again has suggested a maximum of light, and unlimited space. Here . . . Twachtman's delight in the combination of horizontals and verticals is made evident in the docks, connecting piers, and the darker accents in the halls of the yachts and boats, from which rise the lightly drawn masts and rigging. The distant shore and sail-boats are marvels of delicacy and prevision; in line and accent contributes to produce the impression of life, air, and movement, as well as for justness of perspective affect, this etching has been rarely surpassed.[2]

1. Lifetime impressions printed by the New York Etching Club belong to twenty-five private collections and the collections of the Cincinnati Art Museum; the Metropolitan Museum of Art, New York; National Gallery of Canada, Ottawa; the New York Public Library; and the Queen City Club, Cincinnati. Mueller impressions belong to three private collections and to the Brooklyn Museum of Art and the Metropolitan Museum of Art.
2. Wickenden, *Art and Etchings of John Henry Twachtman*, 1921, p. 37.

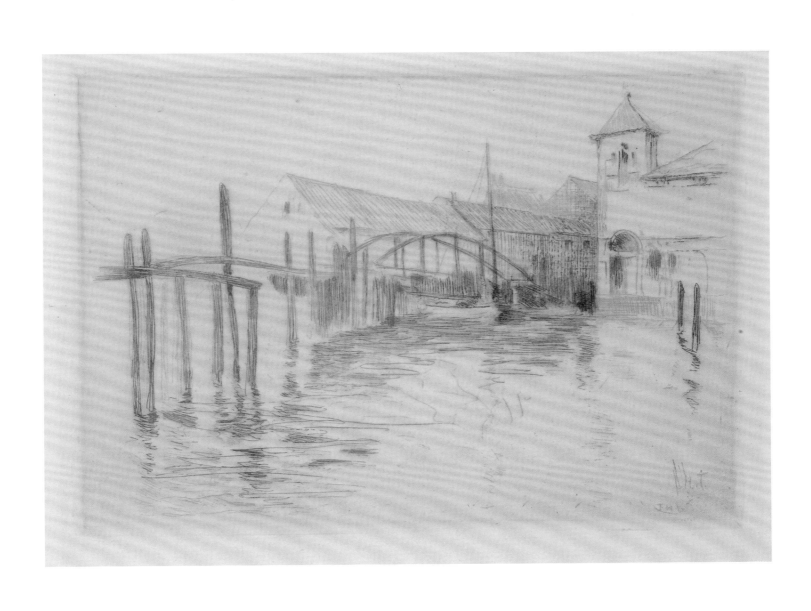

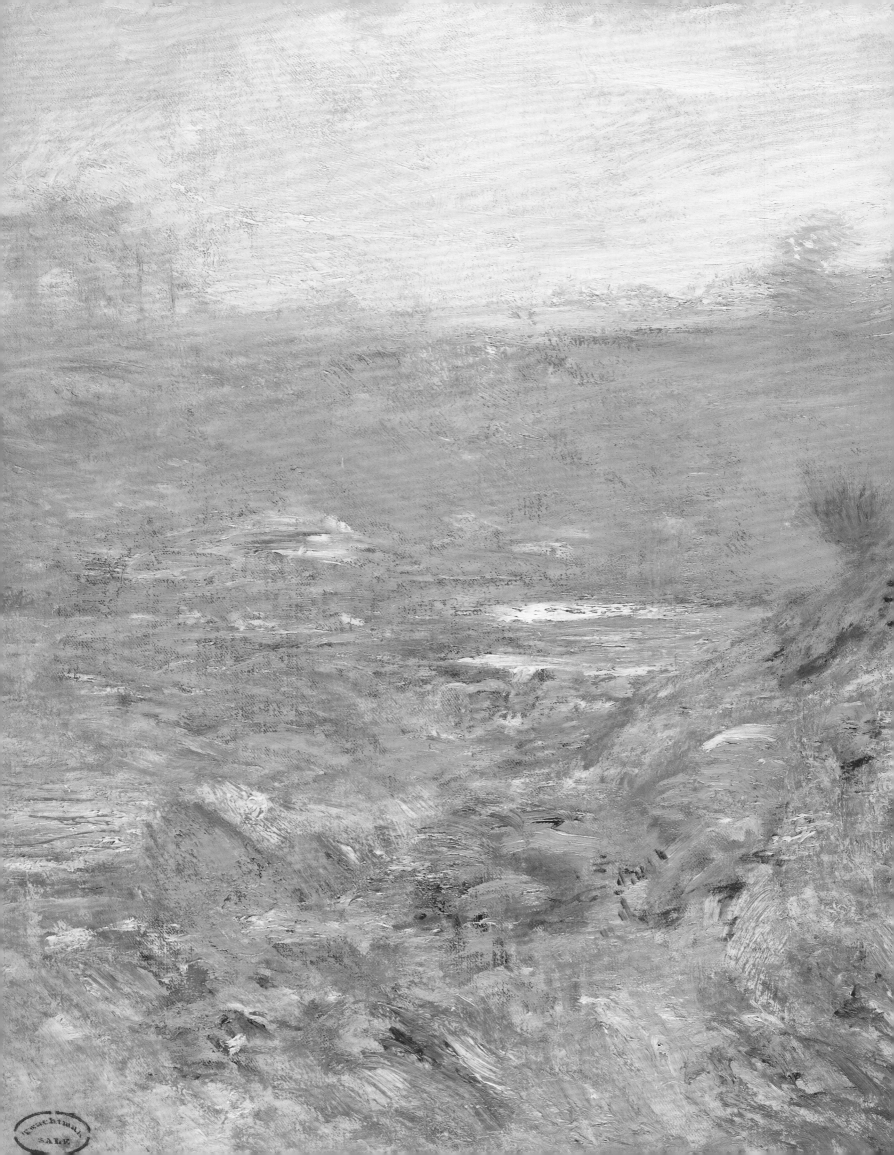

Chronology

1853
August 4. Born in Cincinnati, Ohio, to Frederick Christian Twachtman (1815–1878) and Sophia Droege Twachtman (1823–1895); (siblings: Amilia, b. 1846; Alvina, b. 1851; George, b. 1856; Edward, b. 1859).

Early Years
Lived at 500 and 520 Race Street, at the corner of Race and Fifteenth Streets in Over the Rhine, Cincinnati's German district.

Late 1860s
Helped his father in his work painting window shades for Breneman Brothers Decorating Firm, Cincinnati.

1868–71
Attended Ohio Mechanics Institute, Cincinnati (received first degree award from the school in 1869).

1871–75
Attended McMicken School of Design (classmates included Robert Blum, William J. Baer, Henry Muhrman, and Charles Niehaus).

1873
Exhibited *Tuckerman's Ravine* (Fig. 22) and *View in Tennessee* (location unknown) at Cincinnati Industrial Exposition.

1874–75
Winter–spring. Attended free evening class taught by Frank Duveneck and held at Ohio Mechanics Institute (classmates included Blum, Alfred Brennan, Joseph DeCamp, Kenyon Cox, and Clement Barnhorn).

Worked in Duveneck's Pike Street studio in Cincinnati along with Henry Farny and Frank Dengler.

1875
August. Left with Frank Duveneck for Munich.

October 15. Enrolled at Munich Royal Academy in a class in life drawing taught by Ludwig von Löfftz.

1876
In Munich.
At some point between April 1 and May 7, signed Streicher Inn guest book, Polling, Germany. Probably visited Polling with Wilder Darling and Charles Ulrich, who signed during the same period of time.

1877
In Munich through end of May.
Late May. Joined William Merritt Chase and Frank Duveneck in Venice. Took care of Chase, who became ill with malaria.

1878
March. Participated in the first exhibition of the Society of American Artists (he would also show at the society in 1879–83, 1887–88, 1892, 1894–96).

Probably by late April. Returned to Cincinnati on learning of the death of his father.

April. Showed at the Women's Art Museum Association, Cincinnati.

1879
Winter. Moved to New York. Resided in the University Building on Washington Square. Painted scenes of New York harbors and the shore of Jersey City, New Jersey. Became a member of the Tile Club.

April–May. Exhibited at the National Academy of Design for the first time (he would also show at the academy in 1880, 1882–83, 1888, 1892, 1894–95, 1897, 1898).

Spring. Exhibited six etchings at Museum of Fine Arts, Boston.

June–July. Traveled with the Tile Club on a barge trip up the Hudson River to Lake Champlain.

October 16. Became a member of the Society of American Artists.

Fall. Returned to Cincinnati. Began teaching drawing and oil painting at the Women's Art Museum Association.

December–January 1880. Joined the Etching Club of Cincinnati.

Opposite:
Upland Pastures
(detail of Cat. 45).

239

1880

Painted in the hills of Cincinnati.

Continued teaching at Women's Art Museum Association.

June 15. Left Cincinnati for New York. Then traveled along the Atlantic seacoast.

June 29. Wrote to J. Alden Weir from Nonquit Beach, New Bedford. Massachusetts. Visited there with R. Swain Gifford and William Merritt Chase. Possibly visited Block Island with Chase and other members of the Tile Club.

August. Spent time in New York.
Exhibited etchings at Inter-State Industrial Exposition of Chicago, along with a collection from the New York Etching Club.

Early September. Returned to Cincinnati.

October 2. Sailed for Europe, as indicated in a letter to Weir.

Early November. Became a teacher at Duveneck's art school in Florence. Painted in Tuscany.

1881

Remained in Tuscany during first few months of the year.

April 21. Married Martha Scudder in Cincinnati at Swendenborgian-affiliated New Jerusalem Church, to which Martha's father, Dr. John Milton Scudder, belonged.

Late June. Participated in Tile Club schooner trip on Long Island Sound with Chase, William MacKay Laffan, J. Alden Weir, and others.

Early July. Left for honeymoon in Europe. Joined J. Alden Weir and John Ferguson Weir in Dordrecht, Holland. Visited and painted in Dordrecht and neighboring Pappendrecht and Alblassadam.

July or August. Visited Anton Mauve in The Hague.

August 1. Signed register at Frans Hals Museum, Haarlem.

Between August 15 and 20. Left Holland and traveled south to Munich and Schleissheim in Bavaria.

Fall. In Venice, joined there by Blum, Duveneck, and Muhrman.

Mid-December. Returned to Cincinnati. Resumed teaching at Women's Art Museum Association.

1882

Resided in Avondale, Ohio, a suburb of Cincinnati, in the home of his father-in-law, Dr. Scudder.

January–February. Exhibited at the Fifteenth Annual Exhibition of the American Watercolor Society at the National Academy of Design.

March 5. John Alden, the artist's first child, is born.

Painted landscapes in Avondale.

1883

Remained in Avondale for part of the year. Continued to paint Avondale scenes.

February. Exhibited at Closson's Gallery, Cincinnati, with Cox, DeCamp, George Hopkins, and Theodore Wendel.

Summer or fall. Left with his wife and son for Paris. Resided at 141 avenue de Villiers in the seventeenth arrondissement.

Fall. Enrolled at Académie Julian on the faubourg St. Denis under Gustave Boulanger and Jules-Joseph Lefebvre. Met future members of the Ten: Frank Benson, Willard Metcalf, Robert Reid, Edward Simmons, and Edmund Tarbell. Other classmates included Arthur Wesley Dow and Charles Adams Platt (see Cat. 18).

1884

Continued to study at Académie Julian.

June 5. Marjorie, the artist's second child, is born.

Summer. Rented a château with a garden in the Normandy town of Arques-la-Bataille. Visited Dieppe.

Visited Honfleur, where he probably spent time with Homer Dodge Martin.

December 25. Marjorie baptized in Paris, as noted in letter to Weir.

1885

Winter. Continued to study at Académie Julian.

February. First one-man show, held at J. Eastman Chase's Gallery, Boston.

April. In Normandy, possibly Honfleur.

April 16. Martha Twachtman and the artist's children leave Europe, bound for Cincinnati.

By June. In Dordrecht and painted in Kinderdijk.

June 11. Signed register at Frans Hals Museum, Haarlem.

Summer. Remained in Holland. Created pastels, probably his first works in the medium.

September 5. Signed the register at the Frans Hals Museum, probably with William Merritt Chase and Walter Launt Palmer, who signed the museum's register the same day.

October 1. Arrived in Venice. Resided with Blum at Palazzo Contarini di Scrigni in the San Trovaso quarter on the Grand Canal. Nursed Blum through a bout of cholera.

December. Duveneck arrived in Venice.

Late December or early January. Returned to America.

1886
January. Probably went directly to Cincinnati after sailing home.

January–February. Second one-man show, also at J. Eastman Chase's Gallery, Boston.

June 10. On Pelee Island, Ontario, Canada, in Lake Erie, where he tended cattle at Dr. Scudder's marsh farm. Wrote to Weir that he had received word that the crate of his works sent from Europe were to be salvaged from the S.S. *Oregon*, which had sunk off the coast of Fire Island, New York.

By October 10. In Chicago. Participated in painting cyclorama of the Civil War Battle of Gettysburg, erected in Pittsburgh (opened June 14, 1887). Other participants included Oliver Dennett Grover and Thadeus Welch.

Probably also worked in Chicago on cyclorama of Civil War Battle of Shiloh, financed by H. H. Gross and built adjacent to the B & O passenger depot on Chicago's Michigan Avenue. Other participants included Charles Corwin, Grover, and Frank C. Peyraud.

November 2. Elsie, the artist's third child, is born.

1887
Spent time on Pelee Island, probably in the summer.

By fall (or winter 1888). In New York City. Shared a studio in the Benedick Building on Washington Square with William Langson Lathrop.

1888
Winter or spring. Began visiting frequently with J. Alden Weir in Branchville, Connecticut.

May 1888. Exhibited at second exhibition of Society of Painters in Pastel. Showed Dutch and Venetian subjects.

Summer. Rented a house in Branchville near Weir's farm. Created pastels and paintings in Branchville and etchings on Weir's press.

Summer or fall. Began working in Bridgeport, on the Connecticut coast. Created paintings, etchings, pastels, and watercolors.

1889
Early February. Joint exhibition and sale with J. Alden Weir of paintings and pastels at Fifth Avenue Galleries, New York. Sale conducted on February 7 by Ortgies & Co.

By June 4. In Newport, taught an art class.

June 21. Instructing his Newport students in outdoor painting methods.

July. Exhibited at third exhibition of Society of Painters in Pastel.

Summer. Probably remained in Newport.

Fall. Began teaching at Art Students League, New York, as instructor of the Preparatory Antique Class. Held this position until the end of his life.

Late October. In Newport, as noted in diary of Anna Hunter.

Late fall. Probably settled in Greenwich, Connecticut, renting a house at 30 Round Hill Road. Began focusing on motifs found on his property.

Became a member of the Players Club, New York.

1890
February 18. Purchased house and three acres of land in Greenwich from David S. Husted.

March 7. Sold his Greenwich house to Charles Cameron, who quit-claimed it to Twachtman's wife, Martha, the same day.

May 2. Eric Christian, the artist's fourth child, is born.

June. Participated in fourth and final exhibition of the Society of Painters in Pastel.

Summer. Probably began teaching summer classes in Cos Cob with J. Alden Weir.

1891
March. One-man show at Wunderlich Gallery, New York. Showed pastels and oils.

Summer. Probably taught with Weir in Cos Cob.

September 25. Death of Eric Christian Twachtman.

December 1. Purchased additional 13.4 acres of land in Greenwich from David S. Husted.

1892
Summer. Taught with Weir in Cos Cob. Continued to teach classes after Weir left for Chicago in August.

September 6. Quentin Twachtman, the artist's fifth child, is born.

1893

May. Exhibition with Weir, Claude Monet, and Paul-Albert Besnard at American Art Galleries, New York.

Summer. Taught in Cos Cob with Weir.

Late October. To Boston to attend wedding of J. Alden Weir to Ella Baker. Saw exhibition of Japanese prints at the Museum of Fine Arts, Boston.

November. Joint show with Weir at St. Botolph Club, Boston.

November 8. Twachtman's wife, Martha, and his children leave for Cincinnati, as noted by Theodore Robinson in his diaries.

1894

Winter. Probably stayed in Buffalo with Dr. Charles Cary and his wife, Evelyn Rumsey Cary, and painted Niagara Falls.

Began teaching the elementary cast drawing classes at the Cooper Union School of Design for Women.

February 17. Death of Twachtman's father-in-law, Dr. Scudder.

April 9. Twachtman's wife and family return from Cincinnati, as noted by Theodore Robinson in his diaries.

Worked on images of Chicago World's Columbian Exposition for deluxe history of the fair.

By July 1. Had visited Niagara Falls. In his diaries, Robinson mentions that Twachtman "showd [*sic*] us some canvases done at Niegara [*sic*]."

Summer. Taught in Cos Cob with Weir.

Mid-August. Twachtman had malaria. Robinson wrote on August 17: "saw Twachtman with his class in the orchard—he has had malaria." Robinson diaries. Robinson wrote in his diaries on November 16: "saw Taylor & Twachtman—the latter looked peakish—has had malaria all summer."

December 2. Twachtman began stay in New York City for the winter, possibly with his family. Robinson wrote in his diaries: "Twachtman came in at 5, has moved in town for the winter, Wash. Sq."

December 16. Robinson mentions dining with "the Twachtmans, Wash. Sq." Robinson diaries.

December. On hanging committee of Sixty-fourth Annual Exhibition of Pennsylvania Academy of the Fine Arts. Won Temple Award for the best landscape by an artist under the age of forty from the academy for *Autumn.*

December 30. Twachtman and his eldest son, Alden, quarantined from other family members who were ill with scarlet fever.

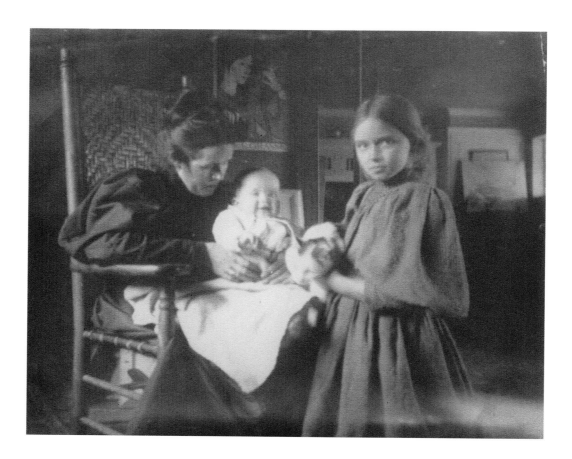

Fig. 95
Photograph, Martha Twachtman with daughter Marjorie and baby son Quentin, ca. 1892–93, private collection.

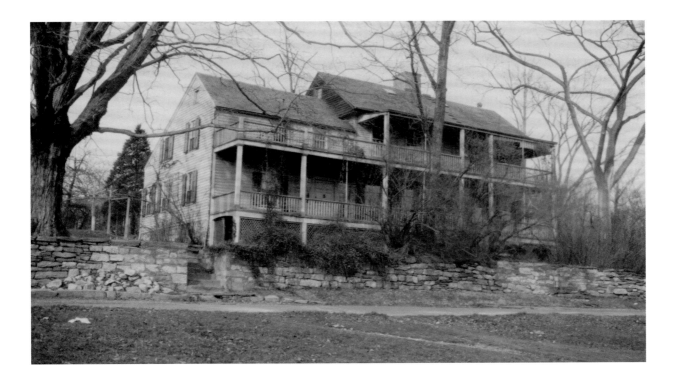

Fig. 96
Photograph, Front view,
Bush-Holley House,
ca. 1900s, Historical
Society of the Town of
Greenwich, Cos Cob,
Connecticut.

1895

January 13. Death of daughter Elsie, age nine, from scarlet fever.

January 14. Funeral for Elsie held in Greenwich.

February. Twachtman's wife and children in Lakewood, New Jersey, while he may have remained in New York with Alden. Robinson diaries, February 11 and 13, 1895.

May 23. Violet Twachtman, the artist's sixth child, is born.

Summer. Taught at Cos Cob with Weir. Death of Twachtman's mother.

Mid-September–October 1. Visited Yellowstone Park in Wyoming, a trip funded by Major William A. Wadsworth, Geneseo, New York.

1896

April 2. Death of Theodore Robinson in New York.

Summer. Taught in Cos Cob with Weir.

1897

Resigned from Society of American Artists. Helped to form the Ten American Painters.

Summer. Taught alone in Cos Cob.

Early December. Show of Twachtman's Cos Cob students' work at Art Students League.

Godfrey Twachtman, the artist's seventh child, is born.

1898

March–April. Showed with the Ten at Durand-Ruel Galleries, New York.

April–May. Showed with the Ten at St. Botolph Club, Boston.

Summer. Taught at the Art Students League first summer session in Norwich, Connecticut, with Bryson Burroughs.

1899

April. Showed with the Ten at Durand-Ruel Galleries, New York.

Summer. Taught alone in Cos Cob.

1900

February–March. Joint show with his son, J. Alden, at St. Botolph Club, Boston.

Winter. May have moved with his family from Greenwich.

March. Showed with the Ten at Durand-Ruel Galleries, New York.

April. Show of work by Twachtman and his son at Cincinnati Art Museum. Acquisition by the museum of Twachtman's *Waterfall, Blue Brook.*

Showed with the Ten at St. Botolph Club, Boston.

May. Participated in *Twenty-fifth Anniversary Exhibition of the Art Students League*, New York.

By June 21. In Gloucester, Massachusetts, with his family. Stayed through end of September, residing at the Rockaway Hotel on Rocky Neck.

August. Participated in exhibition at the Rockaway Hotel.

Fall. May have stayed at the Holley House with his family.

1901

Winter, probably. Martha Twachtman and children leave for Paris, where son Alden began study at the École des Beaux-Arts. Twachtman remained behind.

By January 7. Arrived in Chicago, where a show of his work opened January 8.

January 15. Left Chicago for Columbus, Ohio.

Mid-January. In Columbus, Ohio, where a show of his works were on view in the studio of Albert Fauley.

February 2. Spoke to group at Fauley's studio in Columbus.

March–April. Staying alternately at the Players Club and the Holley House.

April 12. Show of Twachtman's work opened at Cincinnati Art Museum.

May. Staying some of the time at the Players Club.

Early summer. Joined family in Honfleur, France. The family remained abroad, probably moving to Paris in the fall. Twachtman returned to the United States after a month abroad.

Mid-summer. To Gloucester, taught with Joseph DeCamp for Art Students League.

October 9. Began a stay at the Holley House that lasted until January 15, 1902.

1902

January 2. Wrote to Josephine Holley from the Players Club.

Through January 15. Stayed at the Holley House.

January 17. Wrote to Josephine Holley from the Players Club, asking when he could return to the Holley House.

January 25. Wrote to Josephine Holley from the Players Club.

January 29–February 2. Stayed at the Holley House.

February 4. Wrote to Josephine Holley from the Players Club.

March–April. Showed with the Ten at Durand-Ruel Galleries, New York.

April–May. Showed with the Ten at St. Botolph Club, Boston.

April 11–May 30. Stayed at the Holley House.

June 4. Arrived at Chamberlin and Hygeia, Fort Monroe, Viriginia. Wrote to Josephine Holley indicating that his doctor had "recommended a sea voyage."

By June 21. In East Gloucester, wrote from the Harbor View Hotel, to Josephine Holley.

Summer. Stayed at the Harbor View Hotel in East Gloucester and taught classes with Joseph DeCamp.

July 18. Daughter Marjorie arrived in New York from Europe. Probably spent the night in Cos Cob before departing for Gloucester to join her father.

August 8. Died of brain aneurysm after short illness at Addison-Gilbert Hospital, Gloucester.

1903

March 24. Sale of ninety-eight works from the artist's estate at American Art Galleries, New York.

Selected Exhibitions

[1885 J. Eastman Chase's]
J. Eastman Chase's Gallery, Boston, *Paintings by John H. Twachtman*, February 10–20, 1885.

[1886 J. Eastman Chase's]
J. Eastman Chase's Gallery, Boston, *Paintings and Pastels by John H. Twachtman*, January 19–30, 1886.

[1889 Fifth Avenue Galleries]
Fifth Avenue Galleries, New York, *Paintings in Oil and Pastel by J. A. Weir and J. H. Twachtman*, February 1–6, 1889 (sale conducted by Ortgies and Company on February 7).

[1891 Wunderlich Gallery]
H. Wunderlich & Co., New York, *Paintings in Oil and Pastels by J. H. Twachtman*, March 1891.

[1893 American Art Galleries]
American Art Galleries, New York, *Paintings, Pastels, and Etchings by J. Alden Weir and J. H. Twachtman*, May 1893.

[1893 St. Botolph Club, Boston]
St. Botolph Club, Boston, *An Exhibition of Oil Paintings by Messrs. Weir and Twachtman*, November 27–December 9, 1893.

[1900 St. Botolph Club, Boston]
St. Botolph Club, Boston, *Exhibition of Paintings by J. H. Twachtman and His Son Alden Twachtman*, February 26–March 13, 1900.

[1900 Cincinnati Art Museum]
Cincinnati Art Museum, *Exhibition of Paintings, Drawings, and Pastels by J. H. Twachtman and His son Alden Twachtman*, April 6–May 13, 1900.

[1901 Art Institute of Chicago]
Art Institute of Chicago, *Exhibition of Works by John H. Twachtman*, January 8–13, 1901.

[1901 Durand-Ruel Gallery, New York]
Durand-Ruel Gallery, New York, *Paintings and Pastels by John H. Twachtman*, March 4–16, 1901.

[1901 Cincinnati Art Museum]
Cincinnati Art Museum, *Exhibition of Sixty Paintings by Mr. John H. Twachtman Formerly Resident in Cincinnati*, April 12–May 16, 1901.

[1905 M. Knoedler and Company]
M. Knoedler and Company, New York, *Memorial Exhibition of Pictures by John H. Twachtman*, January 1905.

[1907 Lotos Club]
Lotos Club, New York, *Exhibition of Paintings by the Late John H. Twachtman*, January 5–31, 1907.

[1913 New York School of Applied Design]
New York School of Applied Design for Women, New York, *Fifty Paintings by the Late John H. Twachtman*, January 15–February 15, 1913.

[1913 Buffalo Fine Arts Academy]
Buffalo Fine Arts Academy, Albright Art Gallery, New York, *Paintings and Pastels by the Late John H. Twachtman*, March 11–April 2, 1913.

[1919 Macbeth Gallery]
Macbeth Gallery, New York, *Exhibition of Paintings by John H. Twachtman*, January 1919.

[1919 Vose Galleries I]
Vose Galleries, Boston, *Exhibition of Selected Works by John H. Twachtman*, January 27–February 15, 1919.

[1919 Vose Galleries II]
Vose Galleries, Boston, *Exhibition of Paintings by J. H. Twachtman*, November 10–22, 1919.

[1928 Milch Galleries]
E. & A. Milch Galleries, New York, *An Important Exhibition of Paintings and Pastels by John H. Twachtman*, March 12–24, 1928.

[1937 Brooklyn Museum]
Brooklyn Museum, New York, *Leaders of American Impressionism: Mary Cassatt, Childe Hassam, John H. Twachtman, J. Alden Weir*, October 17–November 28, 1937.

[1939 Munson-Williams-Proctor]
Munson-Williams-Proctor Institute, Utica, New York, *Presenting the Work of John H. Twachtman, American Painter*, November 5–28, 1939.

[1942 Babcock Galleries]
Babcock Galleries, New York, *Paintings, Water Colors, Pastels by John H. Twachtman*, February 9–28, 1942.

[1949 Milch Galleries]
Milch Galleries, New York, *John H. Twachtman*, November 14–December 3, 1949.

[1952 Century Association]
Century Association, New York, *Exhibition of Paintings by Abbott Thayer and John Twachtman*, March 5–May 4, 1952.

[1966 Cincinnati Art Museum]
Cincinnati Art Museum, *John Henry Twachtman: A Retrospective Exhibition*, October 7–November 20, 1966.

[1968 Ira Spanierman]
Ira Spanierman, Inc., New York, *John Henry Twachtman, 1853–1902: An Exhibition of Paintings and Pastels*, February 3–24, 1968.

[1987 Spanierman Gallery]
Spanierman Gallery, New York, *Twachtman in Gloucester: His Last Years, 1900–1902*, May 12–June 13, 1987.

[1989 Spanierman Gallery]
Spanierman Gallery, New York, *In the Sunlight: The Floral and Figurative Art of J. H. Twachtman*, May 10–June 10, 1989.

[1989 National Gallery of Art]
National Gallery of Art, Washington, D.C., *John Twachtman: Connecticut Landscapes*, October 15, 1989–January 28, 1990 (traveled to Wadsworth Atheneum, Hartford, Connecticut, March 18–May 20, 1990).

[1993 Spanierman Gallery]
Spanierman Gallery, New York, *The Intimate Landscapes of John H. Twachtman (1853–1902)*, May 5–July 2, 1993.

[1999 High Museum of Art]
High Museum of Art, Atlanta, Georgia, *John Henry Twachtman: An American Impressionist*, February 26–May 21, 2000 (traveled to Cincinnati Art Museum, June 6–September 5, 1999 and Pennsylvania Academy of the Fine Arts, Philadelphia, October 16, 1999–January 2, 2000).

Selected References

[Baskett, *John Henry Twachtman: American Impressionist Painter as Printmaker*, 1999]
Baskett, Mary Welsh. *John Henry Twachtman: American Impressionist Painter as Printmaker—A Catalogue Raisonné of His Prints.* Bronxville, N.Y.: M. Hausberg, 1999.

[Boyle, "John H. Twachtman," 1978]
Boyle, Richard J. "John H. Twachtman: An Appreciation." *American Art and Antiques* (November–December 1978), pp. 71–77.

[Boyle, *John Twachtman*, 1979]
Boyle, Richard J. *John Twachtman.* New York: Watson-Guptill, 1979.

[Boyle, "John Henry Twachtman," 1980]
Boyle, Richard J. "John Henry Twachtman: Tone Poems on Canvas." *Antiques World* 3 (December 1980), pp. 64–69.

[Chotner, Peters, and Pyne, *John Twachtman: Connecticut Landscapes*, 1989]
Chotner, Deborah, Lisa N. Peters, and Kathleen A. Pyne. *John Twachtman: Connecticut Landscapes.* Exh. cat. Washington, D.C.: National Gallery of Art, 1989.

[Clark, "John Henry Twachtman," 1919]
Clark, Eliot. "John Henry Twachtman (1853–1902)." *Art in America* 7 (April 1919), pp. 129–37.

[Clark, "Art of John Twachtman," 1921]
Clark, Eliot. "The Art of John Twachtman." *International Studio* 72 (January 1921), pp. lxxvii–lxxxvi.

[Clark, *John Twachtman*, 1924]
Clark, Eliot. *John Twachtman.* New York: privately printed, 1924.

[Corn, "Looking at Art," 1992]
Corn, Alfred. "Looking at Art—John Henry Twachtman: A Soft Roaring." *Art News* 91 (September 1992), pp. 45–46.

[Cournos, "John H. Twachtman," 1914]
Cournos, John. "John H. Twachtman." *Forum* (August 1914), pp. 245–48.

[Curran, "Art of John H. Twachtman," 1910]
Curran, Charles. "The Art of John H. Twachtman." *Literary Miscellany* 3 (Winter 1910), pp. 69–78.

[De Kay, "John H. Twachtman, 1918]
De Kay, Charles. "John H. Twachtman." *Arts and Decoration* 9 (June 1918), pp. 73–76, 112, 114.

[Dewing et al, "John Twachtman: An Estimation," 1903]
Dewing, T[homas] W[ilmer], Childe Hassam, Robert Reid, Edward Simmons, and J. Alden Weir. "John Twachtman: An Estimation." *North American Review* 176 (April 1903), pp. 554–62.

[Goodwin, "An Artist's Unspoiled Country Home," 1905]
Goodwin, Alfred. "An Artist's Unspoiled Country Home." *Country Life in America* 8 (October 1905), pp. 625–30.

[Hale, *Life and Creative Development*, 1957]
Hale, John Douglass. *The Life and Creative Development of John H. Twachtman.* 2 vols. Ph.D. diss., Ohio State University, 1957. Ann Arbor, Mich.: University Microforms International, 1958.

[Hale, Boyle, and Gerdts, *Twachtman in Gloucester*, 1987]
Hale, John Douglass, Richard J. Boyle, and William H. Gerdts. *Twachtman in Gloucester: His Last Years, 1900–1902.* Exh. cat. New York: Spanierman Gallery, 1987.

[Larkin, "On Home Ground," 1996]
Larkin, Susan G. "On Home Ground: John Twachtman and the Familiar Landscape." In *"A Regular Rendezvous for Impressionists": The Cos Cob Art Colony 1882–1920."* Ph.D. diss., City University of New York, 1996. Ann Arbor, Mich.: University Microforms International, 1996, pp. 214–39.

[Larkin, "On Home Ground," 1998]
Larkin, Susan G. "On Home Ground: John Twachtman and the Familiar Landscape." *American Art Journal* 29 (1998), pp. 52–85.

[Mase, "John H. Twachtman," 1921]
Mase, Carolyn C. "John H. Twachtman." *International Studio* 72 (January 1921), pp. lxxxi–lxxx.

[May, "Twachtman at the Wadsworth," 1990]
May, Stephen. "Twachtman at the Wadsworth Atheneum." *Art Times* 6 (March 1990), pp. 7–9.

[May, "Visual Poetry," 1991]
May, Stephen. "Visual Poetry: The Landscapes of John Henry Twachtman." *Carnegie Magazine* 60 (January–February 1991), pp. 32–40.

[Peters et al, *In the Sunlight*, 1989]
Peters, Lisa N., John Douglass Hale, William H. Gerdts, and Richard J. Boyle. *In the Sunlight: The Floral and Figurative Art of J. H. Twachtman.* Exh. cat. New York: Spanierman Gallery, 1989.

[Peters, "Twachtman: A 'Modern' in Venice," 1992]
Peters, Lisa N. "Twachtman: A 'Modern' in Venice." In *Insight and Inspiration II: The Italian Presence in American Art: 1860–1920*, ed. Irma Jaffe, pp. 62–81. New York: Fordham University Press, 1992.

[Peters, "Suburban Aesthetic: John Twachtman's *White Bridge*," 1994–96]
Peters, Lisa N. "The Suburban Aesthetic: John Twachtman's White Bridge." *Porticus: Journal of the Memorial Art Gallery of the University of Rochester*, 1994–96, pp. 50–56.

[Peters, *John Twachtman (1853–1902) and the American Scene*, 1995]
Peters, Lisa N. *John Twachtman (1853–1902) and the American Scene in the Late Nineteenth Century: The Frontier within the Terrain of the Familiar.* Ph.D. diss., City University of New York, 1995. Ann Arbor, Mich.: University Microforms International, 1996.

[Peters, *John Henry Twachtman: An American Impressionist*, 1999]
Peters, Lisa N. *John Henry Twachtman: An American Impressionist.* Exh. cat. Atlanta, Ga.: High Museum of Art, 1999.

[Peters, "'Spiritualized Naturalism,'" 2005]
Peters, Lisa N. "'Spiritualized Naturalism': The Tonal-Impressionist Art of J. Alden Weir and John H. Twachtman," in Ralph Sessions et al. *The Poetic Vision: American Tonalism.* Exh. cat. New York: Spanierman Gallery, 2005, pp. 73–88.

[Phillips, "Twachtman—An Appreciation," 1919]
Phillips, Duncan. "Twachtman—An Appreciation." *International Studio* 66 (February 1919), pp. cvi–cvii.

[Reed, "Twachtman's Sensitive Poetry," 1949]
Reed, Judith Kaye. "Twachtman's Sensitive Poetry." *Art Digest* 24 (November 1949), p. 17.

[Roof, "Work of John H. Twachtman," 1903]
Roof, Katherine Metcalf. "The Work of John H. Twachtman." *Brush and Pencil* 7 (July 1903), pp. 243–46.

[Ryerson, "John H. Twachtman's Etchings," 1920]
Ryerson, Margery Austen. "John H. Twachtman's Etchings." *Art in America* 8 (February 1920), pp. 92–96.

[Thorpe, "John H. Twachtman," 1921]
Thorpe, Jonathan. "John H. Twachtman." *Arts* 2 (October 1921), pp. 4–10.

[Tucker, *John H. Twachtman*, 1931]
Tucker, Allen. *John H. Twachtman.* New York: Whitney Museum of American Art, 1931.

[Watson, "John H. Twachtman," 1920]
Watson, Forbes. "John H. Twachtman: A Painter Pure and Simple." *Arts and Decoration* 12 (April 1920), pp. 395–434.

[Wickenden, *Art and Etchings of John Henry Twachtman*, 1921]
Wickenden, Robert J. *The Art and Etchings of John Henry Twachtman.* New York: Frederick Kepple [*sic*, Keppel] and Co., 1921.

Contributors

John Nelson is a retired admiralty lawyer, currently serving as a director and vice chair of Soundwaters, Incorporated, an educational and environmental organization based in Stamford, Connecticut.

Simon Parkes is the principal of Simon Parkes Art Conservation, founded in 1976 in London and re-established in New York in 1979. Parkes has lectured at New York University's conferences on American painting and conducts classes in art restoration for the American Arts Course, Sotheby's, New York. Parkes is also a landscape painter, whose work is the subject of the monograph by Angus Wilkie, *Summer Places: Eastern Long Island and New England* (2005, Vendome Press).

Lisa N. Peters is director of research and publications and co-author of the John H. Twachtman Catalogue Raisonné at Spanierman Gallery, LLC. Among her publications are an article for *American Art Journal* (2000) on the American artists' colony in Polling, Bavaria, 1872–81; *John Henry Twachtman: An American Impressionist* (1999, High Museum); *Visions of Home: American Impressionist Images of Suburban Leisure and Country Comfort* (1997, Dickinson College); *A Personal Gathering: Paintings and Sculpture from the Collection of William I. Koch* (1996, Wichita Art Museum); and an essay in *John Twachtman: Connecticut Landscapes* (1989, National Gallery of Art).

Index

Introductory Note: Bold page references indicate art illustrations, italicized page references indicate photographs, and endnotes are indicated with a small letter "*n*" followed by the endnote number.

Photo Credits

Cat. 49 Photo Credit: John Bigelow Taylor
Fig. 1 Photo Credit: Lisa N. Peters
Fig. 4 Photo Credit: Lisa N. Peters
Fig. 33 Photo Credit: Bruce M. White
Fig. 35 Photo Credit: George Holms
Fig. 45 Photo Credit: Sotheby's, New York
Fig. 46 Photo Credit: Meredith Long and Company, Houston, Texas
Fig. 49 Photo Credit: Christies, New York
Fig. 51 Photograph © 1992 The Metropolitan Museum of Art
Fig. 54 Photograph © 2006 Museum of Fine Arts, Boston
Fig. 56 Photograph © 1985 The Detroit Institute of Arts
Fig. 58 Photo Credit: Christie's, New York
Fig. 67 Image © 2006 Board of Trustees, National Gallery of Art
Fig. 72 Photo Credit: Weir Farm National Historic Site, Wilton, Connecticut
Fig. 73 Photo Credit: Courtesy of William Vareika Fine Arts, Ltd., Newport, Rhode Island
Fig. 74 Photo Credit: Clabir Corporation, Greenwich, Connecticut
Fig. 92 Photo Credit: Jack Abraham

22.

Windmills ca. 1885

Oil on canvas
38 × 51½ inches

See pages 122–23 for full entry.

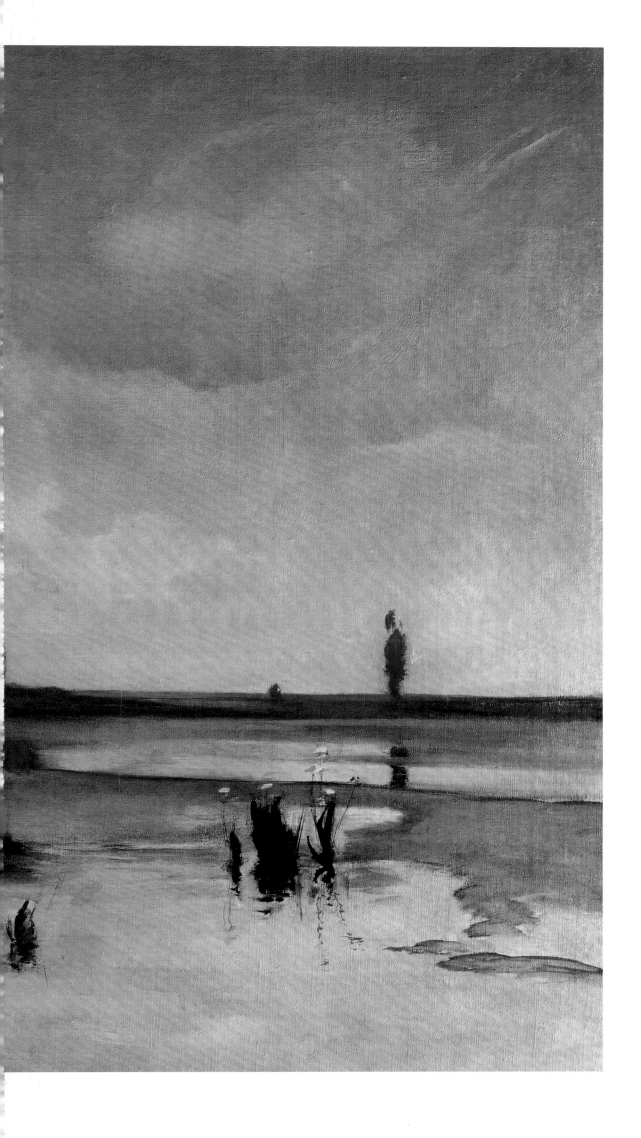

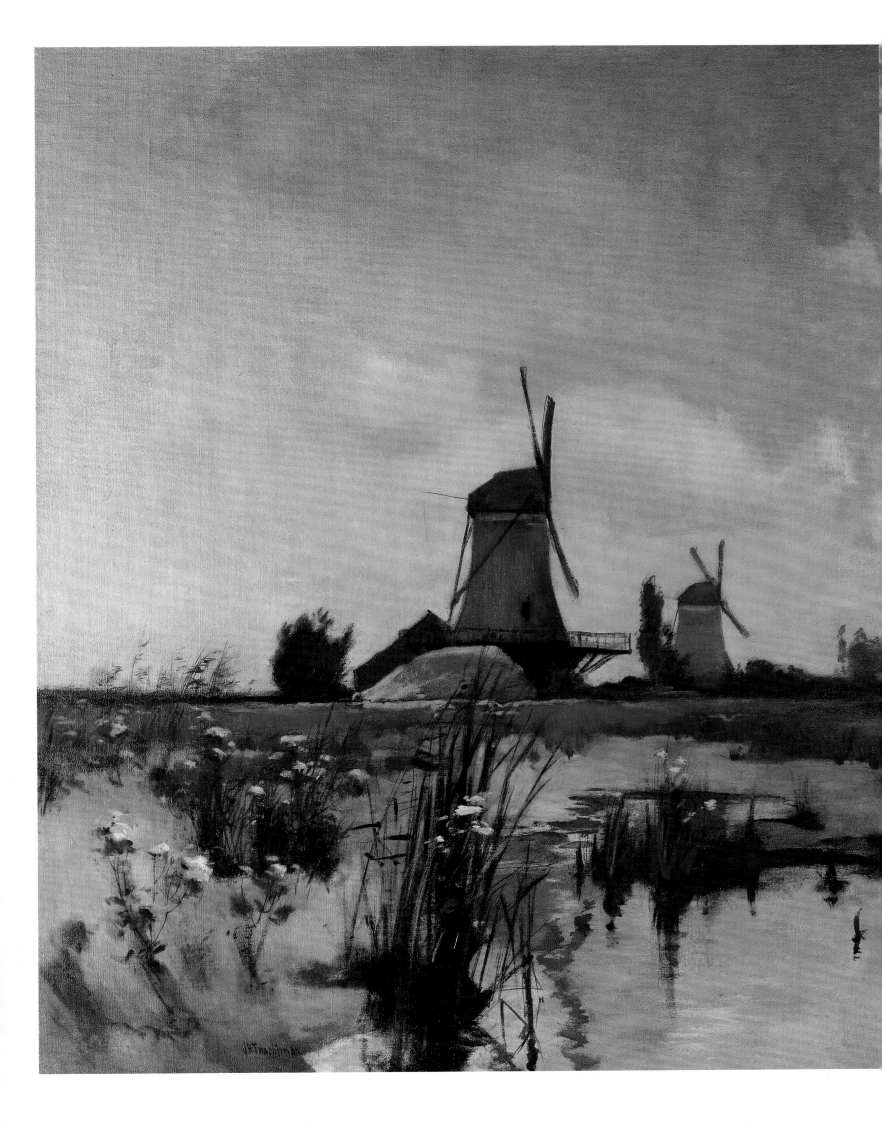